HOW TO
CREATE & SELL
PHOTO PRODUCTS

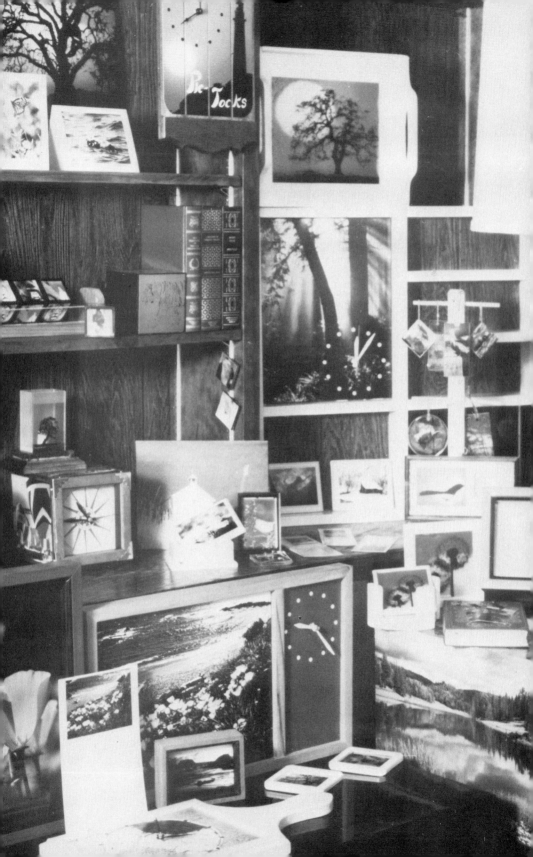

HOW TO CREATE & SELL PHOTO PRODUCTS

Mike & Carol Werner

Writer's Digest Books

Cincinnati, Ohio

How to Create & Sell Photo Products. Copyright 1982 by Michael Werner and Carol Werner. Printed and bound in the United States of America. All rights reserved. No part of this book may be reproduced in any form or by any electronic or mechanical means including information storage and retrieval systems without permission in writing from the publisher, except by a reviewer who may quote brief passages in a review. Published by Writer's Digest Books, 9933 Alliance Road, Cincinnati, Ohio 45242. First edition.

Library of Congress Cataloging in Publication Data

Werner, Michael, 1937-
 How to create & sell photo products.

 Includes index.
1. Photography, Commercial. 2. Photography—Business methods. 3. Photographs—Marketing. I. Werner, Carol, 1936-. II. Title. III. Title: How to create and sell photo products.
TR690.W47 1982 770'.68 82-17392
ISBN 0-89879-088-3
ISBN 0-89879-098-0 (pbk.)

DEDICATION

To Sylvia, Rick, and Jackie—our most enthusiastic fans.

ACKNOWLEDGMENTS

In creating this book, we've received information and ideas from a great variety of sources, including retailers and other photo products entrepreneurs. We'd like to extend our sincere appreciation to all of them. We'd particularly like to thank Georgene Jones and Sammy Berman of the Craftsman's Gallery in Monterey, where the whole idea got its start; Bob Lutz, editor of *Photographer's Market*, for his support from the beginning; our editor, Carol Cartaino, who made us make this the "exemplary how-to" she was sure it was destined to be, and kept us going when the whole project threatened to bog us down; Carol Winters, Sharon Stump, and the other stalwart members of the production department, who helped bring a very complex project to a happy ending; and Ann Colowick, who, we sincerely hope, survived the first draft of our manuscript.

CONTENTS

INTRODUCTION

Competition is a hard fact of life for anyone who wants to make money with a camera. But you can beat that competition—and this is the book to help you do it.

Whether you're a beginner, an experienced freelancer, or a studio photographer who wants to expand his marketing options in an overcrowded field, *How to Create and Sell Photo Products* offers you a real alternative. Photo products can be almost anything you can put a photo on, in, around, or over—photo plaques, framed prints, postcards, calendars, key chains, coasters, puzzles, posters, and much more.

Photo products offer you the chance to photograph what you like and sell those shots in a variety of ways, through outlets in your own hometown or wherever you choose. Why compete with hundreds of thousands of other photographers for already established markets when you can create your own relatively competition-free market?

We'll show you how to accomplish this. We've packed this book with information and illustrations; we'll tell you what to make, how to make it, and how to sell it. We'll go into the practical and legal aspects of setting up a successful photo products business, and describe techniques that can help you add punch to your products. We'll even show how your photo products experience can help you sell your extra shots to the direct submission markets and major manufacturers, if you want to.

The book is organized to make it easy for you to get started. We've presented the topics in order of ease and cost, working from the simpler and more reasonably priced to more complex and expensive products. You can choose those that best suit your interests and goals as a photographer.

We've also included cost and pricing guidelines, but it must be remembered that these will vary with time and from place to place, because of cost-of-living and inflationary factors.

No matter where you live or what your goals as a photographer, the Photo Products Alternative can work for you. It can become an enjoyable and highly profitable part- or full-time business. Whether you're a professional, an aspiring pro, or an amateur looking for a means of "supporting the habit," this book can give you a valuable edge in a very competitive field.

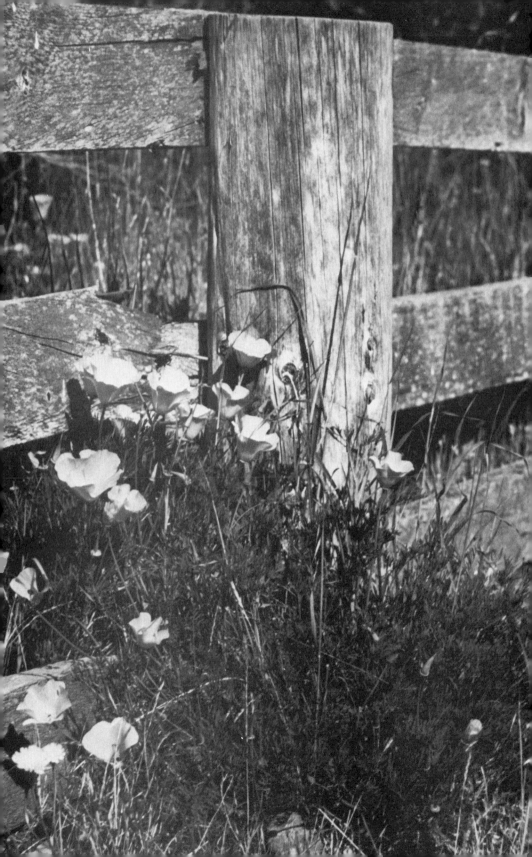

PART
ONE

THE PHOTO
PRODUCTS
ALTERNATIVE

WHY PHOTO PRODUCTS?

Anyone who has ever tried to sell his photographs through the standard methods—by direct submission to publishers and other picture buyers, or opening a studio or gallery—knows just how fierce the competition can be. It is a blunt fact of photographic life that there are too many photographers trying for too few markets. For every one who scores, many more come away empty-handed.

Now there is an alternative. One that allows you to:

* Sell your photographs no matter where you live.
* Start making money right away, regardless of how much photographic or selling experience you have.
* Operate where competition is thin or in many cases nonexistent.
* Establish a highly profitable part-time or full-time business.
* Expand that business until you're making as much money as you want.
* Travel and get paid for it through your photography.
* In short, make a living on your own terms, doing what you want to do—take pictures!

Best of all, this photo marketing alternative can be started and operated right from your own home with very little initial investment of money, time, or space.

Sound like an impossible dream? Well, it's not. In fact, it can be quite simple . . . if you go about it in the right way.

The strategy is to create and sell your own photo products—items that find a ready market in virtually every community.

What exactly are photo products? Stated simply, they are photographs put to work. As clocks, they tell time. As greeting cards, they convey messages or feelings. Photo products can brighten a room, mark a place in a book, and serve a variety of other purposes.

The *Photo Products Alternative* is a method for marketing photography

How to Create & Sell Photo Products

that will work for beginner and professional alike. It can be employed in conjunction with the more conventional photo marketing methods, or it can become a thriving business by itself. Either way, it can give you an important edge over the competition.

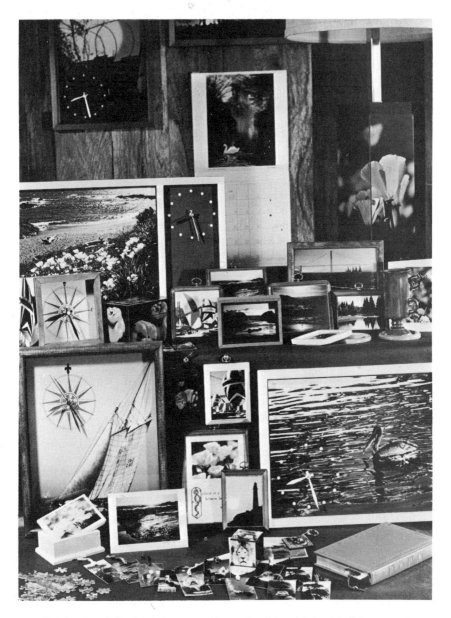

Illustration 1-1: *This is just a small sample of the wide world of photo products you can create from your own photographs and sell to a waiting public.*

THE TROUBLE WITH S.O.P.S

S.O.P.s—standard operating procedures—are ruts we all fall into at one time or another. We do things a certain way because someone told us to. Or because we saw someone else doing them that way. Or because we couldn't think of another way to do them. And the common assumption seems to be: the deeper the rut, the better the S.O.P. After all, a rut was created because a lot of people took a certain course . . . right?

Right. And that's the trouble with S.O.P.s.

Illustration 1-2 shows how S.O.P.s work when it comes to photo marketing. Most photographers try to sell their work in one of two ways. Either they open a studio or gallery locally, or else they contact publishers and other photo buyers through the mail. Those that use the first method have been termed "service" photographers; those that use the second, "stock" photographers. Because of differences in equipment, film, and market demands, the two approaches rarely overlap to any great extent.

These two standard operating procedures have worked in the past for a lot of people. Unfortunately, therein lies their major disadvantage, especially to beginners: competition. The simple fact is that the S.O.P.s in photography are overused.

Service photography. Flip through the Yellow Pages of your phone book. Chances are you'll find plenty of service photographers listed. Dig a little deeper and, unless your community is atypical, you'll probably discover an overabundance of this species, some of whom are commercially successful, many of whom are barely afloat. Together, they constitute a photographic establishment that's mighty tough for a beginner to break into.

Furthermore, opening a formal studio introduces you right off the bat to fixed overhead, those expenses that must be paid on a regular basis, regardless of how much income your business is generating. Fixed overhead is a gremlin in a business suit that can undermine a fledgling operation right from the start.

There you stand in your new studio with the gremlin on your shoulder gobbling up money in the form of rent, advertising, utilities, and sales help. The Fixed Overhead Gremlin has a hearty appetite. It doesn't care if customers are slow in coming or if other expenses—film, processing, photo equipment—are rapidly soaring out of sight. All it knows is that it must be fed day after day, month after month—if your studio lasts that long.

It takes time to establish any business, and a photography studio is no exception. Considerable risk is involved in any enterprise that must earn, right from the start, hundreds of dollars a month just to pay expenses.

Of course, you can start out slowly and less formally by utilizing a spare room at home. This approach can keep the Gremlin at bay, but it, too, has a major drawback: lack of that all-important prerequisite of success we'll call *visibility*. You and your work must be seen to be appreciated. People have to know who you are and what you do before they can hire you to do it.

And that's essentially what service photographers do: take pictures that people hire them to take. Depending on your temperament, it can become a pretty boring task. A service photographer friend of ours once asked, "Aren't there times when you just can't face getting up in the morning?" Our answer

How to Create & Sell Photo Products

was an emphatic *no*. By and large we photograph what we want to, when we want to. If we feel like going to the mountains, we do that. If we find ourselves in an ocean mood, we pack our gear and head for the water. And if we don't want to go anywhere, we can tackle some creative work right at home in our studio. Not a portrait studio, but a place to create exciting special effects. The point is this: We can make those decisions because we photograph *for our own products!*

On a recent photo trip it struck us that we no longer take vacations. Vacations in the normal sense don't seem necessary, because we're doing exactly what we most like to do, each and every day. And there's no reason in the world why you can't do the same.

Stock photography. This approach to photo marketing generally offers more variety than service photography, although the pressures of competition are forcing increased specialization. Direct submission to publishers and other photo buyers can be done right from home with little or no fixed overhead. This method is appealing to beginners, and consequently photo editors are swamped with submissions. Competition is awesome for the major markets, and compensation poor for the minor ones.

As with service photography, the beginner is captive to standard operating procedure. He or she will probably first obtain a "marketplace" publication, study it for likely buyers, select a few of the more promising (generally those that pay the highest), package up some photos, and send them off. And then, with great expectations, sit back and wait.

And wait.

And wait some more.

Until, more often than not, the photos come back, accompanied by coldly impersonal form letters: "Dear Photographer, Thank you for your interest . . . however . . . "

Deadly, that word "however." Deadly to dreams and ambitions.

An aspiring stock photographer is lost without such market guides, and yet take a moment to consider the effect they have on the marketplace itself. They take a lot of the work out of locating markets, but by making direct submission easier, they encourage more photographers to give it a try. And by focusing attention on the buyers listed, *they actually increase the competition for those markets*. (A no-win situation, if ever there was one.)

Photo marketing guides are invaluable tools if you know how to use them effectively and if you're willing to work at meeting the needs of the buyers. Frankly, it takes a great deal of time and effort to become a successful stock photographer. Just accumulating enough slides for a decent start can be a problem.

For example, we regularly receive invitations to submit slides to a church-bulletin publisher. Photographers are encouraged to send any number of slides they wish, and, as the invitation notes, some respond by sending *thousands*. Few beginners can match that output!

While most photo buyers are much more restrictive in terms of the size of the submissions they will accept (from twenty of your *very best* transparencies on up), the point remains: Most beginners simply do not have enough photos to meet the demands of a thriving stock business.

In stock photography there's no such thing as overnight success. Granted, there's frequently that first sale that comes right away, that makes it all seem so easy. A check for $200 arrives—one-time calendar use for a Pacific sunset photograph. That's how it started for us. Oh boy, we had it made!

Well, it didn't quite work out that way. Nearly a year went by before we made our second sale. By that time we were somewhat wiser about the realities of direct submission. The growth of a stock photographer is like that of a good solid oak tree—slow and steady. The oak adapts to the elements of nature, the stock photographer to the demands of the marketplace.

Stock photography is a worthy goal, one we encourage you to pursue as part of your overall marketing strategy (see Chapter 13). But for impatient people like us, it wasn't enough. We wanted a way to make money right away. The question became: How can a beginner start making a reliable income from photography as quickly as possible? The answer for us was the Photo Products Alternative.

WHY PHOTO PRODUCTS?

The most overwhelming argument in favor of the photo products approach is the lack of competition. Creating and selling your own products allows you to work locally, in areas of low competition. And these areas are available to every photographer, no matter where he or she lives.

True, making photo products may require some additional skills over and above photography. But some you already have: If you can glue a photograph to a piece of paper you can make greeting cards. If you can put a photograph into a ready-made frame, you can sell framed prints. Others are easily learned, or you can arrange to have the work done for you. But you may find, as we did, a great deal of satisfaction in learning and perfecting the varied skills of product making itself.

Photo products can provide a steady income right from the start. There may be some fluctuations—tourist seasons, for example, or times of peak buying activity such as Christmas, followed by slower periods—but these become predictable. As we (and countless other photographers) have learned, stock photography can be feast or famine (mostly famine) in the beginning. Just because you sell to a calendar company once doesn't necessarily mean you'll sell to them again. Nor does it mean that anyone else will be interested in that particular photo. Each new submission is another "sell."

Not so with photo products. Once you've placed them with a retailer, that person assumes the task of selling them. The same photograph can be sold hundreds or thousands of times in a variety of ways. And each and every sale puts money in your pocket!

Increasing your income is simply a matter of increasing your sales outlets and your production. But your "selling job" only has to be done once for each marketing outlet you establish. And if the products are well done, they will sell themselves to merchants and, ultimately, to their customers.

After all, you may be the only photographer a merchant sees all year. In fact—and this has happened to us—he might even have been looking for someone just like you, someone who can give him a locally oriented product that he can't get anywhere else.

How to Create & Sell Photo Products

THE PHOTO PRODUCTS ALTERNATIVE

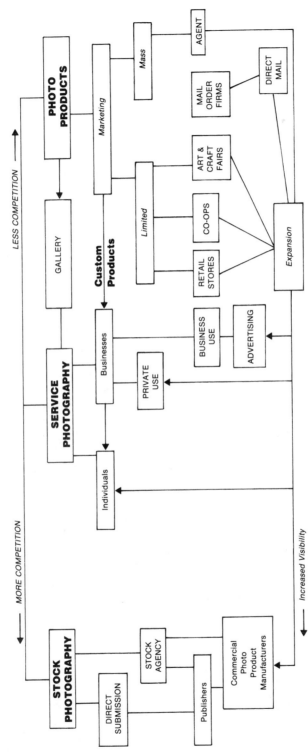

Illustration 1-2: *A graphic overview of the Photo Products Alternative. As a business in itself, or in league with more conventional marketing methods, it can be your path to success.*

Contrast that with the thousands of photographers a photo editor sees through their submissions in a year and you'll begin to understand the meaning of low competition. Even in prime tourist areas where photographers are likely to be more active, you may be the only one who can supply a specific product—cards, plaques, bookmarks, whatever—that will set your photography apart. Photo products offer you the opportunity to greatly expand the marketing potential of your photographs.

Plus a bonus. Your products can serve as stepping stones to both service and stock photography. For example, we've found that becoming our own editors has sharpened our feeling for what will sell on a broader scale. Putting a photo on *your own product* makes you more critical; you begin to understand why some were rejected by those unseen and unfeeling editors with their impersonal "howevers." You will gain insight into the kinds of photographs people want to buy, and you may be in for some surprises!

Creating and selling your own photo products actually improves your photography, makes it more commercial. And the effects will carry over into your stock photo sales.

Expanding your business to include custom photo products can lead you into the field of advertising photography as well. Made-to-order items such as photo signs, photo business cards, and photo letterheads can help you achieve that all-important *visibility* within your community and beyond—wherever you choose to market your products.

Of course, developing your own product line does mean becoming your own editor, salesperson, and assembly worker, at least initially. But the first two jobs must be tackled no matter how you market your work. The third need present no great problem, since many of the products can be easily and quickly assembled in fairly large numbers. Later on, as your business grows, you can contract out the more repetitive work.

And where does it all lead?

Independence. As a photographer, you can develop your own photo lifestyle if you wish, living where you want to live, supporting yourself through your photography and own ingenuity, prospering even in the places where no one else can eke out a living. Or you can concentrate on the business angle.

A study of the market guides from a different point of view reveals that most of the buyers listed are themselves photo product manufacturers of one sort or another. Their products—magazines, books, cards, calendars, etc.— are intended for different markets than yours will be (at least in the beginning). Most, if not all, started out small, just as you propose to do. From a single photographer or cooperative group, they steadily expanded to become big full-time businesses that buy other people's pictures. You can do the same, if you're so inclined. Every business in every field had to start somewhere, and photography is no exception.

The important thing is to *start*. And to know where you're going. Others have done it and so can you.

That's what this book is all about. In it you will discover a wealth of products that you can adapt to your local market. And once your business is established, you can expand to other communities and even nationwide if you desire.

TAKING THE SECOND STEP

In reading this far, you've already taken a very important first step: You've opened your mind to a different photo marketing approach—one that can take you as far as you want to go. The purpose of this book is to help you achieve that potential.

We'll go about this in two ways: first by examining a variety of products and marketing techniques that have proven records in the marketplace. They have worked for us and for other photographers and they can do the same for you. You can adapt these ideas to your own talents and marketing area and be reasonably certain of success. The products will give you a vehicle for selling your photography, but in the final analysis it is your photography that will sell your products. With this in mind, we have offered suggestions concerning *how* and *what* to photograph in order to maximize your sales.

Second, we have focused on the matter of originality—how to come up with your own photo product ideas. To some this may be the most important part of the book. Daring to be different can be risky, but the rewards can be great. Many of the products discussed in Chapter 8 are admittedly flights of fancy, intended to arouse your creativity, to get you thinking. The purpose of this chapter is to carry you beyond the confines of the book, so that the Photo Products Alternative doesn't become just another S.O.P.

Your next step is to examine yourself and your marketing area. Determine your strong points as a photographer, then select those products that best suit your talents and situation.

Finally, don't lose sight of the overall photo marketing picture outlined in Illustration 1-2. Your photo product business can become a means to an end, or it can become an end in itself. Whatever your goal, it will allow you to control your own future in photography.

LAYING THE GROUNDWORK

Two factors will greatly influence the direction your photo products business takes right from the start. The first is your understanding of yourself as a photographer, and the second is your understanding of your marketing area.

Evaluation is an important part of any business. In fact, it's an ongoing process in just about every aspect of life. Each day we reel through a series of decisions and opinions—some requiring a degree of thought, others seeming to come naturally. Sometimes we agonize over a problem; other times we reach a solution in a flash of intuition.

Both methods of evaluation have their place in photography. Sometimes there is simply no substitute for careful thought and planning. At other times, we must be prepared to go with the moment, to act on intuition.

These two decision-making processes—rational thought and intuition—are more closely related than one might imagine. Careful planning, thoughtful evaluation—both can set the stage for those all-important flashes of insight. (In Chapters 4 and 8 we'll consider some ways to prime the intuitive "pump.")

Actually, you're well on your way toward developing these evaluative skills in relation to photography. Certainly you've admired the work of one photographer and criticized that of another for whatever reason—subject matter, technique, or simply because you liked or disliked it. "I know what I like" is a valid criterion, and in fact it's a major determining factor in the purchase of photo products—something to keep in mind when assessing the tastes of your prospective customers.

This evaluative process probably continued with the acquisition of your first camera. If it was a gift from Aunt Louise, you had to decide how serious you were about photography, whether to pursue the hobby or consign the camera to a closet until the next time Aunt Louise came to visit. On the other hand, if you bought your first camera, you chose a particular make and model over all others. Maybe you liked the way it looked or handled, its features, or its price. Or you were influenced by technical comparisons in the photography

magazines or by recommendations from a friend. Or could it be that you picked the camera the attractive fashion model or the well-known football player was advertising on television? One way or another, you made an evaluation and went with it. And the process continues whenever you pick up that camera.

Every time you compose a shot you're evaluating. Lighting conditions, subject placement, foreground and background—all these things and more must be taken into consideration. At first it's almost overwhelming; all the details must be kept in mind. But gradually more and more becomes second nature, freeing you to become increasingly creative, to develop your individuality, your own "eye."

Again, when you sort through the finished photos, keeping those you like and discarding the rest, you're evaluating.

What we would like you to do at this point is to organize your evaluative process, to channel it toward getting your photo products business off to a solid start.

FIRST, EVALUATE YOURSELF AS A PHOTOGRAPHER

Here you need to be tough and honest with yourself—as impartial as the buying public will be once your products are in the marketplace. By and large, your customers won't care who you are, how many degrees you have, what kind of camera you use, what kind of creative statement you are trying to make, or how qualified you are. They will buy a product because they like the photograph.

Anyone can produce a salable photograph. The hard part is *consistently* producing salable photographs. So first you want to ask yourself some probing questions to determine your level of skills.

How well do you know your camera? Do you take enough photos to be thoroughly familiar with its operation?

Do you know how it reacts under various lighting and weather conditions? Can you come up with consistently good exposures whether you're shooting in the snow, in heavy shadows, or at sunset? Do you understand how to control depth of field? If you have several lenses, can you use them to full advantage?

You should be able to answer yes to these and many more questions about the operation of your photo equipment. If not, try these two things. First, read about your camera. Start with your camera manual (have you ever really read it from beginning to end?)—that may be enough. Or a basic how-to book in camera operation may be helpful (see Appendix B). Second, go out and take pictures. That may sound too simple, but the best way to get to know your camera is to use it. The more you use it, the more effective you'll become.

Do you have access to a darkroom? If so, how competent are you? Can you make your own color prints, for example? Or would you prefer to leave that to someone else? If you don't have darkroom experience, would you be willing to learn? And is there someplace—a nearby college or photography store, perhaps—where you can get the training you need?

Although darkroom experience is not a prerequisite for a successful photo products business, it is helpful, especially in the beginning. The more you can

do for yourself, the greater your profits.

How do you rank yourself as a photographer: beginner, intermediate, or professional caliber? The quality of your photography may have little or no relationship to how long you've been taking pictures. We've known shutterbugs who've been at it for years and can still only come up with beginner's results. Others can produce consistently beautiful shots right from their very first roll of film.

The point is: How does your work compare to what you see in magazines or on calendars and greeting cards? Almost anyone can succeed in photo products. But it's important to recognize your own level of competence and then work in the right direction.

Don't discourage yourself by believing that professional photographers take only great photos. Professional photographers take shots that sell. And the salability of a photograph is often determined by how well it does an intended job—how well it illustrates what the buyer wishes to have illustrated. There are definitely times to curb the creative urge, especially when simple, direct communication is called for.

This is often the case with tourist-oriented photo products. For example, we market-tested two different photographs of pelicans in a shop in Monterey, California. One was what we considered to be a beautiful shot of an immature brown pelican bobbing amid the bright reflections of yachts in the harbor. It was consistently outsold, however, by a standard photo of the mature bird standing on a concrete piling.

Why?

Because, as one lady explained, "It looks more like a pelican!"

And of course she was right. Although greatly outnumbered by the immature birds, the white-headed adult was what most people regarded as *the* pelican.

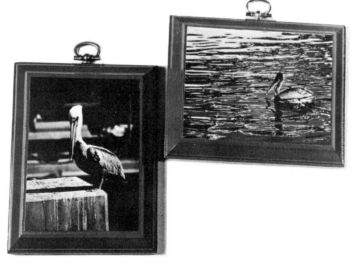

Illustration 2-1: *From the standpoint of salability, the choice of "best" photo will be made by your customers.*

In photographing for products, consider first the best representation of your subject and second, the artistic treatment. As a general rule, the latter should not be permitted to interfere with a clear photographic statement.

Certainly there are places in your photo products line for your great shots as well, but it is much more important that you be able to take photographs that do the job. This you can learn to do no matter what your level of skill or experience.

IS IT ART?

Learning to take the kinds of photographs that people will buy sometimes means going against the grain of past training. This is especially true if you've taken classes that emphasize the art approach to photography.

It isn't easy (and might be impossible) to define exactly what constitutes art, particularly where photography is concerned. One man grumbles, "If it doesn't make any sense, it's art." A woman comments, "I don't know if it's art, but I know what I like."

A sculptor friend once explained, "It's up to the artist. If he wants to call it art, then it's art."

And how do you get to be an artist? "By calling yourself one."

If you want to call yourself an artist, fine. And if you want to market your work as art, that's okay, too. In Chapter 7 we'll consider photography as both pure and applied art—in this case as applied to home and office decor. And in Chapters 14 and 15 we'll describe photographic techniques for making big, bold graphic-arts images.

But for the time being, it's perhaps best to put aside those abstract shots you've accumulated in the wake of classroom assignments. Sad but true, the art photography market is very limited (and in many areas nonexistent) for beginners. That being the case, we'll concentrate on making photography both appealing and affordable to the widest possible audience. And, frankly, that's an "art" in itself!

EVALUATING YOUR PHOTOGRAPHY

At this point, take some time to study the photos you already have in your collection. Divide them into three groups (not including any of those abstract shots you've already set aside): black and white, color slides, and color negatives. Later on, we'll consider the advantages and disadvantages of each in your total marketing strategy. Right now, however, you're interested in determining the following things: (1) what you like to photograph, (2) what you photograph best, and (3) how many photographs you can use immediately on your products.

Let's start with your color work since it's more applicable to photo products. Choose either your color slides or color negatives depending on which group is the larger. Now divide that selection into categories, keeping them general at first; for example, scenics, people, or animals.

Again, choose the largest group. Arrange the photos on your desk or a table according to subject: mountains, oceans, or lakes. Once again, select the largest group, say mountains, and further subdivide it. At this point you might have a stack of shots of a local attraction called Mount Mighty, another for

Mount Misty, another for Mount Majestic, and a collection of mountains in general (those for which you have no name or which occur with several other peaks).

Since your first marketing area will probably be in or near your hometown, put yourself in the shoes of your potential customers. What kinds of photographs would you buy (or take) if you were a tourist or a local resident interested in home decor or gifts that are representative of the area? Select the stacks that illustrate features you think will sell to these customers. If Mount Mighty is the most popular attraction, concentrate on it first. Go through your Mount Mighty photos and eliminate any that are obviously unsatisfactory. Weed out any that are over- or under-exposed, that have scratched or damaged surfaces, that have Uncle Joe (or anyone else) staring at the camera.

Now look at the remaining Mount Mighty shots with an ultra-critical eye. Study each one carefully, asking yourself, "Is this the best I can do?" and "Is this photo good enough for *my* products, with *my* name on it?" If you can answer "yes" to both questions, keep the photograph in your selection. A no demotes it from your "photo products starter selection." Don't throw these demoted shots away, however; they may still be salable through direct submission.

Label a sheet of paper "Mount Mighty." On it, list the good photos you have of the mountain, dividing them into even narrower categories. These categories might include "Mount Mighty in the Summer" and in other seasons, "Activities on Mount Mighty" such as skiing and rock climbing. Then look for holes in your coverage of this subject. Perhaps you'll find that you don't have any winter shots; if so, jot this possibility down on your list. These holes will become future photo assignments that you can make for yourself (Chapter 4 will go into this in more detail).

Once you've finished analyzing your Mount Mighty shots, do the same for photographs of other attractions in your area. Again, set up some assignments for yourself to plug any holes you find.

Finally, ask yourself if there are any attractions you may have overlooked—the scenic water-powered mill, for example, or the historic country inn. Add these to your list of future assignments.

At this point your "photo products starter selection" will include geographical, historical, and general-interest features shot in your area. But photographs don't neccessarily have to be local in order to be of interest. Suppose you live in Kansas, but you just happen to have a fine collection of dramatic ocean scenics taken while on vacation in California. Does this mean you can't use them on products because they aren't representative of your local area?

Not at all. In fact they could be among your best sellers.

Some subjects are in demand almost everywhere, and the sea quite possibly tops the list. For some reason it fascinates us all. For many a landlubber a lake will suffice, but in lieu of either, a photograph is the next best thing to being there. Other subjects of wide appeal are mountains, rivers, waterfalls—awe-inspiring examples of nature's grandeur. On the other end of the scale, nature in microcosm—a solitary wild flower, for example—can be just as inspiring and popular. A case in point is the California poppy, one of our bestselling subjects.

The idea is to study your photography, to find out exactly what you have to

How to Create & Sell Photo Products

offer. Chances are, if an image really appeals to you, it will probably appeal to others as well, regardless of where it was taken. The ultimate test, of course, is in the marketplace.

As you categorize, notice your own preferences when you photograph. Do people frequently appear in your photos? If so, are those people incidental (you overlooked them when snapping the shot) or planned as part of your overall composition? If the latter is true, do you like to zero in, to take close-ups of faces and of people interacting? Or do you tend to shoot things—automobiles or boats, for example?

No matter what you like to photograph, there's a market for it in photo products. Most people love to take scenics, which is one reason they're so tough to sell by direct submission. Photo products are ideal for your scenics, which might also include some evidence of human activity such as a solitary canoe on a lake at sunset or hot-air balloons. Animals, sports action, delicious-looking things to eat, buildings of historical interest—even people (usually thought of as a subject for direct submission)—all would make good photo products subjects (in Chapter 4 we'll go into the specifics of photo products photography in more detail).

Are you primarily a color or B&W photographer? When it comes to making money, both have their pros and cons in either the photo products or direct submission market (see Chapter 13). Since both approaches will have a part in your overall marketing strategy, you should keep both in mind when photographing.

Again, as you sort through your photos, keep asking yourself, "Is this one really good enough to go on one of *my* products?" If the answer is no, try to determine what you could have done to improve it.

Perhaps you discovered too many of those incidental people mentioned above. A leg walking into a picture or a telephone pole sprouting from someone's head—things you didn't even see when you snapped the picture. Putting the camera on a tripod for a while can help eliminate these oversights. Once set up, you can take time to view every aspect of composition, as well as the picture as a whole, and be sure it's exactly what you want before snapping the shutter. Once you've mastered the important technique of really *seeing* through your viewfinder, you may wish to forgo the tripod again except when it's needed for other reasons.

Now back to your categories. Have you answered the questions: (1) What do I like to photograph? and (2) What do I photograph best? These might not be the same, nor are they necessarily indicated by numbers of slides. Quantity may indicate only proximity or convenience—the subject was handy, so you shot it . . . and shot it. But you might be happiest spending the day in a field getting dramatic photographs of horses, something that's not all that easy to do. Or perhaps eating the dust at a dirt track, catching motorcyclists in action. Even if your favorite category doesn't seem likely for photo products, set aside your best shots anyway. Later in this book, you'll learn how to find the best market for them.

When you've finished your lists and critical review of your photographs, you should have a pretty good idea of your strong and weak points. The next step involves a little footwork. Visit local card shops and stationery stores and

look at the photo products they have on display. Compare the quality of the photographs with your own work; see how similar subjects are handled. You don't want to copy anyone else, but you do want to get an idea of what is selling. From here, your concern is to constantly improve your work and make it more salable. Studying the marketplace can help you do this.

You might also give some thought at this time to a filing system for your slides. We've suggested some approaches in Chapter 12, but if you get organized right at the beginning, it will save you a lot of time later on. Hang onto your lists, too. We'll talk more about how to use them in later parts of the book.

GET TO KNOW YOUR MARKETING AREA
AND YOUR COMPETITION

No business stands much chance of success unless two things are fully understood at the outset: (1) the potential customers and (2) the competition.

Communities differ. What meets with spectacular success in one place may fizzle in another. What about your community? Is it rural or urban? How do people make their livings? Is the population relatively stable or regularly infused with tourists? Can you identify any special interests in your area? Are there large numbers of horse ranches, for example? Is there an air base or a college? Is it a railroading community? All these considerations and more have a bearing on the kinds of photographs and products you sell. The better you understand your marketing area, the better your chances of success.

Where you choose to start is up to you. For the sake of convenience, you may pick your own community or one nearby. A town where you already know some local merchants who might handle your products would be an ideal place.

We believe that the Photo Products Alternative will work for you no matter where you live. Don't, however, automatically expect your hometown to be the best place to put your shingle out. Obviously, you need customers for your products. If you live in the country or in a small community, you may have to go a little farther afield to get your start. That's precisely what we had to do. No one is all that far from a regional shopping center these days. And there is always the option of marketing by mail order (see Chapter 11).

On the other hand, you may have taken most of your photos elsewhere—a nearby tourist attraction, for example. If so, that might make a more logical starting point. Tourist areas have the advantage of a constant flow of new customers for your products. Such places, however, are more subject to seasonal fluctuations in buying activity. You can also expect greater competition from other photographers. Consequently, your early marketing research will have to be extra thorough—you will have to carefully study what is already being done and what approach will best get your foot in the door.

The important thing is to choose an area that you can get to know and photograph really well.

Researching your market. No matter where you begin, or how often you expand into new locations, your first step should always be the same: Research your market. Learn as much as you can about the people, the place, the photographic possibilities, and the marketing outlets available.

Again, do some footwork. Visit local stores to determine the tastes—tra-

18

ditional, avant-garde, whatever—of their customers. Start with gift shops, then go on to outlets such as stationery, department, discount, and bookstores. Try religious gift and bookstores as well as art supply stores and galleries. Even garden and auto stores can tell you about the tastes of your community and, eventually, become outlets for your photo products. The products you see are meeting an existing need, just as your products will be. We'll be returning to this consideration frequently in connection with specific products.

Fulfilling a need is the cornerstone of any business. If you are to succeed financially, *you must find out what people want and then supply it.*

Sometimes, of course, people don't realize they want something until they see it. Take the Pet Rock phenonmenon, for example. Who could have predicted that craze? Even the originator of the idea has found it difficult to duplicate its success.

Photo products are less likely to meet with such spectacular success (although the "Hang In There" cat poster undoubtedly made a fortune for someone!), but some combinations will prove more popular than others. We really didn't expect our photo bookmarks to take off like they did. Likewise, it came as a pleasant surprise to discover that a Canadian tourist had bought out our whole supply of photo plaques—only a week after we had introduced them in that particular shop!

Surprises—good and bad—are part of market research, especially in the beginning. Achieving consistent success means developing a feel for what will or will not sell in your chosen area.

Toward this end seek advice wherever you can get it. This doesn't mean you have to act on all free advice as though it were carved in stone, only that it can serve as a useful guide. Through your market research you will meet many merchants who have made a good living over the years by anticipating and meeting the needs of their customers. You can certainly profit from their experience. We did, and still do!

The community in which we live isn't exactly a photographer's paradise, but it does have one feature of interest to tourists. Yet, for years we had managed to overlook it—photographically speaking—until a local shopkeeper commented on the large number of requests she got for photographs of the historical county courthouse. She had even asked a local photographer to make her some prints . . . but he hadn't "gotten around to it." She didn't have to ask us twice, and her advice proved sound.

For a photographer what the competition is *not* doing is often more important than what it *is* doing. Be thorough with your investigative footwork. Wander into furniture or interior-decorating stores, sporting-goods or specialty shops—anywhere and everywhere that might feature photography. You may find that you have a wide-open field. If so, grab the ball and run as fast as you can before some other local photographer catches on to what you're doing!

Or you may discover that someone is already selling the obvious photo products such as locally oriented framed prints or greeting cards. This will be especially true in a prime tourist area. If so, take a look at what's already available, but don't be too discouraged. That was the situation we faced when we started our photo products business in California's Carmel-Monterey area.

The Monterey Peninsula probably contains more photographers per

Illustration 2-2: *Photographs don't have to be "great" to be salable on photo products. Take advantage of whatever your community or marketing area has to offer. Local merchants often know what their customers are looking for.*

square foot than anyplace else on earth—at least that's the way it seemed to us. Everywhere, galleries and shops overflowed with framed prints and greeting cards of one sort or another. Not only were photographers stumbling over each other, but all kinds of artists and craftspeople competed in droves for the tourist dollar. Talk about discouraging!

When we mentioned the possibility of displaying our work in the more conventional ways, we were greeted with anything from a polite "No, sorry" to an outright burst of laughter. "Are you serious?" (accompanied by a wave of the hand—toward the door). The implication was: Who needs you?

It's hard to imagine a more difficult place in which to gain a foothold! But we did try—with a new approach—and we succeeded. In fact, the very first shopkeeper we spoke to wanted to hang our work at once! Up on the wall went our samples, and we found ourselves rushing home to make a second set for another gallery owned by the same person. Not only was that merchant our first retailer, she was also among our first customers.

How to Create & Sell Photo Products

No, she wasn't a kindly relative. She was a businessperson who recognized the potential of photo products.

Our secret?

Simply that our photographs were different from those of the other four photographers she represented. The difference went beyond style—our photographs *did something extra*. In that particular case, they told time. And those clocks were the beginning of our photo products business.

We have since expanded our line and our outlets, but the essential point is this: Those clocks got someone's attention because at the time no one else was doing quite the same thing we were. Our product stood out, it opened the door. Our clocks gave us *visibility*; your products can do the same for you.

Admittedly, we spent a great deal of time studying the market and the competition, determining what was needed to make the breakthrough. Once we decided on clocks, there still remained the critical matter of designing them for that particular market. One of the aims of this book is to help you do the same thing for your area.

Selecting your own door openers. Seen in retrospect, clocks were a pretty ambitious first product. They're relatively expensive to make and require a high price tag, which makes them a big gamble, especially if you haven't had a chance to market-test the photographs themselves.

Base your own choices for first products on your market research, but try to keep them as simple as possible. Mounted prints are ideal because you will be testing only one thing for salability—the photograph itself. Even the simple act of framing it will add another element—people may like the print but not the type of frame you choose. A good compromise is to offer both. Hang some framed prints as finished products and also display some, matted or mounted, in racks such as those shown in Appendix F.

If someone in your area is already doing framed or mounted prints, you might try plaques. If greeting cards have been done, consider a calligraphy variation or perhaps bookmarks. There's almost always something you can do to open the door and get an edge on the competition.

SOME PHOTO PRODUCTS BASICS

Commercial success in photography demands that you develop a good photographic eye as well as a good command of your equipment. It also demands a commitment in time. This is true regardless of how you choose to market your work.

The rate at which your business will grow depends to a large extent on how much time you devote to it. Time spent learning your craft, both through study and behind the camera; time spent researching your markets; time spent preparing the photographs for sale—all of this, plus time lost wandering down blind alleys, can add up to a considerable investment, especially in the beginning. But with experience comes efficiency. Markets become established. And you learn from blind alleys. Your business gets on track and starts to roll.

Now you find yourself with other problems—the problems of success. Eventually, you may need to make some decisions. Do you want to grow large enough to become a full-time operation? Do you plan to do all the work yourself or hire others? Do you want to apply the brakes a bit, slow down, keep your

photography business only a supplement to your current job?

In the beginning, however, you and you alone decide how much time you want to spend. You can control the expansion of your business as you see fit, at any rate you feel you can handle.

In one sense, marketing your photos as products will be more timeconsuming than selling them through direct submission. You'll have to put together a lot of cards or plaques to match a hundred-dollar sale to a calendar publisher. On the other hand, it may take you six to eight weeks to make a calendar sale, during which time you could easily have made *several* hundred dollars' worth of cards or plaques or whatever products you choose. With the Photo Products Alternative both marketing methods complement each other nicely. And of course there's always the very real chance that your submission will come back with a "however" letter, in which case that period of time would indeed have been lost were it not for your photo products.

Elbow room. Creating your own photo products also requires a certain amount of space. Naturally, it's nice to have a shop for woodworking and painting, a studio and a darkroom for photography, and an office for the required paperwork. Nice but not necessary. We started out assembling our simpler products—cards, bookmarks, framed prints, even plaques—on our kitchen table. Unglamorous, but it worked. From there, we graduated to a corner of a spare bedroom with an old folding table purchased at a garage sale. A little dedicated cleaning and rearranging gave us part of a closet for storage of materials and finished products. A little more cleaning and rearranging moved the operation into the garage.

And so on. It's a rare house or apartment that won't allow you enough elbow room to make a great variety of products.

Capital investment. How much will it cost to get started in photo products? That depends on where you start and what equipment you already have available. Some products—clocks and photo furniture, for example—require a larger investment in materials and specialized tools. But given only simple equipment common to most households, plus a few inexpensive materials readily available in most communities, you can assemble a set of sample prints and products—greeting cards, plaques, frames, bookmarks—for under $25. In fact, if you happen to have the right kind of print already, it's possible that you could turn a quick profit of several hundred dollars with an initial investment of the price of a postage stamp.

Sound incredible? Not so. We'll show you how to do it in Chapter 3.

The key to limiting your investment is to start slowly and then, as your business begins to generate income, pour some or all of your profits back into expansion. If you follow this formula, the Photo Products Alternative is virtually risk-free.

Generally speaking, little is required beyond your basic photographic equipment. Naturally, there are tools that make certain jobs quicker and easier—a paper cutter, for example—and you may wish to purchase them as your budget allows and increased sales warrant. But in the beginning you'll find most of what you need right around the house. Your main expense will be the cost of prints, which, as we will show in the next chapter, need not be prohibitive.

How to Create & Sell Photo Products

Cameras and lenses. Here is where most photographers would rather spend their money, and with good reason. The single most important selling point of any photo product is the photograph. That, more than anything else, will cause a customer to buy or reject it.

From the point of view of convenience and versatility, we prefer a late-model single-lens reflex camera (35mm), preferably automatic with manual override. With this camera and a standard 50mm lens, you should be able to take enough good pictures to get your photo products business off to a running start.

We also own a slightly larger format camera that takes 6cm by 4.5cm slides that we use primarily for submission to greeting card and calendar companies. If you are considering direct submission, especially of your scenics, the larger transparencies will give you an edge over the competition. The larger-format camera can also be used for product photography, since it is a fact that the larger your original transparency or negative, the better the quality of the resultant print.

But there are other things to consider. Large-format cameras cost more than 35mm cameras, as do the lenses and accessories. They are heavier and more awkward to move around and are more likely to require a tripod. And while many commercial greeting card and calendar firms prefer to see the larger formats, more and more are looking at and buying 35mm slides as the quality of 35mm film and lenses improves.

Though you can get the job done with a single camera and lens, your work will become a lot easier and more creative if you also acquire the following:

1. *A zoom lens.* Zoom lenses have their drawbacks, one of which is their bulk. In addition to being heavier to carry, the larger zooms put added strain on the camera-lens coupling which may cause future problems. However, modern lens technology is resulting in increasingly smaller and lighter zooms, making this less of a complaint. Of more concern is their clarity: They simply do not produce as sharp an image as corresponding fixed focal length lenses.

 On the plus side a zoom lens's greatest asset is its versatility. Instead of several lenses, you need carry only one, and that one will give you a variety of shots from a single location. Your zoom will help make important decisions about how much or how little to include in your scenic photos. It's also useful when going after wildlife. (Pictures of animals, particularly ones for which your area is noted, are generally good sellers.) Finally, since most of the prints used on photo products aren't very large (11x14 or smaller), the loss in sharpness isn't that critical.

 The 70-210 zoom (or one near that range) is a good choice for product photography.
2. *Close-up lenses or attachments.* We've found that a 135mm macro lens is excellent for close-up work such as that involved in flower photography. A plus is the different point of view—compression of distances and narrow depth of field—given by a slightly longer lens, which seems to lend itself to a more creative treatment of almost any

subject. However, any sort of macro lens that allows you to zero in on flowers, insects, interesting details, etc., can add variety and impact to your products.

Insects? Yes! Monarch butterflies are among the top sellers throughout our whole range of products.

A much less expensive approach to macrophotography is to purchase a set of close-up attachments. These are available in different strengths or powers and come in sets of three, including +1, +2, and +4 attachments. The higher the number, the greater the magnification and the closer the lens allows you to get to your subject. These auxiliary lenses fit the standard lens like filters and can be used individually or in combination to get the desired effect. They can bring you as close to your subject as a macro lens, sometimes even closer. Their disadvantages are that they have to be added or removed (one more thing to carry around) and that they collect more dust than macro lenses.

Auxiliary close-up lenses can also be purchased as part of a square filter system designed to fit all lenses through the use of adapters (see Chapter 14).

3. *A second camera body.* As you do more and more photography, you'll find that a second camera body is a great advantage. It's useful, for example, to have one body fitted with a standard lens and the second with the zoom. When a picture turns up unexpectedly (both wildlife and lighting effects can be fleeting), you'll have both lenses quickly at hand. It's very frustrating to miss a great shot because you're fumbling with lenses, trying to get them changed. Or worse yet, because you left the second lens back in the car!

Some photographers carry color film in one camera body and black-and-white film in the other, thus giving them greater versatility. We shoot primarily Kodachrome 25, but we keep one automatic body loaded with 64. That little extra speed often comes in handy when photographing wildlife or action.

A second body is also invaluable when the first camera fails or when you run out of film just as the perfect shot appears. Or both! Such as the day we were photographing river runners. Not only did we run out of film (just as a pair of kayakers plunged into a section of particularly wild water), but the film jammed as we started to rewind it. We were able to switch quickly to a second body and get the photos we wanted. Without that option, our choices would have been to open the camera and risk losing some of the shots we already had or else lose those that promised to be even better. There just wasn't time to solve the problem on the spot.

Other equipment. It seems the longer you pursue photography, the more equipment you need (or at least *think* you need). Sometimes it's a snowball effect—you just roll along picking up everything you come across. You can become overequipped to the point where lugging around all that gear actually interferes with the photography itself. More than once, we've seen someone

How to Create & Sell Photo Products

miss a shot just because he was busy running back and forth to his car. By the time everything was assembled to his satisfaction, the shot was gone.

Still, there are other useful accessories: an assortment of special-effects filters (see Chapter 14), a long lens for animals (400mm or 500mm), a bellows for ultra-close-ups, a flash unit, and so on and so on and so on. As you get more and more involved, you'll come across pieces of equipment that seem necessary to you. The key word is *necessary*: Will they improve your photography or your products? From now on the purchase of equipment should be considered a business expense, one you can justify as *necessary*.

Film. One of the reasons that the functions of service and stock photographers rarely overlap is that they generally use different kinds of film. For color, most service photographers prefer negative film, whereas stock photographers shoot transparencies. The reason? The demands of the market.

Negative-type color film is easier and cheaper to process and print—an important consideration in service photography. Custom processing labs are geared to handle negative film and frequently charge extra for prints made from transparencies. The service photographer deals primarily in photographic prints.

Stock photo markets, on the other hand, rarely use color negatives. Thus a stock photographer's color collection will consist almost exclusively of slides.

As a photo products photographer, you can use either. Negative film will probably reduce the cost of the prints you use on your products. On the other hand, it will virtually exclude you from the direct submission market. For this reason, we recommend that you use Kodachrome 25 or 64 and keep that option open.

Use faster films only when necessary—if, for example, you anticipate a lot of action shots under poor lighting conditions. Just as the size of your transparency influences the quality of the resultant print, so does the speed of the film. ASA 25 film will be less grainy and reproduce better than film of ASA 400. This increased graininess will be less apparent in the smaller prints you use on products. But again, you'll probably want to keep direct submission markets in mind. Remember, you'll probably create many more pictures than even a booming photo products business can use.

A darkroom. Being able to make your own color prints is a distinct advantage, especially when you're just getting started. You can be certain of good, consistent quality at a price you can afford. You'll also be able to introduce greater variety into your product line. That's important in determining what will and won't sell in your area.

Sometimes handling your own darkroom work will help you more accurately judge the reproduction quality of your photographs. As soon as we started making our own prints, we discovered a tendency toward dense photos. The colors looked superb when viewed with a projector, but many transparencies were just too dark to reproduce well. Undoubtedly this cost us direct submission sales in the early going.

Density can be a problem in slides. A photograph that looks great with a bright projector lamp behind it may need from one-half to a full stop more exposure in order to reproduce well. It's also true that some markets—certain greeting card manufacturers, for example—like a light, airy photo while oth-

ers, like photo magazines, often prefer greater color saturation. Working in your own darkroom can help you to discern these differences in your photos and to make decisions about which slides to send out.

Darkroom ability also enables you to experiment with special effects— those attention getters that can draw a customer's eye to your products.

Even when your photo products business has reached the point where mass commercial printing is necessary, you can still turn out sample prints for your custom lab to work from. This helps to guarantee the results you want.

We realize that some photographers have neither the time nor the space to get involved with a darkroom. Still others may lack the money or interest. If you fall into any of these categories, there are other options. These will be dealt with in the chapters that discuss specific products. Suffice it to restate at this point that although helpful, a darkroom is not a prerequisite for a successful photo products business.

PART TWO

THE PRODUCTS: WHAT TO MAKE

FIVE EASY-TO-MAKE BESTSELLERS

Okay, enough of the preliminaries. Roll up your sleeves and let's get down to the essence of the Photo Products Alternative—the products themselves!

Assuming you've done the marketing groundwork described in Chapter 2, you're now ready to decide how best to approach your market. There are five products that make ideal starters: framed or unframed prints, greeting cards, calligraphy cards, photo plaques, and postcards. They are simple and inexpensive to make and should virtually sell themselves just about anywhere. In your area consider any of the places where you did your market research—gift, stationery, and bookstores, specialty shops, etc. (see Chapter 9). Depending on what's already available in your area, you can go with any or all of the five; each has its own niche in the marketplace.

Unlike bookmarks—another good seller—none of the five requires any special darkroom operation. A commercial lab can handle your printing in any quality or quantity you desire. Consequently, all lend themselves well to both limited and large-scale production.

For those who wish to do their own darkroom work, directions are given in Chapter 15, for the construction of printing masks. These masks facilitate making multiple prints—four card-sized photos, for example—on a single sheet of photographic paper.

In this chapter we'll consider each of the five in practical terms, including construction and assembly techniques. The next chapter will be devoted to the all-important subjects of *how* and *what* to photograph for these and subsequent products.

PHOTOGRAPHIC PRINTS

Mounted prints, either framed or unframed, are versatile products. They can command high prices when produced on a limited basis and hung in galleries as fine art, or they can be turned out as economically as possible for sale to the mass market. The latter includes not only tourists who want "memory"

How to Create & Sell Photo Products

pictures for themselves or for gifts, but also people who are seeking inexpensive accessories for home and office decor.

Reasonably priced photo-art is in demand. We know numerous photographers who average several hundred dollars a month in sales from a *single marketing outlet*. They offer prints ranging in size from 3½x5 to 11x14 inches, mounted on cardboard, matted, or inexpensively framed, generally priced from $5-$25. As might be expected, the smaller sizes sell in greater volume because of their lower price. The same is generally true of unframed versus framed prints. The most popular photographs are usually those that give a strong feeling of place, rendered in a moody, romantic style—plenty of early and late daylight, sunsets, warm color tones. These photographers are accomplished artists who take pictures for the general public, not just for collectors.

Chapter 7, "Art and Decor Art," will consider the more expensive print forms and presentations; here we're interested in reaching a broader spectrum of customers. We want to make photography as affordable as possible in order to maximize sales.

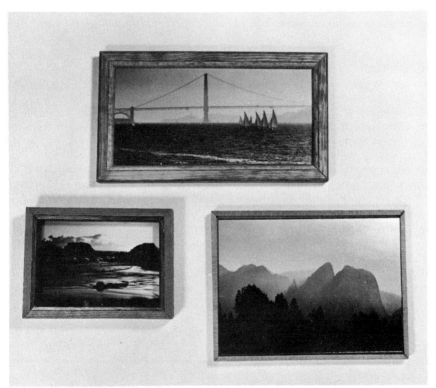

Illustration 3-1: *Reasonably priced framed prints. Keep the cost low by offering the prints mounted on cardboard, matted, or inexpensively framed. The frames shown were made from standard molding available at lumberyards or building supply stores. You can sometimes arrange with a local framing specialist to supply you with inexpensive ready-made moldings.*

Start by eliminating the frame hang-up. Mention a framed print and what comes to mind? Usually the full exhibition treatment: photograph matted behind glass, all encased in an ornate or sleekly modern frame. And—presto!—a $10 print is transformed into a $40 investment (frequently much, much more) that may draw admiring glances but few, if any, buyers.

You want to turn those admiring glances into sales. The best way to do that is to give people something they can afford, and this means trimming away the frills. (If an occasional buyer wants full exhibition treatment, either provide it on a custom basis and charge extra or let him take the print to a framing specialist.) Settle for the least expensive, attractive frame you can find. Or economize even further by making your own, even if it means investing in a backsaw and miter box, both of which are necessary for tight-fitting corners. Lumberyards and home-improvement centers generally have a wide selection of frame moldings, or you can save even more by designing your own from cheaper materials, as shown in Illustrations 3-2 through 3-7.

Compromise on print quality. Cutting costs also means economizing as much as possible on the prints themselves. Again, this is easier in the beginning if you do your own darkroom work, although many mail-order labs now offer excellent prices on quantity orders of automated machine prints. The results should be adequate as long as your original transparency or negative is of good quality. Some labs are better than others, however, and prices do vary; so you might want to check with your local camera store or fellow photographers for recommendations. Or simply shop around.

People who buy inexpensive photographic prints aren't looking for exhibition quality. Nor do they expect such prints to last forever. Moods and tastes change. What is comfortable and "right" today may chafe and seem out of place next month or next year. Like it or not, ours is a disposable society. Be cheered by the thought that the buyer who tires of one print and consigns it to the attic or Goodwill bin may return to purchase another to take its place.

Walk a fine line when it comes to quality. Spend only as much as is necessary to get an acceptable print.

Print groupings. One way to encourage multiple purchases is to offer several photographs related by a common theme—color tones, subject matter and location, lighting, mood, texture. The prints may be sold as a unit or merely displayed together to emphasize their unity. For example, photographs of local wild flowers, scenic attractions, or animals might be grouped together. Depending on the nature of your market, you might even add a touch of whimsy like a giraffe photographed such that its head, neck, and body appear in three separate prints. Use a similar approach to create a scenic panorama or an action sequence like a kitten spying a ball of yarn, giving it a tentative paw, and finally wrapped in yarn from nose to tail.

HOW TO: Framed Prints

Framing your own prints need not be expensive or time consuming. You can buy your frames ready-made or construct them using inexpensive material and hand tools.

Ready-made frames. As always, the biggest problem is keeping the cost down. For example, if you plan a sale price of $6 for a 3½x5-inch framed

print, your cost should run no higher than $1.50 in order to make a reasonable profit. This means you can afford to budget around $1 (preferably less) for a frame and about 50 cents for the print. (Chapter 9 will discuss more thoroughly the matter of pricing your products.) This cost factor will probably restrict you to simple wood or plastic frames. The simpler frames will also have the widest appeal.

Start your search for frames locally, especially in discount stores. Take along pencil and paper to note manufacturer's names and addresses when you find suitable frames, even if they're not quite in the right price range. Write the manufacturers to see if you can buy in quantity at wholesale prices.

Another good place to locate manufacturers or suppliers is in photography or crafts magazines (prices tend to be lower in the latter). Visit your local library or newsstand.

And finally, check with your local custom-framing specialists; it's possible they can give you a price break or at least put you in touch with some sources of inexpensive frames.

Making your own frames. You will need a miter box and a backsaw for cutting joints, a hammer and some small finishing nails (brads) or staples, and a strong but easy-to-use glue such as Elmer's professional carpenter's wood glue. Picture-frame molding can be purchased by the foot from framing shops, lumberyards, home-improvement centers, or mail-order suppliers (see Appendix A). Manufactured molding will have a rabbet, or notch, cut along the inside edge to hold the picture in place. Again, the simpler styles will be the least expensive.

Determine the amount of frame molding needed by first measuring the length and width of the photograph, then doubling the figure. Since you will be making diagonal cuts, you will also have to allow for a certain amount of waste. If the frame molding is narrow ($\frac{1}{4}$ to $\frac{3}{4}$ inch), add about 5 inches. For wider moldings measure the width of the molding itself, multiply by 6, and add this to your initial figure.

For example, if you wish to frame an 8x10-inch photo, the overall dimensions will be 8 + 10 x 2, or 36 inches. For a narrow molding, buy 41 inches of

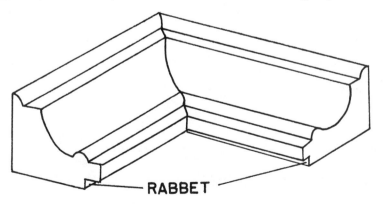

RABBET

Illustration 3-2: *Commercial moldings have a precut notch called a rabbet to hold the picture in place.*

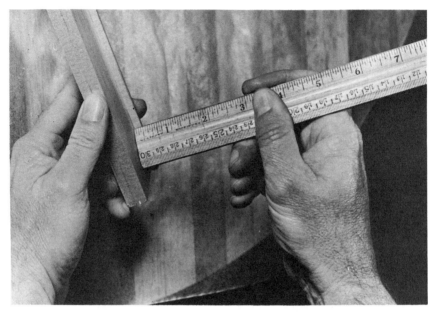

Illustration 3-3: *Measuring the depth of the rabbet to determine the frame dimensions before cutting.*

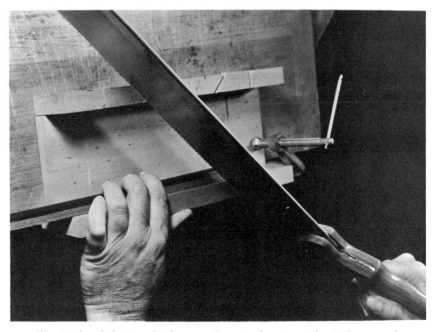

Illustration 3-4: *Use a backsaw and a miter box to cut the 45-degree angles for the frame. Although more elaborate miter boxes, including powered ones, are available, the simple type shown will work just fine with a little practice.*

material. If the molding you choose is wide, say 2 inches, multiply the width by 6 (12 inches). You would then need to buy 48 inches of the wider molding.

Before making any cuts, measure to see how far the frame is going to overlap the photo (see Illustration 3-3). For a narrow frame it will probably be ¼ inch on each side. When you make your cuts, you will have to allow for this overlap. It might help to think of frame making as similar to cutting mats. When you cut a mat for an 8x10-inch photo, the opening measures 7½x9½ inches. The same is true for a frame cut to fit that particular photo; in other words, you would cut two pieces with an *inside* (rabbet side) measurement of 7½ inches and two pieces measuring 9½ inches. Make similar adjustments for other-size prints or rabbets.

Use a backsaw and miter box to cut accurate 45-degree angles. Saw from the front of the molding to the back to avoid splintering the viewing side of the frame. It will help to clamp the miter box to a solid surface and to use a piece of scrap wood to support the rabbet.

The frame pieces may be fastened together with brads or staples. Larger frames may require stronger joints, which can be achieved by gluing and then nailing the joints. Use corner clamps to keep the frame square, or make a simple jig as described in Appendix D.

Filling nail holes and joints with wood dough is usually reserved for more expensive frames (and will be covered in more detail in connection with photo clocks in Chapter 6), and the same holds true to extensive finishing. Some frames will be attractive enough to market as is—those made of redwood or oak, for example. Others may require a coat of paint or stain, the latter followed by a coat of varnish or polyurethane varnish.

The photographs can be glued to mount board with rubber cement (or use a mount press or have your custom lab mount them for you—both options will be more expensive) and held in the frame with brads or special nails available from framing shops.

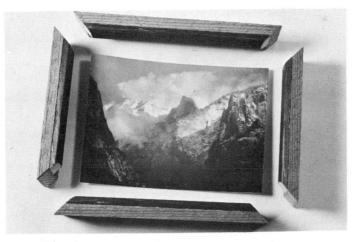

Illustration 3-5: *A simple frame, cut and ready to assemble. The corners may be nailed with small brads or stapled from the back.*

Designing your own moldings. You can cut your framing costs approximately in half by assembling your frames from standard trim moldings, normally used around doors or windows or between wall and ceiling. Some are shaped so that an angle can be used as the rabbet; others can be combined to form a rabbet. Shop around to see what materials are available in your area. Those used for the moldings in Illustration 3-6 can be found in most lumber and building supply stores. If you explain what you are trying to do, the sales personnel can often make helpful suggestions.

Illustration 3-6 shows how a lattice strip can be combined with a variety of standard trim moldings—in this case, quarter round and cove moldings. A lattice strip will give you a frame approximately 1⅜ inches deep, with the width determined by your choice of trim molding (see Illustration 3-7).

First, glue the trim molding to the lattice strip to form a rabbet. Rubber bands can be used to hold the pieces together while the glue dries. You can paint or stain the molding after the bond is firm, or you can wait until the frame is cut and assembled. For variety, the trim molding and the lattice strip can be finished in different colors before gluing (avoid painting the edges that are to be glued, however).

The finishing touches. Your least expensive framed prints will be just that: a frame and a mounted print—no hooks, hanging wire, mats, glass, or other embellishments. However, you can tailor your framed prints to just about any price range you desire by adding any or all of the above and by giving the frame itself a more polished, professional-looking appearance (see Chapters 6 and 7).

Unframed prints. By eliminating the frame altogether, in favor of prints mounted on cardboard or matted, you can reduce the price even further. It's a good idea, when possible, to offer *both* framed and unframed prints, thus giving your customers the option of adding the finishing touches themselves.

Although you can buy the materials to cut your own mats at most frame shops, purchasing them ready-made will save you time and probably give better-looking results. A custom-framing specialist can cut your mats for you

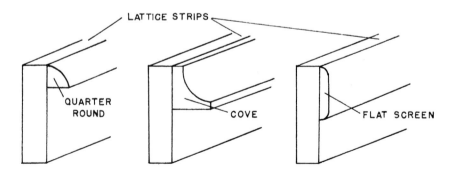

Illustration 3-6: *One way to make attractive, inexpensive frames is to combine standard trim moldings to form a rabbet.*

NOSE
AND COVE

QUARTER
ROUND

HALF ROUND

CAP

LATTICE

SCREEN

CASING AND BASE

CORNER
GUARD

COVE

NECK

PICTURE

SHELF CLEAT

Illustration 3-7: *A variety of commercial moldings suitable for frames.*

quite inexpensively, or you can order them from suppliers (see Appendix A). As with frames, cost should be the most important consideration. Stick to standard sizes and a few neutral colors that will go with a great range of prints—beige, gray, blue-gray, gray-green, off-white, etc. Mounted or matted prints can be displayed in racks such as the one shown on page 139. Construction details for this and other display racks are given in Appendix F.

GREETING CARDS

"The card that's also a gift." These words, appearing on a display of photo cards, are one photographer's way of distinguishing his product from a host of similar mass-produced items already on the market. Without going into production on a large scale himself, there's no way he could offer fine color photographs for the same price as the photo cards of a major greeting card manufacturer. So instead he emphasized the *gift* aspect—the fact that his cards feature a small (3½x5-inch), signed original photograph suitable for framing. Each is mounted on a folded piece of high-quality paper and comes with a matching envelope.

Your line of greeting cards will face a similar situation. You will be asking people to pay two or three times as much for your product as they would for a mass-produced card. They will do that if you can give them something they can't get from the major manufacturer.

Give them a more personal treatment. Your card is something that can't be purchased just anywhere, and it features a *signed* print—not an impersonal lithographic reproduction. When they send your card, they will indeed be sending a unique gift.

And take advantage of another edge you have over the mass producers— give a local slant to your product. Commercial card manufacturers must ap-

peal to the tastes of the general public nationwide (or at least throughout their distribution area). They can't afford to focus as sharply on a specific market as you can.

Visit any local card shop. Pick a popular greeting card theme—sunsets, for example. Most could have been taken anywhere (including a studio, as was one of ours that we sold to a major manufacturer). Commercial manufacturers are out to capture mood, not place. You can do both.

While you're there, browse a bit. You can get a general idea of what sells (and what *you* should photograph and how) by studying those commercial cards. Companies like Hallmark, American Greetings, and Paramount have put a lot of time, effort, and expense into researching the buying habits and tastes of greeting card customers. Learn as much as you can from their experience. Ask the sales personnel what themes seem to be popular—many of these can be given a local slant. In Chapter 4 we'll give more consideration to the various approaches you can take in your product photography, but for the time being it's enough to say that you can learn a great deal from the work of other photographers, no matter where you find it. Always be on the lookout for fresh ideas. Don't copy, but rather give them your own creative interpretation. Any subject can be seen and expressed in a variety of ways.

Color cards. The main problem with color cards is obtaining prints at affordable prices. With higher-priced items such as photo clocks or decor-art prints, you have more leeway in absorbing this cost; for inexpensive products like cards, however, that margin becomes pretty slim. Your cards have to carry a price tag in the $1.75 to $3.00 range or they simply won't sell.

In order to make a reasonable profit, you'll have to keep your cost per card under $.75. This includes print, paper, envelope, and whatever protective packaging you choose. So unless you do your own darkroom work, shopping around for the best deal is even more important for cards than for framed prints.

If you plan to offer a variety of products—for example, cards, framed prints, and plaques—you might consider standardizing your prints. Pick one size, 3½x5 inches, for example, and use that on all your products, at least in the beginning. That way you can cut costs by placing larger orders.

You can purchase paper and matching envelopes in a variety of textures, colors, and styles either at stationery stores or from job printers. Since the latter usually have the best prices, it's a good idea to get to know a printer, especially if you plan to try printed messages or calligraphy on your products. Be selective. Choose one with whom you can establish a good relationship—one who will not only give you a good price but take the time to answer your questions and offer advice.

When marketing your cards, a worthwhile extra touch is to package them individually in clear plastic envelopes which keep them clean and give them an exclusive look. For this purpose, you can use plastic sandwich bags from the supermarket or discount store.

Black-and-white photo cards. We seem to live in a color-oriented world these days, which makes B&W photography somewhat difficult to sell except through direct submission or, in some cases, as art. Many collectors prefer B&W photographs, which they consider to be more permanent than color, which has a tendency to fade with time. Still, for products purposes, B&W

photos can have a drama all their own. If you're a B&W photographer, selling them this way is certainly worth a try (and the effort to identify pictures—and themes—that work well as products in black and white).

Because black-and-white cards are cheaper to produce, you can offer them at a lower selling price. They are also cheaper and easier to *mass-produce*, an important consideration when it comes to expansion.

Mass production of color cards is an expensive and specialized process. Few job printers are set up to handle color work, although most have contacts in the field and can get it done for you, often at better rates—through professional discounts—than you can find on your own. Press runs in the thousands are necessary to bring the cost per color card down to a reasonable level. Until you've built up an extensive marketing network and your products have proven themselves, placing such large orders isn't practical except in the case of custom cards or products (see Chapter 10).

Black-and-white cards, on the other hand, can usually be printed locally and in smaller numbers, although the larger-the-quantity-the-greater-the-savings axiom still holds true.

We've seen dramatic scenics, action sports, and even flowers done effectively as B&W cards. Mood shots also lend themselves to B&W interpretation, as do the ever-popular animals, especially in humorous situations. Historical points of interest—old buildings, trains, or sites for example—can often be better placed in a context of time through black-and-white or sepia tones. In short, in any situation where color is subordinate to subject matter, you might consider black and white for cards or other products. Understand, however, that B&W cards will be at a disadvantage in the marketplace. The prints must therefore be of very high quality.

HOW TO: Gift Cards

To make your own gift cards you will need prints, heavy paper—greeting card or announcement stock, similar in weight to construction paper—matching envelopes, and rubber cement, or spray-on photo adhesive. We find that 3½x5-inch prints work well with 6¼x9-inch paper, although you can adjust the dimensions to suit your own taste. Proportion is the primary consideration—some combinations just don't look right.

Illustrations 3-8 to 3-10 show how you can make your own card-size prints in the darkroom. Refer to Chapter 15 for a more complete discussion of the techniques involved as well as for instructions on how to make the printing mask.

Prints may be glued to the paper stock with rubber cement or spray-on photo adhesive. First, fold the paper in half crosswise, then center the photograph from side to side, but allow a little more space at the bottom than at the top. This bottom space will be used for captions (subject, location, etc.). Once you have a picture location that seems right, you can speed up the assembly process by making a positioning guide from heavy paper or cardboard. Simply cut the guide to the width of the lower margin, then mark the side margins on it. When using rubber cement to glue the photo in place, a stronger bond will be obtained if you apply a thin coat to both the back of the picture and the card stock.

With the photograph glued in place, cover the card with a sheet of

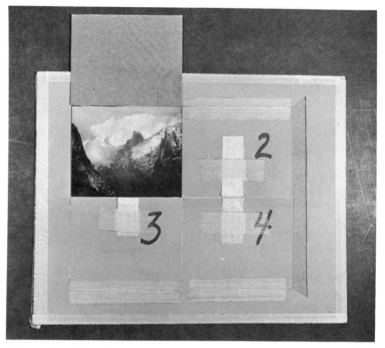

Illustration 3-8: *When you do your own darkroom work, a printing mask will allow you to make four 4x5-inch prints on one sheet of 8x10-inch photographic paper.*

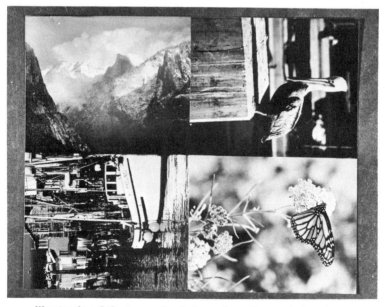

Illustration 3-9: *A completed sheet of greeting-card-size photos.*

Illustration 3-10: *Use scissors or a paper cutter to trim the prints to the desired size.*

smooth, blank paper (typing or waxed paper will work; anything without print or texture that might be transferred to the photo), then weight down with books and allow the cement to set.

Sign the photograph in a lower corner with a fine-tip pen and add any appropriate captions in the lower margin. Keep your captions short but include any important selling points such as subject or location. On the back of the card put your copyright information: © symbol, the year, and your name.

Seasonal cards. Card buying peaks during certain times of the year: religious holidays such as Easter/Passover, Christmas/Hanukkah, etc.; May and June for graduations and weddings; and summer months for tourism, to cite the more obvious. Be aware of the special opportunities these periods offer, and prepare for them. Add to the list any local or regional celebrations or events. People are usually receptive to cards that reflect their lifestyles or area; try to give them what they want.

And think ahead. While it may be impractical for you to develop a line of Christmas cards (at least in the beginning), you can still provide winter scenics that might be just what some people are looking for. You can't shoot those frosty scenes in midsummer. Well, you can if you know what you're doing, but it's a lot easier and cheaper to get those shots in the winter when there is snow, and that may be a year in advance of when the card actually goes on the market. The big manufacturers have to plan ahead and you will too. Photograph this autumn for next fall's line. Catch the spring flowers when they're fresh. Take advantage of what each season has to offer.

Custom cards. Holiday and special seasons are also good times to promote custom cards featuring individual homes, family gatherings, businesses,

Illustration 3-11: *Glue the print to the card stock with rubber cement or spray-on photo adhesive. Center the photograph from side to side but allow a little more space at the bottom than at the top. You can position the photo more quickly and easily if you first make a guide. Cotton gloves are a good idea in order to avoid smudges and fingerprints while smoothing out the photo.*

Illustration 3-12: *Use a fine-tip pen to sign the photograph. Your caption beneath the print should identify the subject and location, or any other pertinent data (for example, "Half Dome in Winter, Yosemite Nat'l Park, CA").*

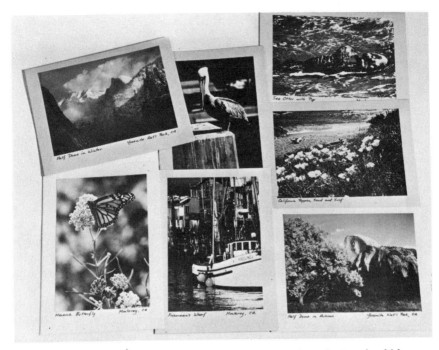

Illustration 3-13: *A selection of best-selling photo gift cards. You should be able to come up with an appealing selection suited to your own marketing area.*

etc. Be sure to advertise this service well in advance (two to three months for a major holiday like Christmas). Even so, a lot of people will wait until the very last minute to order! Custom products will be discussed in Chapter 10.

CALLIGRAPHY CARDS

The simple photo gift card provides space for the sender to write his or her own message. People often have difficulty finding the right words to suit an occasion, or else they just don't want to go to the trouble of thinking them up. If you can come up with those elusive appropriate thoughts to go with your photography, it will be to your advantage, especially in the face of competition.

While this type of card is particularly suited to holiday or special situations (birthdays, condolences, bon voyage), mood-type photos coupled with inspirational messages are popular all year round. In fact, there's a very strong market for inspirational and religious-oriented photo products of all kinds. Most communities have one or more shops that specialize in such items; be sure to include these as part of your marketing research.

You can test your own abilities as sage and poet by making up your own messages, or you can use someone else's words. Check your library for books of poems, quotes, or toasts. (There are quite a few good ones around these days.) Other good sources of material are local toastmasters' clubs and sacred works. Naturally, the message and the photograph should complement each other as much as possible.

Five Bestsellers

Illustration 3-14: *Calligraphy can be a worthwhile addition to your greeting cards.*

When using other people's words, keep this in mind: Current copyright laws protect a person's written words for fifty years from time of death. Material from scriptures or from most newspaper articles (unless specifically copyrighted) may be used without difficulty. To stay on firm legal ground, however, don't use written material from anyone who's still living (or has recently died) without first obtaining permission. Be especially careful about poetry and song lyrics.

Have your job printer add the message to the paper stock before you attach the photo. You can minimize the printing costs by having the message "camera-ready" so that no typesetting is involved. This means you supply it in finished form so that all the printer has to do is run off the copies. If you have a steady hand and good penmanship, you're in business. If not, you can buy a mechanical lettering set or have someone do the lettering for you. Other alternatives are to buy gummed or rub-on letters and do your own composition. Both are available in a variety of sizes and styles at stationery stores or from most printers. Be sure to check with your printer first regarding his requirements for camera-ready copy and for his recommendations.

Calligraphy—the art of beautiful handwriting. One Oregon photographer we know earns several hundred dollars a month by combining her photography with calligraphy. On a photo greeting card the handwritten message can range from a simple "Season's Greetings" or "Wish You Were Here" to quotes or whole poems. Either the photo or the calligraphy can dominate, de-

44 How to Create & Sell Photo Products

pending on your preference and the effect you wish to achieve.

If you have the talent, calligraphy is a skill worth learning. It's wise to consider anything that might give you an advantage over other photographers. There are numerous instruction manuals, practice pads, and pens available in most stationery stores. The current renaissance in calligraphy is such that many books have been published on the subject in recent years and some colleges and other organizations are even offering classes on the subject. You can choose from a variety of accepted styles or you can develop one all your own. Calligraphy is a discipline, and a free-flowing hand comes with practice, but the time is well spent if it can increase your sales.

If you're not interested in learning the art yourself, you can usually find someone to do your calligraphy for you. If classes are offered in your community or one nearby, contact the instructor for recommendations. A store that handles supplies might also be able to put you in touch with a calligrapher. Other places to try include the art or mechanical-drawing department of your local high school or college, the community art league, a shop that sells calligraphy, and perhaps even your job printer. In the event that all of these sources come up dry, we've included a custom calligraphy service in Appendix A.

Another alternative is to fudge a bit and use the rub-on type lettering previously mentioned. This comes in a variety of calligraphic styles, and the individual letters are transferred to your paper by simply rubbing them with the point of a pencil.

What to say . . . what to say . . . ? A glance at *Barlett's Book of Familiar Quotations* reveals that there are a lot of different ways to say things. So how do you choose *what* to say and *the best way* to express it?

Illustration 3-15: *A mechanical lettering set simplifies preparation of camera-ready copy. Such sets are usually available at stationery or art supply stores.*

Ideally, what you say in words is what you have already said—or suggested—in your picture, and we'll show you an approach that will help you achieve this a little later on (see Chapter 4).

At this point, let's just say that you want messages with the broadest possible appeal. That doesn't mean the words have to fit all or even the majority of occasions, only that they will express thoughts many people can identify with.

By itself, the photograph of a hang glider will probably appeal primarily to hang-gliding or "aerial" enthusiasts—a pretty limited market. But the addition of a few words like those on the plaque, or even the simple statement "Dare to Dream," will broaden its appeal. The photograph no longer deals with hang-gliding per se, but with human aspiration—something that touches us all.

PHOTO PLAQUES

In areas where competition in framed prints is heavy, photo plaques are an alternative. Well done, they are also beautiful items in their own right, and their popularity is demonstrated by the fact that even giants like Hallmark have begun manufacturing them.

There are several advantages to mounting a photograph on a plaque instead of framing it. First of all, fewer photographers are using that approach, and second, there is no woodworking involved other than a little fine sanding to remove sawmill "fuzz." The plaque blanks are precut and shaped. Some basic wood-finishing skills are required—sanding, staining, painting, varnishing—but a few simple instructions and a little practice should yield professional-looking results.

In some ways plaques give more creative leeway than frames. Since they are available (or can be made) in a great variety of shapes, you are freed from constantly thinking in terms of squares or rectangles. This can be especially handy for products designed for children, kitchen decor, or other special situations. Butterflies can be mounted on butterfly-shaped plaques, mushrooms on mushroom-shaped plaques, kitchen-art photos on teapot- or soup kettle-shaped plaques, and so on.

Plaques can also be color-coordinated with photographs to produce striking *total* effects. We put brilliant California poppies on orange plaques and sailboats on white or blue. Sunsets go especially well on plaques with redwood or mahogany finishes. In Chapter 6, we'll deal further with the idea of *total effect* as it relates to photo products.

Your photo plaques can open up possibilities to which conventional framed prints aren't particularly suited—inexpensive kitchen and bathroom decor, for example. Anything hung on a kitchen wall soon becomes coated with grease and dust. In a bathroom the problem is high humidity. These conditions are tough on photographs, even those behind glass. The photo on a plaque, however, can be easily sealed with clear plastic to protect it from moisture and allow it to be sponged clean.

Unfinished plaque blanks can be purchased in a variety of materials, shapes, and sizes at most hobby and craft stores or from woodworkers' supply catalogs. Be prepared to shop around, because prices and quality can vary a great deal. Although you may wish to try some of the larger sizes, the smaller

How to Create & Sell Photo Products

Illustration 3-16: *A. A selection of wooden plaque blanks which may be purchased from craft stores or suppliers. B. The finished photo plaques.*

ones—with 3x4-inch or 4x5-inch photo faces—will probably sell best, especially as gifts. For larger photographs people generally prefer framed prints.

Once you've found a style you like and market-test the finished product to be sure it will sell in your area, you can buy the blanks direct from the manufacturer at considerable savings. Store markups of 100-200 percent are common for such craft items, so a blank that costs a dollar locally can probably be ordered wholesale for fifty cents. Of course, you'll have to meet the manufacturer's minimum purchase requirements in order to qualify for a wholesale discount.

You can find the manufacturer's name and address stamped on the back of the blank itself or somewhere on the packaging. We have listed some suppliers in Appendix A; you can locate others closer to your own area by studying crafts magazines. Write for catalogs and price lists. Some will offer metal hangers at a bulk discount as well.

As always, try to keep your production costs as low as possible. Chapter 9 will cover product pricing in more detail, but for now the following formula will serve as a convenient rule of thumb: To turn a reasonable profit, the shelf price of the product must be at least four and preferably six times its production cost. In dollars and cents this means if it costs you $1.50 to make a 3x4-inch photo plaque, you'll have to sell it for at least $6. Of course, not all of the $4.50 over cost will be profit. Your retailer will take up to 50 percent of the recommended sale price as his commission, or wholesale discount if he buys outright. This leaves you with a profit of $1.50 to $2 per plaque.

In determining the feasibility of a product, it's a good idea to look at similar items already on the market. Note their prices, then figure backward to see if you can keep your version competitive. Although people can be expected to pay a little more for a higher-quality, locally oriented product, your prices can't be *too* far out of line.

HOW TO: Photo Plaques

In addition to the unfinished plaque blank, you will need some fine sandpaper (# 120 or # 160 grade), wood stain or paint (including a primer), polyurethane varnish (a clear, brush-on liquid plastic available at lumber or paint stores) for sealing the photograph, and stain, rubber cement or a photo adhesive, and a metal hanger. A small hand drill is helpful for installing the hanger, although a hammer and small nail can also be used.

Sand off any rough spots or mill "fuzz," then apply stain or primer coat evenly to the plaque, including the back, following the instructions on the can.

The darkness of the finish is determined by how long you allow the stain to penetrate the wood before wiping it off. Cross-cut ends will absorb stain (and darken) more quickly than the smoother sides cut with the grain. The latter should be stained first and allowed to "set" longer. (Spots that seem too light can be recoated if necessary.) Apply a coat of polyurethane varnish over the stain once it's dry (this will raise the grain). Allow the varnish to dry, then sand smooth before mounting the photo.

On painted plaques, the primer coat will cause the grain to rise; sand it smooth with fine sandpaper before applying the finish coat. If more than one finish coat is required, sand lightly between each coat. The back of the plaque need not be finished.

Illustration 3-17: *Sand off any rough spots or mill "fuzz," then apply stain or primer coat evenly to plaque as per instructions on the can.*

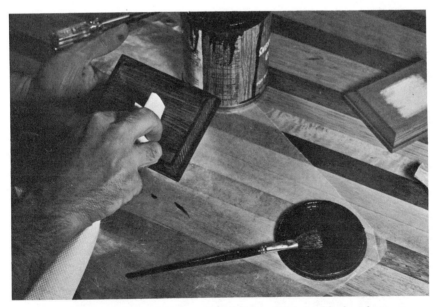

Illustration 3-18: *The darkness of the finish is determined by how long you allow the stain to penetrate the wood before wiping it off. Crosscut ends will darken more quickly than the smoother sides cut with the grain. The latter should be stained first and allowed to "set" longer.*

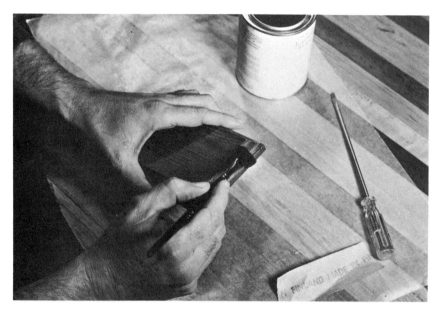

Illustration 3-19: *Apply a coat of polyurethane varnish over the stain. Allow it to dry thoroughly, then lightly sand the mounting area before attaching the photo.*

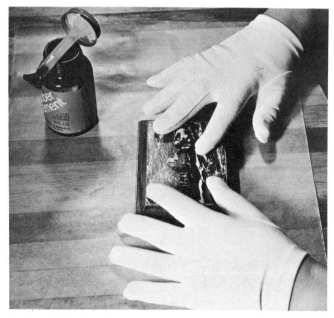

Illustration 3-20: *Glue the photograph in place with rubber cement or spray-on photo adhesive. Cover it with a sheet of smooth, blank paper and weight it with several books until it's dry.*

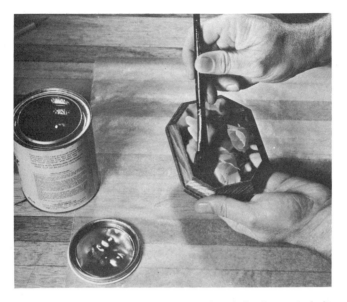

Illustration 3-21: *For stained finishes give the whole plaque, including the photograph, another coat of liquid plastic (polyurethane varnish). For painted plaques only the photo needs to be sealed (it can be left unsealed, but then it won't be moisture-proof).*

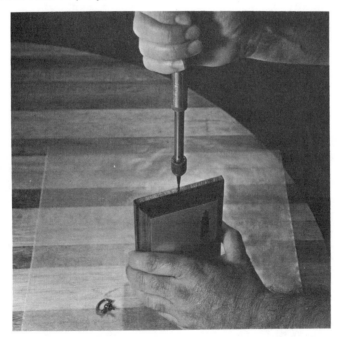

Illustration 3-22: *Drill a small pilot hole (or use a nail) and install the hanger.*

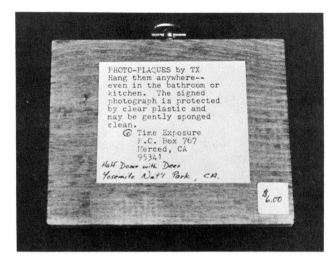

Illustration 3-23: *It's a good idea to include the following information on the label of every plaque: copyright, subject and location, and your name and address, in case an enthusiastic customer wishes to contact you personally.*

Glue the photograph in place with rubber cement or spray-on photo adhesive—be sure the edges are secure or they may rise slightly when varnished. Cover with a sheet of smooth, blank paper and weight until dry.

For stained finishes, give the whole plaque (excluding the back but including the photograph) another coat of polyurethane varnish. For painted plaques, only the photo needs to be sealed (it can be left unsealed, but then it won't be waterproof). Let the varnish dry in a dust-free environment—placing the plaque under a clean cardboard box will do.

Drill a small hole (or make one with a nail) and install the hanger. You can eliminate the added expense of the hanger by drilling a ¼-inch hole in the back of the plaque for hanging—center the hole from side to side and about an inch from the top.

We sign the photograph in the lower right- or left-hand corner just as we do prints and greeting cards. This should be done before sealing with varnish. Polyurethane varnish gives you a choice of two finishes: glossy and satin. Examples of both are generally available at paint and lumber stores, so pick the one you prefer. It might also be a good idea to market-test both to see if one has better customer acceptance in your area.

An alternative finish for your plaques is a pouring resin that gives a thick, durable, and high-gloss coat. This material, which is harder to use than polyurethane varnish, will be discussed a little later in connection with photo key chains and ornaments (see Chapter 5).

Top off your plaques with a product label such as that shown in Illustration 3-23. You can type up a full page of these labels, then run off copies on a photocopier. Use rubber cement to affix them to the backs of the plaques.

Calligraphy plaques. Calligraphy can be used very effectively on photo plaques, and much of what was said earlier also applies here. Although

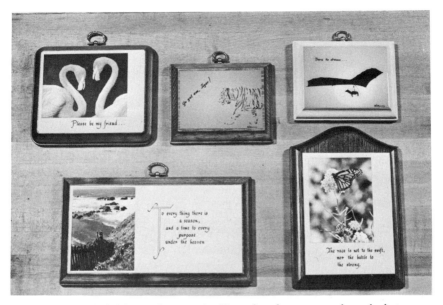

Illustration 3-24: *A selection of calligraphy plaques—words and photos make a good selling combination.*

short messages can be placed right on the photograph (if you have sublime faith in your hand . . . or your calligrapher . . . or use press-on letters), it's probably best to prepare a separate master and use larger plaques that allow space for photo and message side by side. The ocean scenic plaque in Illustration 3-24, for example, has a flat photo face measuring 4x8 inches.

You can run off copies of the master on a photocopier or have them printed on heavier greeting card stock. Glue the message to the plaque either next to the photo or with part of the sheet providing a frame, as with the ocean scenic plaque. The biblical quotations and inspirational sayings suggested for cards also do well on plaques, especially in stores that sell religious items.

Specialty plaques. Plaques are versatile not only because of the variety of shapes and sizes available but because they can be made to serve some function beyond pure decoration (this is a major consideration in Chapter 5 also). Fitted with hooks, they can become holders for keys or hot pads; with candle cups, they become sconces; with bars, they become towel racks. Small plaques may be purchased with routed holes for displaying several miniphotos, and large plaques can become photo signs or even wall clocks. These and other applications of plaques are covered in later sections of this book.

POSTCARDS

Consider the lowly postcard. This most common of photo products can be a real winner for the beginning entrepreneur. There's nothing to make (you simply take the picture and turn the production over to someone else); consequently, the postcard is one of the easiest products to mass-produce. You can sell a lot of them because the retail price is so low, and they're versatile enough

to fit a great variety of marketing situations. An obvious choice for major tourist areas, they can be used practically anywhere for advertising. And there's no town so humble that it doesn't have local scenic or historical attractions.

Two kinds of commercially prepared blanks are available for making your own postcards. One, for black and white, is made from light-sensitive paper on the back of which is printed the usual postcard format. The photograph is printed on the blank in the darkroom just as it would be on standard photo paper. Black-and-white postcards can also be turned out by local job printers. The second type of postcard blank can be used for either B&W or color, and consists of printed card stock which is preglued so that all you need to do is attach the photo. An option is to have your job printer run off similar blanks and do the gluing yourself, generally at considerable savings.

These alternatives might be useful for B&W photos or for testing color ideas. However, the situation with regard to postcards is similar to that for greeting cards: Black and white is simply not as popular as color. And any color cards produced by these methods will be too expensive to compete with mass-produced postcards. Since postcards are usually considered throwaway items, your price will have to be competitive—the people who buy them won't be as inclined to pay a little more for quality and originality as those who buy greeting cards.

In order to be profitable, color postcards must generate volume sales. The reason is simple: Most color printers require a minimum order of three thousand postcards *of a single subject*. This means the subject must be pretty thoroughly market-tested before you can afford to take the risk. It's possible that if you work through your job printer, he may be able to locate a manufacturer who will go as low as one thousand cards, but probably at a correspondingly higher cost per card. So unlike the other four bestsellers, success depends on mass production right from the start.

Who takes the mass-production risk? Mass production almost always means a sizable investment up front, to get things rolling. In this case, someone has to put up the money for a large run of color postcards. If you have the money and a photograph you're confident will sell in large numbers, you may be tempted to assume the risk yourself. Our advice is *don't*. At least not until you're certain you have enough marketing outlets for those cards. It's generally better to find someone else who will take that risk, or at least share it with you.

But before making a decision, arm yourself with some facts and figures. Talk with your job printer about color presses and ask for his recommendations. Or check the list of suppliers in Appendix A. Write for information. Most firms will send you a complete sample kit, including not only postcards but all the custom photo products they print (these will be covered in Chapter 10).

Here's how it works with many such manufacturers. Let's say you want to order six thousand postcards for promoting a motel. From one manufacturer's list we find that number costs $330. That's the price you quote your customer (the motel owner) according to the following terms as spelled out on the price list: a required deposit of $138 and the $192 balance to be paid on delivery. Actually, that deposit is a commission the postcard manufacturer pays you for selling the product and his services. You pocket the deposit and send off the or-

der, which is filled and sent to your customer, who remits the balance due.

If, on the other hand, you had decided to place an order on your own, you would pay only the $192 for your six thousand cards. Your profit would then be earned when you sold them to retailers or through displays. Now, let's take a closer look at these two possible approaches.

Promotional postcards. Many businesses and organizations use postcards for promotional purposes. Potential customers for this kind of custom photography service include hotels and motels, museums, sports centers, athletic teams, hospitals, jewelers, campgrounds, restaurants, truck stops, nurseries, political candidates, and resorts, to name just a few.

In some cases, they may already have photos they want turned into postcards. Under these circumstances, this becomes strictly a business transaction without any picture taking on your part. If photography is involved, however, you can increase your profit by doing the job for an additional fee. This charge would be based on the time required plus expenses—film, processing, travel, etc. Establish the hourly rate by consulting other service photographers in your area. If no such guidelines are available, estimate your total costs at full retail price the average consumer would pay and double that figure.

In shooting of this type ("work for hire"), the question arises as to who owns the photograph, the customer or the photographer? Legally, the customer owns any photographs made from the negative or transparency; the photographer, however, has the right to retain that negative or transparency unless that right was surrendered by previous agreement. Although you cannot produce any additional prints of the photograph without your customer's consent, retaining control of the negative or transparency could lead to further profits if the customer himself decides to order more postcards. *Avoid giving up control of your negatives or transparencies whenever possible.*

Promotional postcards are closely related to other custom photo products that will be covered in Chapter 10.

Going it on your own. Suppose that custom service work doesn't appeal to you, that you're more interested in choosing your own subjects for postcards. Here your potential customers will be card shops, drugstores, variety stores, newsstands, souvenir shops, restaurants, hotels, and so forth. Start as always by looking for a need and then filling it. Do your market research. Study the postcards already available in your area. Do they cover all the local attractions? Can you spot any omissions—sites or activities that aren't featured? What about a sleeper like the historic courthouse mentioned earlier? Or some annual event that draws both participants and spectators to your area?

If you already have the right slide and a print of it, postcards are one photo product that will allow you to turn a quick profit with a very small investment—possibly several hundred dollars in return for the price of a postage stamp. And some legwork.

The "right" slide could be a photograph of an area attraction that nobody has capitalized on as yet. The print is to show to retailers in your community, which is also where the legwork comes in. And the postage stamp? That's to request information and a sample products kit from any of those postcard manufacturers who, as shown earlier, will pay you a commission for selling your postcard idea and contracting with them for the printing.

If you've already market-tested subjects on other products and found some winners, they might be good choices for postcards—provided no one has beaten you to it. That super shot of the picturesque old covered bridge outside of town—what can you do if you're convinced it could be a bestselling post-card?

Well, you can shoulder the entire risk yourself. You can go ahead and or-der your six thousand postcards (or a smaller number if you can arrange it) at $192, or $.03 a card. If you can sell them to local retailers for $.10 apiece, you'll realize a profit of $.07 per card (check to see what similar postcards are selling for in your area; you may be able to make a larger markup). Thus, if you sell all your cards, your profit will be $227.50, more than you would earn on a com-mission basis. Which is the way it should be, because you're taking all the risk and doing more selling. Remember, you'll have to sell 2,750 cards just to cover your costs and before you break into the profit column. And there's always the chance you'll be stuck with some or even all of them if you can't generate any interest.

A better approach is to do your selling *before* you place an order. Visit some local merchants to see what they think of the idea. Try to get some orders up front. If you can get ten firm commitments of 250 cards each, you will have assured that you will at least cover your costs. Then you can go ahead. Once you've filled your advance orders, keep an eye on each outlet. Be ready to han-dle resales when the time comes.

Your profits can soar even higher if you can interest a distributor in your product. Although he is a middleman and will take a commission, he can probably place your cards in many more locations than you can yourself. Dis-tributors can be contacted through retailers or often by simply looking in the Yellow Pages under specific products (Greeting Cards—Wholesale, Gift-ware—Wholesale, etc.).

And if you don't happen to have the "right" photo, or if you can't come up with anything that hasn't already been done, what then? Try for fresh angles on the old themes. Could any of those existing postcards be updated? Look for old cars or out-of-fashion clothing. Sometimes merchants will continue to buy outdated cards simply because no one has come up with anything newer. Or different. If there's a summertime photo of that old bridge on the market, try catching it in the fall or winter. Or find a more interesting viewpoint.

Finally, you may come across a local firm that prints postcards for your area. If you don't want to get involved in having postcards printed yourself, you might be able to sell your photos directly to it.

How to Create & Sell Photo Products

Chapter 4

THE PHOTO—YOUR KEY TO SUCCESS

Now that you're thinking photo products, let's take a closer look at what will make them sell—the photograph. Much of what follows applies not only to the five bestsellers, but to many of the products covered in succeeding chapters as well. As suggested earlier, the photograph that sells best may not necessarily be the "best" from an aesthetic point of view.

There are numerous directions your own product photography can take, but you can find a good starting point by studying that of the major manufacturers. Look at the subjects they feature and the ways they present them. Find out what sells best in your area by asking shop owners and clerks. Then use the approaches and ideas that are successful, but give them your own local interpretation.

Test the results on your products. Some may work for you, others may not. Drop those that don't sell from your line and add new ones; don't be afraid to make mistakes and changes—this is an inevitable part of learning and growing as a commercial photographer (and as a human being!). In time you'll develop a selection of photos that will sell again and again in a variety of ways. More important, you'll be able to spot salable shots more quickly and consistently. You will have sharpened your commercial "eye."

Your bestselling photos will probably be of the outstanding attractions within your marketing area—the scenics that most photographers love to take. Part of your market will be local people buying items for their homes or gifts for friends or relatives. Another important segment will be tourists, whether they come to visit those picturesque attractions or for some other reason such as a convention or even if they are "just passing through." Marketing in a tourist area has its advantages—and disadvantages. On the plus side is the constant flow of customers for your products. On the minus side is the likelihood of competition, which can be intense.

BEATING THE COMPETITION IN TOURIST AREAS

We've already noted how the products approach can give you an edge over the competition; now let's consider how the photographs themselves can sharpen that edge. Whatever a customer's reason for buying, your aim is to get him to choose *your* photography over that of your competitors. To accomplish this, your handling of the more or less standard tourist views must be more appealing, but not so different, as pointed out earlier, that they don't look like they're "supposed to." You have to walk a fine line between art and documentation.

The job is getting tougher and tougher. Today's tourist can buy a camera that will focus automatically, measure lighting conditions and compute lens and shutter settings, add flash where necessary, switch from regular to telephoto to lens—in short, do everything but select a subject and push its own shutter release. Any tourist who wants to can get a satisfactory "memory" shot on his own.

So why should he buy your photographs? He won't . . . unless you can give him something he *can't* get on his own. A product. Or a fresh angle on a tired subject. Or a more discerning "eye." He'll buy your version because, frankly, you take a better picture than he does. Either that, or perhaps you got the shot that he missed . . . or never even saw.

Offer shots that are hard to get. In the Monterey area one of the most popular tourist attractions is the sea otter. Some of our hottest-selling items feature this lovable creature. The average visitor considers himself lucky to see one at all—even at a distance—let alone capture one on film. Our advantage is that we have the time, the patience, and the equipment to take better otter photographs. Experience has also taught us how to locate the animals under the best conditions and how to come up with shots that aren't available to someone who has only a few days to spend seeing the whole area. You will have to seek out and exploit similar opportunities in your own marketing area. When you come up with the right photos, they can become bestsellers throughout your whole range of products.

Follow the seasons. Sometimes you can gain an advantage over the competition and attract the memory photo takers through the simple device of off-season photography. Most people travel during the summer, and that fact is reflected in tourist-oriented and memory-type photography. But many areas are equally (or even more) attractive during other seasons. There might well be a demand for fall, winter, or spring shots—offer the visitor a blaze of fall color or a dramatic sun through snow-laden trees. To someone tied to a summer vacation schedule, your photograph of a field of wildflowers can be a breath of spring.

Create a mood. We've mentioned this kind of photography before; now let's see if we can get a better handle on it. People respond to photos that capture the late-day light, for example, or the sun's rays streaming through the trees—pictures that create mood. Mood photography elicits an emotional response from the viewer (a response that, you hope, will result in a purchase).

"Wow!" you say. "How do I accomplish that?"

By taking a very simple approach. Start with a word that expresses a common emotion or feeling. Power. Peace or tranquility. Love. Or start with a quo-

Illustration 4-1: *A popular subject can be featured on many different products in a wide price range. Try to offer something for everyone's budget.*

tation: "Dare to Dream." "Life is not a rehearsal." Notice which themes prevail in commercial photo products such as greeting cards or posters (remember all that expensive market research the big companies did?), then interpret those themes in your own photography. Shoot to the word or words that best state those themes.

Literally, in some cases.

If, for example, you can plan to put a message on the photograph, keep that in mind when you shoot. This concept of a copy or commercial space in your pictures will be discussed further in connection with photo clocks (Chapter 6), but for now let's just say that it can make the difference between a sale and a rejection—in a photo product or direct submission. A photograph intended for use with calligraphy should be visualized as complete, with the message in place. The same is true when composing a photo for a magazine cover or book jacket or submission to a greeting card manufacturer; in your mind's eye, see the logo or a possible message in place *before* snapping the shutter. This doesn't mean that *every* shot you take must have copy space, only that you should consider all the alternative uses and approaches for every subject.

Take a word like "peace" or a quotation like "Leave room in your day for silence." To interpret this mood photographically, you might have to enlist the aid of your alarm clock to rouse you from bed when your world is in fact tranquil. The reflection of a solitary duck in still water at sunrise, a grand glacier-

Your Key to Success

covered peak, or the morning mist rising from a river would effectively express this mood.

At the other end of the scale is the word "power," as seen in a giant wave crashing against the rocky shoreline. Or an impressive granite monolith, seamed and cracked by time and weather, but still standing in all its awesome majesty.

There are all kinds of moods, including bad ones. Concentrate on those that are positive: happy, hopeful, adventurous, thoughtful, and so forth. With photo products, as in life, people prefer to remember the good times. Photographs that express courage, tenderness, whimsy, tenacity, or love would be good choices. Pick a word and then let your camera do the talking. It's a good way to get people to listen . . . and to buy.

Stalking mood with your camera. As with people, every area has a variety of moods. The sea that thunders against the shore today may be a tranquil mirror tomorrow. A mountain that holds no secrets when framed by a clear summer sky may be a brooding, forbidding place of mystery when enshrouded by winter's clouds. Moods are where you find them, and capturing them on film is no easy matter. The successful stalker must be prepared to arise early, stay out late, and brave all sorts of weather to get the right shots. Even then, there's more involved than just being in the right place at the right time; there's the matter of getting the photo itself—the best possible image for its purpose. If this means working harder and learning more about your craft, so be it. The rewards of this extra effort will be increased sales and recognition!

Arise at daybreak and the chances are you won't find many tourists up and about. Most people have little desire to roll out of bed to catch a sunrise under normal circumstances, let alone while on vacation. And they'll photograph a sunset only if it happens to be convenient. Which it usually isn't—at least not the really spectacular sunsets, which, in many areas, aren't all that common during peak tourist seasons. Summer in Monterey or San Francisco, for example, is more likely to be a time of chilling fog, where the visitor counts himself lucky to see the sun, much less the sunset!

Sunrise . . . sunset. You, on the other hand, can become an expert on local sunrises and sunsets. You can search out the best locations, make sure you're in the right place at the best times. And tourists will repay you for your initiative. "Sunsets are trite and overdone"—favorite words from photography instructors and techniques books. When it comes to photo products, don't you believe it. People love sunsets. And products that feature them are sure to be among your bestsellers.

When taking those sunsets, however, give considerable thought to composition. An interesting (and salable) sunset is more than just a big red ball in the sky (although such shots can also have their uses—see Chapter 14). It usually requires some other point of interest to give it a sense of mood or place. Sunsets go well with water and reflections, for example, or with silhouettes of people and interesting trees or grasses.

Automatic cameras (and many light meters) tend to underexpose sunsets when the sun is still above the horizon. If you point your camera or meter directly at the sun, the resultant photograph may be completely lacking in foreground detail. On the other hand, if you take your readings off a foreground

How to Create & Sell Photo Products

Illustration 4-2: *Ocean sunsets are frequently good sellers on photo products.*

Illustration 4-3: *Instructors in photography classes may say that sunsets are trite or overdone, but for photo products, don't you believe it.*

Illustration 4-4: *Layering of rocks and crashing waves can be enhanced by the addition of a light yellow or orange filter.*

tree or lighthouse, you may end up with a pallid, washed-out sunset. Since foreground composition and detail are often important elements in setting mood, the picture you want lies somewhere between the two extremes.

So until you've taken enough sunsets to know exactly how your camera reacts, it's a good idea to bracket your exposures—take one at the meter reading; another, one f-stop below; and a third, one f-stop above. This is a good habit to get into no matter what you're shooting, but especially in critical situations. It makes no sense at all to miss a once-in-a-lifetime shot just because you wanted to save film!

Spectacular sunsets are among the most dramatic results of unusual weather and lighting conditions, but there are many other situations that can be just as effective in creating mood: fog through which a special view emerges; the soft light just before sunrise or after sunset; the sun's rays breaking though clouds; rainbows; smoggy days that can bathe a scene in a warm, even glow.

When smoke gets in your eyes. Even smoke can give you once-in-a-life- time shots. This happened to us on a trip to Yosemite National Park in California. We were in the park to photograph fall color and were quite disappointed (furious, in fact) when a thick pall of smoke from a controlled management fire began to blanket the valley. One by one, the familiar sites disappeared in the haze. Gone were the granite monoliths, El Capitan and Half Dome; gone were the plunging waterfalls, even the sheer rock walls of the valley itself.

Nothing but eye-stinging smoke.

The day seemed destined to be a washout until we stopped bemoaning our losses—those broad vistas the smoke had taken away. Because that same smoke was giving us something in exchange; it was bathing the valley in a yellow glow that was quite unlike anything we had seen before. The autumn leaves were even more vibrant, and mood . . . well, we got some beautiful photographs that day, almost in spite of ourselves.

Mood is where you find it. If you are willing to brave bad weather, the possibilities are limitless. Winter can be especially rich in opportunity for the simple reason that most photographers, it seems, would rather be at home by the fire than out battling the elements. Snow can be peaceful or threatening, joyous or sad; in league with a warmly lighted window, it can say home or companionship; falling on the shoulders of a lone figure walking the empty streets of a city, it can speak of desolation, of loneliness. Through the lens of your camera, snow can say anything you want it to say.

Don't ignore the ordinary. At this point, perhaps a word of caution is in order. Anything can be overdone. Don't get so caught up in "mood" and being different that you overlook as customers the many nonphotographers who simply want the standard views that to you may seem terribly uninspired. In light of what was said earlier, this may seem like a contradiction; but the aim is still to beat the competition. Your more creative shots will draw potential customers to your display. But once there, don't be surprised if they end up buying the standard, straightforward shots.

After all, those people may be taking their first (and perhaps only) look at something you see all the time. You may be bored, but they're not. So put your-

Illustration 4-5, above, and 4-6, opposite page: *Unusual weather and lighting conditions can help you achieve the "mood" effect so popular on photo products.*

self in your customer's shoes. Ask: What would I want to see if I were coming here for the first time?

Again, word association might help. What words come to mind when you think of your area? Try to think back and see it as you did when it was new to you, or as an outsider would. Our area might be described by "ranching" or "farming." Meaningful words in our Monterey market might be "sea" or "fish-

ing" or "otter"; and in the Mother Lode Country, "gold," "history," "frontier." What associations do the people who live in or visit your area have? Why do they come? What are they expecting to see? Sometimes it's not just a matter of seeing what's there, but absorbing the atmosphere of the place. This latter reason can be a very important consideration in *how* you photograph your subjects.

Even if you don't live in a tourist area, you probably have access to one for marketing purposes. You can use the Photo Products Alternative anywhere, even in another state, if it suits your purposes (more on this in Chapter 11). As we pointed out earlier, we got our start away from home, and you can do the same.

If your region contains a number of distinctive attractions (or even only one that is subject to many moods), consider a photo collage. A collage is a picture made by combining several smaller pictures, as shown in Illustration 8-1. A collage on a San Francisco theme might feature the Golden Gate Bridge, the city skyline, the cable cars, Lombard Street (the "crookedest street in the world"), ornate Victorian houses, Coit Tower, Alcatraz Island, or a host of other possibilities. Collage techniques also work well for subjects such as wild flowers or animals. In upcoming chapters we'll consider other ways to handle multi-image displays.

The Photo Products Alternative gives you the means and methods for facing the competition head-on and beating it, if that's what you want. On the other hand, you can . . .

Your Key to Success

GO WHERE THE COMPETITION IS LIGHTER

Actually, you needn't get involved with the tourist scene at all, if you don't want to. There are plenty of other directions to take—products and photographic approaches that will work whether you market in a quiet backwater, a bustling metropolis, or a highly competitive tourist area.

Don't restrict yourself to scenics. Consider any interest or activity that draws people to your area: skiing, sailing, regional festivals, for example. We

Illustration 4-7: *Both standard "tourist" views and more artistic interpretations have their place in product photography. Although the viewpoint shown above might please the photographer, the more standard view in Illustration 2-2 will probably be a better seller.*

know several photographers who make money on publicity shots for various kinds of races—auto, powerboat, horse—but none are doing products for the spectators. These would seem good opportunities wasted. Wherever there's a collective interest, there's an opportunity.

Try to be aware of the activities in your community. Is there a garden club? A flying club? A street rod club? How sports-oriented is your marketing area? Most local newspapers print social calendars listing meetings and events. Or use your phone book to survey clubs and other organizations for ideas (Chapter 10 will give you some other ideas along this line). No matter what your special situations or interests, you should be able to find an approach that's right for you. Give some though to the following:

Animals. Cats, dogs, and horses always have a lot of fans, but wild animals can sometimes prove even more popular. This is especially true if your area is noted for a particular species—the otters and Monarch butterflies of Monterey are a case in point. And in the mountainous areas of California, deer, elk, and bighorn sheep make their contributions to photo sales. What about your area? If you're lucky enough to capture a wild animal in a terrific scenic, you'll have a real winner!

While experience in wildlife photography is certainly an asset, don't feel that you need to go on an elaborate and expensive safari to get good animal shots. Any number of professionals have made a name for themselves by photographing zoo animals in such a way that the unnatural setting isn't apparent. In fact, although we spent two years in Africa, some of our best shots were taken in California zoos!

Zoos can be excellent sources of animal humor. In this case, it doesn't matter if the setting is zoolike as long as the photo amuses the viewer. Many zoo animals are natural comedians, and often the setting—even the bars—can contribute to their antics.

And don't overlook small animals for funny or "cute" products for children. Kids love animals of all kinds—even rats and snails and cockroaches have their fans!

One California photographer puts kittens, puppies, and mice into interesting situations, then lets nature take its course. His tiny prints—as small as 2x2 inches—of a mouse peering from a wineglass or perched on a ceramic toadstool, and a kitten wound up in a ball of yarn sell very well.

Minimal taxidermy skills enable another photographer to create dioramas of frogs playing poker, hanging out in an Old West saloon, boxing, skiing, golfing, fishing—whatever.

Still another photographer dresses lobsters and crabs from the supermarket in eyeglasses, cardboard top hats, and other accessories.

Whether or not these particular examples appeal to you, remember that the camera can do more than just record reality. It's how the photographer perceives his world that's important, and there's no reason his vision must be true to life. With some ingenuity and a few sample materials, you can create a whole new world where unicorns prance and dragons roar.

As shown in Illustration 4-8, there's a zoo as close as your refrigerator. Or carve all sorts of critters from a block of foam-type plastic (polyurethane foam—look in the Yellow Pages under "Plastics-Foam"). Be inventive. Even if

your first ideas don't sell, they will generate others, and eventually you might come up with something really big.

Flowers. If you like to photograph flowers, products can be a good way to sell those photos (notice how often flowers appear on commercial greeting cards; notice, too, the *kinds* of flowers preferred). Roses are generally well accepted, as are flowers representative of your area—your state flower, for example, or any showy and abundant wild flower. In California photographs of the golden poppy sell well throughout the state, especially to tourists.

Flower photography is of two basic types: (1) photos where the flower predominates and (2) photos, such as scenics, where the flowers are only part of the overall composition. The latter will probably have the widest appeal in your usual marketing outlets. The first type, however, can be marketed effectively through specialty shops that cater to flower lovers.

When photographing flower close-ups, try to choose a lightly overcast day with little or no wind. The colors in flowers almost glow when shot in this kind of flat light. You can get a similar effect on a bright day by diffusing the light through a piece of translucent plastic held between the flower and the sun. Other helpful items for flower photography include a tripod, a large piece of white cardboard (dark on one side) for reflecting light to dark spots or for controlling the wind, a macro lens (or a set of close-up lenses), and a spray bottle filled with water for adding "dew."

Illustration 4-8: *A photographer's world can be real or imagined. An incredible variety of critters lurk as near as your refrigerator. In this case a purple-crested male pea-squash in mating plumage (note the flared tail feathers) investigates a spiny carrottid and a lesser radmouse. Such investigations are characteristic of the nearsighed pea-squash.*

The most effective close-ups feature a single bloom (or two or three attractively grouped) without a distracting background. So don't hesitate to remove sticks or bits of grass that disrupt your composition. There are several ways you can eliminate distracting backgrounds while keeping your center of interest (the flowers) in clear focus. The simplest technique, and the one we prefer, is to focus on the bloom and use a fairly wide aperture (about f4) so that the background becomes a soft, pleasant blur of color. Using a flash results in a more dramatic picture with the flower lighted against a nearly black background. Or try using a piece of cardboard behind the flower, choosing a color that will appear as natural as possible in your photo.

Sports. Sports photos can sell products in a variety of situations. For an annual event such as an air show or auto show, you can take pictures one year and sell them the next (or to local residents and tourists in the interim). In a ski area you can offer products depicting specific local events or provide more artistic interpretations of ski action—to skiers and snow bunnies alike. Whatever your sport or your sports interest, there is a market for it in most areas.

Likewise, acton sports shots make ideal decor for game rooms, offices, lodges, vacation homes. And by *action* we don't mean just the fast-paced activities; don't forget fishing, for example, or hunting and golf. Action in our sense of the word means catching the spirit of the sport, the involvement of the participants . . . the essence. A lot of money is spent each year on sports participation and related items. Inventory the sports that are popular in your area and then get to work with your camera. No matter what the activity, you can come up with a series of knockout photographs and products.

And much, much more. Armed with a box of dominoes (see Illustration 6-1), a set of jacks, a deck of cards, or the paraphernalia of any of a vast array of popular games, you should be able to come up with quite a variety of photos suitable for game or family room decor.

If you live where mushrooms abound, go out with your camera and get down on your knees. Mushrooms are popular in kitchen decor. And since nobody will be eating your photo products, you can even photograph *Amanita muscaria*—a showy though poisonous variety. Locate some kitchen specialty shops and do some browsing. Notice what other themes decorate trivets and wall plaques, dish towels and pot holders, cups and dishes—whatever decorative items are on display. Consider how you can translate the ideas photographically into products.

Do some still lifes with food or kitchen utensils and equipment. There's a great variety of fascinating and photogenic subjects to be found in the kitchen. As you photograph, always keep in mind the whole spectrum of possible products *and* direct submission. We sold one of our kitchen decor photos to a calendar company for $300.

Whenever and wherever you go shopping, be on the lookout for new ideas that can be translated into photography (this principle will be restated and expanded in Chapter 8).

TAKE MORE PICTURES

To conclude this chapter, the best advice we can offer is to go out and take pictures. Set up assignments for yourself whenever you can, load up your cam-

eras, and go out and photograph with some definite objectives in mind.

Get those colorful yachts for your photo products line, but don't fall victim to tunnel vision. Catch those wind surfers, too. Or that big power cruiser. There are markets for those subjects, just as there are for sails in the sunset, or soft-focus couples against a sparkling sea, or sharp shots of crews in action.

Be aware of everything—a colorful kite against a blue sky, an old man feeding a squirrel or a flock of pigeons, flowers blooming unexpectedly along the edge of a city parking lot; you never know when you may happen upon a salable photograph.

See all there is to see. We have several cats and they make excellent subjects for photography. In the beginning, we concentrated on the "cute" or "sleek and handsome" types of photos, preferred by greeting card and calendar firms. But cats and especially kittens can also be hilarious in their behavior and there's a strong market for this sort of humor as well.

Even photos of everyday "cat business" can find markets. A textbook publisher once requested shots of cats eating (which ours do well *and often*), drinking, rubbing against a person's leg to indicate affection, spraying to mark territory, and so forth. All pets have interesting and amusing patterns of behavior, some of which might be appropriate to your products. If an interesting photographic opportunity presents itself, taken full advantage of it; sooner or later you'll probably find a buyer.

Get the most out of every situation. Remember the evaluation of your photos that you started in Chapter 2? Let's go back to those lists and start plugging the holes. Let's build that "photo products starter selection" into a collection of terrific photographs that can help sell your products.

Take those Mount Mighty shots; no doubt you've got plenty of straight-on standard views that would be of interest to tourists as postcards, inexpensive prints, or any number of low-priced products. But have you taken advantage of all that mountain has to offer? Probably not.

Look for holes in your coverage. Give yourself some photo assignments in light of what you've read in this chapter. Vary the face of the mountain by photographing it in the early morning (with and without mist), at sunset, at night with a full moon. What's that? The moon doesn't rise or set over Mount Mighty? The moon ignores Mount Mighty altogether? No problem. We'll show you how to add a moon in Chapter 15. Watch the play of light on the mountain throughout the day, catch the sun peeping along its flanks with a star filter.

Consider how your mountain changes with the seasons. Frame the peak with autumn leaves. Brave the winter to photograph it beneath a mantle of snow. Follow the spring up the slopes, capturing wild flower-filled meadows and reflections in lakes. Remember that these may be sights the average tourist (and many local residents) may never see, except through your photographs.

While you're at it, put some people into those meadows—a couple holding hands, for example—and try for some mood shots. Get up at daybreak to catch the dew on the meadows in the early light. Consider the salability of individual flowers, close-up or with dew or both.

When you've exhausted all the possibilities you can think of in relation to the mountain itself, ask yourself whether it draws people for any other reason. Do they come to ski in the winter or hike and backpack in the summer? Do they

climb the cliffs or hang glide over the meadows or stand in awe at the cascading waterfalls? Is there a rare bird that finds one of its last sanctuaries in Mount Mighty? If so, any and all will suggest new possibilities for photos and new markets for products.

TRICKS OF THE TRADE

Many photographers develop "tricks of the trade" that help them to take more salable pictures. Here are some for you to consider.

Think vertical. Most people take horizontal photos because it seems more natural. Cameras are upright in that position and we're more or less attuned to a horizontal world, perhaps because our eyes are aligned that way. However, in this case doing what comes naturally can cost you sales. Commercial greeting cards, for example (as well as the magazine covers of Chapter 13) require primarily vertical shots. And a customer may specifically request a vertical photo in a particular product.

When researching both product and direct submission markets (see Chapter 13), try to determine the ratio between the numbers of verticals and horizontals used. This ratio need not be exact, but it should give you a pretty good idea of the needs of those markets. Then plan your shooting accordingly. Don't abandon horizontals since many buyers need them as well; just develop the habit of viewing things in vertical terms, too.

Bracket your exposures. Even in this age of automated cameras, it's still possible to miss that great shot you really wanted because of incorrect exposure. Light meters can err for any number of reasons. Unless you make the proper adjustments, snow or very light-colored subjects can come out gray. A sun-lighted flower against a dark background may be overexposed. We have one camera with a light meter that goes crazy, running up and down the scale when exposed to sunlight reflected from a fountain or the ocean.

So when it's really important to come home with results (and when isn't this true?), take more than one exposure, and bracket your light meter readings.

Even when you're absolutely certain your exposure is correct, there's an argument for taking an "insurance" shot, especially when the photographic opportunity isn't likely to present itself again. Any number of our slides have been ruined by nicks or scratches or arc-shaped marks put there by the developer. Occasionally the film emulsion is faulty, resulting in spots or streaks. Remember, too, that you don't see the whole picture through a viewfinder of a single-lens reflex camera. There are narrow borders into which a stray hand or foot or head or whatever might intrude without your catching it—until it shows up projected on a screen or viewer. And by then, of course, that particular opportunity might be gone forever.

Do everything possible to be sure you get the picture.

Decrease exposure for better color. If your slides frequently look pale and washed out, you can get better color saturation by setting your light meter slightly higher than the ASA recommended by the film manufacturer. For example, set ASA 25 film at 32, ASA 64 film at about 85. Cameras differ, so experiment and make adjustments until you get the most pleasing color from your equipment.

Your Key to Success

71

THE VIEW FROM A VAST GRAY PLAIN

In the final analysis, it's what you do with what you've got that will determine your commercial success as a photographer. It's not necessary to live amid wild and spectacular scenery; there are plenty of other approaches to take, including the special-effects and graphic-arts photographs discussed in Chapters 14 and 15. In fact, photographers can become so enamored with scenics that they sometimes ignore other more lucrative possibilities. Perhaps the more creative photographers are those forced by circumstances to turn inward for ideas. In this respect, some time spent living in the middle of a vast gray plain stretching off toward infinity in all directions could be a distinct advantage—provided, of course, that the photographer has an imagination and the willingness to use it. We all have more of the former than we suspect; it's the latter that's usually the problem.

Opportunities are where you find them. A case in point: Remember that photo buyer we mentioned in Chapter 1, the one who spoke in terms of a thousand or more slides from a single photographer? Out of the many thousands that publisher receives, they buy only fifty-two a year, and one year one of them was ours. Was it some fabulous scene of rare beauty accessible only to a daring adventurer? Not at all. It was a picture of a pomegranate taken on a sunny morning in a neighbor's backyard. The assignment we had set for ourselves that day was to photograph Monarch butterflies for our products, and their life cycle for our stock files. The pomegranate was a bonus.

SHOOT . . . SHOOT . . . SHOOT. The more photos you have in your files, the better your chances of coming up with that special shot. The more you photograph, the more proficient you'll become at your craft and the better able you'll be to get the exact results you—and your buyers—want.

How to Create & Sell Photo Products

BUILDING VERSATILITY INTO YOUR PRODUCTS LINE

A mounted print is pure photography in the sense that the picture *is* the product. And the function of the product is primarily decoration. Adding a frame only serves to enhance the photo, to set it off. Putting the print on a plaque or card increases the marketing options, but the photograph is still the dominant selling point.

Calligraphy, however, introduces other elements for the customer's consideration. His eye is drawn not only to the photograph but to the message, the quality and style of the handwriting, and, ultimately, the overall effect. While the picture will certainly influence the sale, it may not be the deciding factor. It has become less important. We are moving away from marketing photography in itself, and moving toward making it serve other functions. Instead of being the star of the show, it will be a member of the supporting cast. We are making photography more versatile, that it may earn its keep.

The products covered in this chapter carry us one step further. Instead of competing with other photographs or illustrations, they will be competing with other products designed to do the same jobs. Your photography is a vital element—it will give your products uniqueness and appeal. But in the end a customer's decision to buy will probably be determined, first and foremost, by whether or not he *needs* the product itself, be it a key chain, a bookmark, or a coaster.

There are those who object to second fiddle status for photography, who feel that such "novelties" are somehow a betrayal of their time and talent. However, working photographers know that the only thing more important than *taking* pictures is *selling* them. Even full-time professionals may spend as little as 20 percent of their time behind the camera and as much as 50 percent on marketing. No matter how you go about it, selling takes time—it's a fact of photographic life.

As far as an aversion to "novelties" is concerned, there's little difference between selling a photo to a bookmark manufacturer and making the book-

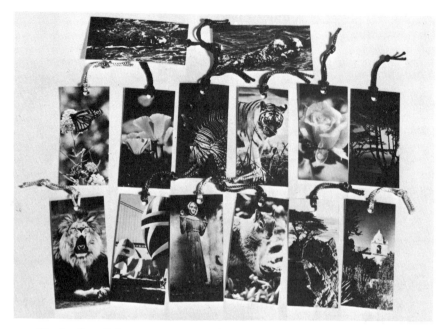

Illustration 5-1: *An assortment of inexpensive and easy-to-make photo bookmarks.*

mark yourself—except that by doing more of the work, you can collect a bigger share of the profit.

With that in mind, let's look at the following: bookmarks, key chains, ornaments (Christmas and others), coasters, place mats, decorative boxes, puzzles, and minicalendars, plus some variations on these themes. Although all are relatively easy to make, some require more complicated darkroom or crafts skills than others. In each case, however, you can either learn the necessary techniques or have the work done for you.

PHOTO BOOKMARKS

Since their introduction into our photo products line, bookmarks have been a popular and fast-selling item. In tourist areas they make a unique and inexpensive gift that can be mailed at about the same cost as a card and yet their usefulness will continue long after a card has been discarded or consigned to the back of a drawer. The memory of the gift is renewed each and every time the recipient opens his book. And believe it or not, there are still a lot of readers around!

Being remembered is very important in the business world. No matter where you live, your photo bookmarks could be produced on a custom basis as business cards or for advertising purposes.

As with plaques and cards, bookmarks can incorporate calligraphy suited to religious-inspirational markets.

Children love bookmarks featuring animals, especially in cute or humorous situations. Sports and adventure themes are also of interest.

How to Create & Sell Photo Products

When designing your bookmarks, keep in mind a profile of your customers. If you're marketing in a tourist area, the same photos that do well on the five bestsellers can be expected to do well on bookmarks. Also consider the *kinds* of books people read—this will work in all marketing areas. Horses, for example, might be a good subject for readers of Westerns; flowers would appeal to readers of romances. Weighting your photo subjects toward feminine interest is a good idea. Women not only do more shopping than men, they seem to be more voracious readers.

HOW TO: Photo Bookmarks

If you're able to do your own printing, you can make a bookmark mask—similar to the greeting card mask—by cutting ten doors instead of four. See Chapter 15 for complete instructions. Thus, you can print ten 2x4-inch bookmarks on a single 8x10-inch sheet of paper.

An alternative, if you don't have darkroom experience, is to have someone else print and rephotograph a sheet of ten bookmarks for you. The result will be a slide or negative from which you can have future bookmark sheets printed directly—this will make production more efficient and cheaper. If you can't find someone to do the job, try the following:

Select ten vertical photographs that could be cropped a little from the sides without harming their overall composition and have a 3½x5-inch print made of each. Trim the prints to 2½x5 inches. Cut a piece of stiff cardboard that measures 10x12½ inches. Glue the cropped prints to the cardboard in two

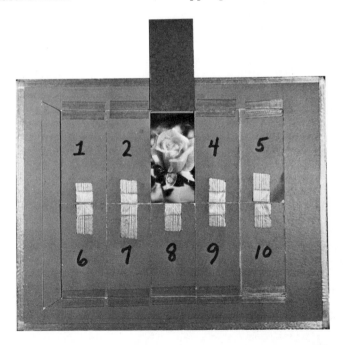

Illustration 5-2: *A bookmark printing mask with one door open for an individual exposure.*

rows so they resemble the standard bookmark sheet shown in Illustration 5-3; then rephotograph them in such that they fill the entire frame. Refer to Appendix E for more complete instructions on rephotographing.

Another option is to deliberately compose photographs that, when printed, can be cut up into bookmark-size pieces. Suppose, for example, that you would like to do a series of wild flower bookmarks. Find a field of flowers and shoot a full-frame photograph, keeping in mind that your aim is to get a number of shots with each click of the shutter, not just one. Set your camera up on a tripod and use the smallest possible aperture (f11, f16, f22—whatever conditions permit) in order to maximize the depth of field. Disregard the "rules of composition" as they apply to the whole; instead, try to visualize as many smaller photos as you can. When you get the knack of it, a single photo can yield more than ten bookmarks, depending on the size of the print and whether or not calligraphy is used.

This technique will work for other products as well. In the beginning, it might be easier to visualize four plaque-size photos, for example.

Obvious choices for this kind of photography are subjects that tend to occur in groups, like flowers, for instance, or autumn leaves. But you need not rely on nature. A trip to a produce market will fill many frames with colorful vegetables. The start of a race can bring together all sorts of groups—yachts, balloons, airplanes, athletes. Gatherings of birds and animals can be found both in nature and in zoos.

Or set up your own groups. Ten small vases with flowers, arranged on two shelves, results in ten bookmarks, ready to cut. Or make your own food arrangements for cookbook aficionados. Speaking of food, make ten refrigerator animals (Illustration 4-5) and line them up on your shelves. Presto! Ten bookmarks aimed at children.

Given a little ingenuity, lack of darkroom experience need not be a disadvantage.

Once you have your bookmark photos, the next step is to make them more durable. This can be done by laminating them with clear plastic film, such as the kind sold in hardware and home supply stores as shelf-lining material. The plastic is already coated with adhesive and needs only to be pressed in place.

Laminating the bookmarks will be easier if you first cut them into blocks of five each. Cut a piece of plastic film large enough to overlap the photo block by about ¼ inch on each side. Peel off the protective paper, then stick one end of the plastic sheet to your worktable, as shown in Illustration 5-4. Laminate the photo side of the block first by slipping it underneath and then pressing the plastic down, slowly and evenly, working from bottom to top. After lamination, you may notice a myriad of tiny bubbles that give the photos a sort of foggy appearance. These will disappear in a short time.

Put copyright and other information (subject, locale, etc.) on the backs of the bookmarks, then laminate the back of the photo block just as you did the front. With scissors or a paper cutter, separate the individual bookmarks and trim away any excess plastic. Given reasonable care, the bookmarks can be expected to last a long time, even though the edges are unprotected. A decorative string or ribbon may be added after punching a hole near the top of the bookmark with an ordinary paper punch. Fabric and sewing supply stores usually have these decorative materials in a variety of styles and colors.

How to Create & Sell Photo Products

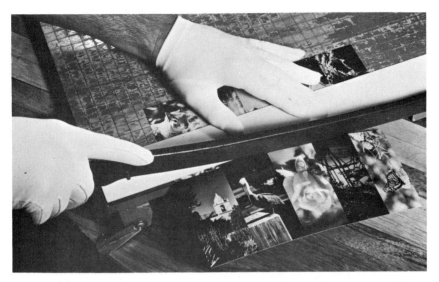

Illustration 5-3: *Use a paper cutter or scissors to separate a sheet of book-mark-size photos into two blocks of five each. Laminating with plastic is done more easily in blocks than individually.*

Illustration 5-4: *Laminate the photo side with clear plastic adhesive film. Stick one end of the plastic to the table, slip the photo block underneath and press the preglued plastic down, working from bottom to top slowly and evenly, smoothing out any air pockets as you go.*

Illustration 5-5: *Put copyright and other information on the backs of the bookmarks and laminate the back of the photo block just as you did the front.*

Illustration 5-6: *Separate each individual bookmark and trim away any excess plastic. Punch a hole with an ordinary paper punch and finish by attaching a decorative string or ribbon, if desired.*

CALLIGRAPHY PHOTO BOOKMARKS

Calligraphy can be combined with photos to make attractive bookmarks. This approach is especially useful when cutting up larger prints, since you can use much smaller pieces and still come up with an impressive product.

Follow the suggestions already given for calligraphy cards and plaques (in Chapter 3). Make up your masters first and have your job printer run off copies. Attach appropriate photos with rubber cement or photo adhesive, laminate, and divide each sheet as you would a sheet of regular photo bookmarks. As long as the paper has a hard finish, the contact plastic can be expected to adhere well. You may run into problems, however, if you try to use a softer stock such as that used for greeting cards. In this case, try laminating the bookmarks one at a time, allowing the plastic to overlap (1/16-1/8-inch), and seal the edges.

Marketing your bookmarks. The most logical place to sell your bookmarks would be the bookstores in your area. Search them out and see what they already have to offer. Also try the same kinds of stores and shops suggested for prints, plaques, and cards.

Bookmarks should be priced in the same range as your cards—around two dollars. You can go a little higher for the calligraphic type and a little lower for a straight photo type without a ribbon.

One advantage of bookmarks over cards is the lower production cost and correspondingly higher profit margin. A card that sells at the same price costs more than twice as much to make.

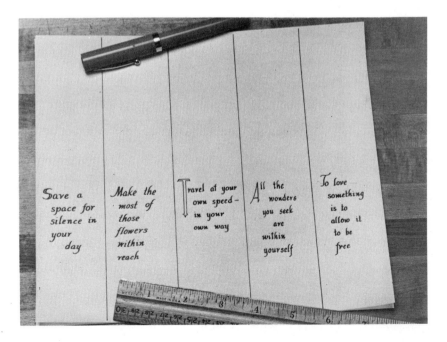

Illustration 5-7: *A camera-ready master sheet of calligraphy bookmarks.*

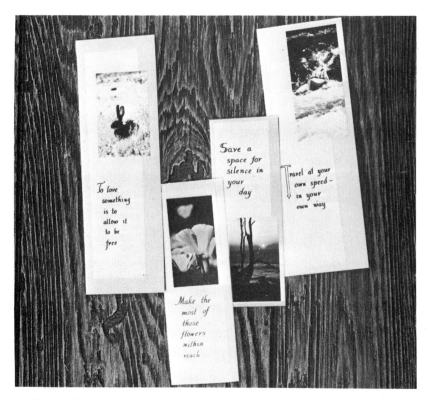

Illustration 5-8: *A selection of finished calligraphy bookmarks. Note the different ways the photo can be placed in relation to the copy.*

PHOTO KEY CHAINS

A lot of readers are content to mark their places with a scrap of paper or anything else that's handy. Losing one's place in a book just isn't as annoying as misplacing a house or car key. One can do without a bookmark, but a key chain of some sort is almost a necessity.

This means there's a stronger market for key chains than for bookmarks—a fact that hasn't gone unnoticed by the major photo products manufacturers. Look for their key chains in card and gift shops and learn what you can from them.

Many photos that are suited to your other photo products would also be suited to key chains. However, the small size of this product should be kept in mind. Stick to photos that are simple and uncluttered. Choose a single mountain peak as opposed to a mountain vista; a close-up of a single flower rather than an entire field.

In tourist areas key chain photography will again be pretty much the same as for any other product, with the point being to provide a souvenir item at a modest price. For other areas consider automobile photos such as classic cars, hot rods, racing cars in action, or distinctive details or emblems like the

How to Create & Sell Photo Products

Mercedes-Benz three-pointed star. The ever-popular flowers and animals do well on key chains, as would sports action shots. Develop key chains for skiers, golfers, hunters, fishing buffs, and so on.

HOW TO: Photo Key Chains

For those doing their own darkroom work, the bookmark printing mask can also be used for key chain photos. To make smaller key chains (2x2 inches), cut a square cardboard plug to divide the exposure opening in half, thus permitting twenty prints to be made instead of the usual ten. Use the suggested procedures for bookmarks if you are a nondarkroom photographer.

Wooden key chains. You will need some wood blanks on which to mount the photographs. These may be purchased in a variety of sizes and shapes from suppliers (see Appendix A), or you can cut your own from plywood, or whatever kind of wood you wish, including a fiberboard material like Masonite. If your area is noted for a particular kind of tree (for example, California's redwood), that might be a good choice if it's readily available.

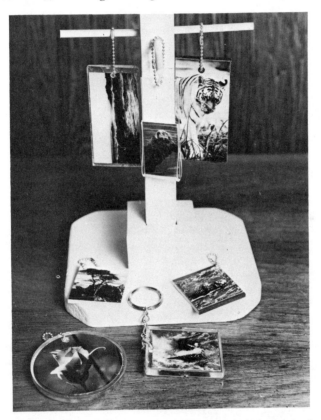

Illustration 5-9: *A selection of photo key chains including plastic photo clip (top center), wood covered with pour-on plastic (tiger and otter below), photo embedments in plastic (kayaker and flower), wood with plastic (cypress tree), and laminated plastic (beach sunset).*

Some wood products manufacturers sell bags of leftover cuttings at reduced prices—these can be ideal for key chains and ornaments. Still another option is to check local lumber and building supply stores for packages of parquet wall and floor tiles. Some brands are composed of numerous key chain-size pieces which can be pulled apart. Material that is $1/8$-$1/4$-inch thick and square (2x2 inches) or rectangular (2x4 inches) works well for key chains (round or odd-shaped blanks can pose problems when it comes to trimming the photograph to fit).

Metal bead chains and other kinds of key rings are available from crafts suppliers or locally from crafts or hardware stores.

A coating of liquid plastic will give the photograph a tough, durable finish. Although you can use several coats of polyurethane varnish, a better choice would be a pour-on polymer coating (Ultra-Glo by Chemco or something similar). This pour-on plastic is used to finish and protect a wide variety of crafts projects and can be purchased at crafts or sometimes building supply stores. Pour-on plastic will give a thicker, more wear-resistant coating, although it is more expensive than polyurethane varnish and a bit more difficult to use.

Paint or stain the parts of the wood blank that won't be covered by the photograph. Cut the photo slightly smaller than the blank so the plastic will provide a complete seal around the edges, then glue it in place with rubber cement or spray-on photo adhesive. Be sure the edges of the photo are securely anchored and that the cement is thoroughly dry; otherwise the plastic may cause curling. Before preparing the plastic, cover your work area with waxed paper. Mix the resin and hardener according to the manufacturer's recommendations, then pour onto the photo surface in a spiral pattern (Illustration 5-10). Use a card to gently spread the plastic to any area not covered.

Allow the plastic coating to cure in a dust-free environment. For a small number of items, this can be simply a matter of covering them with a clean cardboard box.

Some manufacturers recommend sealing porous surfaces like photographs before pouring the plastic coating. For this, you can use a commercial sealant, a thin coat of either polyurethane varnish or pour-on plastic, or a mixture of one part white glue and three parts water. We've coated Cibachrome and RC (resin-coated) papers satisfactorily without sealing them.

A few other pour-on plastic tips: Be sure you read the instructions carefully and exercise the prescribed cautions. The materials are skin irritants. Mix resin and hardener *thoroughly*, or else you may end up with uncured sticky spots. If so, they will have to be scraped away and the whole surface repoured—a procedure that's not only a nuisance but all too often doesn't work. We've found uncured spots next to impossible to remove, so it's best to avoid them in the first place, even if it means more time spent stirring. If any bubbles form during pouring, they can usually be removed by gently exhaling on the surface.

(With practice, you can become adept at coating all manner of photo products, including plaques, ornaments, clocks, coasters—anything that needs a strong attractive seal against grime, moisture, or rough use.)

When the plastic has hardened, add the finishing touches by drilling a hole, then installing the key chain or ring.

Plastic key chains. All-plastic photo key chains may be made by lam-

How to Create & Sell Photo Products

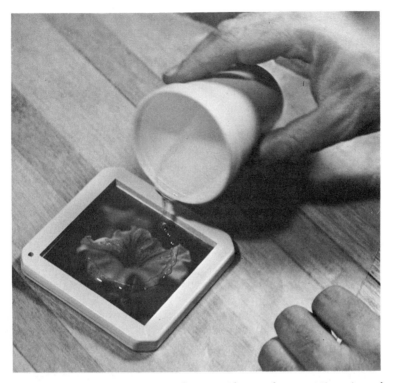

Illustration 5-10: *Cover your work area with waxed paper. Mix resin and hardener (catalyst) according to the manufacturer's instructions. Then pour the polymer onto the surface to be coated in a spiral pattern and use a card to spread it to a uniform thickness.*

ination or by casting. A good material for lamination is sheet acrylic (Plexiglas or something similar) in thicknesses of 1/16-1/8 inches. This material is commonly used in windows and doors and can be purchased from lumber and building products stores. Higher-quality acrylic sheets in a greater variety of colors and thicknesses are also available from artist's suppliers.

To make a laminated key chain, cut two plastic strips, each about 1/4-inch larger along all sides than the photograph (for a standard-size bookmark photo—2x4 inches—each strip would measure 2½x4½ inches). Use a metal straightedge and a sharp utility knife for cutting. Position the photograph as shown in Illustration 5-11, then give the exposed plastic rim a smooth coat of solvent-type plastic adhesive or any other clear plastic glue. Press the cover strip in place and allow the adhesive to dry. Sand any rough edges smooth, drill, and install the key chain or ring.

An alternative method is to use an acrylic strip as a backing for the photograph and apply a coating of pour-on plastic as described for wooden key chains. Use a clear glue or adhesive (rubber cement or a clear model-maker's cement) to hold the photo in place.

Photographs may also be embedded in plastic casting resin, available

Building Versatility

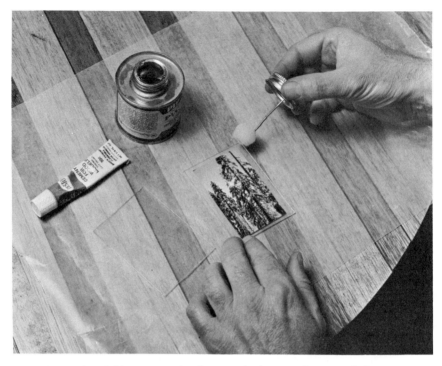

Illustration 5-11: *Position the photograph, then give the exposed plastic rim a smooth coat of plastic adhesive. Press the cover strip in place and allow the adhesive to dry. Sand rough edges smooth or cover them with Mylar tape, drill, and install key chain or ring.*

from crafts stores or suppliers. Appropriate molds are required as well. Commercially made molds are getting harder and harder to find, but there are plenty of alternatives. Visit the kitchen supply area of your local supermarket or gourmet shop and look for small mixing bowls, muffin or cupcake trays, ice-cube trays, gelatin or pastry molds, especially those made of polyethylene, a waxy-feeling plastic.

Castings will easily pop loose from polyethylene molds. The molds must be treated with care, however, since they are soft and easily scratched, and any such scratches will become part of the finished casting. You can use metal molds or make your own from plastic or wood (see page 108), but they must be coated with a mold-releasing agent before casting. Commercially prepared releasing agents are available, or you can use petroleum jelly (heat to melting in a double boiler, then apply with an artist's brush) or liquid dishwashing detergent, also brushed on.

When shopping for molds, keep the following things in mind. People won't buy key chains that are too bulky. Look for molds that will allow you to use standard or half-size bookmark photos. Round molds should be such that the overall diameter of the casting won't exceed 3½ inches. The size of the *bottom* of a prospective mold, not the top, is what to look for, since the final cast-

How to Create & Sell Photo Products

ing will probably be less than ½ inch thick. Consider, too, that multiple molds (ice-cube trays, muffin tins, and the like) may make multiple pourings quicker and easier—an aid in mass production.

Coat the mold with a releasing agent, if necessary, then mix the casting resin and catalyst according to the manufacturer's instructions. Pour the bottom layer about ⅛-inch thick. Let the plastic set to a rubbery consistency before carefully adding the photograph, face down. Pour additional ⅛-inch layers, allowing each to gel before adding the next, until the desired thickness is reached.

When the casting is fully cured, free it from the mold, drill a hole, and add the key chain or ring. Imperfections in the casting can be filed off with a coarse rasp, sanded with fine sandpaper, and then polished with a plastic buffing compound.

An alternative method that's especially useful for odd-shaped key chains is to pour the first layer as directed above, but to allow it to cure completely. The photo is then glued in place, face up, and covered with pour-on plastic.

Illustration 5-12: *Mix casting resin and hardening catalyst according to the manufacturer's instructions. Pour the bottom layer about ⅛ inch thick. Let the plastic set to a rubbery stage before carefully adding the photograph, face down. Pour additional ⅛-inch-thick layers—letting each gel before adding the next—until the desired thickness is reached.*

This procedure eliminates the uneven surface that sometimes occurs on the bottom of a casting.

Adding captions or messages. Captions, greetings, commercial or personal messages, copyright information, and so on can be written on the backs of wooden key chains in waterproof ink or inscribed with a wood-burning tool. For plastic versions write the message on the back of the photo in waterproof ink before laminating or embedding.

Marketing your key chains. Add auto supply stores to your usual list of marketing outlets. Also consider key chains as possible custom products for auto dealers and salesmen, auto repair shops and supply stores, farm and ranch supply stores, farm implement dealers, auto and home insurance agents, and tourist-oriented businesses such as motels.

PHOTO ORNAMENTS

Just as one road leads to another, so does one product often suggest others—a point that will be developed in more detail in Chapter 8. Many of the key chain techniques lend themselves well to the construction of ornaments for special occasions or year-round household decoration.

Simple hanging ornaments. Make these ornaments as you would plastic or wooden key chains, replacing the chain with a ribbon for hanging. Since suspended ornaments may turn with the air currents, it's a good idea to mount a photograph on each side. Create variety by cutting different shapes (or purchasing them ready-made) or by using a selection of different molds.

Magnetic ornaments. This kind of ornament can be used purely for decoration or as a memo holder at home or the office. Check your local stationery, home building supply, or craft stores for thin magnetic strips that can be glued to the backs of wood or plastic ornaments.

Ornament photography. You will be photographing for two kinds of ornaments: seasonal and general. For Christmas ornaments, consider winter scenics or activities (sleigh rides, skating, etc.), or still lifes with decorative candles, toys, miniature villages—the same themes you would find on commercial cards and ornaments. Use these commercial products as guides for other holidays or celebrations: Valentine's Day, Easter, Thanksgiving, and so forth. But don't be bound by them. Use your own imagination.

Nonseasonal ornaments appropriate the year round can be done on tourist themes or with dramatic scenics, flowers, animals—as well as whatever seems popular in your area.

Folding greeting card ornaments. Make these ornaments as you would the greeting cards in Chapter 3 from one large or several small photos. The cutting and folding instructions are printed inside the card. The ornaments may be designed to hang flat or to be folded into a three-dimensional shape.

Variations on the ornament theme. By using thicker (so that the plastic may be shaped with a rasp and sandpaper) or colored acrylics for laminating, or a variety of different-shaped molds for casting, or by combining the simpler forms, your ornaments can become as complex as you want. The only limitation is your imagination . . . and how far you're willing to stray from the photography itself. The more complex an ornament becomes, the

How to Create & Sell Photo Products

Illustration 5-13: *Some simple Christmas tree ornaments. The basic construction techniques are the same as for photo key chains. Create variety by cutting different shapes or using a selection of casting molds.*

more time is required for its construction and thus the higher the price of the finished product. Don't get so fancy that you price yourself right out of the market.

Increasing the number of photos, as in three-dimensional ornaments, will also add to the cost. Keep an accurate record of production expenses—photos, materials, your time, etc—in order to determine whether or not a design can be profitable. In the final analysis, it's all a matter of what people are willing to pay for your creations. It's quite possible that, given the right marketing circumstances, an elaborate and expensive photo ornament can become a good seller. For a Christmas ornament such a circumstance might be one of a growing number of stores that specialize in those decorations year round. The only way to find out is to give it a try in your own area.

Ornaments from other readily available materials. One simple way to add variety to your ornaments is to use free-form wire frames for the

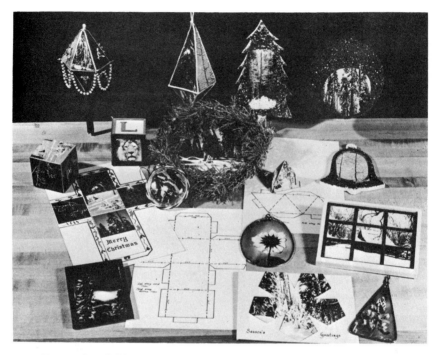

Illustration 5-14: *For more complex ornaments, use commercial materials such as precut Styrofoam blocks and use plastic foliage, beads, ribbon, etc., for trim. The greeting cards pictured here may be cut out and hung flat, or folded to make three-dimensional ornaments. The cutting and folding instructions can be printed inside the card.*

photographs. Use any kind of heavy wire that you can bend by hand (clothes-hanger wire, for example). The shape of the frames can be suggested by the photographs—for example, a snowflake-shaped frame for a winter scenic.

Bend the frame to shape—it should lie flat—and either solder the ends or wrap them with fine brass or copper wire. The frame can be painted to complement your photograph or left as is. Glue the photograph to the underside of the frame (model cement works well) and trim away any excess. A coating of pour-on plastic will protect the print and make an attractive ornament.

A visit to your local hobby and crafts stores will turn up other photo ornament possibilities. One manufacturer, for example, makes a hollow plastic shell that's practically made to order for photographs. After the photo is inserted, the plastic ball can be spruced up a bit with colorful ribbon or glue-on decorations. The result is a relatively inexpensive ornament.

Investigate the variety of Styrofoam shapes available. Some have flat surfaces on which to mount photos; others can be cut with a sharp kitchen knife to provide a photo face. Glue the photographs in place with a heavy spread of rubber cement, or spray-on photo adhesive, then give them a protective coating of liquid plastic—either polyurethane varnish or the pour-on type. The rest of the Styrofoam surfaces can be painted then sprinkled with glitter, or covered

How to Create & Sell Photo Products

Illustration 5-15: *Make free-form ornament frames from easy-to-bend wire such as that used for clothes hangers. Glue a transparency or high-contrast positive to the frame, then trim away excess. When using prints, glue the photo to one side of the frame, trim, turn over, and glue a second print to the other side. Locate the balance point of each frame, then pass a threaded needle through the photo next to the wire. Tying a small swivel to each frame will keep the suspension threads from twisting.*

with colorful cloth, ribbon, trim, sequins, bead, or whatever decorative materials you can find.

Window hangings—ornaments that transmit light. The eye sees photographs in two ways: by reflected light, as with prints, or with the aid of transmitted light, as in the case of slides. The ornaments considered to this point have made use of prints, which are largely opaque. If such an ornament is suspended in a window or from on overhead lighting fixture, only a relatively small amount of light will pass through the photograph. However, this transmitted light effect can be greatly enhanced by using transparencies or high contrast positives instead of prints.

You can have duplicate transparencies made for you, or do them yourself in several ways, including rephotographing with a rear-projection screen as described in Chapter 14. Special slide duplicating equipment is also available from photography suppliers (see Appendix A). Chapter 15 will tell you how to make high contrast positives if you have a darkroom; if not, they too can be prepared by many custom labs.

Laminate the transparencies or positives between sheets of plastic or

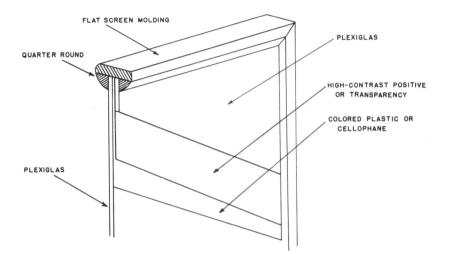

FLAT SCREEN MOLDING

QUARTER ROUND

PLEXIGLAS

PLEXIGLAS

HIGH-CONTRAST POSITIVE
OR TRANSPARENCY

COLORED PLASTIC OR
CELLOPHANE

Illustration 5-16: *You can use standard wood trim molding to make a frame for your window hanging. Assemble three sides of the frame, slip the laminated photo in place, then add the fourth side. (See Chapter 3 for more details on frame-making.)*

Illustration 5-17: *Transparent window hangings can be made with transparencies of high-contrast films, both negatives and positives.*

glass, as described for plastic key chains. In this case, however, there is no size limitation—you can make the ornaments as big as you wish. Of course, the larger you go, the more expensive the final product will be.

Instead of gluing the sheets together, you might consider framing them. The inexpensive frame shown in Illustration 5-16 was made from standard trim molding. Metal frames can be made from materials available at stained-glass or other glass specialty shops. An alternative to framing is to bind the edges with Mylar tape.

Free-form wire frames are also ideal for transparent ornaments. Be sure, however, to coat *both* sides of the transparency or positive with protective plastic.

A high contrast positive will give a black-and-white ornament. In Chapter 15 we consider adding color to the positive itself; however, color can be added to an ornament by laminating the B&W positive with colored glass or plastic.

Mobiles. Another kind of hanging ornament is the mobile, which incorporates a number of smaller ornaments balanced within a wire or wooden framework. Photo mobiles can be done around themes such as the multiple attractions of a tourist area, wild flowers, animals, special-interest activities like sailing, flying, ballooning—whatever might be popular in your location. You can use either opaque or transparent ornaments.

Price your mobiles according to the number of ornaments they contain, plus the cost of extra materials (cross arms, thread, etc.). If your mobile contains four ornaments, each of which is intended to sell for $3, then a good selling price might fall into the $14-$15 range. Whether or not your market will bear this price is something you'll have to test for yourself—you might be better off selling the ornaments individually. Even at that, a mobile might be a good way to display them.

HOW TO: Photo Mobiles

Cross arms can be made from wooden dowels, stiff wire, even branches—peeled or with bark intact. Quarter-inch-diameter dowels may be purchased at hobby shops or lumberyards and can be stained, painted, or left natural. Use coat hangers for wire cross arms or buy a coil of inexpensive 18-gauge galvanized wire at a hardware or home building supply store. If you live near a beach, thin pieces of driftwood would make good cross arms for a mobile with a nautical motif. Suspend the cross arms and ornaments with fine fishing line or strong thread. Small swivels (optional) available at fishing supply stores will allow the ornaments to swing more freely when attached between the ornaments and the suspension lines.

Assemble the mobile from the bottom up as shown in Illustration 5-18. For part A, suspend ornaments from each end of a 4-inch cross arm. Secure each knot with a dab of glue. Tie a 12-inch line to the center of the arm and shift the knot until you find the balance point. Glue the knot in place.

Part B is formed from a cross arm about 6 inches long. Attach an ornament to one end and the line from part A to the other end (adjust the length of the line so that the arrangement looks pleasing). Glue the knots in place. Tie another 12-inch line to the center of the cross arm, again locating the balance point and gluing the knot.

Use an 8-inch cross arm for part C, with an ornament at one end and part

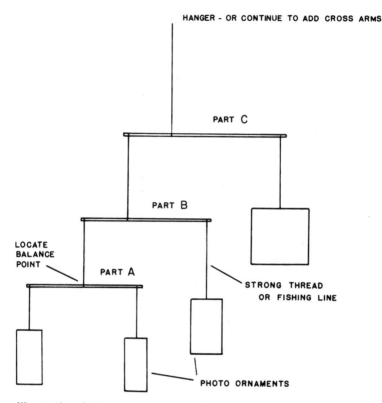

HANGER - OR CONTINUE TO ADD CROSS ARMS

PART C

PART B

LOCATE
BALANCE
POINT

PART A

STRONG THREAD
OR FISHING LINE

PHOTO ORNAMENTS

Illustration 5-18: *A sample mobile design featuring four ornaments.*

B at the other. Position the hanging line as before. You can stop at this point or continue to add cross arms for a larger mobile. By experimenting with different balance points and ornament arrangements, you can make mobiles as complex as you wish. Top off the finished mobile with a 12-inch hanging line and a loop or hook.

PHOTO COASTERS AND PLACE MATS

The basic key chain and ornament techniques can be easily adaped to photo coasters. In addition to their custom product potential, such coasters should find a ready market in home accessory shops, liquor stores and delicatessens, game and bar supply stores, patio supply and furniture stores, and the usual gift and tourist shops. Matching place mats can be easily made by laminating prints with contact plastic film, as was done for bookmarks.

As with all photo products, determine suitable subjects by doing some research in the stores where your items are likely to be on sale. Scenics or photos of local attractions would probably sell well in many locations. A series of sexy semi-nudes (see Chapter 12 for legal and other considerations) would probably sell better in liquor or bar supply stores than in patio or flower shops. Consider game items—dominoes, cards, poker chips, etc.—sports photos, or the ever-popular flowers. Look, then put your imagination to work.

How to Create & Sell Photo Products

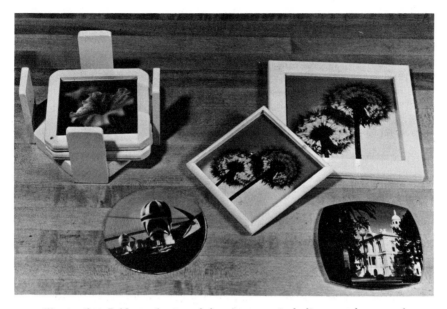

Illustration 5-19: *A selection of photo coasters, including a stack tray and a matching trivet.*

Inexpensive photo coasters. As with kitchen and bathroom products, a major concern with coasters is protecting the photograph from moisture and a moderate degree of heat. The least expensive approach is to mount automated machine prints on heavy cardboard. Coasters should measure 3-4 inches across—you can make them square, with rounded corners, or circular.

Rubber cement or spray-on photo adhesive may be used to mount the photograph, which should be slightly smaller (⅛-¼-inch) than the cardboard. Give all sides of the coaster, including the edges, several coats of polyurethane varnish. A thin sheet of cork may be glued to the bottom if desired (use waterproof glue).

Given reasonable care, this simplest kind of coaster will last quite a while. Its cost will depend largely on how much you have to pay for your prints, but shouldn't run much in excess of $.50. This would make your wholesale price—the price you charge your distributors—around $1. After dealer markup, the retail price should be in the $1.75-$2 range.

A more durable alternative is to mount the photograph on a thin wood blank which has been painted or stained. Again, the entire coaster should be given several coats of polyurethane varnish. If you wish, the photo can be further protected with a coat of pour-on plastic. Add cork to the bottom for a non-slip surface. This treatment will probably increase the cost of each coaster by $.30-$.50.

Laminated plastic coasters. Use any of the plastic lamination techniques suggested for key chains to make even longer-lasting coasters. For variety, try a colored acrylic sheet for the bottom layer and a clear sheet (or pour) for the top layer. Add cork to the bottom. Again, you will be increasing your

cost per coaster by $.25-$.50, depending on the kind of acrylic you use.

Embedded coasters. Follow the instructions for embedding a photograph in casting plastic as given for key chains. Select a flat-bottomed mold or one what will leave a depression or a raised rim in the final casting. Add cork and you'll have a product that will cost about the same as the laminated version.

Coasters with a touch of class. For the ultimate in photo coasters, make a frame for each coaster as shown in Illustration 5-19, or, if you have a lathe, use a mount blank turned from fine wood.

Cut the base of the coaster frame from $\frac{1}{8}$-$\frac{3}{16}$-inch-thick plywood, Masonite, or sturdy wood veneer. The rim is made from $\frac{1}{2}$-inch-wide flat molding or $\frac{1}{4}$-inch quarter-round molding, glued in place with a good-quality wood glue. Round the corners with a rasp (coarse-toothed wood file) if desired and sand all surfaces smooth. Paint or stain, then mount the photograph with rubber cement or spray-on photo adhesive and give it several coats of polyurethane varnish (if stain is used, varnish the whole coaster). Coat the photo with an additional layer of pour-on plastic if you wish. Add cork to the back.

Lathe-turned wood coasters can sometimes be found in crafts supply stores or the catalogs of mail-order suppliers. An alternative is to contact the industrial arts department of your local high school or college. There might be a student who would like to earn extra money by fulfilling your woodworking needs. Have him turn the coaster blank with a diameter of $3\frac{1}{2}$-4 inches. It should have a raised rim and a flat center depression for mounting the photo. Paint or stain, add the photo, seal, and finish off with a cork base.

Wood frame or lathe-turned photo coasters will be the most expensive of all, selling at a shelf price of $4-$5 or even more. In some outlets this might not be a problem; in others the price per item might just be too high. Should this turn out to be the case in your area, you have two choices: Either go with the cheaper versions or offer the higher-quality products in matched sets at a discount off the per-item prices. This method of encouraging multiple purchases was mentioned earlier in connection with framed prints and should be considered in any marketing situation, especially where one product is made up of several smaller ones. A photo mobile, for example, might be priced less than the sum total of its parts. Volume purchase discounts are a bargain for the customer and they can be a bargain for you as well, if they enable you to buy in volume from your suppliers and in turn cut your own costs.

Yet another way to reduce cost is to find a cheaper means of production. Page 108 will show you how to make your own custom molds for turning out plastic versions of your more expensive items.

Stack trays. Coasters may be sold singly, in sets (of 4, 6, 8—whatever), with matching place mats or trivets, or as part of a decor-art arrangement (see Chapter 7). When offering them as a complete set, it's a nice touch to package them in a handy stack tray.

To make a wooden stack tray, cut the base from $\frac{1}{2}$-$\frac{3}{4}$-inch-thick pine or similar stock. The tray is assembled as shown in Illustration 5-21. The uprights are made from 1-inch lattice strips, glued in place (they may be further secured with brads or small wood screws). Paint or stain and varnish the finished tray.

How to Create & Sell Photo Products

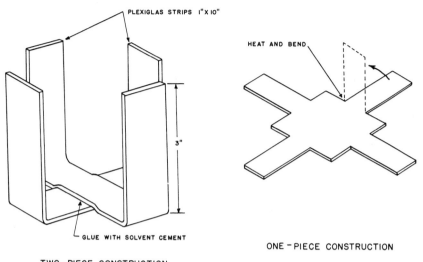

PLEXIGLAS STRIPS 1" X 10"

3"

GLUE WITH SOLVENT CEMENT

TWO-PIECE CONSTRUCTION

HEAT AND BEND

ONE-PIECE CONSTRUCTION

Illustration 5-20: *Construction details for two types of plastic stack trays. See page 106 for a more thorough discussion of plastic-working, including how to make a strip heater for bending.*

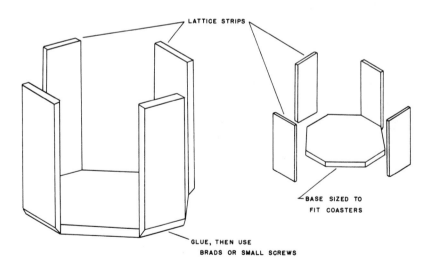

LATTICE STRIPS

BASE SIZED TO FIT COASTERS

GLUE, THEN USE BRADS OR SMALL SCREWS

Illustration 5-21: *Construction details for a wooden stack tray designed to accommodate 4-8 coasters.*

A plastic version can be made by cutting two acrylic strips as shown in Illustration 5-20. Bend the strips by first heating them on a clean cookie sheet in a 300-degree oven, or else over a strip-heater (see page 106 for a complete discussion of bending plastic). Smooth all edges with sandpaper, then glue the pieces together with solvent adhesive or plastic cement. Also shown is an alternative method in which the tray is cut as a single piece with a scroll saw or jigsaw.

Matching trivets. Matching trivets can be made the same way you did your coasters, except on a larger scale—6-8 inches across. Use cork or press-on rubber or plastic buttons (available at hardware or picture-framing stores) on the bottom.

Place mats. Matching place mats can be made by laminating 11x14-inch prints with contact plastic, as described earlier for bookmarks. When done on a small scale, this will result in a rather expensive product, so you would be advised to wait until your number of marketing outlets is such that you can order large quantities of prints (perhaps in conjunction with other products, like clocks, that will use this size print).

DECORATIVE PHOTO BOXES

Imagine a world without boxes. For that matter, imagine your own home without them. The box is the great catch-all of civilization; we use it to enclose and protect, to ship from one place to another, to store, to organize, to get things out of sight, to . . . well, you get the idea. We—and all our possessions—would be lost without boxes!

There are boxes to serve all kinds of specific functions. We have boxes for jewelry, for cigarettes, for cigars, for pipe tobacco, for recipes, for those desk-cluttering items like paper clips, rubber bands, pins—whatever. And best of all: Boxes are useful items with flat surfaces just made for pictures!

In this section we'll take a look at two general styles of decorative boxes which can be altered in size and shape to suit a great variety of purposes. Similar boxes are available assembled but unfinished from suppliers (see Appendix A), or—if you have some woodworking skills—you can make your own. With photographs added, they become attractive and useful additions to home and office decor.

HOW TO: Photo Boxes

Make the following boxes from knot-free plywood, finish-sanded on both sides (Grade A). You will also need a crosscut saw (the smaller and more closely set the teeth, the smoother your cuts will be), some half-inch brads for nailing corners, a good-quality easy-to-use wood glue, and sandpaper in coarse, medium, and fine grades. A wood rasp is also useful for rounding edges if desired.

A simple recipe box. The sides and ends of the box shown in Illustration 5-22 are cut from $3/8$- or $1/4$-inch plywood, the top and bottom from $3/16$-inch plywood. Cut pieces to the dimensions given in the diagram (the exact size of the side pieces will depend on the thickness of the plywood used), then glue them together. Reinforce the joints with brads, countersinking the heads and filling the holes with wood dough.

A simple unhinged box. This style of box would be suitable for hold-

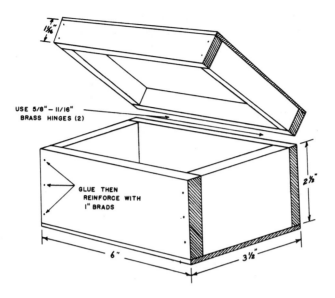

Illustration 5-22: *Construction details for a simple hinged recipe box.*

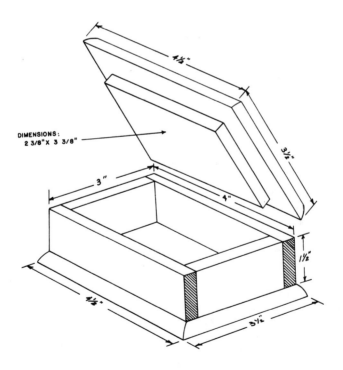

Illustration 5-23: *Construction details for a simple unhinged box.*

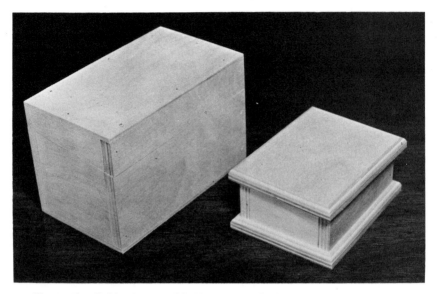

Illustration 5-24: *The assembled boxes ready for finishing. Similar boxes can be purchased ready-made from suppliers (see Appendix A).*

ing cigarettes, jewelry, or desk items like paper clips and pins. Cut all pieces from $3/8$- or $1/4$-inch plywood to the dimensions shown in Illustration 5-23. The edges of the top and bottom pieces can be left square, or rounded with a rasp and sandpaper before assembly. Glue the box together, reinforcing the joint with brads.

Finishing the boxes. After filling all nail holes and imperfections with wood dough, sand all surfaces smooth. If you plan to paint the box, apply a coat of primer. When dry, sand again to smooth the raised grain and then finish with two or three coats of enamel.

The box may also be stained, although the wood plies will be more obvious. Follow up the stain with a coat of polyurethane varnish and sand smooth before mounting the photographs.

Adding the photos. Photographs may be glued with rubber cement or spray-on photo adhesive to as many sides as you wish. Choose photos that suit the purpose of the box—food for a recipe box, male-oriented photos for a cigar box. Flowers will rarely sell a cigar box, but a schooner under full sail will. Seal and protect the photos with several coats of polyurethane varnish.

Use these basic styles as springboards for your own designs. Boxes can also be made from select hardwoods (or veneers) or with interior trays or compartments. Jewelry boxes can be lightly padded and lined with satin or velvet; cigarette and cigar boxes can be sealed on the inside with plastic, for humidity control. Boxes can also be made from sheet acrylic or cast from custom molds that you can make yourself (see page 108). Use your imagination—if you come up with a design that's beyond your skills, you can probably find someone in your town who's capable of doing the job. If not, check with wood products suppliers (Appendix A) for such custom services.

How to Create & Sell Photo Products

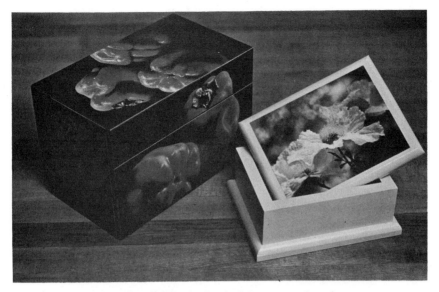

Illustration 5-25: *The finished decorative photo boxes.*

Music boxes.　Decorative boxes can be turned into music boxes simply by installing a music box movement. Inexpensive movements are available at many hobby and crafts shops or from suppliers that can be located in crafts and home projects magazines like *Popular Mechanics* and *Mechanix Illustrated*. Jewelry stores might also be expected to carry movements, or at least provide you with some sources. Or see Appendix A.

Consider gearing your photos to the song. A music box that plays "I Left My Heart in San Francisco" would be an ideal foil for photographs of that city. The same principle can apply to any number of places or themes—what about your area?

PHOTO PUZZLES

Mention photo puzzles and most people think immediately of the jigsaw variety. Certainly it's the most common type of photo puzzle, but for the beginning photo products entrepreneur it's also probably the most expensive approach. As with postcards or posters, the job must be done by a specialist, and that means large-volume production, which is impractical unless you have proven photographs and a large number of marketing outlets. Setting yourself up with the necessary cutting equipment would be even more expensive, although you could doubtless locate a machinist or fabricator that could make it for you. Of course, you could always obtain advance orders—as was suggested for postcards—in which case the project would become feasible.

There are, however, other puzzle options for photographers, including some simpler types for children and the "Four Frustrating Fotos" shown in Illustration 5-26.

Children's puzzles.　Unfinished, precut wooden jigsaw puzzle blanks can be purchased from crafts suppliers, or you can cut your own with a scroll

Building Versatility

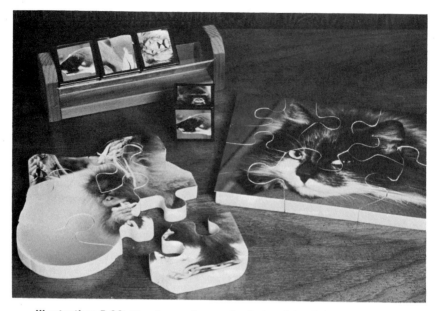

Illustration 5-26: *Simple puzzles can be designed for children and adults alike. Puzzles like the "Four Frustrating Fotos" (left rear), however, are anything but simple to solve.*

or jigsaw. Heavy cardboard can also be used and cut with a sharp utility knife. Choose photographs of interest to children—animals, action sports, fantasy creations (see Chapter 4), food and sweets, etc. Pay a visit to some toy stores for ideas and also with an eye toward possible marketing outlets.

HOW TO: Children's Jigsaw Puzzles

Cut the puzzle blanks from ¾-inch clear pine or fir, using a scroll saw or jigsaw (a power saw will help ensure that the cuts are vertical and that the pieces will easily slip together). Cut pieces so they will interlock and the puzzle will hold together. Also, since these puzzles are designed for small hands, seven to ten pieces should be enough for an 8x10-inch photo. Sand the pieces and give them several coats of paint. Assemble the puzzle on the back of the photograph (see Illustration 5-27), outlining each piece in the process. Cut the photo with scissors or a sharp knife, then glue the picture pieces to the corresponding puzzle pieces with rubber cement or spray-on photo adhesive. Seal and protect the photo surface with several coats of polyurethane varnish.

The above puzzle was done on a standard rectangular format. Another possiblity—if your chosen photograph has a large, clearly defined subject—is to cut the puzzle blank to the shape of the subject, as shown in Illustration 5-28. In fact, many commercially cut puzzle blanks are shapes other than square or rectangular. Animal shapes are quite popular—fish, turtles, rabbits, cats, dogs, frogs, pigs, elephants, and so forth. A visit to the zoo could provide you with plenty of matching photos.

To make your own puzzle of this type, first cut out the photo subject, then

How to Create & Sell Photo Products

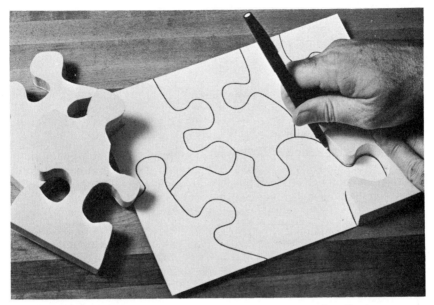

Illustration 5-27: *Children's puzzles made of large, easy-to-handle pieces are available from commercial suppliers, or you can cut your own. Outline each piece on the back of the photograph—in this case an 8x10 print.*

Illustration 5-28: *An alternative is to make an outline puzzle if the photograph has a large, clearly defined subject. First, cut out the subject, then trace the outline onto the wood. Cut the wood and photo into puzzle pieces to fit the subject (in this case, a baby chimp playing with a fishing float).*

trace the outline onto the wood and saw to shape. Next, cut the wood blank and photograph into puzzle pieces and finish as directed above.

Mass-producing your puzzles. You can invest a lot of time in cutting each puzzle individually, and the labor is bound to drive the cost higher and higher. One way to beat this syndrome (mentioned earlier in connection with coasters) is to use plastic instead of wood. This can be done by first making a wood master puzzle, then making a reusable mold of each piece (see page 108). Each piece can then be quickly and inexpensively cast with casting resin, in the same manner as that suggested for key chains and ornaments.

HOW TO: "Four Frustrating Fotos"

Cut cubes from 2x2-inch stock (or visit lumberyards or nearby construction sites for scraps or end cuttings that you can buy inexpensively). Sand the cubes—you will need four per puzzle—and finish them with paint or stain.

You will also need four different photographs, which we will identify as A, B, C, and D. Simple, related images work best—heads of animals, different colored flower close-ups, or any selection where a single element dominates each photo. Obtain eight half bookmark-size (2x2-inch) prints of photo A, six of photo B, and five each of photos C and D. Follow the arrangements shown in Illustration 5-29 in gluing the prints to the sides of the cubes. Give the cubes several coats of polyurethane varnish.

An optional rack for the cube puzzle can be made from ¾-inch-thick clear pine or fir and ¹⁄₁₆-⅛-inch-thick acrylic. See Illustration 5-30 for construction details.

Illustration 5-29: *Glue the photographs to each cube in the order shown. Don't worry about which end is up, only that the photo is in the correct place.*

Illustration 5-29A: *Solution to Four Frustrating Fotos.*

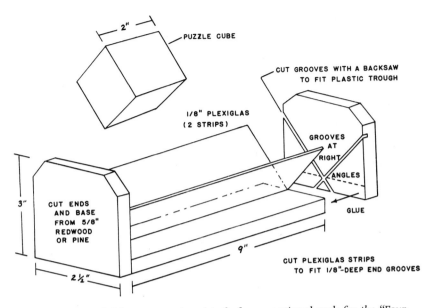

Illustration 5-30: *Construction details for an optional rack for the "Four Frustrating Fotos."*

Placed side by side in their rack, the cubes will display four rows of photo faces. The trick is to arrange the cubes so that no photo appears twice in any row, as shown in Illustration 5-26. Before you get overconfident, remember that's four *rows* of *different* photos!

Use your imagination to create other photo puzzles—for example, a stack-type puzzle consisting of eight cubes, or twenty-seven, or whatever—the more the merrier, and more difficult. And, of course, more expensive.

MINI-CALENDARS

If you can tear yourself away from your photo puzzle, let's get back to paper products. The so-called paper products have an advantage over the other types of photo products—those made from wood, plastic, etc.—in that a large part of the actual production can easily be turned over to someone else. Paper products have two elements: the photographic print, which can be done by a custom lab, and the printed material, if any, which can be handled by your job printer. Both services are readily available, no matter where you live.

In addition to the paper products already mentioned—greeting cards, calligraphy cards, mounted prints, postcards—there is another item found in almost every business or household: the calendar.

Full-size calendars are expensive to produce and, consequently, a bit chancy for beginners. They will be discussed in Chapter 6. Right now, we're interested in a more affordable alternative, the mini-calendar.

Following are three variations on the mini-calendar theme: the greeting card calendar, the wallet calendar, and the calendar plaque. Use them as jumping-off points for many other possibilities.

Building Versatility

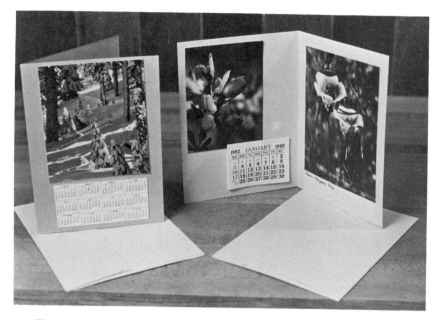

Illustration 5-31: *Greeting card mini-calendars are nearly as easy to make as photo gift cards, and the added calendar function may make them a more popular item.*

HOW TO: Mini-calendars

Greeting card calendars. Make these as you would the photo greeting cards discussed in Chapter 3, except for a few alterations. Mount the photograph so that it complements the calendar. This is best done *before* folding. Horizontal photographs are usually placed above the calendar, and vertical photos to one side. The card may then be folded with calendar and photo on the inside for protection or on the outside for easy viewing through a plastic envelope.

You can have an all-on-one-page calendar printed right on the card stock by your job printer, or you can buy calendar pads from stationery stores or mail-order photo equipment suppliers. You can also draw your own pads and have them run off by your printer or, for smaller numbers, on a photocopier. You can put each month on a separate page or arrange them in groups of two, four, six, or even all on one sheet—any pleasing, useful, or imaginative concept you can come up with.

Glue the photo and calendar to the paper stock with rubber cement or spray-on photo adhesive. Greetings or messages can also be added to the blank pages by your printer. Punch a hole for hanging and include a matching envelope. You can package the calendar and envelope in a plastic bag for protection if you wish.

Wallet calendars. Wallet calendars can be of two types: a small photo-calendar card that actually slips into a wallet or a photo-calendar combination encased in a walletlike plastic folder (see Illustration 5-32). These plastic

How to Create & Sell Photo Products

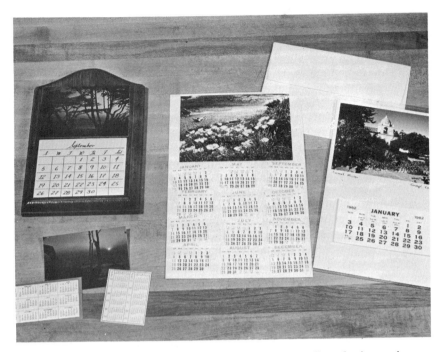

Illustration 5-32: *Wallet and plaque calendars. The wallet calendar on the right makes use of a ready-made plastic envelope. The alternative in the center is made by laminating both photo and calendar with clear contact plastic such as that used for bookmarks. A pocket-size calendar can be made by laminating both photo and calendar back to back using materials such as those shown beneath the plaque.*

Calendar plaques can be made in the same way as calligraphy plaques. Put a calligraphic message on the last page of the calendar so that it remains when the last month is torn off.

folders are available from mail-order plastic products suppliers, or you can make you own by simply laminating both the calendar sheet (all months on one page) and the photograph with contact plastic, as suggested for bookmarks and place mats.

Calendar plaques. Calendar plaques are essentially the same as calligraphy plaques (Chapter 3), except that a calendar pad is substituted for the calligraphic message. An even better approach is to combine the two so that at the end of the year, when the last month is torn off, a calligraphic message remains so the plaque can continue to serve a decorative purpose.

This is easily accomplished if you make your own calendar pad. Simply write the message on the last page, then glue the pad to the plaque. If you wish, the last page can be varnished along with the photograph, and the calendar pages suspended from small hooks.

PLASTICS—ONE WAY TO CUT COSTS AND SPEED UP PRODUCTION

Because it is easy to work with and readily available, wood is recommended for many of the products described in this book, except in cases like ornaments and key chains where a transparent material is required. Wood is relatively strong and has a charm all its own. In a day when so many products are mass-produced in plastic, wholly or in part, wood takes us back to a time of pride in craftsmanship.

It is unfortunately true, however, that many people aren't willing to pay the extra cost of wood craftsmanship. It is more expensive, simply because wood costs more in terms both of materials and construction time.

The great advantage of plastics is that they lend themselves to the repetitive processes of mass production. Plastics enable the manufacturer to lower production costs—an important consideration in all businesses, small or large. Once suitable molds have been created, production is simply a matter of pouring or injecting, curing, and then adding the finishing touches, if any. In some cases a certain amount of additional assembly is involved; in other cases the product pops from the mold ready to sell. Plastic crafting is one key to increased (and cheaper) production that will work for a wide variety of photo products.

HEAT-FORMING ACRYLIC SHEETS

Heating plastic in an oven will work all right for limited production, but the method has some disadvantages and requires certain precautions.

First of all, be sure the oven is accurate (check it with an oven thermometer). At temperatures in excess of 300 degrees F. acrylics may scorch, bubble, or even undergo irreversible molecular change. Err on the low side.

Leave the oven door slightly ajar to prevent buildup of toxic fumes and keep the kitchen or work area well ventilated (even at that, the oven and room will probably smell like plastic for a while).

The plastic should never go untended during the heating process. If the phone rings, or if you are called away for some reason, turn off the oven and remove the plastic.

Acrylic sheets ⅛ inch or less in thickness generally become pliable in about four minutes at 300 degrees F. Quarter-inch-thick sheets require about ten minutes. (Avoid trying to bend anything thicker without specialized equipment.)

One problem with using the oven is the necessity of heating an entire sheet just to make one small bend, as in the case of a plastic stack tray for coasters. Heating small areas can be accomplished with a strip heater.

HOW TO: Strip Heater

Illustration P-1 shows how to assemble a strip heater, a simple device for heating small areas. Required are a band of electric heating tape, a piece of ½-inch thick plywood 6 inches wide and about 6 inches longer than the heating tape (for the base), two ¼-inch-thick pieces of plywood, each 2⅝ inches

How to Create & Sell Photo Products

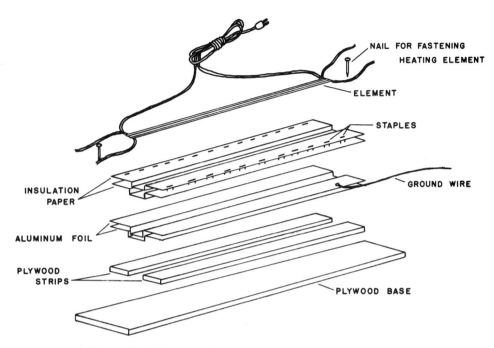

Illustration P-1: *Assembly details for making a strip heater.*

wide and the same length as the heating tape (set ¾ inches apart to form a channel for the tape), some heavy-duty aluminum foil, some high-temperature insulation paper (normally used as an oven liner and available at hardware stores), electrical cord with a plug and another piece for a ground wire—both long enough to reach an electrical outlet.

Nail the plywood strips to the base so they form a ¾-inch channel for the heating tape. Cover the strips and channel with two pieces of heavy-duty aluminum foil. Attach the ground wire to the foil with a screw that goes into the plywood. Cover the foil and channel with a double layer of insulation paper (scored to fit) and staple in place. Fit the heating tape in the center of the channel and twist the end strings around a pair of nails driven into the base.

LOOK FOR THE PLASTIC ALTERNATIVE

If an idea works well in wood, it can generally be translated into plastic, although some design changes may be necessary. As an example of this, consider the lighted photo clock shown on page 167. A simpler plastic variation on that theme is shown in Illustration P-2. The plastic version is less elaborate, requires less time, and is cheaper to make; thus the selling price can be much lower. The price can be cut even further by eliminating the electric light (the high-contrast positive or the transparency can be lighted only by available room light). A translucent plastic back on the light box of the wooden clock will have a similar effect.

The combination light box and stand for the wooden table clock is made from ¾-inch-thick pine, with a ¼-inch plywood back (or use translucent

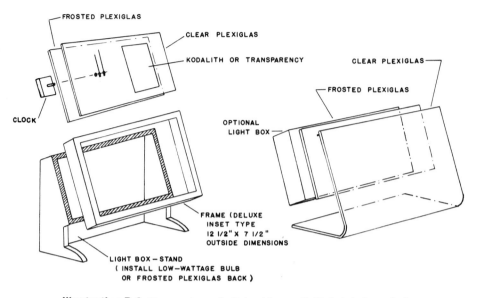

FROSTED PLEXIGLAS

CLEAR PLEXIGLAS

KODALITH OR TRANSPARENCY

CLEAR PLEXIGLAS

FROSTED PLEXIGLAS

CLOCK

OPTIONAL
LIGHT BOX

FRAME (DELUXE
INSET TYPE
12 1/2" X 7 1/2"
OUTSIDE DIMENSIONS

LIGHT BOX — STAND
(INSTALL LOW—WATTAGE BULB
OR FROSTED PLEXIGLAS BACK)

Illustration P-2: *Two versions of a lighted (or available light) photo clock, one in wood and one in plastic.*

acrylic for available light). The front frame is a scaled-down version of a deluxe inset-type frame (see Chapter 6) made from $5/8$x$2\frac{1}{2}$-inch redwood or pine. Position the high-contrast positive or transparency between two pieces of acrylic—the outer one clear, the inner one frosted (a clear piece may be frosted by sanding). The frame may be secured to the stand with a screw through the bottom.

In the plastic version an 11x14-inch sheet of acrylic forms both the base and the face of the clock. The picture is held in place by a second sheet of plastic (6x11 inches), which is frosted. Drill holes approximately ½ inch from each corner and install small brass bolts and nuts to hold the sheets together (the light box can be secured by screws through these holes). A box for housing an electric light can be made from ¾-inch-thick pine or redwood.

Although plastics can give you access to lower-price markets, plastic photo products need not appear "cheap." Well-made plastic creations have clean, modern, sculptural lines that are just as pleasing and expensive-looking as those of their wooden counterparts. As usual, the nature of your market will determine what does and doesn't work.

MAKING YOUR OWN MOLDS

Thus far, products made by casting in plastic have been pretty well restricted by the availability of molds. Granted, there's a great variety of containers that can be used, but what if none of them has quite the right shape or size? Suppose, for example, you'd like to make a coaster tree similar to that shown in Illustration 8-8, only in plastic. And, you would also like to make a plastic version of the photo-frame serving tray with coasters such as those shown in Illustration 5-19.

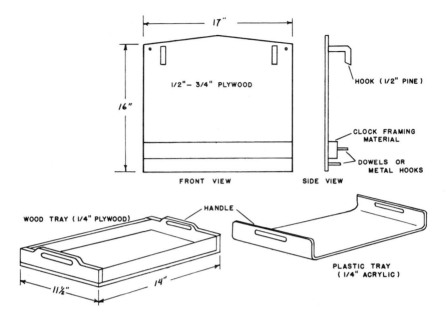

Illustration P-3: *Wood and plastic versions of a coaster/serving tray tree. The tree and tray may be made from plywood or sheet acrylic. The coasters may be cast in any shape desired, by first making a wooden master and then a custom mold.*

In the wooden version the tree and serving tray are made of plywood. Each could be made in a similar design from sheet acrylic. The coasters, however, should be cast in order to make their production cost-efficient, and that means a custom mold. Can you make such molds in any size and shape you wish?

The answer is yes. And the molds can be used again and again. If your plastic coasters start to sell well, you can speed up production by making more molds and pouring more coasters at one time.

HOW TO: Molds for Plastic Casting

You will need a master from which to cast the mold (in this case a wooden coaster—or other product—you wish to duplicate), synthetic rubber molding compound, Plasticine (an oil-base modeling compound), petroleum jelly (or a commercial releasing agent), and a wooden base to hold the master. The base should be large enough to provide at least a 1-inch border all around the master.

Three types of synthetic rubber are available: silicone, polysulfide, and polyurethane. The last is the least expensive and can be purchased (as can Plasticine) from plastics suppliers and from art stores that sell sculptor's materials.

Follow the manufacturer's instructions for mixing polyurethane molding compound; measure the two components carefully—an error of only 5 percent can alter the mold, making it too soft or too rigid for use. Be sure to use glass,

metal, or plastic utensils and containers for mixing in order to protect the compound from moisture, which can keep it from curing fully.

As shown in Illustration P-4, place the master face up on the wooden bases. Hold it in place with a seal of Plasticine. Then make Plasticine walls around the base (see Illustration P-5). The walls should be about ½-inch thick and should extend at least 1 inch higher than the master at its highest point. Coat the interior surfaces of the walls, the master, and the base with a parting agent (petroleum jelly melted in a double boiler and applied with an artist's brush, liquid dishwashing detergent, or a commercial agent).

Mix the molding compound and pour it into the Plasticine box until the master is covered by approximately ½ inch of compound. Allow the mold to cure for about sixteen hours at room temperature, then remove the Plasticine and the wooden base and gently twist the mold free from the master.

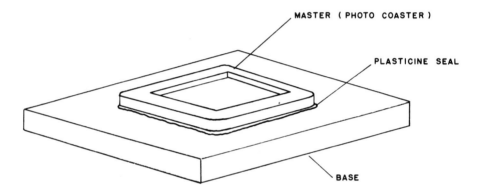

Illustration P-4: *Use Plasticine to seal the master and hold it to the base.*

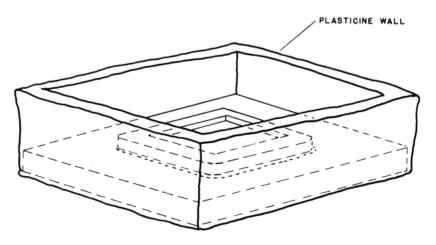

Illustration P-5: *Build Plasticine walls around the base to hold the molding compound.*

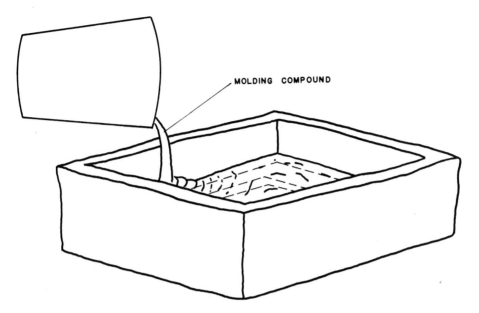

MOLDING COMPOUND

Illustration P-6: *Pour the molding compound into the Plasticine box until the master is covered by approximately ½ inch of compound.*

Making your own molds and using plastic casting techniques can not only speed up production of simple items like coasters, but also spell the difference between life and death of a product in the marketplace. A case in point might be the children's puzzles described in Chapter 5. Made of wood, these puzzles will necessarily be expensive because of the tedious sawing involved. A power saw will hasten the process, but each puzzle must still be cut individually. Once you have a satisfactory master, however, it becomes a simple matter to make a mold for each piece, and after that, the pieces can be quickly and cheaply mass-produced by casting.

THE ATTENTION GETTERS

In today's busy world, full of rushing people who are constantly bombarded with new and ever more inventive attempts to separate them from their money, how do you get them to stop and seriously consider *your* products? You have to get their attention. And in order to do that, your work must stand out in a marketplace crowded with competing products of all types.

One way to accomplish this is size—a big photograph will generally attract more attention than a small one. Another way is to use photos that are real eye-catchers in themselves.

The products covered in this chapter are adaptable to both of these methods. Photo clocks, posters, mini-posters, and calendars can all be designed for visual impact. Among photo products, they are the extroverts, the "barkers" who will call people to your other offerings.

These barkers can be as bold as you want them to be. Use your most dramatic scenics or shots of unusual subjects. Experiment with strong, simple, graphic images. Dare to be different. Higher-priced attention getters such as clocks may not be among your high-volume sellers, but when placed in a display they can pay their way by drawing customers.

PHOTO CLOCKS

There may be some photo clocks already available in your chosen marketing area. If so, take a look at them. Generally, they'll turn out to be mass-produced items ranging in price from less than $20 (when on sale) to over $100, depending on size, type of clock movement, and how well they're finished. Examine the craftsmanship. Usually, the frames are cheaply made, the photos "authentic lithographs of original prints"—or some such euphemism that translates as *cheap*. Notice also that the photographs are almost exclusively scenics.

There is a subtle difference between *inexpensive* and *cheap*. Most of the photo clocks we've seen fall into the latter category. Thus, many people equate

photo clocks with lack of taste: "They're tacky!" You may have to overcome this negative reaction, and you can . . . if you follow a few guidelines, and in short *make a better product.*

The elements of a good photo clock. Keep foremost in mind that you are no longer selling only a photograph, you are selling a clock. This is something the mass producers almost totally ignore. If you are to succeed, to beat them at their own game, you must always remember that people buy clocks in order to tell time. The photograph should not interfere with that function.

Most photo-clock manufacturers are selling pretty or spectacular (or as one critic puts it, "boring") pictures with holes punched in them and clock-works attached. No matter that one has to hack through a tangle of jungly vines or scale a rocky mountain canyon to find out what time it is!

Now, some people don't object to doing that. But those people would probably choose the mass-produced clock instead of yours because it's cheaper. And it will be. There's no way you can make a $20 clock profitably unless you throw quality to the winds. The customer you're after is one who will spend $30 to $70 for a clock that's a handsome addition to a room's decor. And in their own way, the clocks you design will be works of art.

What makes them so?

Unity. Total effect. All elements are designed to complement one another: frame, photograph, clock dial, and the movement itself. All must contribute to a single, total, attractive, *functional* effect.

As an example of this unity, consider the clock in Illustration 6-1. It was designed for use in a game room. The dominoes in the photograph are falling against a red background. The frame is made of wood, finished in glossy black enamel to echo the color of the dominoes. The white dots on the dominoes are repeated on the clock dial by using white stick-on dots for number markers; the hands are also painted white. The Domino Clock incorporates a high-quality quartz movement accurate to one minute per year.

The frame. Depending on where you live, you might be able to find ready-made frames that will suit your purpose. Good-quality picture frames will work fine as long as they're at least 1½ inches deep in order to protect the clockworks and photo face (even when using the smallest movements, ¾ inch is necessary on both sides of the photograph). For clocks designed with protective glass or plastic over the photo face, the frames must be at least another ½ inch deeper. A good size for photo clock frames is 11x14 inches.

If you can't locate any ready-mades, you'll either have to make your own or have someone do it for you. As with framed prints, if you take the job to a professional custom framer, your production costs will skyrocket. On the other hand, he might have suitable frame moldings available at reasonable prices if you're willing to do the cutting and assembly yourself (or he can do the cutting and you can simply put them together).

You can also contact the industrial arts teacher at a local high school or college, as suggested earlier. But let it be known right from the beginning that you expect high-quality workmanship and will accept nothing less.

Whatever frame design you select, remember the concept of *unity*. It should be adaptable to a wide range of finishes from paint to stain to *au na-*

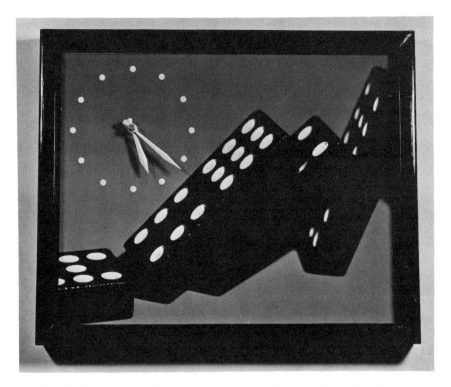

Illustration 6-1: *The domino clock. Try to achieve a unity of effect in your clocks by designing them as a whole, keeping in mind that their main function is to tell time.*

turel. Generally, the simpler the design, the better and more versatile. The frame should not dominate, but rather contribute to the total effect; it should appear (and in fact *be*) sturdy but not massive. And if you're designing your own frame, the simpler you keep it, the easier and more inexpensively it can be produced in volume.

Clockworks. Quartz movements are recommended because of their accuracy, dependability, and convenience. They are small in size, and since they're battery-operated, they need no wiring or electrical outlets.

You can usually find a selection of suitable movements at your local hobby or clock shop. Prices may range from $10 to $15, depending on quality and size, but if you order in quantity straight from suppliers, the cost per unit can be cut almost in half. You can locate clock suppliers from their advertisements in crafts or how-to magazines (or refer to Appendix A in this book).

Whatever type of movement you choose, make sure it's battery-operated. Nobody wants a power cord dangling from a wall clock. A cord is less objectionable in table clocks such as those discussed in Chapter 8, but even then a battery movement is more convenient.

Shop around for the thinnest and lightest movement you can find so that additional supports won't be necessary. Mounting the print on double-weight

114 How to Create & Sell Photo Products

mount board will be sufficient in most cases.

Hands and dial markers can be purchased in a variety of styles from suppliers, although press-on paper dots available at stationery stores work well for the latter and can be color-coordinated with the photo and frame. When possible, key your selections to your photos. Historic subjects are more suited to ornate lettering and hands than modern ones. When no choice seems obvious, opt for simplicity.

The photograph. Although each part is vital to the whole, the photograph is the most important single element. It is the photograph that will sell the clock.

Since you will be making enlargements, sharp focus is critical, especially if you use a 35mm format and plan on photo faces 11x14 inches or larger. We use 35 mm for 11x14-inch clocks with good results. That's a nice average size, although there are clocks on the market ranging from 8x10 inches to 2x4 feet. An exception to the sharp focus edict is, of course, the judicious use of depth of field.

The key to sharp focus is adequate shutter speed. Use $\frac{1}{60}$ of a second or faster for a 50mm lens; $\frac{1}{125}$ or higher for a 135mm lens, and so forth (rule of thumb: match minimum shutter speed and focal length of the lens as closely as possible). If conditions dictate a slower speed, use a sturdy tripod.

The photograph you use should have a natural location for the clock dial, preferably an empty quarter relatively free of subject matter. This might be an area of sky or shadow, of rock or water, but it should have the same overall color tone. This "clock spot" can be light or dark or anywhere in between, but it should be uniform throughout the area of the dial markings so they can be easily read (unless inconsistency of color in that respect is part of your overall design).

You'll quickly learn that not all photographs make good clocks. In fact, as pointed out in Chapter 4, photographing for a specific product such as a calligraphy plaque or a clock may reeducate your "eye." To make your photos more salable, it's a good idea to compose them in terms of quarters, with a relatively empty and noncompetitive "commercial spot" for the clock dial, mini-poster message, calligraphy, or whatever. Even photos you eventually send out to publishers or other photo buyers will frequently be judged by whether or not they have space for a magazine logo, advertising message, or greeting card script. Think *product* when you shoot and your work will be more salable in all respects!

Photographs with no natural clock spot can be used with a specially designed frame (see Illustration 6-9) in which the clock dial is set apart from the picture. Such frames will be a little more expensive to make, but they do have some advantages, not the least of which is that they leave the photograph undamaged and thus reusable for other purposes. And exchanging one photo for another is much easier, since there's no need to dismantle the clockworks—an important consideration for market testing.

Another characteristic of a good clock photograph is simplicity. Once you've decided on your main subject, pay attention to the background. Learn how to use your depth of field scale or preview button to eliminate distractions, elements that compete with the main subject. Think unity.

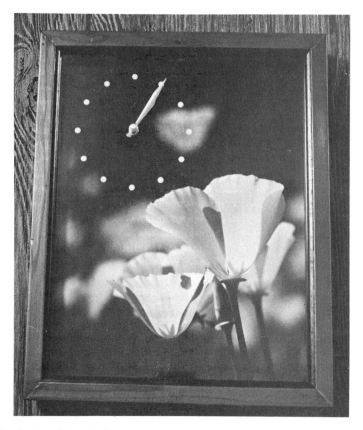

Illustration 6-2: *The "Poppy Clock," an example of selective use of depth of field to control distracting elements.*

For example, consider the Poppy Clock in Illustration 6-2. Notice how the backlighted California poppies fade by degrees into blurs. The poppies stand out from a dark background as vivid splashes of orange light. Orange press-on dots mark the dial and a redwood frame speaks of California, at the same time harmonizing with the color tones of the flowers.

Simplicity is further illustrated by the Hang Glider Clock (Illustration 6-3), which consists of only five elements: the silhouette of a hang glider, a huge yellow sun, an orange sky, the clock dial in black dots and hands, and a frame in either natural redwood or black enamel.

The photograph used for the Hang Glider Clock represents one of two ways to approach a subject. It also defines our basic philosophy of photography. Your camera need not be restricted to recording or even interpreting *only what occurs*; it can also be used to create *what you wish to occur*.

We could have spent countless hours standing around waiting for a hang glider to flash in front of a yellow sun in an orange sky (and possibly have missed the shot when the event did happen), or we could have photographed the elements separately and assembled them to our liking at home. We chose

How to Create & Sell Photo Products

the second approach. Chapters 14 and 15 will show you how you can do the same thing—techniques that can also be used to salvage some of your uninspired throwaway slides, with a little imagination.

The hang glider photograph is also a good example of the multiple use (and income) you can derive from a single shot. Not only does it earn money on clocks, plaques, cards, and other products, but rights were also sold to a publisher for one-time use on the cover of a photography book. Exploiting your photographs to the fullest possible extent will be covered in more detail in Chapter 13.

HOW TO: Photo Wall Clock Frames

To make the following wall clocks, you will need a mounted 11x14-inch print (use double-weight mount board if possible), a battery-powered clock movement, minute and hour hands (2⅝ inches), a sweep second hand (optional), dial markers or numbers (³⁄₁₆ inch)—press-on dot labels work nicely—and either an appropriate 11x14-inch frame or else wood as specified. LED digital movements may also be used if you prefer, and if you can find them.

In order to make your own frames, you will need a backsaw and miter box, wood glue, a hammer, a nailset, and 1-inch finishing nails (brads). Some wood dough or spackling compound is useful for filling nail holes and imperfect joints. You'll also need medium and fine-grain sandpaper and, of course,

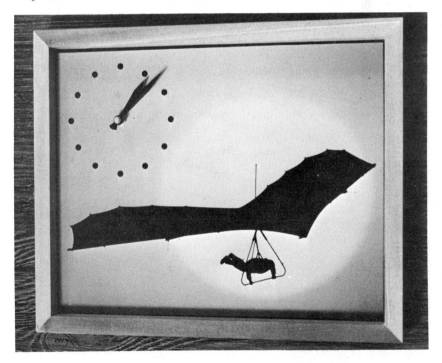

Illustration 6-3: *The "Hang Glider Clock" is the essence of visual simplicity. Making the photo, however, was anything but simple!*

paint and/or stain and varnish, depending on how you wish to finish the frame.

Wood should be kiln-dried and clear (no loose knots). Use pine, fir, or redwood for economy frames. Select hardwoods can also be used, as can commercially cut moldings, but the resultant frames will be more expensive. When selecting wood for frames (or other projects), it's a good idea to consult with a savvy lumberyard salesperson—they can frequently save you time, money, and headaches.

Cutting angles can be tricky, so later on you might wish to invest in a more refined miter box, which holds the saw and framing materials more securely. These miter boxes cost from $50 to $150, depending on quality, but can pay their way by making the job much easier and the results more professional-looking. This is especially true if you plan to make a lot of frames. Power saws suitable for frame cutting are also available but more expensive ($200 and up).

The standard flush-fit frame. The easiest frame to make—and one where the photograph will cover your mistakes—is the flush-fit frame. You'll need approximately 5 feet of ³⁄₄x1¹⁄₂-inch clear fir or pine. Use a miter box to cut the outside dimensions of the frame to correspond to the outside dimensions of the photograph—in this case, 11x14 inches. On the finished clock the photograph will completely overlap the frame.

Obtaining a good square frame will be easier if you either use corner clamps while gluing or build a simple jig to hold the frame (see Appendix D).

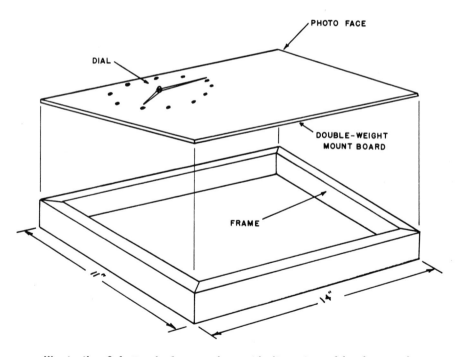

Illustration 6-4: *Cut the frame to the outside dimensions of the photograph, since the photo-face will be mounted to the front of the frame.*

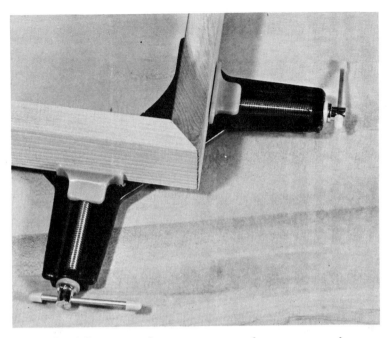

Illustration 6-5: *To get good square corners on a frame, use corner clamps as shown while gluing a simple jig to hold the frame after gluing. Use waxed paper between the frame and work surface to prevent sticking.*

In either case, cover your work surface with waxed paper to prevent the frame from sticking.

Give the glue plenty of time to set, according to the manufacturer's instructions, then further reinforce each corner with two 1-inch brads. Use a nailset (or large nail) to sink the brads, then fill the holes with wood dough or spackling compound. Sand all surfaces smooth and paint or stain and varnish. In choosing finishes, keep in mind the concept of total effect.

The standard inset frame. A variation of the standard frame is one in which the photograph is recessed instead of overlapping the frame members. This inset frame requires a little more material, time, and craftsmanship, but it makes a handsomer final product. It also offers more protection to the clock face, which is a consideration should you ever need to ship your clocks. Remember, too, that your retailers may occasionally have to ship to out-of-town customers.

The wood used for this frame is the same as that used for the flush frame—3/4x1 1/2-inch fir or pine. Since the frame will be more visible, redwood, oak, walnut, or some other attractive wood can also be used and left natural or lightly stained to highlight the grain before varnishing or oiling.

In this case, the photograph is mounted inside the frame, so the *inside* dimensions of the frame must be the same as the *outside* dimensions of the photo. When measuring, allow 1/16-1/8 inch extra to account for variations in wood or print size. Thus, the actual measurements would be 11 1/16x14 1/16 inches for

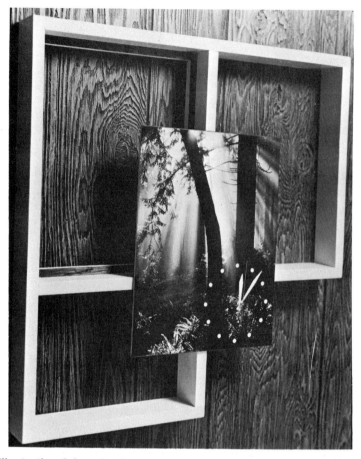

Illustration 6-6: *A finished inset frame and clockface ready to be glued in place. Note how subject matter can appear in the "clock spot" as long as there's a uniform color tone behind the dial markers. The finished version of this clock is pictured in Illustration 6-18.*

a frame that is to hold an 11x14-inch photo. As before, use a miter box to make accurate cuts. Since the corners will show, this is more critical than for the flush-fit frame.

Glue and nail the frame as previously described. Make picture supports from ½-inch-square pine stock or something comparable. Use a miter box and cut the supports to fit inside the frame. Four support strips are required. In order to prevent raw wood from showing around the photograph, blacken one side of each strip—the side to which the photo will be mounted—with a felt-tip pen. Paint or stain and varnish the frame and then install the picture supports by nailing them to the frame with 1-inch brads (these need not be sunk and filled, since the heads will be inside the frame and hidden by the picture). Position the supports so that the photo face will be about ¾ inches from the front of the frame when mounted.

How to Create & Sell Photo Products

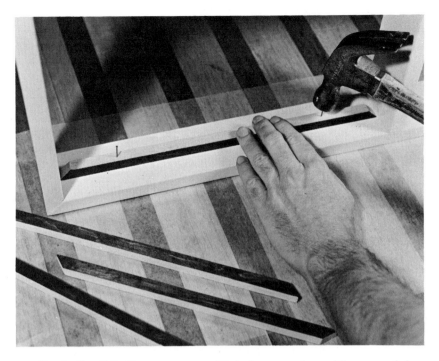

Illustration 6-7: *Picture supports of ½-inch-square pine molding are nailed inside the frame. Blacken the supports with paint or a felt-tip pen before installing them; this will keep raw wood from showing around the photograph.*

Deluxe frames. An even more polished-looking clock can be obtained by installing protective glass or plastic over the clock face (be sure, however, that the movement you use has a rear time adjustment). The standard inset frame can be adapted for this purpose by gluing ¼-inch quarter-round molding inside the front of the frame to form a rabbet. It will also be necessary to add more depth to the frame itself to adequately protect the clockworks. This can be done by using wider framing material—2½ inches, as opposed to 1½ inches for the standard frames—or by nailing a riser made of ½-inch-square pine to the back of the frame, as shown in Illustration 6-8. With rabbet and riser (if necessary) installed, paint or stain and varnish the frame.

Cut (or have the dealer cut) an 11x14-inch piece of glass or clear plastic (1/16-1/8 inch thick). This will be held in place—and separated from the photo face—by spacers made from ¾-inch flat molding. If a little more depth is desired, the spacers may be made from 1-inch-wide lattice strips—this may be necessary when installing some sweep second hands with longer shanks. You will need four spacers, cut so that they fit snugly inside the frame. They may be finished to match the frame or painted black. Install the glass or plastic, then nail the spacers in place with ½-inch brads. The photo face can then be installed (see page 129) and supported with strips cut from ½-inch-wide molding, also nailed to the frame with ½-inch brads.

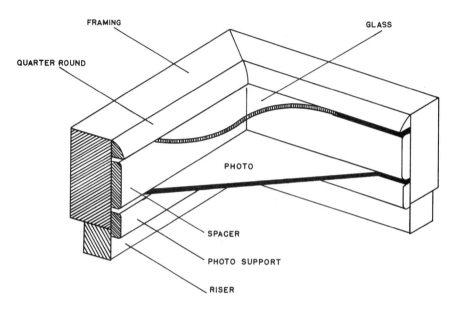

FRAMING GLASS QUARTER ROUND PHOTO SPACER PHOTO SUPPORT RISER

Illustration 6-8: *Cross section of a corner of a deluxe frame, showing construction details.*

Using glass or plastic to protect the photo face has several advantages. although there will be a larger investment in time and materials. First, the photo faces can be more easily exchanged, since they're not glued in place (as are the photo faces on the standard models). It's a simple matter to pry the support pieces loose with a screwdriver and exchange photographs—an important consideration in market testing.

Second, the deluxe clocks can be more easily cleaned, which makes them more adaptable to kitchens or other areas where dirt and grime are a problem.

The obvious disadvantage is that they will be costlier to produce, and their retail price must be correspondingly higher.

In deciding whether to use glass or plastic, consider the following:

1. Glass is cheaper, easier to clean, less likely to have flaws, and more resistant to scratching. Because it's less subject to static electricity, it doesn't attract as much dust.

2. Plastic is more resistant to breaking and can be shipped more successfully. Moreover, sprays are now available to help neutralize static electricity and facilitate cleaning.

Weigh the pros and cons and choose the material that best suits your purposes. A possible compromise is to use glass on clocks intended for local sale and plastic on those to be shipped.

Avoid using nonglare materials. Even when mounted close to the photograph, they cause a noticeable softening. When they're installed at a distance—as is required for a clock—the effect is more than just noticeable, it's

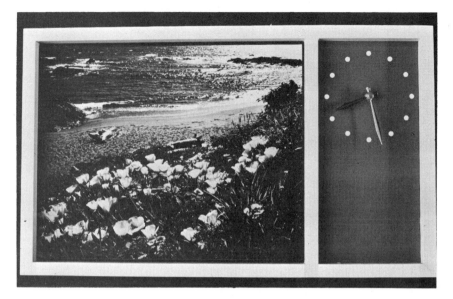

Illustration 6-9: *The "Time Frame" design avoids damage to the photograph. It can therefore be removed and used for other purposes such as framed prints. This design also allows use of photos without a natural clock spot.*

disastrous! An impressionistic painting by Monet may be worth a great deal, but a photograph in the same vein is simply blurry.

The "Time Frame." By extending the dimensions of the standard inset frame and placing the clock face alongside or below the photograph, you can avoid altering the print itself—no holes, no dial markers—and the print is reusable for other purposes. This kind of frame also permits the use of photographs without any natural clock spot.

HOW TO: The Time Frame

To make a Time Frame, use the same materials and procedures outlined for the standard inset frame, but extend the lateral dimensions, as shown in Illustration 6-10, and add a divider strut and separate clock face. Thus, the overall inside dimensions for a Time Frame designed for an 11x14-inch print would be 11$^{1}/_{16}$x20 inches. The divider strut is made from the same material as the rest of the frame, glued, then nailed in place (use 1-inch brads) so that the opening for the photograph measures the standard 11$^{1}/_{16}$x14$^{1}/_{16}$ inches.

Use double-weight mount board for the clock face. The mount board can be either painted or laminated with thin wood veneer such as the strips used on interior walls. Cut supports for the clock face from $^{1}/_{2}$-inch-square pine, just as you did for the photograph. Since this clock face will be a little smaller than that on a standard clock, 2$^{1}/_{8}$-inch hands are recommended.

The deluxe Time Frame. The Time Frame may be adapted for protective glass or plastic in much the same manner as the standard inset frame. Illustration 6-11 shows how the divider strut is constructed. In this case, the strut is not mounted permanently, but instead simply slipped in place and

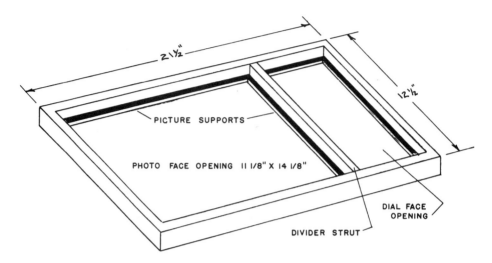

Illustration 6-10: *Lengthen the standard inset frame to allow for a separate clockface.*

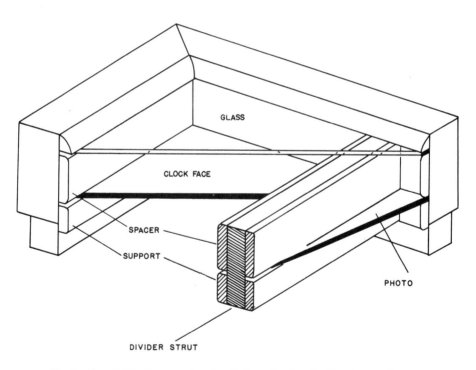

Illustration 6-11: *Construction details for adapting the Time Frame for protective glass or plastic. With the exception of the divider strut, the procedure is the same as for the standard deluxe frame.*

held there by the photograph and clock face (this allows for easier removal of the glass or plastic should it become necessary). Cut the glass or plastic to fit the entire frame, not the photo and clock portions separately.

Adapting ready-made frames or standard moldings for clocks. Ready-made frames or standard frame molding will already have a rabbet to hold the glass or plastic in place. Cut spacers and support pieces as directed for deluxe frames. Generally, commercial molding will cost a dollar or more per foot. Be certain it's deep enough to adequately protect the clock movement. Illustration 6-12 shows a frame made from commercial molding as well as the finished clock.

Finishing your frames. Since clocks are expensive, customers have a right to expect a professional-looking product, and this includes the frame.

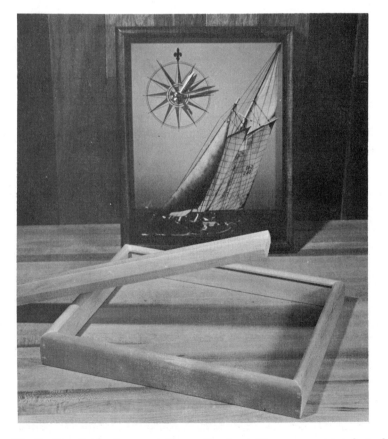

Illustration 6-12: *Commercially cut framing will save one step—that of forming a rabbet. Otherwise, the procedures are pretty much the same as making a frame from scratch. Generally, such commercial molding will cost a dollar or more per foot. Be certain that it's deep enough to give the clock movement adequate protection. Shown is the molding, the unfinished frame, and the completed clock.*

Less-than-perfect joints might be acceptable on low-priced framed prints, but not for higher-priced ones or for clocks.

Frames made of less expensive woods like pine or fir can be painted or stained and varnished. First, fill nail holes and imperfections with wood dough or spackling compound; then go over the whole frame with fine sandpaper. Wipe away the sanding dust. Apply a good-quality primer to the wood and sand smooth when dry (the primer tends to raise the grain). Finish off with two or three coats of enamel, sanding lightly before each coat. Choose colors that complement the photograph and contribute to the total effect.

Follow the same procedure for staining your frames, except instead of primer and paint, apply a good-quality wood stain with a brush. When the stain has "set," or looks dry—a matter of five to fifteen minutes depending on how porous the wood is—wipe with a soft cloth. After the stain has dried thoroughly, brush on a coat of varnish. Polyurethane varnish will work well, but keep separate cans for finishing photographs and for finishing frames, since that used for frames will usually darken from accumulated stain. Sand lightly after the first coat of varnish and then apply a second coat.

Frames made of redwood or select hardwoods can be left natural, oiled with linseed oil, waxed with a good-quality furniture wax, or varnished as mentioned above.

Installing the clock movement. Positioning the dial markers will be easier if you first make a template, as shown in Illustration 6-13. For a standard 11x14-inch photo face, first draw a circle, using a compass set for a 2½-inch radius (the circle will measure 5 inches across). With an inexpensive 30-60-degree triangle (available at most stationery stores) locate and mark the number locations along the circumference of the circle. Position the template over the clock spot of the photograph and mark the location of each dial marker with a pin. Also mark the center of the circle.

Cut the center hole large enough to accept the shaft of the clock movement. Use a sharp-pointed knife, a circular-bladed punch, or a woodcarver's crescent-shaped gouge.

Gummed press-on dots work well for dial markers, since they are inexpensive and available in a wide range of colors. They can be easily applied with the aid of a toothpick. Suppliers also offer numerals or other kinds of markers which can be glued in place with a contact bond cement (Scotch Grip or any similar brand).

Secure the clock movement and the hands to the photograph with their respective mounting nuts. Align all hands in a twelve-o'clock position before tightening them in place. It's a good idea to test clock movements for several days *before* installing them, just to be sure they work properly. *Always* test them before putting the finished clock on the market.

Glue the finished photo face to the frame (picture supports) with a good-quality white or wood glue. Weight down as shown in Illustration 6-17 until dry.

In the case of deluxe frames, the photograph is not glued in place, but rather held by four supports made of ½-inch-wide flat molding (or something similar). These are nailed to the frame with ½-inch brads.

Follow the same procedure when marking the Time Frame dial, but set the compass for a 2¼-inch radius.

How to Create & Sell Photo Products

Illustration 6-13: *Make a dial template using a compass, a square, and a 30-60-degree triangle—all can be purchased in inexpensive versions at stationery stores. First draw a horizontal line through the center of the circle, then a vertical line at right angles to the first. Then use the triangle to divide each quadrant into thirds.*

Guaranteeing the clock movement. As mentioned earlier, always test the movements for several days before putting your clocks on the market. If there's a problem, it should show up in that length of time. Since most movements are guaranteed for at least a year by the manufacturer or supplier (avoid buying movements that aren't guaranteed), it's a good idea—and a sound business practice—to pass that guarantee along to your customer. (See Chapter 12 for more about guarantees.)

More variations on a theme. Given the basic clock idea and a little imagination, there's almost no limit to what a craftsman-photographer can do. As with cards and plaques, calligraphy can be used to zero in on specific markets, such as the inspirational and religious.

The frame design can be altered to incorporate several photographs or to

The Attention Getters

Illustration 6-14: *Using the template to mark the clock dial on the mounted photograph.*

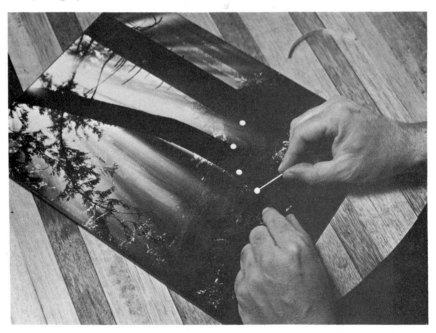

Illustration 6-15: *Gummed press-on dots work well for dial markers. They are inexpensive and available in a wide variety of colors. Suppliers also offer numerals or other kinds of markers. A toothpick makes placing the dots easier.*

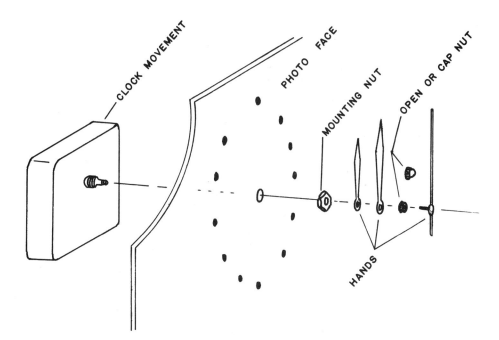

Illustration 6-16: *Assembly sequence for fitting the clock movement to the photograph. Use the open nut with a second hand, a cap nut without.*

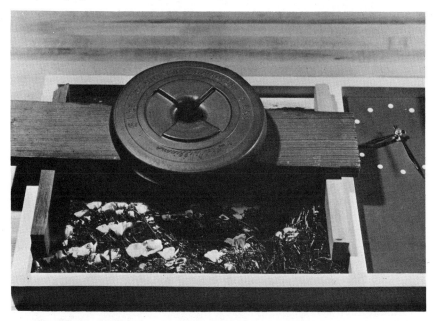

Illustration 6-17: *Glue the finished photo face into the frame and weight down until dry. Use a good-quality white or wood glue.*

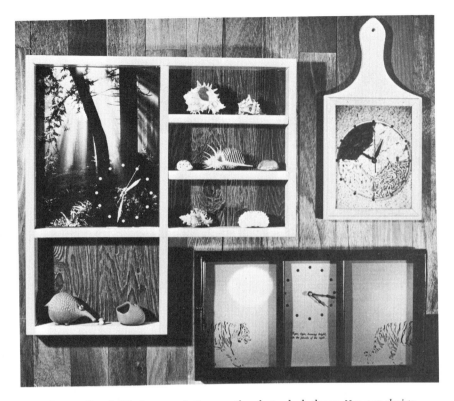

Illustration 6-18: *Some variations on the photo clock theme. You can design your clocks to serve other functions besides telling time (as in the shadow-box clock at left), to complement the decor of a specific room (as in the pasta kitchen clock at upper right), or to display more than one photograph.*

suit special situations. Frames can also be designed to serve other purposes, such as a shadow box for displaying knickknacks, with or without a clock.

The rigid confines of a frame can be abandoned altogether in favor of free-form wooden slabs or plaques. A large plaque in the shape of a skillet or breadboard, for example, would make a unique kitchen clock when combined with an appropriate photo. In this case, it would be necessary to cut a recess in the plaque (or slab) for the movement. As with smaller decorative plaques, the photo face could be sealed against grease and grime with a coating of liquid plastic.

Finally, decorative wall groupings can be designed to go with your clocks. Choose a theme—wild flowers, for example—and use it on several framed prints as well as on a photo clock. They may then be sold as a complete collection or individually.

MINI-POSTERS

In the past decade or so, full-sized posters have become a bestselling pop art form. However, in order to keep the price reasonable, posters must be

How to Create & Sell Photo Products

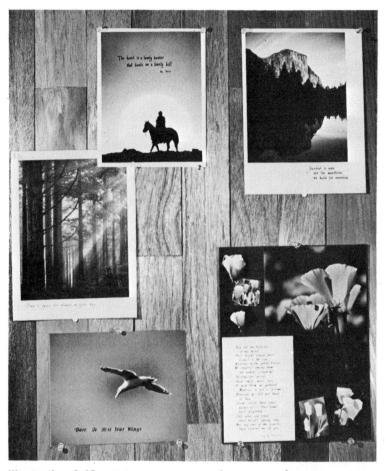

Illustration 6-19: *Mini-posters are a good way to market-test your poster ideas.*

printed in fairly large numbers (press runs in the thousands). This requires a correspondingly large distributing network to market them, all of which translates as high risk. If you guess wrong about the appeal of your idea, you could end up with a deflated bank account and a roomful of unsold posters!

Certainly, there's money to be made in posters—sometimes a *lot of money*. But the problem for beginners is to minimize the risk, to test an idea and form a realistic opinion of its chances for success *before* investing too much money in production.

One way to do this preliminary testing is through your other products. You will have photos that sell better than others; perhaps even some that are runaway bestsellers. Try these photos as mini-posters.

Mini-posters can do anything full-sized posters do, on a smaller scale. For our purposes, we'll define a mini-poster as a photograph-message combination with an overall size between 8x10 and 11x14 inches.

As with plaques, the message may be placed directly on the print or on paper or mount board alongside. Your mini-posters can be sold mounted or unmounted, framed or unframed, or even on large plaques.

Refer back to Chapter 3 for a more complete discussion of calligraphy and printing. Obviously, writing directly on the photograph has its disadvantages, not the least of which is the possibility of misspellings, ink blots, omissions, or other mistakes. The psychological pressure to "do it right the first time" often results in a shaky hand as well. Production costs also rise when each mini-poster has to be done by hand.

For short messages an alternative is to have a rubber stamp made by your local printer. The message can then be stamped directly on the photo using permanent waterproof ink. Be forewarned, however, that this method is by no means foolproof. Have you ever tried to get a perfect imprint with a rubber stamp?

Another possibility is to use rub-on transfer letters available at stationery shops. These can be applied directly to the photo, to a separate sheet of paper or mount board, or—if you have a darkroom—to a clear vinyl sheet, which can be used as a printing mask (see Chapter 15).

Black-and-white mini-posters can be run off in volume by your local job printer (some can also run off color versions at a higher cost or else arrange to have it done for you). If you have an idea that works well in color on a limited basis, you might try something similar in black and white with an eye toward modest mass production. Although having your mini-poster camera-ready will save money, the printer can add the message for you at extra cost.

Marketing mini-posters and posters becomes easier as you find more and more retail outlets for your products. Not only will you have a wider range of distribution, but your increased sales volume will permit bigger discounts on prints, supplies, and printing.

POSTERS

Of all photo products, posters probably have the greatest moneymaking potential. The right idea at the right time can quickly become a bonanza.

Where do you get poster ideas? The same place you go to generate ideas for any of your products: the marketplace. Seek out the shops in your community that sell posters. Spend some time studying their displays. As you did with greeting cards, plaques, and other products, notice what themes prevail and how they are approached photographically. Pay particular attention to those of interest to you. If, for example, you enjoy photographing animals, study with extra care the posters that feature animals. Are they primarily humorous? Are the situations generally natural or are they contrived? What kinds of animals appear most frequently? Are these more popular animals ones that you can photograph?

If more than one poster manufacturer is represented in a store, compare themes. Take notes if that will help (we always carry paper and pencil to jot down ideas, publishers' addresses, etc.). Try to determine percentages of various kinds of posters that fit categories such as the following: animals (serious), animals (humorous), artistic scenics, standard (postcard shot) scenics, scenics combined with inspirational messages, travel, outdoor adventure, sports,

How to Create & Sell Photo Products

romantic (misty, moody, couples doing things), inspirational (other than scenic), humorous, and those featuring celebrities. The percentages will give you an idea of what subjects are selling in your area—someone in another locale may come up with completely different results. Ask the dealers and sales personnel for their opinions on what is and isn't moving.

Don't restrict yourself to color posters. Although you'll probably find color to be more popular—and more widespread—black and white is an easier and less expensive way to break into the multimillion-dollar poster business.

Once you have a good idea of what's already available, and have matched successful themes to your own interests, begin to look for possible variations. If a humorous poster of a dog strikes your fancy, ask yourself how you could have said the same thing in a different way. You're looking for a fresh angle on what's already selling. This sort of "imaginative imitation" will cut the risks involved.

Always be on the lookout for appropriate messages—quotes, poetry, whatever—that appeal to you. As long as they aren't copyrighted or trademarked (look for the copyright notice or trademark registration in fine print on the poster or other product), you can use them on your own posters. Even if they are protected by a copyright, the words themselves might suggest photographic possibilities (see Chapter 4).

As you get a better feel for the market, you may be able to come up with something entirely original. The biggest money, of course, rewards the original idea . . . if it hits.

As suggested earlier, try your ideas in mini-poster form first. You might even consider cutting your prices to the point where they're competitive with commercial posters, even if it means not turning a profit. This could give you a better picture of how the ideas would sell in poster form. Remember that for market-testing purposes, you sometimes have to do a bit of judicious gambling; some businesspeople even sell items at a loss—called loss leaders—in order to attract buyers for follow-up sales (see Chapter 11). In fact, all such testing is a gamble to some degree. If your mini-posters prove popular, you will then face the ultimate gamble—whether or not to risk them as posters.

Again, the risk will be minimized if you go with black-and-white versions, which can be done in limited quantity by your local job printer. He can also advise you as to the cost and procedures for obtaining color posters. You can also consult *The Thomas Register*, available in most libraries, for names of poster manufacturers and distributors.

Selling your posters. Working through distributors is one way of expanding your number of marketing outlets if, as in the case of posters or postcards, you're geared toward mass production. Inquire at stores selling these products for the names and addresses of distributors, or look under posters in the Yellow Pages. Another way to sell your posters is to advertise and market them by mail. Both of these methods will be covered more thoroughly in later chapters on marketing techniques.

Otherwise, try your posters wherever your other products are being sold or in any store that already includes posters in its inventory.

Some final poster-scripts. Since your photos will be blown up very large, sharp, clear images are critical (unless soft focus is your intention), espe-

cially when using a 35mm format (many poster manufacturers buy only larger-format transparencies).

One advantage of getting to know your local job printer very well is that he'll have a better understanding of what you're trying to do. Talk over mass production situations with him. Tell him you need samples for marketing and promotional purposes and that if they generate enough interest, you'll order full press run. Maybe he'll give you a price break, maybe not. It all depends on the kind of relationship you have. Printers are competitive—it's to his advantage as well as yours if your posters or other printed products sell.

CALENDARS

There might be a market in your area for some kind of specialty calendar—one featuring local scenes, for example, or one aimed at skiers or boating enthusiasts. As with posters or any other prospective product, you should first research your area to find out what's already there.

One thing you'll notice is that there are two basic types of full-size photo calendars. Those with separate photos for each month are more expensive to produce and should be considered in the same class as posters—as mass-production items.

The second type features a single photograph and either a year-at-a-glance calendar or a pad containing the separate months. This kind of calendar is better adapted to low-volume production. For a photo try to choose something that will be popular with a large number of people—a local scenic attraction, a terrific sunset with foreground interest, or breath-stopping sports action, to name a few.

For market-testing purposes, you can buy such calendars, minus the photograph, from commercial suppliers (see Appendix A). Some kinds come pre-glued so that all you need do is press your photograph in place. They can be quite expensive, however, and will result in a high-priced and noncompetitive product. If the calendar is a custom job, your customer might not object, since it will be an exclusive item, unavailable to the general public.

In the retail market, where your prices must be in line with those of similar products, a better idea would be to again work through your local job printer. Doubtless, he can come up with a more competitve price, especially if you can provide a camera-ready master copy and are willing to do the gluing yourself.

For those with darkrooms, contact calendar masks are available for use with photo printing paper, either color or black and white. The plastic film mask containing the numeral portion of the calendar is placed on the photo paper, which is then exposed in two steps: the first with your selection of negatives in a large clear opening, and the second while covering the picture section and exposing the numeral portion. Thus, the print itself becomes the calendar.

These contact calendar masks are also available for printing slides with color reversal paper or for using Cibachrome materials.

Mass production of calendars. As suggested with posters, you might wish to price your calendars at break-even or a slight loss to keep them competitive for testing purposes. Once you're sure they will sell, you can investigate volume production.

How to Create & Sell Photo Products

Many custom postcard manufacturers also do calendars. A recent brochure from one such company will give you some idea of the costs involved. Their "thrifty" model featuring four photographs (three months to each photo) can be printed for $2,143 for 3,000 calendars—the minimum order. As expected, the price per unit drops considerably on larger orders: 20,000 calendars cost $3,909.

Single-photo calendars (overall size, 11x17 inches) are priced at $3.60 apiece in orders of 500. The per-unit price drops to $1.90 in orders of 1,000 and $.26 in orders of 10,000.

Six-photo calendars can be purchased for $1.39 apiece in minimum orders of 5,000, and twelve-photo calendars for $2.39.

Prices change, of course, so contact various manufacturers for their current rates. Obviously, you need to be pretty sure of your photographs and your market before you can afford to gamble on mass production.

ART AND DECOR ART

Chapter 3 covered the marketing of framed prints at the most affordable level, where the photographer's aim is to sell large numbers of attractive photos at reasonable prices. Retail outlets for such prints will probably be local gift shops, souvenir stores in tourist areas, and art and crafts cooperatives.

Prints may be marketed in a variety of other ways as well, but they may require different approaches to framing, displaying, and selling. These levels include:

> ***Moderate-price galleries.** Moderate-price galleries fill the gap between gift shops and galleries specializing in photography for collectors. These more modest galleries may include the work of other local artists (painters, lithographers, etc.) as well. Although their prices are generally higher than the types of stores listed above, their primary aim is still to provide attractive artwork that many people can afford.
>
> ***Art galleries that sell photography for collectors.** These galleries deal in limited edition prints. While their sales volume may be lower, their prices are likely to be much higher.
>
> ***Photography as interior decoration.** Interior decoration photography, sometimes called decor art, can range from a single framed print through a wall design featuring a variety of prints to a full-wall photo mural. Photographs can also be incorporated in room accents such as lamps or divider screens, and even in furniture.

MODERATE-PRICE GALLERIES

In marketing through moderate-price galleries, a photographer must be just as cost-conscious as when working with less expensive products. At the same time, the results must have a certain polish. This is generally a matter of presentation and may be dictated, at least in part, by the gallery itself—minimum or recommended framing standards, plus the probability that your al-

How to Create & Sell Photo Products

lotted space will be limited and you must therefore be more selective in what and how you display.

Framing: key to "polish." A popular choice for photographers is aluminum section frames. They have a clean, contemporary look that doesn't compete with your photographs. Similarly, uncluttered wood frames can also be used and may in some cases cost less than the metal frames.

Aluminum section frames come in a variety of finishes including silver, gold, pewter, black, and brown. Of these, the most widely used is silver. They are sold as pairs of matching pieces of various lengths, complete with hardware for assembly. To make an 11x14-inch frame, you would buy a package of two 11-inch sides and another package of 14-inch sides. They may be put together quickly and easily using only a screwdriver.

When you're marketing framed prints, the cost of the frame more or less determines your selling price. Anyone who has ever taken a picture to a custom framer knows that the complete treatment can cost three or more times the price of the picture itself. Thus, you need to be exceedingly careful in shopping for materials in order to get the best possible deal.

If you buy through your local custom frame shop, you could price yourself right out of the market—even if you can obtain a discount. Why? Because there are too many people between you and the manufacturer. Each middleman, including the wholesaler, the distributor, and the framer himself, will add his profit margin before you pay the final retail price. As with all the raw materials you buy for your photo products business, the closer you can get to the manufacturer, the cheaper the price and the lower your production cost.

For aluminum section frames the least expensive sources might well be

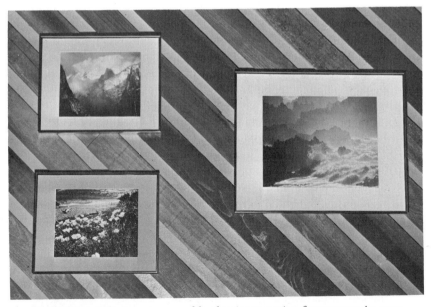

Illustration 7-1: *Easy-to-assemble aluminum section frames can give your photographs a professional appearance.*

those advertised in photo magazines aimed at professionals.

In addition to the frame, you will also need a mounted print, an overmat, protective glass, and corrugated cardboard for backing. Mat board comes in a great variety of colors and textures and should be chosen to harmonize with the photo and the frame. By doing your own darkroom work, you can keep the cost of an 8x10-inch print under $2. With the other items you'll need, the complete framed print should cost around $15. The use of machine-made prints from mail-order processing labs will keep the cost about the same. Custom printing, however, may add another $3 to $5 or more, depending on the size of your order and the custom handling requested.

Fifteen dollars may sound reasonable, but remember this is only the beginning. First add a 100 percent markup to pay yourself for your labor and photography. That will bring the total to $30. On top of that, the gallery will add its commission, which may again double the figure. Thus, the final selling price will be in the $50 to $60 range.

Unfortunately, not everyone who likes your work will want to pay that much, even in medium-price galleries. But there is a good pricing middle ground, one that most gallery owners will find satisfactory. Arrange to hang prints of several of your best photos, attractively framed and priced according to the guidelines outlined above. But also offer for sale a wider selection of prints that are matted, but unframed, and encased in plastic bags to protect them from dirt and fingerprints. This selection should include prints like the

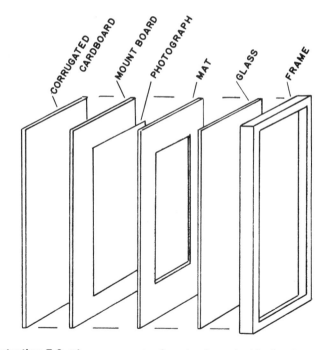

Illustration 7-2: *The components of a print framed with aluminum section frame.*

ones you hang framed, plus additional subjects. These can be displayed in a container that is attached to the wall or placed on a table or other available flat surface. Matted prints should sell in the $15 to $18 range for an 8x10-inch print.

What kind of profit can you expect from this arrangement? An $18 print, after the gallery takes its 50 percent commission, will bring you $9. Assuming you can keep the cost of the print and mat at around $3.50, you stand to clear $5.50 on each sale. In a gallery that does a high-volume business, this could mount up very quickly.

The selling price of your photographs should, however, be influenced by your costs, the gallery percentage, and what people are willing to pay (check the competition) in your area.

The framed prints will be the most important part of your gallery display—they will draw customers to your work—but don't be surprised if most of your actual sales come from the less expensive unframed prints.

Another way to lower the selling price is to use less expensive wooden frames. You can make your own as shown in Chapter 6, but give special attention to the final appearance as outlined in the section "Finishing Your Frames." Corners must fit well, nail holes should be filled and sanded, and the entire surface should be smooth and attractive. Or you can shop around for ready-

Illustration 7-3: *Unframed photographs can be displayed in an attractive container you can make yourself (see construction techniques for display boxes in Appendix F).*

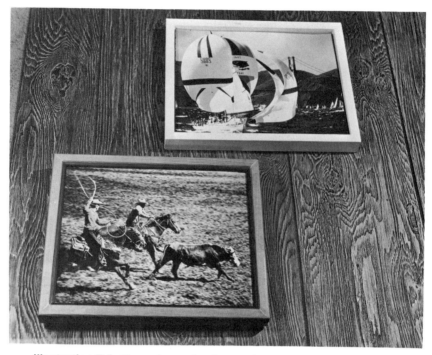

Illustration 7-4: *Photos in wooden frames also work well in moderate-price galleries.*

made frames at reasonable prices. But keep in mind that anything you hang in these moderate-price galleries must look worth the price you're asking.

What to photograph. First, consider what has already worked for you as smaller framed prints or on cards and plaques. From these, eliminate the cute and humorous animals, the obvious tourist shots, the documentary—in short, any photo that tells you everything in one glance. Retain those photos that seem to have an enduring quality—a kind of permanence that makes it a pleasure to look at them again and again. This category can include nature close-ups (patterns in nature), your best mood photos, the most dramatic sports action, or some special effects that may not sell in tourist shops. It's a hard category to define. Perhaps the best approach is still to look at other photographers' work exhibited in the galleries where you'd like to sell, or at photo books that particularly appeal to you.

Where to sell your work. Medium-price outlets will fall into several categories. Some may be strictly local galleries, featuring only the work of local residents (although many will extend membership to anyone willing to pay a fee). Others may specialize in fine art, which may or may not include photography, depending on the owner's definition of "fine art." The work they display may come from anywhere in the United States or even other countries. Still others may be gift shops of a more exclusive nature than those where you market your inexpensive products. Finally, there are cooperatives formed and run

How to Create & Sell Photo Products

by local artists and craftspeople for the purpose of selling their own work. For these, membership is usually required and some selling duties may be involved. (For further information on cooperatives, see Chapter 10.)

Medium-price outlets may not be as readily available as are places to sell less expensive items. Galleries and shops of the types you're seeking will most likely be found in tourist areas, where the traffic flow is heavier. Still, cooperatives and galleries aren't unknown to even the smallest towns.

As with any of your photo products, there's no reason you have to restrict yourself to any particular locale. Range as far as your means and inclinations take you, just be sure you do your basic market research for each new area.

Your next goal is to find galleries and get them to sell your work. The same kind of approach you use in placing any photo products will work here as well (see Chapter 9). However, the portfolio required is somewhat different from the photo products sample case.

YOUR PORTFOLIO

Your portfolio can be critical, so give it a great deal of thought. First, it should contain four to six prints (more about these later) that are framed and ready for hanging. They will show the gallery owner that you have the ability to present your work in polished form. Second, include about twelve prints in sizes 5x7 or 8x10 inches to illustrate the range and variety of your photography. These can be displayed in a loose-leaf binder with plastic pages, or matted and protected with clear plastic envelopes (freezer bags from the supermarket) as you would prepare them for sale. The photographs themselves should fall into two categories: (1) those that feature the area and (2) those that demonstrate your skill and versatility as a photographer. Naturally, the categories will overlap to a degree.

Photos that feature the area fall into two groups:

Group one includes straightforward photos of scenic attractions taken during the day. This is the type of shot a tourist will take on seeing something for the first time. No particular planning is involved: The subject is there; the photographer points his camera and snaps off a picture.

The results are exactly what you would expect: a snapshot! Leave group one photos to the tourists. They have no place in your portfolio.

Group two photos may be straightforward as well, but they show evidence of forethought and planning. A mountain view, for example, might be captured at sunset or after a fresh snowfall or in the early morning with mist rising off a nearby river. Springtime photos of the mountain can be enhanced by a foreground of colorful flowers; autumn shots framed with a halo of golden leaves. Basically, these photographs still show the attraction the tourists came to see, but the photographer has taken special care to capture it at its most charming.

To these we'll add a third group that demonstrates your skill and versatility as a photographer.

Group three is by far the most creative of the groups. Here the photographer's purpose is to create an image that is, as much as possible, a unique view of the world. To accomplish this, any technique he can discover or devise is acceptable, as long as the result captures the interest of his audience and is visu-

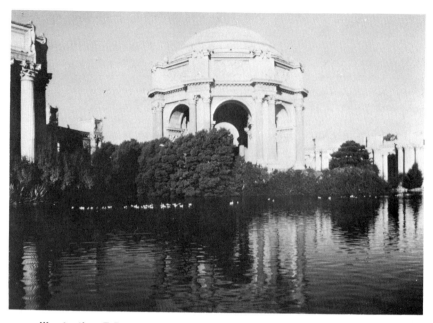

Illustration 7-5: *Group one photos are straightforward postcard shots.*

Illustration 7-6: *Group two photos demonstrate more forethought and planning to capture the subject at its most charming.*

Illustration 7-7: *Group three images are more than just representations. They are—or can be—unique views of the world through the photographer's eye.*

ally pleasing. A photograph of this sort may not sell to the tourist who wants to take home a memory picture, but it should earn the interest and admiration of other professionals, including gallery owners.

For your portfolio, most of the prints—two or three framed and about ten of the others—should represent group two. Choose not only your best work but also those photos you think (or know from experience) will be top sellers.

As an example, for a gallery in the Monterey-Carmel area, we might select a dramatic ocean sunset, a hard-to-obtain close-up of a mother otter grooming her pup, a Monarch butterfly on a brightly colored flower, or a shot of the historic Carmel mission, amid a glorious display of spring flowers, taken very early in the morning when the light is on the front of the building. All have proved to be popular because they're not easy photos for the tourist to take.

To set yourself apart from the crowd of scenic photographers, include four or five images from group three. If you have a truly unique view of a local attraction, it can enhance your portfolio, even if it falls into the pelican-that-doesn't-look-much-like-a-pelican category we described earlier. This is where that kind of photo can work in your favor—when your object is to generate a little excitement in the gallery owner.

Your portfolio is also a place to showcase your special effects. We once asked an owner why no photographers were represented in his gallery. His answer was to the effect: "I tell all photographers the same thing. Show me something *different*, and I'll hang it." We did just that, and the image we used

Illustration 7-8: *A high-contrast tiger stalks through jungle grass against a solid orange background. Chapters 14 and 15 will show you how to create your own eye-catching special-effects images.*

is shown in Illustration 7-8. That photo, and others in the same vein, won him over.

More than once we've had an owner look at our special-effects photos, like what he sees, and agree to hang our work, but then turn right around and ask us, a little apologetically, for "the standard photos that sell." Those standard photos are what he wants to hang in his gallery. Who can blame him? He's in business to make money and so are you. You both want to display pictures that sell. But your group three images can be your door openers and, as such, are very important.

ART SHOWS

Another way to sell moderately priced photographs is through an art show. Where do you find such shows? Well, one approach is to set up your own.

Setting up your own show. First, find a building or store that you can rent for a limited time, say two weeks to a month. This isn't easy because you want a location with foot traffic and you have to be able to hang your photos. Check on these things before you make a commitment. Occasionally, suitable vacancies occur when a business closes or moves and a new permanent tenant hasn't yet been located. The owner of the space may be amenable to picking up some extra money during that interim period. Be sure, however, that the arrangement isn't so casual that a new renter could start to move in right in the middle of your show. Also be sure you understand the liability situation should any personal or property damage occur on the premises (see Chapter 12).

Hang your show, schedule a grand opening, and send out invitations. In addition to friends and acquaintances, you may also be able to obtain a mailing list from local art groups or colleges. The invitations should include information about your opening, possibly a photo of your work, and the length of time your photographs will be on display at that location.

At the opening, visitors will have the opportunity to meet the photographer. You should probably also offer some simple refreshments.

The local newspaper, if contacted ahead of time, will quite likely mention your show in the news, social, or arts pages or under announcements. Provide them with a black-and-white glossy photo of you with one of your photos plus a brief biography. Also check to see if local television stations include a community calendar on which your show could be mentioned. If neither of these works out, or if you would like additional coverage, you might consider running a small advertisement.

Doing it yourself—some problems. Right away, you might notice some disadvantages to setting up your own art show. Perhaps the overriding fear of an exhibitor, especially a first-time one, is: *What if no one comes?* Usually this fear is unfounded. People will come, but they may not come in large enough numbers. Or if they do turn out in droves, they may not spend any money.

Poor attendance can result from a variety of reasons. The location you chose may be difficult to find, for example, or be in what people perceive as a bad part of town. Or there may be a competing event that draws people away from your opening, often the most important selling time of your show. Or there may be just a general lack of interest in photography in your community.

While you can minimize some of these problems through careful planning, there can still be plenty of unforeseen pitfalls.

Even if you find the perfect building in the perfect location, the rental cost may be prohibitive. Or if it isn't, who's going to mind the show while you're away at work? And do you really want to devote that many leisure hours to tending the show yourself? It's exciting to sip a cup of coffee (or for you high rollers, a glass of champagne) and shake hands at an opening, but for the duration of the show you have to either do your own selling or hire a salesperson. You may find yourself pouring money into a venture that may not pay off except in ego gratification. Of course, for some photographers that may be enough. For others it may be just a start.

A one-person show, whether financially successful or not, still adds to your credibility as a photographer. So if you decide to go ahead and try one, it can be included as part of your credentials (see "Establishing a Reputation" later in this chapter).

Group shows. If you would rather share the risks, worries, headaches, and work load, you might put together a group show. You can restrict it to photography—if you can find several other photographers willing to participate— or you can include other artists or craftspersons. A multimedia show will probably draw a greater number of customers because of the variety, and there will be less competition in your field. And any kind of group show, by increasing the number of exhibitors, will surely provide a larger mailing list for invitations, since each will add his own friends, neighbors, and relatives.

It's wise to set up your first group show so that all participants share equally in costs and labor. A meeting early on can help determine who will be responsible for each part of the operation, how financial matters will be handled, and other procedural details. A possible approach would make one person responsible for the building, a second the refreshments, and a third the invitations. Agreement beforehand could set a limit on the amount to be spent on any one item; a totaling up afterward could guarantee that costs were shared equally.

On opening night each artist can be responsible for selling his own work. For the remainder of, say, a three-week show, each artist could agree to spend one week making sales for everyone. Be sure that you also collect sales tax if required in your state (see Chapter 12).

If the show is a financial success, you might wish to make other arrangements for future ventures. Alternatives include handling arrangements and promotion yourself and either charging exhibitors a flat fee or taking a percentage of their sales. Some promoters even do both.

Finding a sponsor. Still another approach is to find a local gallery or custom framing shop or other business that will sponsor a show for you exclusively or for several photographers. In this case, the sponsor would supply the building and clerks and receive a commission on all sales. You would probably share the costs for invitations, advertising, and refreshments.

There are several advantages to having a sponsor. First of all, your initial cash investment will be smaller, since you won't have to pay building rent ahead of time. Your time commitment will also be less, since you'll only have to be present during the opening. While you will still contribute names to the

invitation mailing list, the store or gallery will probably already have a sizable list of its own, which could greatly increase the number of people who come to see your work. And finally, you will be exhibiting at an established location, one people are familiar with. This can be an important factor in a customer's decision to come; sometimes the inconvenience or uncertainty of tracking down an unknown building in an unfamiliar part of town to see the work of an unknown photographer can send a person back to the television set!

When you propose the idea to a gallery or shop owner, be sure you point out the advantages to him, too. First off, he'll be earning a commission. Gallery owners expect this, but for others, your commissions will be additional income. Since both already have to support their overhead gremlins, your show won't increase those costs. If custom framing is a main part of the gallery or shop owner's business, or even a sideline, your show could earn him some extra jobs from customers who buy unframed prints or who want something different from your standard exhibition frames. And since it's a cost-sharing venture, he'll be getting some all-important advertising at reduced rates, especially if coverage of the show appears in the editorial section of the newspaper.

One more possibility, primarily for people in or near medium to large cities, is to contact a promoter who arranges shows. In this case the promoter does all the setup work. Sometimes costs are shared by the artists with the promoter receiving a percentage of the sales (usually 25 to 40 percent) to cover his or her time and responsibility. In other cases the promoter will take a larger percentage of the sales (about 50 percent) and pay the setting-up costs himself.

Locate galleries and framing shops by keeping your eyes open or by consulting the Yellow Pages. Promoters may also be listed in the Yellow Pages or may be located through galleries or other artists. You might also get information about potential sponsors by visiting local shows and making inquiries.

PHOTOGRAPHY FOR COLLECTORS

Another way to sell framed photography is as numbered art prints. To do this you must make a limited number of prints—say, 50 to 150—and then destroy the negative or slide. Each print is then numbered on the matting—1/50, 2/50, 3/50, etc.—and signed by the artist. This is the only way to ensure continuing value in an art print. Nothing will retain its worth if it can be reproduced endlessly. By the same token, the fewer prints a photographer makes, the higher price each one can command.

What kind of photography sells as limited-edition art prints? Entire books have been written on this subject. If you're interested in pursuing it, check your library for additional information. The final word on whether your work qualifies as art will undoubtedly come from the owners of those galleries you choose to approach. They can also offer information about the quality of printing desirable and where to have it done (if you don't do your own). While aluminum section frames are most commonly used for framing, it's best to check with specific galleries.

There are advantages to going for the art market. An important one is the high price tag. Prices usually start around $100, but can run into the thousands. Another is status. But for a beginner there are definite drawbacks. In

the first place, you may have difficulty convincing anyone else of the art value of your work. As observed earlier, many people—including fine-arts gallery owners—aren't quite ready to accept photography as art.

There are, of course, a growing number of strictly photographic galleries. However, most feature only established artists—those with a proven track record or widespread recognition. This is to be expected, since their customers will be investing anywhere from several hundred to many thousands of dollars in a print.

Many fine-arts gallery owners, however, recognize the importance of discovering and encouraging new talent. Locate these sympathetic eyes and ears by visiting galleries and making inquiries, or by consulting marketing guides such as *Photographer's Market*. (These guides will be dealt with more completely in Chapter 13.)

While the odds are stacked against beginners in these high-priced collector's galleries, that shouldn't deter you from giving them a try, especially if art photography is one of your goals.

DECORATING WITH PHOTOGRAPHY

Decorating with photography, sometimes referred to as photo decor or decor art, is becoming more and more popular. It can add individuality to a home or office, cheer up a child's hospital room, or create atmosphere in a restaurant.

The photographer himself can create wall decor—as a single, dramatically lighted photograph, as an entire wall of informally grouped prints, or in a straight eye-level row down a gallery hallway, to name a few possibilities. Or, with special commercial printing, a photo can be enlarged to cover an entire wall or even be reproduced on wallpaper.

Decor-art photography most commonly focuses on nature in one form or another—dramatic scenics, animals, close-ups of flowers, etc.—as these seem to have universal appeal. Perhaps this is because people today are forced to spend so much time indoors, or is simply that nature in its infinite variety pleases the eye and offers a moment of restfulness in a hectic world.

Some photographers may wish to pursue the decor art market exclusively, selling their framed prints through furniture or interior-decorating stores. However, there is also a demand for custom work. Some people might choose, for example, to decorate their homes with series of family portraits or photos of the children growing up or engaged in various activities. Or their photo decor might reflect their interests in skiing or sailing. An executive might want his office done with photographs of his plant or business in operation, an adventurer with the thundering whitewater of river rafting or the dizzying heights of mountain climbing.

For an enterprising photographer, the possibilities are limitless. For someone who can not only take the photographs but advise the customer on the right presentation for his or her home or office and carry the whole project through from beginning to end, there can be a complete career in decor art.

Framed prints and room-decor photography. It's only a short step from gallery photography to decor art, though some additional skills and

How to Create & Sell Photo Products

knowledge are needed to ensure success. For a solid start you should have the following:

* Some appropriate photos.
* Contacts with custom color labs that can turn out quality prints in sizes 11x14 inches and up, including wall-sized murals.
* A source of framing materials in a wide variety (if you plan to do the work yourself) or a creative custom framer who can handle the job for you.
* A portfolio presentation of your work, which will be different in some respects from your gallery portfolio.
* Some knowledge of design that will help you plan attractive photo displays.
* A way to market your skills and products.

Photo furniture and accent products. Photo decor can extend beyond the use of prints as wall hangings, can in fact add color and style to all manner of room accent items, including furniture itself. Photo furniture? Yes indeed. And many other possibilities, including room dividers, end tables or decorator cubes, lamps, even free-form chairs. In Chapter 8 we'll take a look at photo decor, among other things, from a different point of view.

The photographs. Most photo decor makes use of color for visual impact, although dramatic black-and-white shots can also work well. This visual impact can be best achieved, in both black and white and color, through the use of strong, simple graphic images.

Since many decor-art photos will be hung where people will view them from a distance or simply walk past them, they should make clear visual statements that can be understood at a glance. Keep in mind, too, that any photo decor will be part of an overall decorating scheme: It must contribute to the whole, not detract from it. In many cases this may mean coordinating the color tones of the photo with those of the walls, furniture, and other room accessories. You may, in fact, be asked to color-coordinate your work with a customer's eyes or the portrait of her dog which is already hanging in a revered place on the wall—stranger things have happened!

You should therefore try to have a collection of photographs available through the whole spectrum of color tones. One way to achieve this is to have a selection of images that can be backgrounded in a variety of colors. These color adjustments can be made in your darkroom or by a custom processing lab. They can also be done by rephotographing with color filters (see Chapter 14).

In addition to strong, simple images, your photographs should have good color saturation and ultra-sharp focus (except, of course, where softness is part of the desired effect). Any photographer who is really interested in decor art and considering making it a full-time business should give serious thought to purchasing a large-format camera. Although the 35mm format can be used successfully, better-quality enlargements can be obtained from larger negatives or positives.

Custom photography. In addition to general subjects intended to appeal to a broad cross section of the public, plan to have some aimed at the cus-

Illustration 7-9: *This image will look good with an orange sunset background or with predominantly blue or green shades.*

tom market. Some may sell on their own; others by demonstrating your skill and versatility will generate custom jobs. Horses, for example, might make a good custom specialty. They are popular in both rural and urban settings. Horse lovers might buy directly from your selection, owners and ranchers may want you to photograph particular horses. The same can be said of photos of children, sports action, or an almost infinite variety of subjects.

While you may wish to become more involved in some areas than in others, it's wise to stay as versatile as possible, at least in the beginning. You need not have the specialist's knowledge of horses to feature them effectively in decor art. The decor-art photographer specializes in the artistic—not technical—treatment of a subject.

If a jeweler, for example, wants some prints of gems to adorn the walls or display counters of his store, you can rely on him to select the appropriate stones and point out the features he wants highlighted. Your responsibility will be to interpret them photographically. For an industrialist or a hardware store owner, you might turn nuts and bolts into exciting photo-graphics through macrophotography.

Sometimes, you will have to be like a journalist; you will have to gather enough information about both the subject itself and the expectations of your client to do the job right. In the field of custom decor art, you can go as far as your imagination and interests will take you.

The custom color lab. When shopping around for a color lab, try to find one that can satisfy all your needs, from small prints to wall-size murals. It's also convenient to deal with one close to home, probably in the nearest city of some size. Your work will be much simpler if, when you have a problem or special order, you can talk firsthand with the technicians and show them exactly what you have in mind. If you can't find one close by, check the list of suppliers in Appendix A, then write for details and a current price list.

Framing. Thus far, we've dealt with framing from the standpoint of economy and convenience. In the field of decor art, however, the client's tastes and the overall decorating scheme are more important. If the client wants an expensive driftwood frame to complement a nautical photograph, the additional cost can be passed on.

Although photographs generally look best in simple frames, a decor photographer should be aware of the great variety of possibilities. So before setting up your portfolio, visit a custom framing shop and spend some time browsing. Familiarize yourself with what is available in various price ranges so that you will be prepared to make recommendations.

For your portfolio you'll want several framed prints. Choose some appropriate frame styles (more about this in relation to the portfolio) and obtain price quotes for materials as well as for the custom finished product.

Earlier it was suggested that the best price breaks come from mail-order dealers. If you plan to make your own frames (at least in the beginning), mail-order dealers will be your best source of materials from a purely economic point of view. However, when you weigh all the considerations inherent in decor art, there's a strong argument in favor of working with your local framing specialist. First of all, he's readily available. You know what he has in stock at what prices, and you can get whatever you need right away. Later on, when

you're ready to turn your framing jobs over to someone else, he will probably be your logical choice. Second, he can give you valuable advice in areas where you may be weak, like matting and framing techniques or choosing the right frame for a particular photo. But do ask him for a professional discount, say 15 percent. And be sure that he will honor your resale permit (see Chapter 12) so you won't have to pay sales tax on items you plan to resell.

In the beginning you may wish to increase your income by assembling your own frames. As your business grows and your time becomes more valuable, you'll probably want to devote more of it to the actual photography and selling. Thus, you will rely increasingly on your professional framer and pass the additional costs on to your customers. People who purchase decor-art services and products expect to pay more for quality and exclusivity.

The portfolio. As with your gallery presentation, you'll want to include about five framed prints. In this portfolio, however, you'll also want to include two or three large prints and around twenty unframed photographs or slides.

Frame each print differently in order to display as much variety as possible. In decor art the way a photograph is presented may be nearly as important to the total decorating scheme as the picture itself. Keep your portfolio presentations simple, however, since your aim is to sell photography, not frames. Begin by using aluminum section frames for one of your prints. A second should be done with a simple wooden frame. Then consider the concept of total effect mentioned earlier in connection with photo clocks. For example, a bamboo-trimmed frame would be effective with the high-contrast tiger shown in

Illustration 7-10: *An attractive modern look can be achieved by mounting photographs on Masonite. Blacken the edges with paint or a large felt-tip pen.*

Illustration 7-8. In the same vein a Western theme could be enhanced by a barn wood-finish frame or one trimmed with rope. Here again, a competent custom framer can be of help.

Invest in two or three large prints (16x20 inches or larger) that will show potential customers how well your photos stand up to extreme enlargement, and will also let them experience the full impact of your work. These larger prints can be framed or flush-mounted on Masonite with the edges painted black for an unframed look.

The rest of your portfolio photographs may be presented as either prints or slides (if you're using negative film, you'll have to use prints). Choose a consistent size for these prints, one that shows your work to its best advantage, but no larger than 8x10 inches. Display them in a loose-leaf binder with plastic pages. Be sure to keep your presentation looking good. If the plastic pages become scratched or fogged, replace them immediately. Do the same for dog-eared or soiled prints. It bears repeating that in decor art, presentation is almost as important as the photographs themselves. This holds true from initial contact right up until the finishing touches.

Presenting your work as a slide show has certain advantages, one of which is a savings in the cost of prints. You may, however, want to have duplicate slides made to save wear and tear on your originals. Using slides also makes it possible to change your portfolio more easily. You will need to carry along a good projector and a spare bulb (always count on the bulb to fail in the middle of a presentation). If you don't already own a projector, look for one that is lightweight and jamproof. One manufacturer even makes a projector with a pop-out viewing screen that can be used in lieu of a larger screen or white wall.

If you use a large-format camera, the photographs are probably best presented as prints in order to avoid handling of the transparencies. A portable lightbox would be helpful if you would rather show the transparencies, but be sure they are adequately protected by glass or plastic mounts. Use plastic pages for the 2¼x2¼-inch size. These pages will hold six slides and will fit into your loose-leaf binder. Use individual mounts for larger sizes.

Another worthwhile addition to your portfolio would be samples of some of your finished displays. In the beginning, practice on your own home. Visit the library and collect some books on interior decorating. Kodak's *Photo Decor* is an especially useful reference (see Appendix B). It contains excellent ideas on ways to display photos in both homes and offices. Some custom color labs will also provide you with attractive brochures illustrating the use of photography in interior decoration.

Start by setting up some simple combinations of photographs that look good together. Try combining photos with similar themes or color tones. Then experiment with other arrangements, including entire walls. Or relate photos to particular rooms, parts of rooms, or furniture groupings. When you come up with an effect you like, photograph it for inclusion in your portfolio.

You may end up with a lot of holes in your walls, but don't be overly concerned—they can be filled with spackling paste and touched up with paint. If you're a renter with a landlord who views each and every wall hanging as a major policy decision, you can make a fake wall or divider screen on which to hang your displays.

If at all possible, you should make your home or apartment into a living advertisement for your work. Your own environment should become a design laboratory, and your most successful ideas should appear as photographs in your portfolio.

As you do more and more jobs, these too can be added—with your client's permission. Eventually you may develop—and become known for— a style of your own. But learning the basics is prerequisite to developing your own style.

Design. In decor art your responsibilities may include a great deal besides photography. You may be asked to select appropriate material and arrange for framing, choose the best locations for the photographs and design the arrangements, possibly even hang the displays yourself. All of this will require a fundamental knowledge of design.

Although it's not our purpose to deal exhaustively with the subject (there are plenty of more specialized references available), we can offer a few "beginner's tips." Art as decoration should be placed where the largest number of people can see and enjoy it comfortably. In choosing the best locations for photo decor, study the traffic-flow patterns in a room: What areas naturally draw your eyes as you enter? Sit in the furniture arrangements: What areas fall most naturally into your field of vision from these locations? Are there any "viewing stages," areas that can be easily seen from several locations in the room? If so, they might be good choices for a photo-decor display.

Might be. Because lighting is another important consideration. Photographs that are dark, ill-defined blobs on a shadowy wall won't impress anyone, no matter how prominent a "stage" they occupy. How are the windows situated? Will the display be adequately lighted during the day? What about the possibility of glare? No one likes to be bedazzled by a persistent flare of sunlight reflected from the wall. What about nighttime? Will any additional lighting be necessary for an effective display? If so, what kind? Be prepared to make recommendations.

If you're working for a business firm, visit similar offices if possible. Note how and where decor art is used. Gather information, but use your own imagination, too. Don't allow yourself to be shackled by what other interior decorators do. Learn from them, but give your own ideas a chance, too.

Another important consideration will be the number of photos you plan to hang. If more than one or two, it's helpful to develop an interesting pattern that will hold people's attention and lead them through the display, especially if it's extensive. This pattern can be either formally or informally balanced. Formal balance is achieved when pictures of equal size are placed at equal distances on both sides of an imaginary vertical line. For example, a collection of 8x10-inch prints hung in a straight row along a gallery hallway would be formally balanced, as would two similar photographs hung side by side. Formally balanced displays incorporate an even number of pictures; informally balanced ones can have an odd number.

In informal balance the design elements must still be balanced, but it doesn't require the exact same number and size of photos on each side of an imaginary vertical line. To prevent informal balance from slipping into total confusion, think of it in terms of simple patterns. With three photographs consider a triangular arrangement, perhaps with a larger picture balancing two

How to Create & Sell Photo Products

Illustration 7-11: *Several illustrations of formal balance.*

Illustration 7-12: *A formally balanced photographic display.*

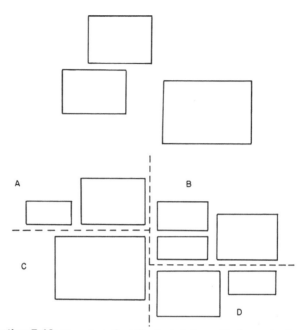

Illustration 7-13: *Drawings that illustrate informal balance. In* the top illustration *two smaller photos balance one larger one. In* the lower illustration *photos are arranged along three main lines* (dotted lines). *Similar photos* (groups A and D) *balance each other; one large photo* (C) *is used to balance three smaller ones* (B).

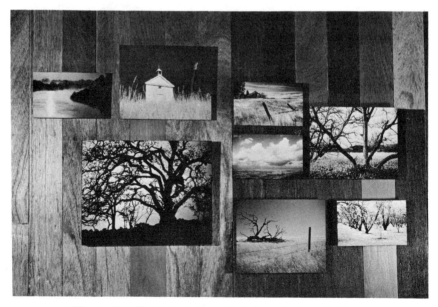

Illustration 7-14: *An informally balanced photo display.*

smaller ones. For more complex arrangements try a circular pattern or one in which most of the pictures are placed along three main lines, as shown in Illustration 7-13.

Marketing your skills and products. When you've done your basics, including experimenting with photo decor in your own home, gathering information and experience, accumulating photographs and incorporating them into a portfolio . . . what then?

Well, you can "hang out your shingle," which is to say, advertise your services and wait for business to come your way . . . and this could be a long wait. Or you can take a more active role in selling yourself by making contacts in the field.

1. *Interior decorators.* Many businesses and individuals have their decorating done by professional interior decorators. Since photography is being used more and more for this purpose, it shouldn't be too difficult to find someone to look at your work.

 Locate interior decorators through home-furnishing and decor stores or in the Yellow Pages. Call or write (it's a good idea to have stationery with your own letterhead, either your standard "professional photographer" stationery or a special decor-art version) and explain what you do. Make an appointment to show your portfolio.

 The exact arrangements you make with a decorator will vary from individual to individual. Generally, you will be a resource person and a supplier of photographic prints and services. If an interior decorator likes your work, you will be called upon when such products and services are needed.

2. *Public places.* Any number of places open to the public can be good locations to display photography, either as an art show or as a permanent part of the decor. These include hospitals, banks, hotels and motels, ski and other sports-oriented lodges, resorts, building lobbies (apartment, offices, etc.), and restaurants. Some you may reach only through an established interior decorator; others you might be able to sell on your own. Still others may be receptive to the idea of a photo-art show, with prints available for sale to customers.

 Hospitals, banks, and hotels, for example, are excellent prospects because they need to decorate so many areas. And very often they make their own decorating decisions rather than working through an accredited professional.

 For some people selling can be very difficult. Although a later chapter will go into the subject in detail, a few comments here will help you get started. First of all, it's wise to familiarize yourself with a prospective location beforehand. Give it a realistic appraisal to determine if there's a need for your services. Are there large expanses of blank wall space? Are there areas where people are forced to stand or sit for extended periods?

 During your preliminary visit, find out the name of the manager or owner of the building or business. A letter to that person can assure you that he will be available for an interview and eliminate those who are not interested. When it comes time for your presenta-

tion, getting yourself in the right frame of mind helps. One photographer figured that he had to make five calls for each successful sale. He wouldn't be discouraged by a no, he concluded, because each one he got brought him another step closer to that inevitable yes.

Remember, too, that people are not doing you a favor by buying your work. It's a two-way street. Your decor art can contribute to a business' success in many ways, not the least of which is making it seem more "human." Many firms now recognize that decor can turn today's impersonal concrete and glass buildings into a warmer, more livable atmosphere and thus create a more pleasant and productive environment for both employees and customers.

3. *Furniture stores.* Many furniture stores try to create a homelike feeling in their displays. They accomplish this by attention to details, all of which contribute to the desired overall effect. Photographs—perhaps more than any other single factor—can add personality to a room display. They can make it seem as though a real person lives there. Through careful planning, they can tell us about his interests, his background, his friends and family. They can transform an otherwise sterile collection of furniture into a home.

Your photographs or other products can be sold *to* furniture and home-accessory stores or *through* them on a consignment basis. Some also offer decorating services to their customers, and they may be potential clients for custom photography. And keep in mind that a successful liaison with such stores might also lead to advertising assignments.

4. *Galleries.* Galleries were discussed earlier in connection with selling prints. Some galleries also offer home-decorating services, including rentals of art work. If your local gallery does not already do so, you might be able to convince the owner of the lucrative possibilities.

5. *Architects.* In addition to designing buildings and supervising their construction, many architects get involved in decorating. They may be located through the Yellow Pages or from on-site signs in construction areas.

Pricing your decor-art photos and services. How much should you charge for your decor-art work? To a certain extent, the answer is dictated by supply and demand in your area. If there is a great need for the type of work you do, then naturally you can ask and get higher prices. The same will be true as your reputation grows. Unlike stock photography, where compensation is more or less set by the photo buyers, photo decor offers much more flexibility.

As a beginner, you can take one of two approaches to pricing. The first is to decide on a fee that represents the amount you feel you should be paid for the time and effort you put into taking and preparing the photographs, plus your day-to-day costs such as rent and camera depreciation. This fee may vary from job to job depending on the size of the project and the amount of time needed to complete it.

Let's suppose you decide on a $100 fee for a particular job. (This is only a hypothetical figure; you need to compute your costs to fit your situation—see

How to Create & Sell Photo Products

Chapter 12.) To this fee, add all the additional costs for the photographs themselves—printing, framing, etc. If, for example, these costs run about $130, your total is now up to $230. For work being sold through furniture stores, interior decorators, or whatever, the necessary commission must be added to reach a final selling price.

A second approach—mentioned earlier in connection with other products—is to take your cost figure and double it to get your discount price to dealers. In the above example this figure would be 2 × $130, or $260.

Frequently, decor-art photos can be sold again and again as prints. Therefore, cost for film and time can be partially absorbed by each sale, resulting in a lower retail price. Your charges for exclusive custom work will, of course, have to be higher, since those costs will have to be recovered on a single sale.

Establishing a reputation. A photographer gains recognition by doing good work and achieving visibility in the community. It's matter of getting your name and your photography in front of the public as much as possible. The better known you become, the better your chances of success. Display your work at every opportunity and be sure your name is prominent.

Enter your photographs in local and state fairs or any other competitions you can find. There are numerous nationally publicized contests, but the response is usually enormous and your chances of winning quite small. On the other hand, there are occasionally lesser known competitions where virtually every decent photo is a winner, simply because so few people enter!

Include any certificates or ribbons you win in your portfolio. Be sure to mention them as credits in any written résumé you prepare.

Join local photography and art groups and hang your work in their galleries and shows as often as possible. When permitted, include a brief résumé with a self-portrait in your display. Let interested people know how to contact you. Membership in such groups will help to spread your name by word of mouth. When people are considering purchasing art work, they frequently ask the opinion of a friend, particularly a friend who's an artist. Make contacts.

Approach local museums about including your work in their collections. If they would like to purchase outright, great! If not, consider making some donations. Donated photographs will still be part of their permanent collections and may be listed on your résumé.

Offer to do free exhibits in local banks, libraries, or other public places. Be sure to include that all-important résumé and photo of yourself. In fact, it's a good idea to have some of these printed up so that you can post them wherever the opportunity arises. And by all means inform the newspaper of your show. They're generally hungry for local news and may give you a good write-up, especially if there's a steady advertiser involved.

As your reputation develops, opportunities will seek you out, sometimes from unlikely directions. One day, for example, our mailman commented on the large number of photos that always seemed to be coming and going from our house. He asked to see some of our work and we invited him over for a slide show the following week. A little later, he called to ask if he could bring along a fellow employee and her husband. "Fine," we said. The husband, it turned out, ran a gallery and framing shop and the end result for us was a show.

The opportunities are out there, but they usually come to those who are willing to stir things up, to make things happen.

Chapter 8

NEW IDEAS—WHERE DO THEY COME FROM?

> Almost all really new ideas have a certain aspect of foolishness when they are first produced.
>
> —*Alfred North Whitehead*

Let's consider the problem-solving process of an oyster. It starts with a tiny bit of grit, an irritation. Gradually, layer by layer, the oyster develops a solution to that problem. Most of the problem solutions an oyster produces are oddly shaped or unpleasantly colored or otherwise flawed. Yet, from time to time, the end result of the oyster's problem-solving is a highly prized, perfect pearl.

In many respects, the way we generate ideas is similar to our friend the oyster: We often need a little irritation to get us started, and our solution may eliminate that irritation without meeting the needs of the marketplace. But from time to time, we too come up with a gem.

Once in a while a brilliant idea will leap full-blown into existence, leaving us shaking our heads in awe, wondering where it came from and by what means. And we hope that it will be followed by others even more brilliant, even as we fear that the idea source is so fragile that the wrong move on our part might shatter it forever.

In fact, that source is more obstinate than fragile. Like the oyster's mother-of-pearl, it frequently has to be prodded. There are steps we can take to get the ideas flowing again—if we understand a little more about the idea-forming process itself.

Scientific research indicates that most of us use only a small part of our potential brain power—maybe as little as 10 percent! *Only 10 percent!* Imagine the tremendous untapped creative energy available to us, if only we can find some way to put it to use.

That's what this chapter is all about.

160 How to Create & Sell Photo Products

So far, we've been covering well-charted territory, concentrating on what already appears in the marketplace. We've presented our own ideas, or adaptations drawn from other successful photo product designers. Although some of the approaches may be new, the products themselves aren't—someone else has already come up with the idea.

Now we're going to help you generate new photo product ideas on your own. We'll put the idea-generating process into action and follow it to its logical conclusion: the products themselves. Bear in mind that these examples will be prototypes—products that aren't necessarily intended for the market *as they stand*. Nor are the construction procedures necessarily the best, in terms of cost efficiency. The "how-to" information won't be as detailed as that in previous chapters. These prototypes are intended to expand your concept of photo products, to get you thinking.

We'll also consider some of the more exotic photo processing techniques that can be applied to products, including liquid photo emulsion, transfer printing on cloth, and the incorporation of photos into ceramics, to name a few. We don't want to get too specific—whole books could be and have been written on these and related subjects. We just want to point out the possibilities and give you some idea of what's involved.

While we realize that some readers may not be particularly interested in developing new *products*—certainly there are enough listed in earlier chapters to start and operate a successful business—we'd like to stress the importance of new *ideas*, both in photography and in photo products. It is the continued generation of fresh ideas that will keep the Photo Products Alternative from becoming just another Standard Operating Procedure. Ideas are essential to the success and growth of your business . . . indeed, of *any* business.

To borrow a thought from *Through the Looking Glass*:

"A slow sort of country," said the Queen. "Now, *here*, you see, it takes all the running you can do, to keep in the same place. If you want to get somewhere else, you must run at least twice as fast as that!"

ON RUNNING TWICE AS FAST

As far as coming up with new ideas is concerned, most of us can all run faster than we do. But it's a lot easier just to sit around and wait for inspiration to strike like a bolt of lightning—which *can* happen. Unfortunately, such flashes of insight too often resemble lightning in another way: They may not strike twice in the same place. So just like a marathon runner, we must train ourselves to exercise our full potential over the long haul. We must get unused regions of our brain working for us. And we must learn to be receptive to ideas when they start to come.

A TRAINING PROGRAM FOR MENTAL RUNNERS

First, understand that just like running, problem-solving is a natural process—one that can be improved through practice. Our training program will focus on two crucial aspects of this process: (1) increasing our ability to generate ideas, and (2) evaluating those ideas from the standpoint of practicality—whether they will work in the marketplace.

Let's get started.

Define your problem. In the broadest sense, the problem is to develop some new photo products. As you come up with possibilities, each will lead to a host of smaller problems connected with the development of each potential product. Actually, the problems will fall into two categories: (1) the major problem of coming up with new product ideas, and (2) the minor problems associated with developing those ideas for the marketplace. You can deal with all problems, large and small, in basically the same way: by first jotting down possible solutions as they come to mind, and then turning them over to your subconscious.

For now, concentrate on the main problem of coming up with new photo product ideas.

Second, don't limit yourself. If a bird really thought about the problems of flying, he'd never get off the ground. If a runner didn't *believe* he could run 26 miles and 385 yards, he probably wouldn't enter a marathon; he certainly wouldn't win. If you tell yourself, "That's silly!" or "I can't do that because I don't know how to work with wood," or "I don't know anything about plastic," or "I can't use a darkroom," then you'll probably never get started either.

Every time you get an idea, write it down. Get in the habit of making idea lists. Almost immediately you'll be able to think of a dozen reasons why an idea won't work—maybe *two* dozen, if you're very creative. But you must give every idea its due, otherwise the ideas will simply stop coming. Think of ideas as water flowing from a faucet. Every restriction you place on yourself is another twist of the knob toward off. Your subconscious registers those restrictions, and the flow of ideas is lessened. Eventually it could stop completely. You're evaluating all right, but in a way that could put your idea-forming process right out of business.

If an idea seems silly, write it down and give it a chance anyway. It may turn out to be exactly that. Or it may only seem silly at first, until with a little alteration here, a different approach there, it turns into a winner!

If lack of expertise looms an obstacle, you can always *learn* what you need to know. That's what libraries are for. Or find someone to do the job for you. That's what specialists are for.

Don't restrict your ideas or they may never lead you to a solution. And worse, you may frighten them away altogether!

Third, absorb information like a sponge. Getting a good idea is not a matter of sitting under the apple tree, waiting for one to drop out of the sky. It may have worked for Isaac Newton, but only because he had already collected a lot of information *before* the apple fell. So start to collect information relevant to your problem—look for photo products possibilities.

Samuel Johnson once said, "Knowledge is of two kinds. We know a subject ourselves, or we know where we can find information upon it."

The library, the marketplace, your own home, and many more places can provide the input you need to fuel the flow of ideas and keep them coming right through to a final solution.

Finally, give your "idea generator" room. Conscious thought certainly serves a purpose in problem-solving, but when you seem to run into a blank wall, be prepared to back off and let your subconscious take over. Define your problem, free yourself of restrictions, gather as much information as you

can, then give your subconscious idea generator a chance to work it all out.

Do something else for a while, as long as necessary. Forget about the problem—your subconscious won't. Most of the time, a solution will come, occasionally in odd ways. It is said that Robert Louis Stevenson, for example, could *dream* complete stories, and even go back and change them on subsequent nights until he arrived at a satisfactory ending.

Weird, you say?

No more so than the dream that led Niels Bohr to conceive the model of the atom—a cornerstone of modern physics. Or the dream of a cannibal attack that helped Elias Howe overcome a major obstacle in developing the sewing machine—he noticed that all those spears pointed his way had holes in their tips!

So whether an idea arrives in a dream or hits you on the head like a falling apple, be prepared for it when it comes.

FUELING THE IDEA GENERATOR

Enough theory. Let's get practical.

Making the photo products we discussed before may have already prompted new ideas, alternative approaches. If so, great! If not, have another look at those earlier chapters with this in mind: There's always a better (or different) way to do something—*find it.*

The purpose of this book is not only to show you what *has* been done, but to get you thinking about what *can* be done . . . by *you.* We'll show you the whole technique of new product development, starting with idea generating and following through to developing a prototype product. So far we've talked about getting your idea generator working on new ideas; but exactly how do you start the process? How *do* you fuel your idea generator? In three ways. First, look for possible adaptations of existing photo products. Second, look for products to which you can add photography. And third, keep an eye out for technical advances that can give you a push into a profitable photo products area. Now let's examine each of these methods.

Existing photo products. Earlier, we advocated browsing in greeting card shops as a means of learning *what* and *how* to photograph. Do the same for new product ideas. Go shopping for them. Not only in the obvious photo products places—card shops, gift stores, home decor shops—but almost anywhere. And begin to train yourself to ask, "What if?"

Use your imagination. And your pencil. Make a list entitled "Existing Photo Products."

Already you've been introduced to the idea of adapting commercially mass-produced products—cards, calendars, etc.—by adding a local photo. Your attractive photo greeting card also demonstrated that an inexpensive product can often be given a "class" treatment and sold to a more exclusive market. The reverse approach is more frequently used: Be on the lookout for products that can be produced more cheaply and sold at lower prices.

Ask yourself over and over, "Is there a *better* way to do that? Or a *different* way? WHAT IF?"

From time to time, we've shown you variations on a theme, different approaches to the same basic product—plaques and calligraphy plaques, for ex-

ample. Or told you how, by the addition of another feature, you could come up with a new product altogether. While shopping for ideas, be on the lookout for possible combinations that might yield useful offspring.

Another way to give the idea-generating process a jolt is to make lists that start with a single type of product, say framed prints. Sit down at your desk and make as complete a list as you can of the reasons people buy them: home or office decor, "memory photos" of an area, gifts for folks back home, birthday or Christmas gifts, because your photography strikes a chord in the heart of a kindred spirit—whatever. Call this your "Reasons People Buy" list.

Put as much thought as you can into your list. Worry over it for a while. This list represents the *needs* of your customers: Your aim is to find better or different ways of meeting those needs. Now turn the problem over to your subconscious idea generator.

While you go about your business, the subconscious problem-solving process will continue, perhaps in the following manner: Hmmm. Memory photos. This area I live in has a lot of things that could be memories for tourists. Hmmm. *Lots* of good memories. How about a presentation that includes more than one photograph? Hmmm. A book? No, that's too expensive. How about a collage—several photos pasted to one mountboard? Yes—a definite possibility. Or a framed print that is, in fact, several prints?

Illustration 8-1 shows where this train of thought led us. For someone else, it might lead in an entirely different direction.

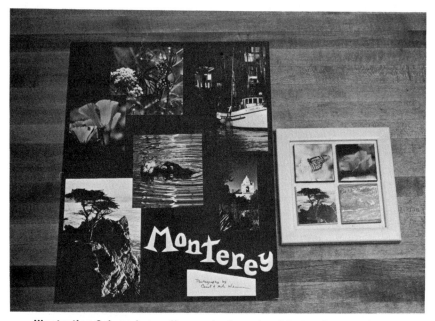

Illustration 8-1: *A photo collage and a framed multiprint photograph—two solutions to the problem of carrying home a lot of memories. When trying to dream up new products, putting yourself in your potential customer's shoes often helps.*

When trying to dream up new products or photo ideas, it often helps to put yourself in your customer's shoes. Try it. Carry the collage idea a little further to see where it leads. What other stores have you shopped through for your idea list? Kitchen? Garden? Western—and you love to photograph horses. Put yourself in the shoes of a horse-loving customer, a youngster perhaps. Wouldn't you like to have a lot of horse photos decorating your room? But a lot of single photos can be expensive, so how about a poster that's a collage of such photos—*your* best photos? This train of thought can lead on to collage posters aimed at a wide range of interests, including sports of all types, flowers, automobiles, aviation, food, or whatever seems suited to your area.

Another way to use your lists is in combination with each other. For example, take your Reasons-People-Buy list and put it beside a list of existing photo products. Now take a second look at the problem of carrying home a lot of memories.

Hmmm. A lot of memories. Need a lot of photos to do that. Hmmm. Have a look at this Existing Photo Products List . . . photo clocks. Could make a collage clock just like we did for prints. Might make telling time a bit confusing though. Hmmm. Give another look at this list . . . photo cubes. Three-dimensional. A lot of sides there on which to mount memory photos. Photo cube . . . photo clock. How about a photo cube table clock? Who ever said photo clocks had to hang on walls, anyway?

New problem: Can such a clock be made profitably?

Method of attacking that new problem: Make a prototype model, and let's see what's involved.

HOW TO: Develop a Prototype Photo Cube Table Clock

Let's start with familiar materials and construction techniques. Cut the basic cube from ¼-inch-thick plywood, finish-sanded on one side. You will need two 6-inch-square pieces for the top and bottom, two 5½x6-inch pieces for the sides, and one 5½-inch-square piece for the back. Mountboard worked all right for the wall clocks, so it can work for the face of our cube clock as well (cut it 5½ inches square).

Now put all the pieces together—hold them, don't glue them—and give the concept some further thought. Look for problems. And, sure enough, one pops up: how to reach the clock movement to set the time or change the batteries. Possible solution: make the face removable. Hmmm. Another possible solution: hinge one of the sides. Yet another solution: cut an access hole in the bottom. All things considered, the latter seems the simplest.

Cut the access hole, then glue the plywood cube together, reinforcing the edges with brads. Mount the clock movement on the cardboard face just as you did for wall clocks. The face can be installed using ½-inch-square pine supports that are inset about ¾ of an inch to protect the hands—the same technique used for wall clocks.

Hmmm. Another problem: The plywood edges aren't very attractive, even when filled and sanded. The edges can be covered with pictures on the sides and back, but that still leaves the front. Hmmm. How about making a frame from pine molding to cover those exposed edges? And if we make that frame from ½-¾-inch flat screen molding (and add ¾-inch flat screen molding spacers), it can also serve to hold a square of protective glass or plastic in place.

Where Do Ideas Come From? 165

The frame pieces need not be glued together—in fact, securing them with brass corners or screws would make them removable and thus allow access to the clock face (in case the movement should ever have to be replaced).

Paint or stain the cube. Glue the photographs to sides, back, and top with rubber cement or spray-on photo adhesive, then finish with several coats of polyurethane varnish. Install the face and the front frame and set the clock on a table.

Another problem: The bottom edges of the photos will get scuffed if the clock is moved around very much. Possible solution: Shorten the photos so they don't fit all the way to the bottom. Another possible solution: Install plastic or rubber buttons on the bottom, or add a base made from 3/4-inch-square pine.

Now: Can this cube clock become a profitable product? Maybe not, as it stands. With all prototype products, keep exact records of costs and construction time—you'll probably find that in order to compensate yourself on both counts, the final sales price will have to be pretty high. You can, of course, market-test the product at that price to see if it will sell.

A better approach would be to look for cost-cutting alternatives. Can you buy a suitable mass-produced cube elsewhere, at a lower cost than if you did the job yourself? To find out, collect some suppliers' catalogs and go through them—you might find just what you need. If not, consider other routes. Some suppliers handle custom orders; inquire as to particulars. Or can you find someone locally to make your cubes at a good price?

Consider cubes made of plastic instead of wood. Plastic lends itself well to cost-cutting and mass-production; see if you can devise suitable molds or have

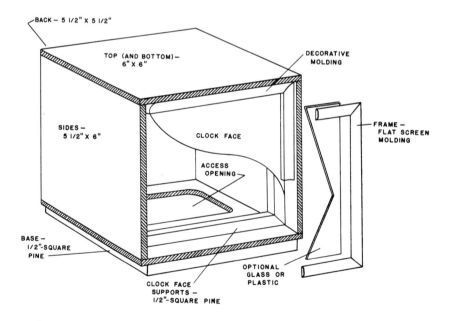

Illustration 8-2: *Construction details for a prototype photo cube clock.*

a fabricator make them for you (check the Yellow Pages). Perhaps you can even locate suitable ready-made cubes.

Making a prototype gives your idea substance. It may give rise to new problems, suggest solutions, or even trigger other ideas. Hmmm. Given the basic photo cube clock, what other possibilities are there? Well, we've already considered the plastic cube alternative.

Plastic. Hmmm.

Why not make the clock face itself from plastic instead of mountboard? Then add a simple light circuit so the time can be read at night? Hmmm. Why not? Because someone will be able to look right through the plastic and see the movement, the light, and the unfinished inside of the cube, that's why not!

Hmmm. Solve that little problem by using frosted plastic, or by simply sanding the inside surface of the plastic face with fine sandpaper until it becomes translucent. Translucent plastic will also diffuse the light nicely.

What else can be done with the basic cube clock?

How about combining the plastic cube and light ideas? And using transparencies or high-contrast positives instead of opaque prints? *Voila!* A decorative combination clock and night-light!

Maybe such a combination will sell, maybe it won't. Maybe it will turn out to be too expensive, and there just won't be any way to get around that. On the other hand, maybe your idea generator will solve that problem too. The point is to start coming up with ideas.

Why restrict yourself to a cube? There are other three-dimensional shapes worth considering. Or keep the idea of a lighted clock and return to the deluxe clock (Chapter 6), only this time in a table version as shown in Illustration 8-3.

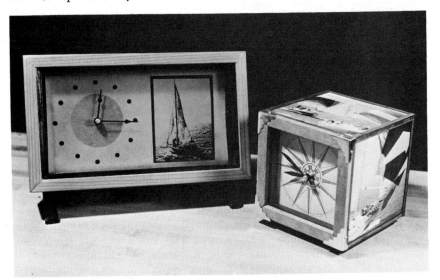

Illustration 8-3: *Two variations on the table clock theme: a photo cube and a translucent-face clock. In the latter a high-contrast positive (or a transparency) is sandwiched between two sheets of acrylic—the inner one frosted, the outer one clear.*

Or, if you're tired of clocks, what about some other instrument? A barometer? A thermometer? A hygrometer? Or combine all three and create a photo weather station.

There you have an example of how the idea-forming process works when applied to existing photo products. Now, let's try the same thing from a different angle.

Products to which you can add photography. Continue your shopping for ideas, only begin to ask yourself the question, "What if a photograph were used instead of . . . ?" Make a "What If?" list.

Now you're looking for products that you can adapt to your photography, products that have some other type of artwork or decoration. Anything that has (or can be redesigned to have) a flat surface large enough to mount a photo on can become a photo product. In fact, that flat surface can also curve, as in the case of a cylindrical wastepaper basket. Later on we'll look at some photo printing processes that work even on spherical or rough surfaces.

The possibilities are indeed numerous, although not all of them will turn out to be good sellers or products you wish to construct. But the more you train your eye and mind in the idea-forming process, the better your chances of coming up with some winners. To a mental runner, generating ideas is exercise—something you must pursue diligently in order to condition your mind and keep it sharp. The same is true of photography itself.

So carry on with your browsing, only this time look not only for items that *are* photo products, but also for those that can *become* photo products.

Consider a garden supply store, for example. Such a store is an obvious choice for flower plaques, prints, and similar products, but have you explored *all* the possibilities? How about a watering can featuring flower photos?

A photo watering can? "You're all wet," you say, "and the photos will be, too!"

Well, you've come up with a problem all right. But before you discard the idea, give a little thought to waterproofing. One solution we've used in the past has been polyurethane varnish—try it and see if it works on this. If you can solve the moisture problem, you can try all sorts of things, including photo pots and planters.

If polyurethane varnish doesn't work, try pour-on plastic. Or perhaps cast your own watering cans in plastic, embedding the photographs. (And if that doesn't work, hold on to your hat; photo decals and photo ceramics are coming up soon!)

List in hand, visit other stores: auto supply outlets, book shops, large chain stores—whatever. Let's return to that old standby, the stationery store.

There on a shelf rests a selection of bookends. Hmmm—the same idea-generating process and techniques (including list-making) spring into action. Since we've already used the basic cube as a clock, why not extend the idea to bookends? Maybe even add a touch of photographic whimsy, as shown in Illustration 12-4. The tiger stretching to contain the row of books is an example of a mixed-media approach to photography. It was first drawn in pen and ink on clear Plexiglas (a high-contrast positive would work also). We used a rear projection screen to add background for the final photograph (see Chapter 15 for a

How to Create & Sell Photo Products

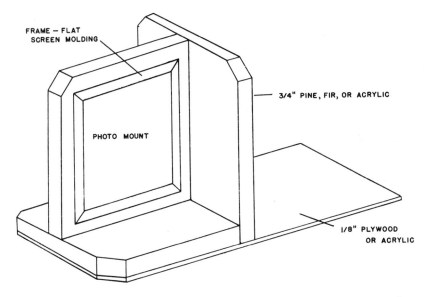

FRAME – FLAT SCREEN MOLDING

PHOTO MOUNT

3/4" PINE, FIR, OR ACRYLIC

1/8" PLYWOOD OR ACRYLIC

Illustration 8-4: *A simple bookend design that can be crafted in either wood or plastic, or both.*

discussion of the techniques involved). Use heavy wood for the cube and attach a non-slip material such as embossed rubber or felt to the bottom. Bookend clubes may be weighted with metal shot (available at hunting supply stores) or gravel.

Or use the design in Illustration 8-4 to make simple photo bookends of wood or plastic or a combination of the two. For prints, use a solid wood photo mount and a frame made of decorative molding. Or laminate transparencies or high-contrast positives to make a plastic photo mount.

Move on from bookends to paperweights. Here, too, a smaller version of the photo cube would work. Or how about a flat-sided rock with a photograph glued in place and sealed with several coats of polyurethane varnish. A decorative frame for the photograph could be fashioned from small stones or wood molding, and glued to the rock with epoxy cement. A photo rock of this sort would also make a good bookend when given a non-scratch, non-slip base—perhaps fashioned from a small plaque. If your area is known for a particularly colorful kind of rock, or scenic features composed of rock—mountains, canyons, buttes—this combination might be a good bet.

Rocks . . . hmmm.

Technological advancements. Take a rock and a can of liquid photo emulsion: Instead of gluing the photograph to the rock, make the image part of the rock itself by printing in black and white directly on the surface. Or on a variety of other surfaces as well, including chinaware, glass, acrylics, wood, eggs, artist's canvas, cloth, paper, jewelry—the options are limitless. In fact, with the appropriate photo emulsions and techniques, you can print in color on fabrics, make photo decals that allow prints to be transferred to curved surfaces, create original photo art without a camera—even print on ceramics before firing them in a kiln!

Where Do Ideas Come From?

Welcome to photo technology.

Actually, making photographic prints on materials other than light-sensitive paper isn't a new idea—the first permanent photographic image was printed on a pewter plate in 1826. By the 1870s, photographs were being printed on sensitized leather, wood, silk, canvas, and—through the use of the newly 'eveloped photo-enamel process—on jewelry and even on tombstones!

What *is* new is the ease with which it can now be accomplished. No longer is it necessary to laboriously mix chemicals, make large negatives, and contact-print them over long periods of time. Now, the light-sensitizing emulsion comes pre-mixed, and the actual printing can be done with an enlarger in the darkroom.

A true wealth of possibilities exists for any adventuresome products photographer. Although the more exotic techniques are beyond the scope of this book, a few of the simpler ones will give you a chance to experiment. Anyone desiring more information is urged to read *Photo Art Processes* by Nancy Howell-Koehler (Davis Publications, Inc.).

HOW TO: Photo Rocks

For the photographer with darkroom experience, printing with liquid photo emulsion is a relatively easy process. The manufacturers' instructions for applying the emulsion to rock and various other surfaces are quite detailed, and the actual printing and developing are pretty much the same as for standard photographic papers. Little is required beyond the can of photo emulsion itself, the rock, fabric—whatever—and a bit of patience.

Even if you don't have a darkroom, you can still make contact prints on emulsion-sensitized surfaces by exposing them to ordinary incandescent or fluorescent light. Since the emulsion is sensitive only to blue light, much of the work can be done under amber, red, or yellow lights (use a darkroom safelight or low-wattage colored bulbs). You will, of course, need some darkroom chemicals: (1) a paper developer such as Kodak Dektol, (2) a stop bath (either commercially prepared, or make your own by diluting one part white vinegar in two parts water), (3) fixer, and (4) hypo clearing agent. Also required are a thermometer and three plastic trays for holding the developing solutions.

The following is intended to give you a general idea of what's involved—detailed step-by-step procedures are found in the instructions accompanying the emulsion.

The printing surface must first be prepared so that the emulsion will adhere. For a rock, this consists of scrubbing with sodium carbonate and rinsing thoroughly. Very porous rocks like sandstone may require sealing with a coat of polyurethane varnish thinned with turpentine.

At room temperature, the emulsion is a solid, so it must be liquefied by placing the can in a container of water at 100-110 degrees F. The melted emulsion is then brushed onto the prepared surface of the rock—and also onto several file cards to be used for testing exposure times. This application step must be done under safelight conditions.

Exposure testing is done according to the manufacturer's instructions, and the test cards developed (follow instructions on the developer bottle) and fixed. Here's where patience comes in. Since exposure times will vary with the

Illustration 8-5: *A pair of rock bookends. Photographs may either be glued in place (bookend on the left) or printed directly on the surface, using liquid photo emulsion (bookend on the right).*

nature of the light source (distance, wattage, etc.), considerable testing may be required, at least until you get the hang of it.

Once the problem of correct exposure is sorted out, the rock itself may be printed. After developing, fixing, and drying, the image may be protected with several coats of polyurethane varnish.

Solvent transfer.　Another photo printing method useful for porous materials is solvent transfer. No darkroom is required for this technique, although you do need access to an electrostatic copy machine (black-and-white photocopiers are usually available for use at job printers, libraries, etc.; color copiers can be found at similar places in larger cities). You also need a print of the photo to be transferred, and an ink solvent such as turpentine, acetone, or lacquer thinner.

HOW TO: Solvent Transfers

Choose a black-and-white print with strong contrast and good line definition, and make an electrostatic copy. Place the copy face down on smooth fabric or other porous material (be sure to protect your work surface with waxed paper). Saturate a small area of the paper backing with solvent. A little experimentation will tell you how much solvent to use—too much may cause the ink to run or blot; too little results in only a partial transfer. Rub the backing paper with a piece of stiff cloth (such as canvas) until the ink has transferred to the

Where Do Ideas Come From?

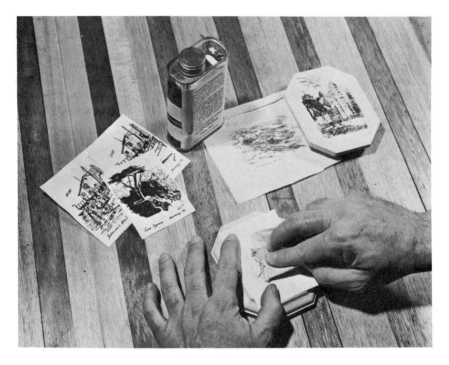

Illustration 8-6: *Photo printing with the solvent transfer technique. A little experimentation will tell you how much solvent to use. Too much may cause the ink to run or blot; too little results in only a partial transfer. Rub the backing with a piece of stiff cloth, such as canvas, until the ink has transferred to the printing cloth.*

printing surface (while holding the copy firmly in place, lift an edge and peek under to note your progress).

If the ink fails to transfer, try the following: (1) rubbing harder, (2) a different solvent, (3) making your photocopy on a different machine. Usually, one or all of these approaches will solve the problem.

Photo fabric made with the emulsion or solvent transfer techniques may be framed (or mounted in various other ways) as a wall hanging, or stitched to another piece of cloth and stuffed to become a pillow. Soft photo sculptures can be made from one or any number of prints in combination, again by stuffing them with shredded polyfoam or styrene pellets.

At this point, the question may arise: If a photo transfer is to be hung on a wall, why not just frame the print and be done with it? Why not avoid the added bother of making photocopies, using solvents or emulsions, and so forth?

The answer: Because that fabric wall hanging is a different product, and often the name of the game is *coming up with a different approach*—one that will make your work stand out. Part of the charm of photographs printed on materials other than paper is the addition of interesting colors and textures—

wood grain, veining or cleavage in rock, the coarseness of burlap or the fine sheen of silk—to the photo itself. Matching the image to the printing medium adds a whole new dimension to the concept of total effect. The two become a whole, each contributing to your photographic statement. And in most cases, additional color can be added to the final product with acrylic or oil paints, or standard photo tints.

Obviously, you can stretch the limits of "photography" pretty far, but then there really are no boundaries in the world of art. Nor in the world of ideas: An essential part of the idea-generating process is stretching the mind, opening it to new possibilities. Many of the more novel photo printing ideas will result in pure art, existing in and of itself, with little practical value except as room decor. Others, however, can be as practical as the shirt on your back.

Although liquid photo emulsion and solvent transfer can be used on cloth, the resultant image will not stand up to repeated washings. These techniques are best used for such products as wall hangings, decorative pillows, soft sculptures, and lampshades, not for clothing.

Thermal Dye Transfer. Numerous methods *do* exist for printing a photograph on fabric so that it can withstand the rigors of the washing machine. One of these is thermal dye transfer. Although this process is used in industry to print millions of yards of colorful and highly detailed fabric each year, it can also be employed on a more modest scale, which makes it useful for our purposes.

As with solvent transfer, the first step is to make an electrostatic copy of the photograph. Next, commercially printed "dye transfer paper" (available in a variety of colors from suppliers—see Appendix A) is placed in contact with the photocopied image.

The two are then enclosed in a protective paper folder and heated at 350 degrees F. in a heat press or dry-mount press. Transfer of the dye to the photocopied print takes fifteen to thirty seconds. For smaller projects or for experimental purposes you can use an iron set at 350-400 degrees F.

The same procedure is now used to transfer the dye to the fabric. The dye-colored photocopy is placed face down on the fabric, covered with a sheet of paper to protect it, and heated for fifteen to thirty seconds, after which the photocopy is peeled away to reveal the imprinted monochromatic image.

More creative effects can be achieved by repeating the process with the same or a different photo in another color. The second colored image will be transferred to the fabric without affecting the first print. It's possible to make overlapping prints in a variety of colors from the original black-and-white photograph.

Dye transfer papers that allow full-color printing from transparencies have also been developed. The procedure is similar to that outlined above, although somewhat more complicated, and does require access to a color photocopy machine.

Naturally, the fabrics used must be able to withstand the high temperatures of the transfer process. Those recommended by the transfer sheet manufacturer are 100 percent polyester, 100 percent cotton, or 50-50 cotton/polyester blends. Other heat-tolerant fabrics will work, but should first be tested in a heat press or with an iron.

Consider using these fabric printing processes to develop prototype products such as T-shirts, hats, or other clothing; bedsheets or comforters; even upholstery for furniture. If you can find some interested buyers, you can investigate having your photo fabric printed commercially.

A LITTLE IDEA CHEMISTRY

Don't be tempted to think that our three methods of fueling your idea generator operate independently of each other. They can, of course, but they don't necessarily have to. Let's return to our lists and our idea-shopping, and do a little fuel mixing, a little idea chemistry.

Back at the stationery store we find an interesting candle holder consisting of a wooden base grooved to accept four vertical glass sheets, each of which has an etched design. Since this item has some flat surfaces, we could include it on our "Why Not" list. However, those flat surfaces are glass and that could be a problem—until we look at our list of technological advancements: Liquid photo emulsion allows us to print on glass. Thus we've combined information

Illustration 8-7: *An ornamental candleholder. Make the base from wood (a plaque blank will work nicely). Cut grooves to hold the glass or plastic uprights or construct inside and outside frames of ½-inch-square stock. Use photo emulsion to print the image on the transparent windows (an alternative is to laminate transparencies or high-contrast positives). For variety, colored glass or plastic may be used.*

from two separate lists in order to make a new product feasible.

We can make the base for the candle holder in Illustration 8-7 from a plaque blank. Grooves can be cut to hold the glass windows, or inside and outside frames can be made from ½-inch square pine. The image may be printed with liquid photo emulsion (an alternative is to laminate transparencies or high-contrast positives). For variety, use colored glass—but whatever kind of glass you use, be sure it is heat resistant.

Although there are doubtless many other potential photo products to be found in the stationery store, let's move on, this time to a shop specializing in gourmet cooking supplies. Here we find an array of pots and pans, utensils, and all manner of kitchen paraphernalia, including decor items. We usually think the role of photography in the kitchen to be one of decor—framed prints or purely ornamental plaques.

However, let's take a look at our "Reasons People Buy" list. Hmm . . . people buy things because they serve a useful function. Now, consider your own kitchen or that of any busy person—chances are it's pretty cluttered. Clutter . . . hmmm . . . organization is a useful function. Organization helps reduce clutter and makes things easier to find. Now, look at your "Existing Photo Products" list. Add some screw-in hooks, and plaques can become holders for hot pads, towels, keys, cups—whatever. Larger plaques can become photo clocks. Cabinet doors can become photo plaques on a grand scale. Photo ornaments can be attached to magnets or spring clips to become memo holders.

Combining our "Why Not?" and "Technological Advances" lists, we can come up with photo towels, hot pads, aprons, chef's hats, or fabric kitchen-oriented wall hangings. In league with a potter, the photo products designer can turn out a line of mugs and dishes—even cookware. Photo mugs can be created by printing on ceramic with the proper emulsion, then firing. Photo decals can also be made by silkscreening a low-fire glaze onto special decal paper, which can be applied to curved ceramic surfaces before firing. The potential is there, provided by technology. All that's needed is to develop the idea into a marketable product. If this sort of thing appeals to you, find a potter and talk it over with him.

Remember photo coasters? Why not a matching set of coasters and serving tray done on a theme—sailing, wild flowers, whatever you like. You can even add matching mugs. Then make a "tree" to hold them all as shown in Illustration 8-8. In this case, the "tree" is made from ¼-inch plywood, as is the serving tray (the handles are cut from ½-inch pine). Ready-made but unfinished trays are available from suppliers.

THE SHAPE OF THINGS TO COME

It's not only technological advances in photography that can apply to photo products. Plastics technology, for example, has given us numerous materials that can serve as fuel for your idea generator. Visit a crafts or hobby supply store and look at the great variety of shapes in styrofoam, a highly porous plastic. Or wander into a hardware or plumbing supply store that sells plastic pipe and fittings—elbows, T-joints, and the like. Then get prepared to start another list.

Illustration 8-8: *A coaster-serving tray "tree" serves both an ornamental and a functional purpose in kitchen or game room. Matching photo mugs can be created by printing with the proper emulsion on ceramic, which is then fired in a kiln. Photo decals can also be made by silkscreening in a low fire glaze onto decal paper. The decal can then be applied to curved ceramic surfaces before firing.*

A seat-of-the-pants approach to getting ideas. Take a styrofoam ball or any other interestingly shaped material, sit down at your desk or kitchen table, and title a list "Styrofoam Ball Photo Products." Or "Plastic T-joint Photo Products." Or whatever happens to have struck your fancy. Then see what you can come up with. Refer back to your other lists to see if anything is adaptable to this new shape or form.

We did just that with a plastic elbow used to connect 4-inch PVC sewer pipe. We noticed that the light diffused through the translucent plastic illuminated transparencies and high contrast positives very nicely. Thus, with the addition of a square plaque for a base, the elbow became a pop art frame.

How to Create & Sell Photo Products

And the installation of a low-wattage light bulb yielded the pop art night light shown in Illustration 8-9.

Another seat-of-the-pants method of getting ideas is to leaf through crafts magazines, looking for projects that can incorporate photography; the same is true of home projects magazines like *Popular Mechanics* or *Mechanix Illustrated*. The "Four Frustrating Fotos" puzzle in Chapter 5 was an adaptation of a idea we came across in a similar source.

While you're sitting there, take a look at your desk itself. What useful products have you gathered there? Which ones could become photo products? What about a pen holder that's also a framed photograph . . . or perhaps has a photo cast into a plastic base?

Or what about a gooseneck desk lamp that emerges from a photo cube . . . which is also a clock? Or a photo desk calendar? Or a business record book with a photo on the cover? Or photo stationery? Or . . . well, you get the idea: another list.

Add to your list by glancing around the room with an appraising eye—an eye that you're training to see photographs everywhere. How about a photo

Illustration 8-9: *A wooden plaque forms the base for this night-light made from a plastic pipe elbow. The photos may be either transparencies or high-contrast positives. An alternative is to print directly on frosted plastic with liquid photo emulsion.*

lamp over there in the corner? On top of that table . . . that *photo* table? Right next to that . . . *photo chair?*

WHY NOT?

Photo furniture and room accents. It all boils down to this: Almost anything with a surface large enough to mount a photo on can become a photo product. And with the techniques for printing photo fabric, that surface doesn't even have to be flat. Of course, this doesn't mean that everything you put a photo on will become a profitable photo product—or even a salable one. But again, our main purpose in this chapter is to generate ideas, so with that in mind, let's look at some other ways to turn photography into functional decor.

The first step? You guessed it: back to the lists. Photo table . . . hmmm. Here's the cube photo clock—how about making a cube big enough to become a table? We can cover it with photos and hinge the front and we've got a photo cube *storage* table. Will it sell? That depends on what's involved. Let's make a prototype and find out.

HOW TO: Developing a Photo Cube Storage Table Prototype

This will be bigger than a cube clock so we'd better use heavier material—½-inch plywood finish-sanded on both sides should do. How much bigger? That depends on the kind of table.

Take some measurements from the furniture in your apartment or home; determine the most convenient sizes for various types of occasional tables. By so doing, we learned that a 2-foot cube would work well beside a chair or

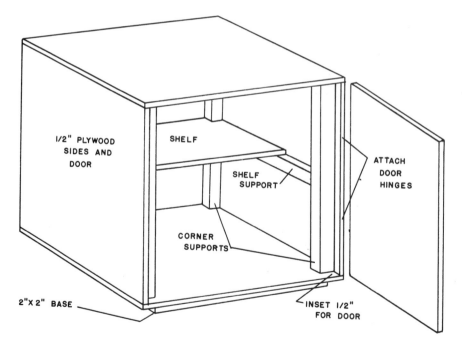

Illustration 8-10: *Construction details for a prototype photo cube storage table.*

couch, or in a corner to support a lamp. A 16-inch size would make a good end table or could be grouped to form a sort of coffee table cluster. Let's think big and make the larger size.

Cut two 24-inch square pieces of plywood for the top and bottom, two 23x24-inch pieces for the sides, and two 23-inch square pieces for the front and back. To reinforce the corners, cut four 23-inch-long supports from 2x2-inch lumber, then glue and nail them to the side pieces. The supports should be inset ½ inch from the edges so the front and back pieces will fit flush with the sides.

Perhaps a shelf inside would make storage more convenient. Cut two shelf supports to fit between the corner supports and glue, then nail, one to each side so that the shelf itself will be 12 inches above the bottom of the cube. Then glue and nail (use 1- to 1½-inch finishing nails) the top, bottom, sides, and back together. Remember that the front will be hinged to form the door.

Any photos we mount on the cube will have the same problem as those on the cube clock—they'll become scuffed and torn every time the table is moved. Solution? The same as for the clock, except on a larger scale: cut four 23-inch pieces of 2x2-inch stock for the base, mitering the ends. Glue and nail them to the bottom. Cut the shelf to fit—it may be glued or simply laid in place. Sink all nailheads and fill the holes with wood dough. Paint or stain the cube, including the inside and the door.

Glue the photographs to as many sides as you wish, including the top, with rubber cement, spray-on photo adhesive, or wheat paste. They may be arranged in a patchwork pattern or in a regular arrangement, which is then framed with flat screen molding.

Give the photo surfaces several coats of polyurethane varnish, then mount the hinges and install the door.

The cube is by no means the only style adaptable to photo tables. However, since they must be considered rather avant-garde, it's probably best to stick to modern designs. Mount photographs on the tops of Parsons tables (inexpensive plastic versions are readily available in most areas), or embed them in free-form plastic slabs. If you wish, you can even progress from the simple cube to more complex geometric or free-form shapes that will more nearly resemble sculpture than furniture. The direction you go will be determined by your own inclinations and the nature of your market.

HOW TO: Photo Lamps

Convert the clock cube (Illustration 8-2) to a small desk or accent lamp—with or without the clock—by altering the top to accept a round frosted glass globe and wiring in a light socket and switch (see Illustration 8-11). Glass globes are available in various sizes at lighting and electrical supply stores (while there, look for similar mass-produced lamps that can be adapted to photos).

Or create a larger table lamp by stretching the vertical dimensions of the cube. Either way you go about it, the construction techniques are basically the same as for the Photo Cube Clock, with the following exceptions:

(1) The clock face becomes a solid plywood side (unless, of course; you plan a combination lamp-clock).

(2) A square socket support is cut from plywood, drilled for the electric cord, and installed prior to gluing the top in place. The exact location of the support will depend on the size of the socket you use (position the support so that the top of the socket is roughly in line with the top of the finished cube). Nail the support in place and sink the nails, filling the holes as usual. Install the socket and wire (a hole will be necessary in the bottom).

(3) Before installing the top piece, cut a round hole large enough to accept the rim of the glass globe (it's a good idea to choose a light socket that will also fit through this hole—just in case it should ever need to be replaced).

(4) You can either add a switch to the lamp itself or use the in-line type shown in the drawing.

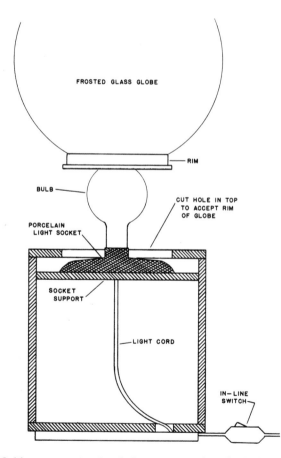

Illustration 8-11: *Construction details for converting the cube clock design to an accent lamp.*

The photo lamp design in Illustration 8-12 makes use of two 11x14 inch "wrap-around" photos. The sides are made of plywood in the same way as the cube lamp, except that each photo face measures 5½x14 inches. The square top and bottom caps are cut from ¾- or 1-inch-thick pine or fir. Before gluing the bottom cap in place, cut a two-inch (in diameter) hole in the center with a scroll saw. Then bore a ⅜-inch hole through from one side as shown in the cross-section in Illustration 8-12.

Bore holes in the top and bottom so the threaded pipe will fit snugly. This pipe supports the socket and also acts as a conduit for the wire. The neck can be made of electrical conduit or pipe (chrome, copper, brass, plastic—whatever goes well with the photographs); however, the inside diameter of the neck must be large enough to slip over the threaded pipe. Paint or stain the lamp base.

Install the threaded pipe, neck, and socket cap. Run the wire through the ⅜-inch hole in the base and through the threaded pipe, and make the necessary connections at the socket. Glue the photographs in place, then give them a

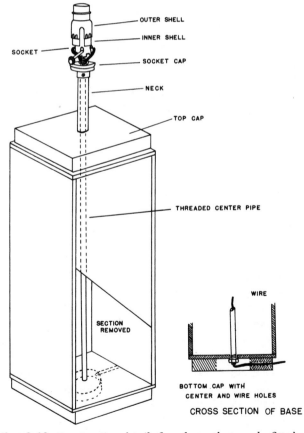

Illustration 8-12: *Construction details for a lamp that can be fitted with either a standard shade or one made with photo cloth.*

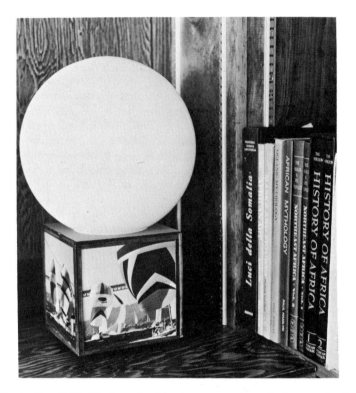

Illustration 8-13: *The base for this photo accent lamp is the same basic design as that for the cube clock.*

protective coat of polyurethane varnish. Add a plug, a bulb, a suitable lampshade, and let there be beautiful light!

The cube and rectangular boxes are only two possible designs for a lamp base. Other geometric shapes will also work, as will free-form or more conventional designs in styrofoam, acrylic, or ceramic. You might even turn the base into an eye-catching night-light by making it from plastic and using transparencies instead of prints. A low-wattage light bulb could be installed inside the base and controlled by a separate switch.

So far, we've developed prototype photo products that not only serve as decorative room accents, but also provide light, or space to store things on or in. Since this is a seat-of-the-pants exercise in getting ideas, how about sitting on a photograph?

HOW TO: Photo Bean Bag Chairs

Using any of a number of fabric printing processes that will give permanent images, turn 4½ yards of 45-inch-wide heavy, machine-washable cotton into a photo display.

Cut the material as shown in Illustration 8-14. You'll also need a lining of the same size and shape made from unbleached muslin. Buy two 12-inch zippers (one for the outer bag and one for the lining) and about 14 pounds of sty-

How to Create & Sell Photo Products

Illustration 8-14: *Pattern for the photo beanbag chair. Cut panels as shown from photo-imprinted cloth.*

rene foam pellets. Ask for pellets that are fully expanded and fire resistant.

Stitch the pieces together, allowing for ½-inch seams. Locate the zippers along the center seam of the base of each bag (in the same place on each bag). The muslin lining is made the same way, except you use ⅝-inch seams. Slip the linig into the outer bag and pour the styrene pellets into the lining bag. The outer bag can be removed for occasional washing.

HOW TO: Photo Pillow Chair

This chair is actually a set of free-form pillows cut from flexible polyure-thane foam, which is available in most locations (check the Yellow Pages un-der "Plastics—Foam"). The foam slabs may be cut into practically any shape, using hand tools—a saw, razor blade, or sharp knife. If you have difficulty finding thick-enough slabs, you can bond thinner pieces with white glue, rub-ber cement, or epoxy resins. Illustration 8-15 shows how a set of individual shapes can be combined to form a chair, a couch, or a chaise longue.

Illustration 8-15: *A foam furniture design that can become a chair, a chaise longue, or—by widening the dimensions—a loveseat or even a couch.*

Or design your own shapes (or use conventional pillow shapes, available from polyfoam suppliers or mail-order department stores like Sears or Wards) and cover them with tight-fitting slipcovers of photo fabric. And while you're at it, don't forget to experiment with individual decorator pillows.

For something a little less casual, you might consider designing a wood frame to support your polyfoam cushions or photo chair. Or, in lieu of using photo fabric, you might design the frame so that the sides of the chair become frames for photographic prints. Scout through home projects magazines and other publications for furniture designs that might be adapted to photography. And don't feel that you have to become a carpenter (although some people may enjoy that nearly as much as the photography!). As with any of the aforementioned products, you can generally find someone to do the construction for you.

THE BOTTOM LINE

Come on now! Will people really buy photo chairs?

Maybe. Maybe not. Photo chairs are ideas, just like all the other prototypes in this chapter. How successful they become depends on the nature of your marketing area, and whether or not the ideas can be developed into cost-efficient products. We've no doubt that some enterprising photo products designer will do well with chairs, especially in the field of custom photo decor. Certainly there's a strong market for photo accent pieces, including many possibilities that have gone unmentioned: photo screens and room dividers, planters, desks. . . .

How to Create & Sell Photo Products

But hold it!

The whole idea of this chapter is to start *you* thinking. Ideas are where you find them, and we haven't begun to exhaust the supply of fuel for your idea generator. We hope we've given you enough to get the process started; now it's up to *you* to follow through. Not everything you come up with will be right for you or your area, but be assured of this: The ideas will come. And along with them, problems. And then solutions to those problems. Spectacular success is only the right idea away!

PART THREE
GETTING DOWN TO BUSINESS

Chapter 9

MARKETING YOUR PRODUCTS INTO PROFITS

The aim of the Photo Products Alternative is to get your photography moving in a commercial direction, generating income. To do that, you first need ideas—either all your own, or adapted from existing products. Then those ideas must be turned into products suitable to your particular talents and situation. But even when both of those objectives have been accomplished, you're still not earning any money. It all goes nowhere without marketing.

There's no way around it. You'll have to get out and do some selling.

As we have stressed repeatedly, visibility is an important prerequisite to making money in photography. People have to *see* your products before they can buy them. One way to attain this visibility is to open your own shop or gallery, but this, as indicated in Chapter 1, would bring with it that not-so-silent partner, the Fixed Overhead Gremlin. Remember that greedy fellow with the insatiable appetite? Better to let someone else feed him, at least for a while. You'll be busy enough refining your photography, developing your products, and locating places to market them.

Locating appropriate places shouldn't be too difficult, but getting the merchants involved to display or carry your products line will require a certain amount of salesmanship.

ONE VIEW OF SALESMANSHIP

Believe it or not, we're all salespeople, though we may not list it as our profession. In one way or another we've been "selling" all our lives—selling ourselves, our needs and desires, our hopes and ideas. Sailing under widely disparate flags—meeting, greeting, explaining, convincing, arguing, teaching, impressing, rationalizing, and on and on—the course we steer is still salesmanship. To varying degrees we're all "born salespeople"; what we need to do now is channel those abilities toward selling photo products.

Some people will find this easier to do than others. No matter how opti-

How to Create & Sell Photo Products

mistically we treat the subject of selling, the fact remains: There are those who aren't the least bit bothered by the prospect of walking into a store and talking a total stranger into buying or handling a product, whereas others would go to almost any extreme to avoid the experience.

Most people fall somewhere in between. Conscious selling makes them uncomfortable. There are plenty of things they would rather be doing—taking pictures, for example. If that pretty well sums up your view, be assured you're not alone. In fact, we're right there with you!

But it's an inescapable fact that the most successful photographers are those who most effectively sell themselves and their work. Salesmanship is the single most important element in success—more so even than talent. Anyone who is content to sit back and wait to be "discovered" had best avail himself of a comfortable chair and prepare for a long and lonely vigil.

Dame Fortune *could* intercede on your behalf. But better not to trust to luck; she has a notoriously perverse nature. And besides, what we often mistake for good luck is really only the result of hard work and salesmanship.

Unfortunately, many of us shy away from the former and distrust the latter. Salesmanship has a tarnished image in many people's eyes. Taking photographs is great, but selling them—well, that's another matter altogether.

Person-to-person sales contacts *can* be distressing and difficult. But there are ways to ease the strain, perhaps even make those contacts enjoyable. For one thing, your role in the selling process in this case is primarily one of presentation. If your products are attractive and you've done your market research, simple presentation will usually be enough to make the sale without the need to resort to high-pressure tactics. Then the retailer will assume the salesman's role, selling your products for you—in fact, your photo products will sell themselves, again and again and again!

At first glance the more impersonal forms of photo marketing, such as direct submission, might seem to have a real advantage. When you send your work off through the mail, you don't have to take that "No, thank you" face to face. There's a soothing anonymity in distance. But that doesn't make the negative shake of the head any less real. A no that's traveled two thousand miles is pretty much the same as one that's come a mere two feet.

Noes are a fact of business life. And there's a lesson in each one . . . if you can only learn it.

But learning from noes can be next to impossible in direct submission. Anonymity works both ways. That distant editor doesn't know you, and you don't know him. You don't really know what he wants or needs, and he doesn't really know what you can provide. All he knows is what he sees in your submission. Generally, you have no idea of how you missed the mark. Beyond the photo package and a couple of form letters—yours to him and his reply—there was no interaction, no interchange of ideas. You both remain anonymous.

If only you could have *talked* to him . . .

Seen from this perspective, personal contact is one of the great advantages of the Photo Products Alternative. You *do* have someone you can talk to about your photography. You *do* have someone with whom you can exchange ideas and marketing information. You have the retailer who will ultimately sell your

products for you. You have the distributor or sales representative who will place your products for you.

And, though you may not actually talk with them, you'll have the customers who buy your products. They'll express their opinions through their choices of one photo over another or one product over another.

Add these all together and you'll have a full spectrum of responses to help you determine the directions your photography and products should take. You will no longer be toiling in the dark.

So let's get down to business.

DO SOME ADVANCE SCOUTING

Your advance scouting consists primarily of collecting information to make your selling job easier and increase your chances of success. This scouting process should be entered into right from the start, as an integral part of your preliminary market research. While you're checking out the activities of possible competitors and determining what kinds of photographs and products might sell in your area, you should also be shopping around for possible marketing and display locations.

Retail outlets. Gift shops would probably lead any list of possible retail outlets. Such a list would also include souvenir shops, clock shops, furniture stores, gourmet, kitchen, or other specialty shops for the home, even flower shops if you have a suitable product. Also consider bookstores and card or stationery shops.

The more versatile your photography and products, the more varied your marketing outlets can be. You could, for example, develop sailing-oriented items for boat dealers. Or sports-related products for sporting-goods dealers. As you do your advance scouting, keep your eyes open for any kind of store for which you might develop a successful products line.

Sometimes marketing ideas can come from sources other than the stores themselves. Participants in various events or activities can provide you with useful information on what to shoot and where to sell it. Often they'll go out of their way to be helpful. They'll not only help you get the best possible shot but put you in touch with other people with similar interests by suggesting newsletters or magazines where you might advertise your products (or submit your photos) or retail stores that might handle them directly.

Free display space. You can also sometimes locate free spaces in which to display and sell your products. However, they present somewhat different problems from retail outlets and so will be dealt with separately later in this chapter.

Choosing products to suit the location. Whenever possible, avoid walking into a possible retail outlet with an armful of products and the hope that the owner will find *something* he likes among them. Instead, visit such places beforehand and browse around a bit. Get a feel for the kinds of products featured, the tastes of the shop's owner and his customers, then make a choice from your own products to suit the situation. Notice, too, the kind of display space that's available. A shop with shelves on every wall would probably be a poor choice for framed prints or wall clocks. But it might be perfect for smaller

How to Create & Sell Photo Products

items such as photo boxes and greeting cards.

Also consider the merchandise itself. Be sure the featured products are in the same general category and price range as your own. Trying to place inexpensive tourist-oriented plaques or key chains in a posh shop that displays only exclusive items with high price tags would most likely be a mistake, if not a disaster. On the other hand, stylish framed prints might be welcomed.

At the risk of being repetitious: Match the products to the outlets for which they are intended. The adaptability of the Photo Products Alternative is a great advantage in your favor. You can create a photo product to fit just about any marketing situation. Your only limitations are your own imagination and personal tastes, and those of the merchants with whom you deal. Some merchants consider key chains or scenic "peep show" viewers too tacky to undertake; others make hundreds of dollars a week selling these very items.

So don't do a merchant the injustice of offering him inappropriate products. It only goes to show that you haven't done your homework. Do your market research and scouting and then try to meet each merchant's needs. Come up with something he can use; something that will make you *both* a profit.

Try to be aware of all the possible marketing outlets as you do your preliminary research. Think not only in terms of what you already do photographically but what you *can* do—which is probably just about anything you set your mind to!

A final note: Presenting a retailer with appropriate products doesn't mean you can't talk about your *other* products should the occasion arise. It's not uncommon to find someone who owns several shops, one or more of which might be just right for something else in your line. If some of those shops are located in other communities, so much the better—that's a good way to expand your marketing area. Be prepared to seize any opportunity that presents itself.

Evaluating the outlet. Approach each prospective marketing outlet from the point of view of both a manufacturer and a potential customer. Do a little careful evaluating. Is the store an attractive place to shop? Are the displays well set up so that items are shown off to their best advantage? Or is the place so crowded with merchandise that your products might get lost in the confusion? Such overstuffed shops can be mindboggling to customers. For you, too much merchandise can mean too much competition. On the other hand, too little merchandise or a lack of variety may discourage shoppers from making return visits. These concerns are less important if you sell your products to the retailer outright, at a wholesale discount (more about this later). If, however, he handles them on a consignment basis—where you get paid only for what sells—you want to assure yourself of the largest possible volume.

Some stores seem to be beehives of activity, others livened only by staff. Be aware of such things when selecting outlets. Obviously, the more customers, the more potential buyers for *your* products and the better the chances that the shop itself will stay afloat during troubled economic times.

There are always risks to opening a business, especially a small one. Choose your outlets carefully, because those risks can affect you indirectly through shop closings. Though your merchandise, if on consignment, should be returned to you, it could be tied up in legal strings for considerable time. And we've known cases where the owner simply disappeared with most of the

higher-priced items, regardless of their ownership! So if a store doesn't seem to be doing well, it may not be a good choice, no matter how enthusiastic the proprietor is about your products.

What influences this customer activity? Location, for one thing, especially in tourist areas. If you intend to market in such an area, it would be wise to spend some time people watching. Note what they go to see and the routes they take to get there. In Monterey, California, for example, one of the prime tourist attractions is Fisherman's Wharf. Cars and buses disgorge thousands of people daily during peak seasons, and these travelers head straight for the Wharf. Shops along their routes prosper, others only a block or so away falter.

Locations within easy walking distances of airline or bus terminals or railway stations (on an Amtrak route) are good. People tend to browse while killing time between connections. Locations near hotels can likewise be favorable, especially if they stay open in the evenings and lie en route to major tourist attractions.

A store's sales personnel can also affect customer activity, as can the management. Notice if clerks are friendly, helpful, or if they just stand around talking to each other. Or, at the other extreme, if they descend like sharks on anyone who walks through the door. High-pressure sales pitches can be a very effective way to drive people off.

These and other factors will have a direct bearing on how well your products do in the marketplace. There's no sure-fire way to pick the right places for your products, but thoughtful screening can certainly tilt the odds in your favor. And that's very important, especially in the beginning. Success builds upon itself; failure has a way of doing the same thing.

MAKING YOUR APPROACH

Before you even start, be sure you've polished your product-making techniques. Don't try to talk anyone into displaying or handling anything that's not first-rate, that doesn't represent your best efforts. Pick some products you think you can handle and make some samples for yourself, just to get the feel of it. If you're disappointed with the initial results, try again. With a bit of practice the improvement can be dramatic.

The products. Arrange to have variety—both in your products and in your photography—when you make your calls. Everyone has opinions and prejudices and it's best to plan for them. A merchant who dislikes the very idea of photo clocks might find your framed prints or plaques too appealing to resist.

Sometimes, though, showing a merchant your actual product can change his opinion. Often a person has a preconceived notion of what a particular product will look like, based upon what he's seen in the past. It's a prejudice that can work for or against you depending on the exact nature of that past experience. Photo clocks, for example, might meet with a negative reaction among merchants who are familiar with only the cheap varieties. This initial response is more easily overcome if you can *show* them your version.

The presentation. Whenever possible, make your presentation in person. It's harder for someone to turn you down face to face than over the phone or through the mail. It's that old anonymity of the written word or the telephone voice again. There's another bit of psychology at work here, too: People

would generally rather be the bearer of good tidings than bad. They would rather see you happy than disappointed (after all, you represent a potential customer to them, too). Even if they have serious reservations, they're far more likely to say, "Let's give it a try," if you're standing right there. So make no mistake about it, your physical presence is important and could well be the deciding factor.

With luck, you may never encounter someone who takes pleasure in putting other people down. Although rare in the field of direct retail marketing, such persons do exist, though how they stay in business is a mystery. What with their surliness and disregard for the feelings of customers or anyone else, one would expect their shops to be empty. Some hide their attitudes under a veneer of sophistication or snobbishness; others seem to be just plain mean. The best way to handle them is to avoid them in the first place.

How? Through screening. Consider the following approach that allows you to size up the situation *before* you commit yourself.

When you go into a store, spend a little time getting to know the merchant before you make your presentation—in fact, before you even mention what you do. Show some interest in what he does. Ask about the business, the kinds of customers he deals with—whatever seems appropriate at the moment. Even the weather—the rainstorm, the blizzard, the heat wave, the smog—can help to break the ice. Or start with a few compliments about his shop. Play it by ear, but above all be genuine. Merchants deal with real faces and false faces every day, and it usually doesn't take them long to spot the difference. Try to establish a rapport. You can generally tell in a very short time whether or not your products will meet wth a receptive audience. A good indicator is: If *you* do, *they* will. This is the approach we use, and an expression of interest sends us back to the car for our samples (see Chapter 11 for a way to handle your samples).

If possible, make your actual presentation during the off-season or during slack business hours, when owners or managers have time to give your products the attention they deserve, and make an appointment to come back later if necessary. Remember that a merchant with customers to serve will be likely to say no, just to get you off his back.

If the owner is too busy to talk or isn't available that day, we simply pick up a business card or a name and address and contact him or her later by mail. The letter will include our credentials, information about our work, and a request for an appointment to show our samples. The primary goal of the letter is to create enough interest on the part of the shop owner to get him to look at your work. Include anything that you think will help accomplish this. Don't be afraid to brag, to represent yourself in the best possible light. If you've done shows or won contests (Chapter 7 tells you how to acquire some of these credits), have sold or had any photos published, or have displays in other shops or galleries, put that information into your letter. If we have a photo that's particularly appropriate to the owner's shop or area, we may include a plaque, card, or bookmark featuring that photo. Make it clear that this is a gift to keep whether he or she chooses to look at your work or not. Who knows, a reluctant owner might change his mind after using your bookmark or enjoying your plaque for a while.

As stated earlier, try to avoid making initial contact by letter. It's all too

easy to say no by return letter or even not to respond at all. But for those times when the best approach just isn't feasible (you're only in town for the day and the owner isn't available, for example), a letter may have to do. If so, give it your best effort and make it as businesslike and professional-looking as possible.

When making your presentations, remember one very important thing: A business arrangement is a two-way street. A merchant or businessperson is not doing you a favor by handling or displaying your products; nor are you doing him a favor by offering him the opportunity. Your products can make him, and you, money. In this sense it's a partnership that you're proposing.

Occasionally, we've come across merchants for whom we could provide a special service, as in the case of the courthouse photographs mentioned in Chapter 2. They earned us not only money but no small amount of gratitude. Custom products of this sort will be covered more thoroughly in the next chapter, but you should always be on the lookout for such opportunities. Sometimes the custom product is a way of opening the door for your other products, so don't hesitate to ask an amiable merchant what you can do for him.

LOCATING FREE DISPLAY SPACE

Placing your products in retail outlets will cost you money, either in the form of a wholesale discount if you sell them directly to the retailer or as a commission if he handles them on consignment. You are, in effect, paying him to sell your products and also helping to feed his Fixed Overhead Gremlin. There's nothing wrong with this arrangement, but there are alternatives, one of which is to take advantage of any free display space you can find.

As with any marketing method, the use of free display space has its pros and cons. Since there is no charge to you, you won't be helping to support anybody's Fixed Overhead Gremlin, and this translates into more profit on each sale. You may or may not have to pay someone to handle the actual sales. If not, you have no one to split the profit with; it all goes into your pocket. If you do have to pay someone, that person will probably only collect the money and pass it on to you; there will be no active selling involved. Consequently, the commission you pay may be as low as 10 percent and certainly no higher than 25 percent of the selling price. Again, this means more money for you. That benefit, however, may be offset by disadvantages, as we shall shortly see.

It's important to place your products so that as many people as possible can see them—again, the idea of *visibility*. So before you make any commitments, spend a little time analyzing the traffic flow. A free display space that sees only a minimum of pedestrian traffic probably won't do you much good, whereas one that costs a bit in rental fees, commissions, or wholesale discounts, but gives you good visibility, could be a much better arrangement in the long run.

Still, try to minimize the cost as much as possible. If someone offers to rent you display space, you might try a little bartering. See if you can trade off a custom photo job, for example. Offer to make some Christmas cards free, or any of a variety of products that might be suitable (see Chapter 10 for some custom product ideas). Try to keep your investment as low as possible, especially if you're trying to get started on a shoestring.

How to Create & Sell Photo Products

As with the framed photography discussed in Chapter 7, don't think only in terms of stores. Many professional offices, such as those of doctors or dentists, will often permit and even welcome displays as a means of brightening their decor. Banks also fall into this category. Numerous photographers (including us) have hung shows in banks free of charge. So always be on the lookout for blank walls wherever there's a steady flow of people, especially in places you're familiar with—enterprises with which you've already had personal contact.

Sometimes your chances of making a sale are better if that flow of people is "stop and go" (such as in a restaurant) in addition to being steady. In a relaxed atmosphere people seem more inclined to purchase something right on the spot, whereas in a busier location, such as a bank, they might be in too much of a hurry to give your products more than a cursory glance.

One of the biggest problems with free display space is that probably no one will undertake the actual selling for you. If this is the case, your display should clearly indicate that the material is for sale as well as explain how potential customers can make their purchases. Be specific. Spell out the procedure on a notice alongside your products. If someone at the location will collect money for you, fine. If not, be sure your notice tells how to get in touch with you. Always try to make it as easy as possible for someone to buy your products.

If you expect a clerk or secretary or someone else to collect the money or do any selling for you, then it's only fair to reimburse him. A commission of 10-25 percent on each sale would be appropriate, depending on how much he actually has to do. Since he will then have a vested interest in your success, he might put out a little effort on your behalf, and this commission can come back to you in the form of increased sales.

As mentioned earlier, the advantage of free space is that you stand to make a greater profit on each sale. Even when a commission is involved, it will be considerably less than in a retail store. However, you'll sell products pretty much on a catch-as-catch-can basis. People don't go into a dentist's office to buy gifts. They may be tempted when they see your display, but they're going to have other matters on their minds. In other words, selling conditions are not optimal!

THE DOLLARS AND CENTS OF MARKETING YOUR PRODUCTS

As mentioned earlier, there are numerous ways to secure display space for your products. You'll probably encounter some merchants who are sufficiently impressed with your work to place an order—that's the kind of response you'd like to get each and every time. At the other end of the scale is an outright "not interested." Consignment falls somewhere in between, depending on the exact nature of the agreement.

Wholesaling your products. This means selling your products directly to the dealer at a discount off your recommended retail price. The dealer then adds his profit margin and determines the actual retail price for his store.

Wholesaling your products eliminates most of the speculation, since you will know from the order exactly how many products to make and how much

you will be paid for them. This means you may be able to take advantage of large-volume discounts on materials, thus cutting your costs and increasing your profit even more. If you require a deposit or encourage advance payment (perhaps by offering an additional 2-5 percent discount or absorbing shipping costs), you will have some money up front for production, thus minimizing your own investment.

The wholesale discount offered to a merchant is generally around 50 percent of the anticipated retail price. In dollars and cents this means that if you calculate a retail price of $6.00 for a particular product, you should be prepared to offer it to a dealer for half that, or $3.00. And that $3.00 must adequately cover your production costs and profit, or you'll quickly work yourself right out of business!

Consider setting up your wholesale discount on a graduated scale that encourages larger-volume purchases. Thus, you might offer a $6.00 item at $3.50 apiece in lots of 25 or fewer; $3.25 apiece in lots of 26 to 50; $3.00 apiece in lots of 51-75; and for larger orders, $2.75 apiece. This is common practice in business, and retailers understand that manufacturers are likewise trying to take advantage of discounts from their suppliers. Do, however, require a substantial deposit—25 to 50 percent—on very large orders so that you won't be left holding the bag should the merchant try to back out of his commitment.

Consignment. Frequently, after you've made your presentation and discussed prices and discounts, an interested merchant will ask, "Do you ever leave your products on consignment?" We know photographers who reply, "No, but I have a guaranteed buy-back. I know they'll sell, but to set your mind at ease, I'll guarantee to buy back any that don't." That's one way to avoid consignment, but the result may be pretty much the same: You'll be stuck with any products that don't sell.

When a merchant accepts your products on consignment, he agrees to display them on a trial basis. In return, he will expect a commission on each sale. Consignment is certainly better than nothing, though it is, in fact, speculation: You bear the cost of making the display products and any backup stock, and you bear the loss if they don't sell.

The consignee has less vested interest in your products because they haven't tied up any of his money. This may result in less enthusiastic promotion, even though he certainly stands to gain if they do well. Consignment is a low-risk situation as far as he's concerned, which is probably why it's the most common way to retail crafts items these days, especially for beginners. Consignment-only shops seem to be proliferating, and, depending on the salability of your products, they can be a good or a bad deal.

They can be an especially bad deal if you involve yourself with one that charges a rental fee for display space. This increases your investment and your risk, even though the commission you have to pay will probably be much lower than on straight consignment. Try to avoid this sort of arrangement, at least until you have a pretty good idea of the salability of your products. We know photographers who pay $300 to $500 or more a year for display space in such shops, and still make several thousand dollars' profit. On the other hand, we've known some who didn't even recover their rental investment, let alone their production costs. As a beginner, your only option may be consignment, but

How to Create & Sell Photo Products

you still have considerable leeway in negotiating the deal.

Since a merchant is assuming less risk by handling products on consignment, it's reasonable to expect him to take a smaller share of the profit—a commission of 25 to 40 percent as opposed to a 50 percent wholesale discount. Reasonable, but not always realistic. You may have to go as high as that 50 percent figure for prime locations in tourist areas, where competition for shelf space is intense.

There are no hard-and-fast rules for handling financial arrangements. Each situation has to be resolved on its own merits though some sort of give-and-take with the merchant. Obviously, it's best to try for an outright purchase order involving a wholesale discount or, in lieu of that, consignment with profit percentages weighted in your favor. Before negotiating commissions, it's wise to do a little research among other craftspeople in your area. Find out what the going rates are before you make your approach. Still, the bottom line is this: If a merchant really wants what you have to offer, he'll give you the best deal he can. If he's lukewarm about the idea, you'll probably have to take what you can get or try elsewhere. The important thing is to get you products into the marketplace; if they do well, you'll be in a much stronger bargaining position the next time around.

DETERMINING YOUR RETAIL PRICES

The price you expect a retail customer—the person who walks in off the street and makes a purchase—to pay for your product is the basis of all your financial negotiations. Your wholesale discount is determined by your retail price, as are any commissions paid to consignees. The retail price you suggest may not, in fact, be the actual selling price in a store—that's up to the merchant who buys the products. But it must be realistic enough so that those products at that price are both competitive and profitable.

So how do you arrive at this all-important figure? Again, there are no hard and fast rules that work for every situation. The same item may carry a high price tag in one area and a low price tag in another for a variety of reasons, not the least of which is fixed overhead. The Gremlin is fat and sassy in Carmel, California; only a few miles away, in Monterey, he takes on a much more gaunt appearance. And the farther away from the coast one gets, the leaner he becomes. Retail prices reflect this fact. Similar situations will probably be found in your area.

Production costs will also vary from place to place. If you live in a high-rent area and have to pay premium prices for your materials, this will be reflected in your suggested retail price. The same will be true if you have to order most of your materials and end up paying postage and shipping charges.

Another factor in pricing is the item itself. You may end up with some products you can't even give away. On the other hand, if you come up with a real winner, you can increase your profit margin as much as the market will bear. Should you happen to find yourself in this fortunate situation, however, tread softly. The business world is littered with manufacturers who got too greedy, who wrote their own epitaphs by pricing themselves right out of their own market. Raise your prices slowly, and be ready to pull back the moment you notice any drop in sales. Consider the reasons for that drop; talk to your re-

tailers. It could be a reflection of the economy as a whole, or it could be that you went too far. In any event you'll have to make adjustments and learn from the lesson. In the final analysis it's not what you think people *should* pay that determines the retail price, but what they *will* pay. And only the marketplace can tell you that.

Still, you've got to come up with a ball-park figure to get the whole thing started, so let's develop some rule-of-thumb formulas. These guidelines will help you in the beginning, and you can made adjustments as soon as you have a better idea of how well your products are going to sell.

Low-cost items. For low-cost items such as cards, bookmarks, and key chains, first figure your production cost per item. This includes the cost of the photographs and any material needed for construction. Then double this cost to arrive at a preliminary figure for your wholesale price. The difference between your cost and the wholesale price will be your profit margin—the amount of money you and your business make on the sale of that item.

To determine if that amount is realistic, figure out how many of those items you can make in a regular workday, and then in a forty-hour week. If you arrive at what you consider to be a reasonable wage, then go with that wholesale price. If not, adjust that preliminary figure until you have the wage you want (only you can be the judge of how much is enough—some of us may be happy with $5 an hour and the freedom to be our own boss and do what we like; others would be dissatisfied with ten times that much).

Double your wholesale price to arrive at a suggested retail price. This figure should be comparable to similar items already in the marketplace—if such items exist.

As an example, suppose it costs you $1 to make a photo plaque. This might break down to $.50 for the wood blank, $.30 for the photo, and $.15 for the metal hanger. There will, of course, be some other expenses (paint or stain and varnish, rubber cement), but these are hard to prorate, so let's set $.05 as a cost figure to cover them. Doubling the cost would give you a preliminary wholesale price of $2, half of which would be your earnings.

Now, let's further suppose that you determine you could turn out twenty-five plaques a day. This gives you a wage of $25 a day, $125 a week, or $500 a month. Not too promising.

But you go ahead with your calculations anyway. Doubling your wholesale price gives you a suggested retail price of $4. At this point you go into the marketplace and find that similar plaques are selling for $6 to $8.

So you do a little adjusting of your preliminary figures and find that you could double your profit margin and still compete with the lowest-priced plaques. Your new wage would be $50 a day, $250 a week, or $1,000 a month. Suddenly things are looking a lot brighter! Actually, once you get your operation in gear and perfect your techniques, you'll probably find you can exceed that original twenty-five plaques per day estimate by quite a bit.

High-cost items. On higher-priced items such as clock or photo furniture, you should be prepared to take a smaller profit percentage-wise. Figure your profit margin at 50-75 percent of your cost (instead of 100 percent); otherwise, you're liable to price yourself right out of business. Again, if your products prove popular enough, or if you're doing them on a custom basis, you can always raise your prices.

In dollars and cents this works out for a clock as follows: If your cost is $14, add on $7 (50 percent of the cost) as your profit. You can then afford to offer it to a dealer at $21 for eventual resale at a recommended retail price of $42.

As before, determine if the profit is acceptable by computing your daily, then weekly wage, then make any necessary adjustments.

DISPLAYS—YOUR INVITATION TO BUY

How your products are displayed can directly affect the way they sell. Something hidden away in a dark, remote corner of a store can hardly be expected to do as well as it would in an eye-catching spot near the entry. There may be nothing you can do about the way your products are displayed by some retailers; others may give you a great deal of leeway or even require you to handle the whole matter yourself. The extent of your involvement with the actual merchandising will depend on the arrangement you have with the wholesale buyer or consignment seller.

Sometimes, however, you can exert considerable influence by simply offering to provide your own display materials. As shown in Illustration 9-1, these can range from adaptations of as common an item as a wicker basket to custom racks designed for specific products. Refer to Appendix F for construction techniques for these and other display materials.

There's another reason custom racks are a good idea: Many photo products—bookmarks, key chains, and unframed prints, to name a few—aren't

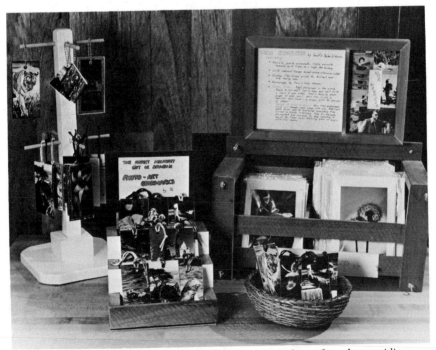

Illustration 9-1: *You can do yourself and your retailers a favor by providing display materials for difficult items like bookmarks or greeting cards. This can also give you more control over how your products are displayed.*

particularly suited to the standard display facilities found in many stores. A little help in solving this problem might be greatly appreciated by the retailer. Display materials can be loaned, rented, sold, or given away free of charge to your retailers. It's difficult to retain control of these items once they're out of your hands (some retailers might be tempted to use them for someone else's products)—a situation you can often avoid by including advertising of your products on the container.

On those occasions where you are responsible for designing your own displays (as might occur in the case of a marketing co-op—see Chapter 10), be sure to include some large eye-catching items that will draw people to your whole range of products. These "attention getters" can be large framed prints, clocks, mini-posters—whatever, as long as the photograph is dramatic. Then build the rest of your display around this center of interest, if possible keeping all products together and not scattered throughout the store.

ADVERTISING

Once your products are on display somewhere, you can undertake your own advertising campaign if you wish. We'll go into the subject in more detail in connection with custom products (Chapter 10) and mail order (Chapter 11), but two techniques can be especially useful in retail sales.

An added boost for your products. Your retailers will have regular promotional programs of their own, but their ads might not refer to your products specifically. In fact, the chances are that they won't. Most gift-shop advertising is pretty general. You can correct that problem by taking out some newspaper ads of your own, especially during peak buying periods such as the Christmas season.

Your retailers will often help foot the bill, since they stand to benefit from your ad as well. Talk the idea over with them. They can help you with the actual wording and also get you special rates because of their own bulk advertising arrangements. It's certainly worth a try.

An advertising "door opener." Generally speaking, there's no use advertising until your products are on display in a retail outlet. Ads directing people to come to your home to make their purchases probably won't be all that effective and in some cases could get you into trouble.

In the first place people are reluctant to go into the home of a total stranger on a matter of business. In the second place some communities have zoning laws that prohibit this kind of selling (see Chapter 12). So in most cases your products must be on public display before advertising will do you any good.

But as with any rule of thumb there are exceptions. A case in point: the ad intended to generate advance interest in a new product, to get people talking and inquiring at local shops as to its availability. Nothing makes a retailer more receptive to a new idea than the knowledge that it has already developed a market.

Such ads are common enough in the business world; you can usually spot them by such phrases as "Coming soon!" or "Be on the lookout for . . ." or "Ask your local dealer." If enough people ask, the local dealer will certainly follow through. On the other hand, if the ads fail to stir up the desired public re-

How to Create & Sell Photo Products

sponse, the dealer may be less than enthusiastic when the product does arrive on the scene.

Although advance ads are a gamble, they can be useful in situations where you're fighting stiff competition for shelf space. In such cases you might try the following approach:

Compose a newspaper advertisement for your products line, one that's big enough to attract attention. Since newspaper advertising rates vary widely according to circulation, you'll have to check locally for exact costs. In your ad, list in a prominent place the names of the retail outlets you hope will carry your products.

Before running the ad, show it to each merchant on your list and ask him to take your products on consignment. Chances are he won't turn down the free advertising. If he does, remove his name from the list. Place your products with the retailers who agree to participate, then run your ad. It could prove to be the door opener you need.

EVALUATING THE SUCCESS OF YOUR PRODUCTS

This process begins as soon as your products go on sale, but be careful not to overreact. As frequently happens, someone will buy something right away and your aspirations will soar. If a sunset clock sold, you'll be tempted to make a half dozen more, just be ready for the stampede that's sure to follow. Indeed, one of the easiest generalizations to make is: If one person liked it, others will, too. That may very well prove true, but exercise a little restraint nevertheless. Otherwise, you may end up with sixty-seven unsold sunset clocks!

It takes a certain amount of time to gather enough information to be able to make accurate sales projections. If a second sunset clock sells, replace it with another. That particular item may very well become a good seller, in which case you might wish to vary the theme: Try other sunsets on that product, or that sunset on other products.

How many different products you try will depend on the arrangements you have with your retailers. The same is true of variations on a single product. If a retailer allows you space for ten plaques, for example, put up ten *different* plaques and provide a backup for each. Keep track of sales from the word go. Increase your stock of items that sell and replace those that don't with new ideas. In this way you'll begin to develop a feel for the market.

Think small. A strong argument can be made for starting out with the smaller, less expensive items. In the first place they're generally easier to make, which means you minimize your investment in both time and money. Second, they have a wider market than do higher-priced products like clocks, and retailers may find their volume sales potential more appealing. And finally, you can afford to experiment with a greater variety of photos and products, which in turn leads to quicker results in terms of feedback.

Keep a running account of your sales. Learn to be hardhearted and objective. Be willing to drop products or photographs that don't sell, no matter how much *you* like them (although some products may pay their way in other locations, and some photos might do likewise through direct submission). In the business world it's what the *customer* likes that counts. Fortunately, more often than not your tastes will coincide.

Products into Profits

Number of products sold, June 1-June 30

Subject	Cards	Book-marks	Plaques	Prints
Calif. poppies	2	8	2	1
Fisherman's Wharf	1	1	2	0
Otters	8	5	1	1
Carmel sunset	3	8	1	0
Carmel Mission	0	3	0	0
Monarch butterfly	4	8	2	1
Lone cypress	5	10	4	0
Pelican	1	10	1	2
Sea lion	0	3	1	2

Above is an example of a partial account for one of our Monterey outlets.

A complete accounting would list everything that sold, since even the less popular items might suggest new approaches.

As previously mentioned, shops have their own personalities, and this often affects the kinds of people who come in to browse and eventually to buy. The above shop was located near a major hotel and convention center. We soon noticed that sales came in spurts—whenever a convention was in town. By studying sales receipts we also detected spurts within spurts. One day a person would buy four or five bookmarks or cards, and the next day several people would do the same. We could almost see the first conventioneer returning to the hotel with his purchases, spreading the word, and sales jumping the next day.

Of course, you won't always have access to such detailed information, but you can tell nearly as much just from observation. The sooner you can discern a reliable pattern, the sooner you can shift your operation into a higher gear.

Your sales breakdown will tell you where to increase production and where to cut back. For us, bookmarks did very well in that particular shop, especially those featuring poppies, sunsets, Monarch butterflies, the magnificent lone cypress, and—surprisingly—pelicans, which outsold otters. On greeting cards, however, the otters shone.

The Carmel Mission scored low, which isn't surprising. Conventioneers' minds are probably elsewhere. That subject would be more popular in a religion-oriented store. Fisherman's Wharf and the sea lion didn't fare well either. We thought they should have, since both are popular attractions, so we went back to our cameras to try some new approaches—a humorous sea lion shot and the wharf with anchored fishing boats captured at sunrise—which worked out very well. The pelican—a previous month's loser—had taught us a valuable lesson: Don't give up on a subject too soon. Maybe the problem isn't with the subject, but with the photography. Remember the pelican that "doesn't look like a pelican"? Another look at that subject gave us a bestseller.

Evaluate and reevaluate. Resist the temptation to make judgments based on insufficient data. The sales record of a single month may not give you enough information, especially in the beginning. Sometimes it takes several months for a product to "take off." Other times a product may start off with a bang and fizzle out just as fast. In the long run more than one surefire idea has

How to Create & Sell Photo Products

proved anything but. And the world is full of long shots that have come up winners. So be thorough and patient until a consistent pattern emerges. Then act.

If you have something that doesn't sell, try to determine what the problem is. Ask your retailers for their opinions; after all, they're right there on the scene and can observe their customers' reaction to your products firsthand.

Test . . . test . . . test. New ideas are critical to any business. And don't take time to sit back and bask in your own rosy glow if you come up with something that hits big. Why? Because imitators will flock, a fickle public will lose interest, or you yourself will lose momentum. As in the old game of dodgeball you played as a kid, you've got to keep moving. Success can spur you on, or it can make you complacent. And nothing stifles creativity better than smugness!

There will probably be a great deal of hit-or-miss in your early marketing efforts, but it's all part of the learning process, and eventually the feel will come. For every "marketing genius" there are thousands of us less mortals who have to acquire the knack the hard way. The better you understand your marketing area, the easier those early lessons will be.

SPECIAL MARKETING OPPORTUNITIES

There's more involved in seeing than just opening our eyes. We sometimes have to open our minds as well. Opportunity may knock, but all too often we open the wrong door. Or we open the right door the wrong way. Or we simply refuse to open a door at all because it faces the wrong way, and we're convinced that no real opportunity could come from that direction.

But behind that closed door there may be a special marketing opportunity. And sometimes, where none already exists, you can create your own. These special situations can become the core of your business, or they can be just a part of a much broader photo products enterprise.

COMMUNITIES WITHIN COMMUNITIES

For years we kept such a door closed—literally and figuratively—because of noise. The town in which we lived and taught lay directly in the flight path of one of the busiest air force bases in the world, and very few people would consider ear-shattering jet roar to be an opportunity in any way, shape, or form. It was an annoyance, to say the least, and we treated it as such, purchasing a home as far away as possible from those incessant comings and goings.

Then we got involved with photo products, and suddenly the knock of opportunity could be heard above the roar.

Where there is an air force base, there is an interest in aircraft—everything from antique to modern-day "warbirds," from factory-built recreational planes to handmade experimental designs, from hang gliders to hot-air balloons.

Seen from this angle, an air force base takes on a whole new perspective. Opportunity knocks. And an opened door leads to a special marketing situation for photo products. Items that feature aircraft and related subjects are bound to find a market in an air force town. And while your customers may be primarily military personnel, chances are you'll find many local citizens who share the same interest.

How can you reach this or any other military community? In a sense it will come to you. As a civilian you can market your special-interest items in the same places that handle your general-interest products. If they prove popular, they will attract a following by word of mouth—a following that, as with tourism, is subject to constant turnover. Thus, there is always a flow of new customers. And you'll also find that local retailers are keenly aware of this military market; they're always on the lookout for items that meet the needs of this special-interest group.

A person on active duty in any branch of the service will probably have an edge over a civilian in dealing with certain aspects of the military market. He may, for example, be able to design products of a more specific nature—photo clocks with unit insignias or custom prints of pilots or crews with their planes.

A word of caution, however: Whether you're a civilian or on active duty, be careful when photographing on or near a military installation. There are bound to be restrictions, so be sure you find out *exactly* what they are in relation to photography. Secure the necessary permission *before* you start to shoot. Even off base, when photographing private aircraft for commercial purposes, you must have written permission from the owner if the plane can be identified. This is true not only of aircraft but of any private property that is photographed in such a way that its ownership can be determined (see Chapter 12).

Military bases and other government installations such as power plants and scientific centers aren't the only communities within communities. Colleges and universities, convention centers, and camps of all kinds can have a similar impact, as can cultural or sporting events—anything that regularly attracts a large number of people. In this sense tourist attractions are also a special marketing situation, as are major geographical features such as mountains, which attract skiers or hikers, and large bodies of water, which draw boating enthusiasts.

You can develop a line of products for just about any specialized interest, such as sports-related products for sporting goods dealers: hunting, fishing, tennis, soccer, skiing, bicycling, ballooning (we know of at least one photographer who sells ballooning cards by mail order), motorcycling, auto racing—you name it.

The list can go on and on. Obviously, if there's only one sky diving enthusiast you couldn't expect to do well with a complete line of products featuring that subject—except perhaps on a custom basis.

On the other hand, don't overlook a golden opportunity just because a popular activity doesn't appeal to you personally. It's possible that if you took a little time to become involved, you might become as enthusiastic as the aficionados—especially if it proves productive financially! That's happened to us. We're always getting caught up in one thing or another. But that's one of the exciting aspects of photography: the people you meet and the great diversity of their activities. People are rarely dull when they're totally absorbed in what they're doing. And they're usually willing to bend over backward to help you get a good picture. We once had a total stranger paddle himself to near exhaustion to give us the perfect "ender." (See Illustration 10-1.)

Seeking out and exploiting the buying potential of special-interest groups is important to many businesses; and yours is no exception. So open your eyes to any special marketing situations that might be available in your area.

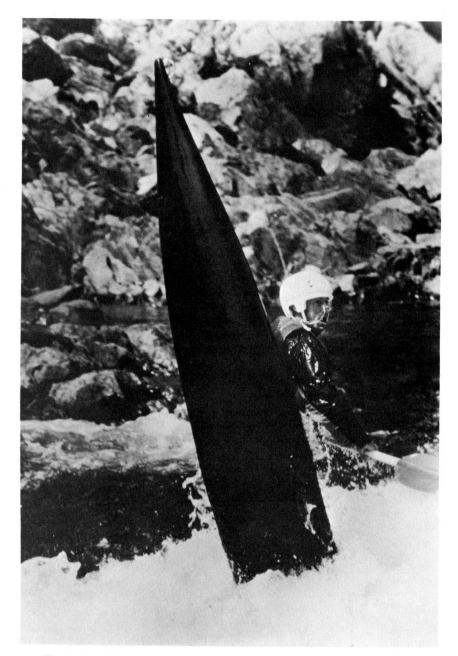

Illustration 10-1: *Involving yourself as an enthusiastic spectator can uncover hidden markets for your products as well as provide some spectacular shots. Such experts as the one shown here doing a kayaking maneuver called an ender can also advise you where to sell your photos, both as products and by direct submission.*

MARKETING COOPERATIVES

Cooperative marketing is another special opportunity that might exist or could be started in your area. Co-ops are usually formed when local artists and craftspeople pool their resources to open an outlet for their work. Although the specifics vary, each member generally shares in the costs of renting, preparing, and operating the shop. The contribution may be in the form of a flat membership fee, a percentage of each sale, time spent working as a sales clerk, or some combination thereof.

We belonged to a co-op that offered the following membership possibilities:

1. A membership fee based on the amount of space used for display. A $300 annual payment entitled the artist to a wall space approximately three feet wide and twelve feet high. In addition to the annual payment, the co-op charged a 25 percent commission on each sale and required the member to work (or pay someone else to work) one day a month in the store.

2. After the first year, if a member's work is selling well, he was offered the option of a 60-40 percent artist-gallery split on all sales. Under this option no in-store work was required, nor was there a yearly fee.

3. Straight consignment wherein the co-op received a 50 percent commission on all sales. This arrangement was for nonmember artists.

Under options one and two each member was responsible for setting up and stocking his own display. Under option three this was done by the two founding members. They also managed the store and handled the overall business operations, including advertising of the gallery in general.

Some cooperatives are established by local art leagues or similar organizations. We know of one such operation that charges a modest $5 yearly membership fee and a 25 percent commission on each sale. In spite of the fact that it exists in a tiny California coastal community of only a few hundred people, the business is very successful because of a steady tourist flow. With such reasonable membership requirements in exchange for such broad exposure, there's little risk for local artists. They can hardly afford not to join.

If there are co-ops in your area, check them out. If they are set up and managed properly, they can benefit all concerned. Choose a cooperative as you would any other marketing outlet, with an eye to the shop's location, its attractiveness, and its customer flow. If possible, talk to some of its members—their enthusiasm (or lack thereof) can tell you a lot.

Like everything else, marketing cooperatives can have their disadvantages. In order to avoid excessive internal competition, they often set membership limitations in each field. The ones in your area may already have their quota of photographers. This happened to us in one of our marketing areas, but the versatility of the Photo Products Alternative give us our "in." Our approach was different from that of the other photographers, who were selling primarily framed prints.

The lack of paid sales help can also be a problem. A good artist is not nec-

essarily a good salesperson, and the limited experience afforded by co-op duties doesn't do much to improve the situation. An artist's discomfort with the selling role may be conveyed to the customer, resulting in fewer sales. Others may be more interested in selling their own work than in promoting yours (an understandable point of view that you will probably share on your workdays).

If the membership or space rental fee is high, you may not recover your initial investment if your products don't sell. A $300 fee is fixed overhead; it must be paid regardless of sales. Unless you're quite sure of the appeal of your products, you would probably be better off going with straight consignment at first. When is a 50 percent share better than a 75 percent one? When the latter is eaten up by the Fixed Overhead Gremlin as a fat membership fee.

On the other hand, the high-fee, low-commission arrangement works in your favor for high-volume sales. Once you're sure your products can sell at a sufficiently high rate, you can always pursue a different option when contract renewal time rolls around.

Working a sales shift in a cooperative can also be an opportunity. It helps a great deal to actually observe the browsing and buying habits of customers and how they react to your display. You can learn firsthand how effective it is and make changes as necessary. You may also get actual customer comments on individual photos or products.

Cooperatives can also offer great market-testing opportunities if you have leeway when it comes to the kinds of products you offer. If your agreement is to market *only* photo clocks, for example, you could be stuck for the duration in a losing proposition if they don't sell in that particular store. On the other hand, if you can introduce other items until you find the most profitable combination, both you and the co-op stand to benefit. And even when sales are going well, it can be an excellent place to test new ideas in photographs or products.

Starting your own marketing cooperative. If no such operations exist in your area, and if there are some other interested artists and craftspeople, you might consider opening your own co-op. Since start-up and operating costs will be shared by a number of people, overhead won't be as formidable as if you were going it alone. Be forewarned, however, that group endeavors of this sort can present their own difficulties. (Remember that artists and craftspeople are notorious individualists.) You'll want to be sure of that vital cooperation before you become too involved.

For one thing you'll want to be certain that all partners will fulfill their obligations. Toward this end, all responsibilities of each and every member should be put into writing in some sort of contract or agreement. And you would be wise to consult a lawyer and any available small-business advisers. Many communities have volunteer groups of active or retired businesspersons who are only too happy to serve in this capacity, and you can usually locate them through your Chamber of Commerce. Check city, county, and federal government agency listings in your phone book to see if any provide this assistance, and also the Yellow Pages for any commercial firms specializing as consultants to small businesses.

A number of informative pamphlets and booklets on starting and operating small businesses are available from the federal government. Many of these can be found in your local library, or they can be ordered from the U.S. Small Business Administration, P.O. Box 15434, Fort Worth, TX 76119. Write for

How to Create & Sell Photo Products

their list of free management assistance publications.

One way to test interest in a project of this sort would be to visit artist or crafts groups in your area—clubs, classes, informal gatherings. Once you suggest the idea, one of these groups might take it on themselves. If not, you might still find enough interest to make the project worthwhile.

Other cooperative marketing ventures. Craft fairs and art shows are examples of cooperative marketing methods that do not require long-term commitments. They were mentioned earlier in connection with selling your prints as art, and they will be covered in more detail in Chapter 11 as a method of expanding your marketing area. Such shows can be held indoors or out and are a good way to test the cooperative marketing concept *before* opening a store.

Cooperation can also cut costs in direct mail advertising (see Chapter 11) or even in local newspaper ads. If other artists or craftspeople have their work in the same shop as you, put your heads together to write the ad, and your billfolds together to share the cost.

Some photo products themselves can become affordable through cooperation. The cost of producing a six- or twelve-photo calendar, for example, can be prohibitive for a beginner. If several photographers contribute photographs and share the cost, however, such a calendar can become a reality. Of course, it won't be exclusively yours, but the tradeoff might be the best (and perhaps the *only*) way to get over the high-cost hurdle. Cooperative groups of this kind have gone on to become some of the more prestigious photo buyers listed in *Photographer's Market* (see Chapter 13). With talent and shrewd marketing, you could very well do the same!

ESTABLISHING A CARD OR GIFT MAILING SERVICE

Essentially, there are three ways to sell a photo product. One is to place it in a store or gallery, where it speaks for itself. People see it, and when the right person comes along, a sale results. The second is more aggressive—calling attention to the product through advertising. This advertising can be directed at products available in stores or those you intend to sell by mail order. However, advertising costs money and so your expenses rise accordingly. A third way is to build a service around your product and then sell the service. In a sense this is what studio and advertising photographers do: Both offer a service that incorporates their product.

So far, the thrust of the Photo Products Alternative has been to *sell the photos you like to take*, to maximize your creative freedom within the limitations of the marketplace. Throughout this book we have referred to the "custom market"—situations where products could be developed to meet a customer's specific needs. Frequently, you can serve this market while retaining a degree of independence in your photography. How much independence is up to you. The custom market can lead toward photographing exclusively what other people want. You will have to decide whether or not this is for you and draw the line accordingly.

How to be of "service." There are ways to serve and still maintain your own independence. One such way, as mentioned above, is to build a service around one or more products.

As an example of what's possible along this line, let's take two simple and inexpensive photo products—greeting cards and bookmarks—and design a service business around them, one that can be conducted from the home with little capital investment or fixed overhead.

The first step? As always, look for a need to fill.

For this example, we need to look no farther than our mailbox. We all receive greeting cards or announcements not only from friends and relatives but also from numerous businesspeople. Insurance or real estate agents make it a practice to remember holidays, birthdays, anniversaries, and other special occasions with cards or notes. So do car dealers, shopkeepers, doctors, dentists, optometrists, lawyers, accountants—indeed, all manner of professionals involved in continuing business relationships.

These mailings require time—time spent to purchase cards, address and mail them, and so forth. And this is where you, as a photographer and a photo products manufacturer, come into the picture. You can sell your time and products, thus freeing your client to devote *his* time to more important aspects of his business. You can contract to provide a mailing service; for a fee you do your client's remembering for him.

Obviously, you don't have to be a photographer to establish such a service; there are plenty of commercially manufactured cards available. But if you make your own, you'll make more money, especially when customers desire custom products.

The idea of a gift mailing service certainly isn't new. The months preceding the Christmas season bring a proliferation of catalogs from a great variety of companies, all offering to send their products directly to the persons on your gift list. It's a solution to the shopping problem that many of us have used at one time or another.

Your own photo cards and bookmarks will, of necessity, cost your clients more than standard mass-produced cards (unless you reach the point where you can go into large-volume production yourself). This added cost can put your products at a disadvantage. Some people may not wish to pay the higher price, a fact that leaves you with two alternatives. You can only take on clients who wish to buy *your* cards, but to do so might restrict your business unnecessarily. Or you can include a selection of commercial cards, which you can obtain locally or, once your business becomes established, in volume from a wholesaler. Providing standard cards is probably the better choice, since some clients who start out buying the cheaper cards might switch to your line later on.

Your own photo products may cost more, but they can be tailored to suit the needs of your clients. They can feature his place of business, his products or services, his employees, his family, his hobbies or special interests, local historical or geographical sites—any number of subjects unavailable on over-the-counter cards.

Another advantage of your own line of cards over the standard ones (an advantage you should be quick to point out) is that your products are likely to be kept longer. Most greeting cards quickly find their way into the wastebasket. The thought is there . . . then gone. But your cards can become framed photographs that will keep the thought alive. And bookmarks will find contin-

ued use because they do something more than just deliver a message. The essential point is this: By investing in your product, the sender ensures that his thoughtfulness will be remembered. He will be sending a gift, not a throwaway.

The dollars and cents of a mailing service. How much money can you reasonably expect to make from such a service? That will depend on the number of accounts and the sort of arrangements in effect with each. Some individuals or businesses send out only a few cards each year; others may send out hundreds or even thousands.

For illustration, let's consider the moneymaking possibilities from one hypothetical customer, the Dub L. Indemnity Insurance Agency, which subscribes to your service. If Dub L. supplies you with a mailing list of 100 names, how much profit can you expect?

To begin with, you offer the following options:

1. Mailing service with commercial cards.
2. Mailing service with your photo cards or bookmarks.
3. Mailing service with cards or bookmarks that you develop exclusively from him.
4. Photo cards or bookmarks without the mailing service.
5. Custom cards or bookmarks without the mailing service.

The first option will probably include only cards, but any of the others could also include other appropriate products if the customer is interested. In this case key chains might be such an item, especially if Dub L. handles home or auto insurance.

Now let's consider the first option. If Dub L. chooses to send its customers commercial greeting cards, you need to charge them for the following: the cards themselves, stamps (first class postage adds an important personal touch), and your time. Of these the hardest to price will be your time—time spent buying cards, preparing them for mailing, and taking them to the post office.

The following system can help you price your time. First, decide on an hourly wage you think you should make for the kind of work you'll be doing. For the purposes of this illustration, let's choose a figure of $6 per hour. Let's further assume that you can address and stamp 30 cards in one hour. But that doesn't leave any time for shopping, mailing, or record keeping. So let's set aside a third of your time to take care of those jobs. You don't have to allow time for separate trips to the post office and the card shop on each order because these can often be combined. That leaves you with a productivity of 20 cards per hour, or a fee (or "mailing charge") of $6 per 20 cards, or $3 per 10 cards. Your expenses and fees for 10 cards could run as follows:

Mailing charge	$ 3.00
Cost of cards @ $.50 each	$ 5.00
Postage @ $.20 per card	$ 2.00
Total for 10 cards	$10.00

Inquire at card shops about a reduced price if you're buying cards in quantity. Always try to get the best deal. Eventually, you can buy your cards wholesale, which will further increase your profits.

Keep in mind, too, that these are guidelines only and should be adjusted to meet the needs of each individual community and to reflect such factors as inflation and cost of living.

After mailing Dub L.'s 100 cards, you'll have earned $30 for your work—not a large amount of money. But let's consider how the picture changes if they choose their cards from your line.

The only alteration you would make in your cost computations is the price of the cards. Say it costs you $.75 to make each of your cards ($.50 for the photo and $.25 for the paper and envelope), which you would sell to a retailer at a wholesale price of $1.25 to $1.50. By selling it to Dub L. for $1.75, you could pick up an extra $.25 to $.50 profit. Thus, the amount the company would pay for 10 cards is $17.50 plus the $3 mailing charge and $2 for postage, for a total of $22.50. This is the same price (or less) that they would pay for 10 similar cards from a retailer. From you, for that price, they'll get them mailed as well.

And now, instead of earning $30 for mailing 100 cards, you'll be earning $130. Of this, $30 is still for the mailing service; $100 is for your photography (each card makes you $1).

Now let's consider Dub L.'s third option—that of using custom photography. The two options involving custom photography will bring you the most income, since you can charge extra for your time as a photographer at a substantially higher rate than your time as a mailer. Again, we can provide some general guidelines, but you may have to make adjustments to fit your particular situation.

With the custom photography option, your basic charges should remain the same as when Dub L. chooses its cards from your line. That is, you would still earn $30 for mailing the cards and $100 for the production of the cards themselves. However, there would be two additional charges: (1) an hourly fee for the time spent doing the custom photography and (2) the actual expenses for the job.

Again, let's take an example. Suppose you spent approximately two hours doing the job at $25 per hour, for a total of $50. In addition, you used a roll of 36-exposure slide film at $12 (current retail price—not the discount price you should be paying—for the film and processing) and incurred $8 in automobile mileage and other miscellaneous expenses. You would then bill Dub L. for an additional $70. Your expenses and fees would then run as follows for the 100 cards:

Mailing charge	$ 30.00
Cost of cards @ $1.75	$175.00
Postage @ $.20	$ 20.00
Photographer's time @ $25 per hour	$ 50.00
Film, processing, and other expenses	$ 20.00
Total for 100 cards	$295.00

How to Create & Sell Photo Products

Of this total, $115 covers your cost for materials. The remaining $180 pays you for your time and talent in producing the photos and products. If Dub L. should want two cards (different ones, of course) sent—say for Christmas and a birthday—your profit would increase accordingly.

And unlike most direct submission sales this isn't a one-shot deal. Dub L.'s account offers continuous income which can go on year after year—as long as they're satisfied with your service.

That last point can't be stressed too strongly. Aim to please your clients and generate repeat business.

Increasing your income is simply a matter of increasing your number of clients. If one account earns you $100 a year, ten with similar arrangements will earn you $1,000. In practice some will bring you less, some more.

You may also notice a sort of snowball effect that is common in this type of business—if it is, in fact, meeting a legitimate need in your community. As word of the service spreads, clients might even seek you out. And there's always the very real possibility that people who receive your cards and gifts will like them enough to place orders themselves—for individual products or possibly even for the service itself.

How to get started. Once you've ironed out the kinks in your plan and figured costs and pricing, the next step is to drum up some business.

Personal selling is the best way to sell your service, since it allows the seller to answer objections and the buyer to see the product. This will be your eventual goal. First, however, you need to make contact to set up an appointment. This can be done by telephone or by direct mail advertising—sending out letters or circulars.

In direct mail advertising, be prepared to describe your service and spell out benefits to the client in detail. Also be prepared to talk about costs, but without mentioning specific prices (our service can cost as little as 10 cents a card. Only a dime! The price of the cards alone can vary that much from store to store!). The cost of the cards themselves will differ, depending on the kinds chosen; save that information for your personal selling.

If you opt for the direct mail approach, begin your letter with a proposition that will get the recipient's attention and dramatize the benefits your service offers, something that will start the reader thinking in positive terms. You want to ensure that your potential client will continue reading to the end. Conclude by making it easy for that person to get in touch with you. Include a phone number and a handy coupon or postpaid card to return for more information. You can make an even stronger approach by putting your direct mail message into one of your own cards.

The sample letter shown on page 214 is one possible way of making the initial contact.

Writing successful direct mail advertising is something of an art, one at which we do not claim to be experts. You can have the job done for you by an advertising agency, or if you decide to try it on your own, you might wish to read Bob Stone's *Successful Direct Marketing Methods* (Crain Books); it's been called the bible of the industry.

Whom do you mail your promotions to? Anyone in business can be considered a potential client. Businesses that count on repeat customers or have

[Your letterhead goes here.]

WANT TO SAVE TIME AND MONEY WHILE GENERATING
GOODWILL AND REPEAT BUSINESS?

If the answer is yes, we have an offer that will interest you.

Many businesspeople have discovered the value of the personalized touch--a note or card sent to special friends or customers throughout the year. Whether the greeting commemorates a birthday, an anniversary, a holiday, or some other event, it shows your consideration...that you remembered. A greeting card is one of the most inexpensive and convenient ways of expressing appreciation and cementing good relationships.

Our mailing service can make this even more inexpensive and convenient. We'll do your remembering for you. Our prices are reasonable and may actually save you money by freeing your personnel to concentrate on more pressing matters.

Consider the benefits:

* No more time lost shopping for cards.
* No more time wasted addressing, stamping, and mailing.
* No more trying to keep important dates straight.
* No more forgetting birthdays, anniversaries, etc.

We'll do your remembering for you. We guarantee it!

We offer a wide variety of cards from which to choose, including our own. As professional photographers, we can create custom cards or other products especially for you. For further details simply return the enclosed postcard or call [your phone number]. We'll be happy to arrange an appointment at your convenience.

Illustration 10-2: *A sample direct mail letter to prospective clients.*

regular clientele are especially good bets. Refer to the beginning of this section for a listing of some of the better prospects.

Your best resource is your phone book, and you can also check with the local Chamber of Commerce for any mailing lists they might have (there is frequently a charge for these lists; see Chapter 11).

And don't overlook individuals who may wish to make use of such a mailing service. Among the growing number of working couples and single persons whose jobs or family commitments are overwhelming, there are surely some who would be interested in your service. Reaching them, however, will require a different approach. You might consider posting advertising fliers in grocery stores, hairstyling establishments, or anywhere that community bulletin boards are handy. In the beginning take your accounts wherever you can get them; you can be more selective later on if you wish.

As with any other approach to selling your products, be prepared for "No, not interested." Anyone who has ever worked in a store knows that for every hundred people passing through, only a handful will actually buy anything. It may be necessary to send out two dozen letters or more just to get one interested reply. Accept that as a fact of business life and send out two dozen more to get a second nibble. As you build a clientele, you can ask them for referrals. Do whatever you must to increase your accounts. Incidentally, you don't have to restrict your mailings to your hometown and neighboring communities. Solicit business as far afield as you choose. Remember, however, that eventually you will have to meet your prospective clients face to face in order to make your presentations.

Selling yourself and your service. The sales letter will be only the first step in getting clients. You'll need to follow up in person with a selection of sample cards and products, plus specific pricing information.

For your samples you'll need some sort of portfolio. An inexpensive loose-leaf photo album would be a good choice for flat items such as cards and bookmarks. You might also wish to carry a briefcase (one that your photo album will fit into) if you intend to include any other products such as key chains or plaques. Choose an assortment of cards or bookmarks that will fit a variety of occasions and display them in your sample album in such a way that both the front picture and any inside or back message are visible. List the price beneath each product and give each a code number to avoid confusion. You may think you'll remember which item a customer chooses, but don't count on it. A code number is quicker and more reliable than a scribbled description.

Your album should also include a pricing sheet. It's a good idea to have some copies printed so that you can leave one with each customer (this sheet will also have your name and address on it). The sheet should show customers the cost of each type of card or product under the various options and in specified quantities (25, 50, 100, 150, etc.). It should also include the costs of postage and mailing.

If you plan to include any standard commercial cards, choose a total of 10-20 cards, suited to a variety of occasions. Try to avoid extremes—too religious, too cute, too risque—and include some things for both masculine and feminine tastes. You might be able to arrange for free samples, or at least a cut-rate price, from a local card shop, if you explain what you're doing and agree to make future purchases from them.

Also buy a large appointment calendar. Those sold in book form might be best so that your records won't accidentally get torn off and thrown away. On it, keep a record of names and dates specified by your clients. Addresses may be kept in a separate file. Check your calendar daily and remember to allow for postal transit time if an item is to arrive on a designated day, and to allow extra time if it's to be sent out of town or during peak mailing periods such as holidays.

Make an appointment with each prospective client. Take along your sample album and explain how your service works and the costs involved; then allow him to make his selections. Secure his mailing list and be sure that all arrangements are fully understood. Don't forget to determine if your client wants to sign the cards himself or if he'd rather have you do it. And if you're to do it, get the specifics: his name or the firm's. Or he may wish to have them imprinted, so you should be prepared to quote any additional costs involved. You might even wish to spell everything out in a simple contract, which both of you can sign, so that there will be no misunderstandings.

Once you have a commitment from a client, you're in business. How you handle payment is up to you. It's best to collect the entire fee in advance so that you have no out-of-pocket expenses. This could be for a single mailing, say Christmas, or it could be for a whole year's mailings of birthdays and special occasions. If a client seems uncertain about the idea, or would like to try it for a while before making the entire payment, you might suggest a quarterly arrangement. Payment would be divided into four installments, the first due on signing the contract, the others to be billed quarterly. If, for some reason, he no longer wished to continue the service beyond the end of the first quarter, he could cancel at that time and owe nothing more.

As with any other aspect of your business, keep complete and accurate records right from the start (see Chapter 12). It will be very easy for confusion to set in as your number of accounts grows. Remember, too, that your business will be subject to taxes and possibly business licenses. Chapter 12 deals with these subjects as well.

A mailing service is only one kind of photo products service; there are plenty of others that could be better suited to you or your particular situation. For example, you might consider starting a photo-decor rental business in which you rent photo products or artwork (yours or those of other artists as well) to businesses or individuals. Or start a gift service where you visit the homes of shut-ins or other people who find it difficult to do their own shopping, and offer them a selection of photo products they can purchase and have mailed for them. Or consider becoming an art show promoter. This will supply you with a continuing display opportunity for your own work as well as offer a service to other artists in your community. Mind you, this is not a free service you offer them, but one they will pay for through set fees or a commission.

The possibilities for establishing a photo products service are numerous. The key is to find a need and then exploit it.

THE CUSTOM PRODUCTS MARKET

All of the photo products described in preceding chapters lend themselves

to the custom market—any of them can be made to order. The main advantage of this sort of arrangement is that, in effect, you sell the product before you make it. Speculation is minimized. In some cases—postcards, for example—you don't invest a cent until you know you have a sale. In others your investment stops with a set of sample products.

A disadvantage is that you'll end up photographing what you're *paid* to, instead of what you *want* to. On the other hand, you may find that you enjoy doing the type of photography a particular customer wants, and you can enjoy the best of both worlds.

In working with custom products your role will be much like that of the studio or service photographer, with an essential difference: your product advantage. Unlike most service photographers, you can offer not only prints but a full range of other photo specialities: plaques, cards, calendars, clocks, key chains—whatever products you've chosen to develop. Again the versatility of the Photo Products Alternative works in your favor, only this time the products are exclusive, made to order.

So how does a beginner crack this market?

One route is through wholesale and retail sales (covered in Chapter 9). Not only will your sales contacts put you in touch with potential custom clients, but they will also give your products visibility. Advertising custom photo services in any of the common media (newspapers, shopping guides, business directories) does little good unless your products are on public display. As pointed out earlier, people are often reluctant to come into your home to look at your work, unless local zoning laws permit converting a portion of the residence into a retail store.

Have slides, will travel. Linking your products to a specific service and then selling that service is another way to reach the custom market. A variation of this approach is the direct presentation to groups whose members might be interested in your services.

Although it may seem more difficult until you develop the knack, going out and talking to groups of people is usually more effective than impersonal media advertising, especially when your products aren't on display anywhere. Potential customers have a chance to see firsthand exactly what they're buying, and you can vary your presentations to zero in on specific markets. Furthermore, making your presentation in the form of a slide show enables you to display the range of your photographic abilities much better than a retail display ever would.

There's another advantage to the personal presentation—one with even greater potential. Businesspeople are generally active in local clubs and organizations, often for the same reason you are: to gain visibility. Thus, the contacts you make can lead to other opportunities.

Where do you start? Most communities have no shortage of special-interest clubs and organizations. Perhaps you belong to one or even several. If so, you know that program chairpeople are often on the lookout (sometimes desperately!) for someone to entertain or educate their groups. This task isn't made any easier by the fact that rarely are such groups willing or able to pay for their programs. No matter. Let it be known that you're like television: willing to entertain if you can intersperse a few commercials along the way.

Let's suppose that your slide collection includes a large number of wildlife shots. Put together a twenty-minute-to-half-hour program of your best work. That needn't require very many slides when you consider the time given to narration and "commercials." Then contact groups that might be interested, such as fish and game clubs, hiking or camping groups, conservation societies, and youth organizations like the Girl or Boy Scouts. Before you give your presentation, make a set of sample products geared to your audience. Also have some business cards or promotional material available to pass out.

If you don't actually make any sales the first time, don't give up. The next presentation could be profitable, and each one increases your visibility. Pass your business cards out freely. When someone in your audience needs a photographer that does the kind of work you do, you want to be the person he'll contact.

The slide show is a low-key approach to selling yourself and your work. With a little practice your "commercials" can become such an integral part of your program that they won't seem like selling at all. It's even possible that your programs will become polished enough that you can demand and get a fee. Many photographers support themselves very well with just such traveling road shows. In this case your program becomes your product. And if you love to travel, this may be the perfect photo product for you.

Photo seminars. If appearing before groups sounds appealing, you might also consider conducting free seminars in photo techniques. An accomplished flower photographer, for example, might share his expertise with the members of a local garden club. And while he's at it, he will of course make them aware of the products and services he has to offer.

Not all seminar members will have cameras, and those who do might not be especially proficient. So a seminar of this sort can lead to jobs photographing gardens, homes, families, etc. Even when your work hangs in private homes, it can enhance your reputation and your visibility. Word of mouth is a powerful force in advertising. "Hey, I like that! Where can I get one?"—music to the ears and money in the pocket.

Products with someone else's photo. "Hey, I like that! Can you make one with *my* photo?" This response can also mean money in your pocket, even though it doesn't involve *your* photography. And because you're not taking the pictures, you may wish to reply with a polite no.

But putting other people's photos on custom products is a way of earning extra money, and it may be important in the beginning. It's also a way to hone your construction skills while turning a profit.

You can pursue this sort of custom service by taking your presentations to local camera clubs or by advertising in the newsletters of other sorts of clubs and organizations. Almost every group is bound to have photographers among its membership.

You might also talk to the owner or manager of the local camera store. Explain your service and ask if you could hang a sample display. Depending on your relationship or how much business you do with him, he might let you hang your display free. If not, offer him a piece of the action. Yours is a service he can sell for a nominal commission, say 5 to 10 percent of the price. And remember that this kind of display, too, can give you valuable exposure for your own work.

How to Create & Sell Photo Products

CUSTOM PHOTO PRODUCTS ARE GOOD BUSINESS

Chapter 7 covered the role of photography in office and showroom decor—an application that certainly overlaps the custom market. But, as shown earlier in this chapter, photo products have far more to offer the business community than decoration: They can become very effective sales tools in a variety of ways. They can generate goodwill, present merchandise at its most appealing, and keep a business name before its customers. The use of photo products can put money into a businessperson's pocket, and being in a position to supply those needs can be an important business opportunity for you.

Many of the products already described can be adapted in one way or another to serve the needs of the business community. In many cases we've included specific suggestions; in others, commercial applications may be less readily apparent. Clocks and prints, for example, can be used not only as wall decor but to brighten up a dull window display. And with the name of the business added, these products can become business signs.

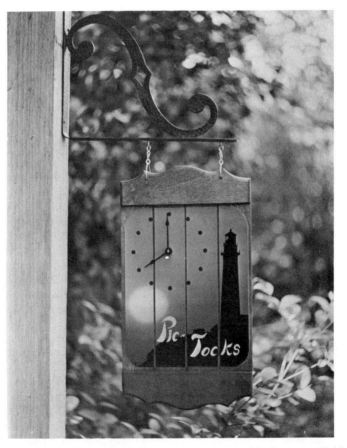

Illustration 10-3: *A photo business sign. Wooden sign blanks are available in many shapes and sizes from suppliers (see Appendix A), or you can make your own.*

Wooden sign blanks are available in many sizes and designs from suppliers, or you can make your own. Lettering can be done directly on the photograph in paint or ink, freehand or with stencils, or stick-on letters may be used. The sign may also be designed so that the lettering goes beside or under the photograph, in which case the logo could be routed or burned into the wood. After the lettering has been added, the sign can be covered with a protective coat of liquid plastic for indoor use or polyurethane varnish for outdoor use. An alternative for either indoor or outdoor use is to laminate the photograph and accompanying logo between sheets of acrylic.

Cards, calendars, bookmarks, and key chains—to name but a few possibilities—can serve not only promotional but practical purposes, and in the process can earn the sender a customer's goodwill.

Local businesspeople might be approached with ideas for photo products that will do the following:

1. Illustrate the merchandise they make or sell, the services they offer, or their physical plant itself, for promotional or educational purposes or as a benefit to the customer.

2. Feature dramatic scenes or subject matter which, when displayed in their shop windows, will attract the attention of passersby.

3. Serve a useful function within the business itself.

4. Capture their hobbies or interests for office decor.

5. Fulfill a merchant's need for a particular product that he feels can be resold at a profit.

Let's examine each of these possibilities in a little more detail.

Products that inform or benefit the customer. Photo products in this category serve three functions: (1) advertising—presenting a product and encouraging people to buy it; (2) education—acquainting people with the company itself or with up-to-date information on existing products or services; or (3) simply providing material useful or beneficial to customers or the public as a whole.

Frequently, a single photo product can perform more than one of these functions. Take the postcard, for example. Hotels and motels are but two of many types of businesses that offer free postcards (or similar handouts) to their customers. The benefit to the customer lies in the fact that he has a "wish you were here" item that he can send to the folks back home or to business associates for only the cost of the stamp. Everyone likes to get something for nothing, so the hostelry generates a little goodwill and maybe gains a repeat customer. Not to mention some good advertising, since the picture on that free card is usually of the hotel or motel itself. And who's to say when the recipients of the cards will be struck by the urge to travel?

Providing those custom commercial postcards is something you can do very easily. As indicated in Chapter 3, you can charge for the actual photography and also collect a commission on each sale from the postcard manufacturer.

That same manufacturer can supply you with other photo products that serve similar functions, including double-size and panorama postcards, photo business cards, letterheads and envelopes, Christmas cards, calendars in all sizes and price ranges, brochures, catalog sheets, catalogs, menu covers, and even framable prints in large quantities. A request for a sample kit may bring you many other product ideas as well.

You, of course, must make the sale and do the necessary photography. The manufacturers are happy to offer suggestions along both lines. Gather your sample materials and price quotes from as many sources as you can (see Appendix A).

Besides the usual tourist-oriented businesses, numerous other possible markets for postcards were listed in Chapter 3. Many of these are promising for other products, too. Business cards, letterheads, and envelopes, for example, are practically necessities in today's business world. Photo versions will be more expensive than plainer kinds, but the added cost can sometimes be justified from an advertising point of view. The right photograph can indeed be "worth a thousand words," and each card or letter becomes an advertisement in itself. Furthermore, an envelope with an eye-catching picture might keep prospective clients or customers from tossing it into the wastebasket as just another piece of junk mail.

Illustration 10-4: *Photo products can serve a great variety of functions in the business world. Many such products can be turned out by your local job printer, or if color is desired, by custom postcard manufacturers.*

And what's inside could be a brochure or catalog sheet—also items that you can supply through the postcard manufacturer. Many will prepare full-size sketches of such advertisements for your customer at no extra charge. Just send the manufacturer your photographs and your customer's advertising copy. That way your client will have a good idea of what the finished product will look like.

Tourist attractions and recreational areas abound with potential brochure customers. Visit these areas and look for materials that are outdated, as evidenced by old cars, out-of-fashion clothing, etc. When you find brochures that could be improved upon, contact the appropriate concessionaire or manager. Perhaps he's looking for someone to do that job for him; and even if he hasn't been looking, he may hire you once the need is pointed out. If not, give him your business card for future reference—he might just change his mind. There's a lot of competition for the tourist dollar and everyone in the industry wants to keep their business looking as attractive as possible.

In new or developing areas you might find a wide-open field. Be on the lookout for business construction. As soon as a new hotel, motel, resort, or whatever goes up, make contact and explain your services. The sooner the better, even before the ground is broken if possible. Get there before someone else does.

And while you're at it, talk to builders, contractors, architects, and anyone else directly involved. It's entirely possible they could use your services as well. Get permission to photograph the job site, and while you're there use the opportunity to build up a stock photo file on the construction trades. There are certainly plenty of markets for such photographs (see Chapter 13 for guidelines in locating these and other direct submission markets).

Always be aware of your full range of options. One thing will lead to another . . . and another . . . and another.

Suppose that while prowling around a construction site, you get a super shot of a particular piece of heavy equipment—a bulldozer, for example. Let's further assume that this picture shows no identifiable person or business name other than the manufacturer of the bulldozer. You take the photo to the nearest bulldozer dealer and he buys a large print for office or showroom decor. He might even be interested in using it in his local advertising campaign. Through your job printer or a postcard manufacturer, you can supply him with magazine ad inserts, sales sheets, catalog inserts, mail stuffers, calendars, and a host of other items. He might even order some of your own products, such as mini-calendars or key chains to use as advertising-goodwill handouts.

From him you obtain the address of the bulldozer manufacturer. A query there might result in the use of your photo in its nationwide advertising or for a cover of its annual report. Many large industries publish their own periodicals for distribution to dealers and customers. Your photograph could end up in such a magazine, opening the door to future submissions and possibly even an assignment.

And the bulldozer is only the beginning. The wood used in the construction project was produced by a company, as were the steel girders and so on. Follow up those possible markets. There are thousands of industrial publica-

How to Create & Sell Photo Products

tions printed in the United States, and there's a great demand for photographs that show products or services in action.

Which products and services? Consult *Photographer's Market* or the *Gebbie House Magazine Directory* (see Appendix B) for listings of companies that issue their own publications. If you're interested in expanding your photography in this direction, these two references will give you some idea of where to concentrate.

Although the details may vary, such a chain of events can happen. Opportunities snowball; they aren't isolated "bolts from the blue," but natural sequences set in motion by photographers in the know—photographers who take advantage of their marketing options. When it comes to promotional products, postcards are just the tip of the iceberg!

Window displays. Earlier we stressed the importance of drawing attention to you own photo products displays. In this you have an advantage over most businesspeople: Photography can have a tremendous visual impact! When you want to attract attention, you can. It's as simple as that. Because of the nature of your business, you can be as dramatic as you wish.

Frankly, a lot of products in today's marketplace aren't all that exciting. Necessary maybe, but dull, dull, dull in a store window. A shoe is a shoe is a shoe except for subtle differences in design, construction, and price. There they sit, looking like . . . shoes.

A lot of products and services fall into the same category, and the people who sell or perform them are sometimes hard put to distinguish themselves from the competition. All of this translates to another opportunity for you. Through your photography and products, you have a means of attracting attention to your client, no matter what product or service he's selling.

Turn your unconscious idea generator loose (see Chapter 8), and you can come up with dozens of ways to give any product or service an image that is exciting, offbeat, or humorous—in short, attention getting.

Or just let a shoe be a shoe but provide spectacular scenic or other dramatic shots that may have nothing whatever to do with the product or service itself. This isn't a new idea by any means. Cigarette and beer manufacturers have been selling "image" for years. You can do it, too, on a local scale. The important thing is to get people to stop, and when they do they'll see what your client has to offer.

Perhaps you could even develop a sort of "Rent Some Attention" service in your marketing area. Instead of selling your photography, you rent it, thus making it more affordable to your clients.

Keep an eye open for special situations. Suppose some of the jewelers in your community clear their windows at night because of the risk of burglary. A few dramatic prints of their specialities, properly lighted, would attract evening strollers and eliminate the vacant look. Indeed, a strong argument could be made that the photos would be more eye-catching than the actual items during the daytime as well.

Other functional photo products. Some items that fall into this category were mentioned earlier in connection with advertising—letterheads and envelopes and business cards, for example. Another product along this line, one that you can also provide through the custom postcard manufacturer (or

job printer), is the cover for a restaurant menu. Photos of the establishment itself, delicious-looking food specialities, or area scenic or historical attractions (or anything the owner wishes) would work well for such covers. And that's just a start. You can also supply place mats and coasters on the same theme, "table tents" (those little placecards on individual tables that illustrate food specialities), postcards, matchbooks (pick up some samples and contact the manufacturer for details), even custom ceramic mugs and plates. Not to mention photo cloth aprons for waitresses.

The next time you're in a restaurant, program your unconscious idea generator. See how many photo products you can come up with for that particular situation. Do the same for other businesses as well. Many of the items listed above (and others such as calendars and desk pen sets) can be adapted for use by a variety of businesses.

Custom decor. This particular aspect of the Photo Products Alternative was covered in detail in Chapter 7. Whenever you're photographing, think of custom decor possibilities. If you're working with flowers, consider who else might be interested—the owner of a flower shop or a garden-style restaurant, for example. Locate them through the Yellow Pages or a business directory and make an appointment to show them the kind of work you do.

When you're photographing an event, find out not only who's participating but who the sponsors are. Then make a list of other businesses or individuals who might be involved or interested. This list might include manufacturers whose products are being used or local dealers who sell those products. (Be sure to check Chapter 12 for information concerning legal ramifications such as permissions and model releases.)

Work these events for all they're worth. And include on your list any magazines or other publications that feature the kinds of photos you'll be taking, or in which you might advertise your decor items or related products (see Chapter 11). The photo decor market extends far beyond your own immediate area.

Custom products for retail sale. Again, this subject was treated earlier (remember our courthouse photos?), so only a few additional points need be made.

You can photograph any subject a merchant desires and put it on any of your products. In other words, you can give him exactly what he wants or needs. However, the result may not be what anyone else wants or needs . . . including his customers. After all, he's not infallible when it comes to judging what will or won't sell; the idea is to keep *his* mistake from hurting *you*.

For this reason it's wise to handle custom orders of this sort only on a wholesale basis. Do the photography, make the products, and sell them to him at you dealer discount. If you have other products on consignment with him, he may suggest continuing this arrangement for custom products. This may seem reasonable and logical from his point of view but not from yours. Insist on wholesale; that way if he misjudges the item's salabilty, you won't be stuck with products you can't place anywhere else.

There are some possible exceptions to this rule. You might want to run the risk if it's a matter of getting your foot in the door. If his suggested product does well, he may be more agreeable to handling the rest, or at least part, of your

line. Consignment might also be a better arrangement if you see the product as one you could sell in a variety of outlets, not just his. In such cases you'll have to decide what's best. But unless you've got a firm commitment to buy, it's smart not to go into production too enthusiastically.

Also consider the possibility of selling a product idea to a number of merchants. If you live in a region that has several communities with common interests, such as a ski area, you might find some merchants in each community who will share the cost of more expensive items like calendars or tourist booklets featuring photos and information about the area. Be certain, however, that each participant understands that he won't be getting an exclusive product. The cost to each individual would depend on the size of his order and on whether or not he wanted exclusive marketing rights in his community—for this, he should expect to pay more.

There are many possible products and approaches that will fit the custom market; this chapter has done little more than scratch the surface of the varied and lucrative custom market. As with most things, it's the person who comes up with something new (or a new variation on an old theme) who stands to gain the most.

Some photographers have taken the old key chain "peep show" viewer idea and turned it into an inexpensive but highly profitable custom product. They spend their weekends at the golf course or other sports activities sites— indeed, anywhere that draws a crowd—snapping shots and taking orders for transparencies mounted in plastic key-chain viewers. Proponents of this relatively simple enterprise claim net profits of several hundred dollars a day, and as much as $50,000 a year!

Maybe this kind of thing will work for you, maybe not. Certainly there are photo products available to suit just about anyone's taste, and vanity is one of the oldest and strongest motivators when it comes to buying.

Chapter 11

EXPANDING YOUR MARKETING AREA

Venturing into deeper water has its problems. For this reason some photographers may be content to just get their feet wet, to limit their marketing, their headaches, and their income, especially if personal satisfaction is more important than money. Although the financial rewards vary, selling through a single outlet will rarely provide a livable income. It's not unreasonable to expect $500 worth of sales during a peak month, but it's more realistic to think in terms of $100 to $200 as a working average, at least in the beginning. Of course, as you acquire a feel for what sells best and make the necessary adjustments in your inventory, your income will rise accordingly.

Developing this feel is very important in order to avoid the dangers of expansion. Before you increase production, you must have an accurate idea of the salability of your products. This means you've thoroughly market-tested them. If you know what appeals to people in your area, you can move successfully into other areas.

Making more money in photo products is a matter of simple mathematics. If your first outlet earns you an average of $200 a month, ten similar outlets should bring you ten times as much, or $2,000. Increasing to twenty-five stores or shops should raise your monthly income to $5,000, and so on. Since you can go as far afield as you wish in locating outlets, the practical limit to your earning power is your production capacity.

In actual practice it's not quite *that* simple, of course. Sales are influenced by any number of factors, including the number of items on display, the store's percentage, the time of the year, the location of the outlet, the prominence of the product display, and customer tastes, to name a few. Thus your profits may be high in one place and minimal in another.

As observed earlier, marketing outlets have their own personalities and, as a result, attract particular kinds of customers. Learning to match products with personalities is part of getting a feel for the marketplace.

How to Create & Sell Photo Products

BECOME YOUR OWN TRAVELING SALESMAN

Go with success. When you have an item that does well, look for similar shops or stores in which to place it. This doesn't mean that you should abandon everything else, only that you should concentrate on your strengths.

When you've exhausted the suitable outlets in your own community, try neighboring towns and cities. Make a sample case as shown in Illustration 11-1. A suitcase will work fine for this purpose. It's a good idea to put the smaller products in individual plastic bags and use pieces of polyurethane foam for padding. Keep the number of samples limited to a few of your very best in each category. Carrying along too many becomes a hassle, and you may start coming up with very logical excuses for leaving everything at home. At that point you cease to be your own best salesperson.

Every time you go out on a photo safari (or anyplace, for that matter), be sure to take your sample case. You can never tell when you'll come across a marketing opportunity. Schedule some browsing time in your travels or go out for the express purpose of seeking new outlets—whichever works best for you. With each new prospect follow the same procedures as you did in your initial market research.

Using this method, you can expand as far as you wish. There's no reason an Iowa photographer, for example, can't seek out and exploit markets

Illustration 11-1: *Although you can carry your samples in cardboard boxes, fitting out an old suitcase is more convenient and professional looking. Use pieces of polyurethane foam for padding. It's a good idea to put samples into individual plastic bags for added protection.*

throughout his home state and beyond. The Photo Products Alternative has no geographical limits. If those subzero winters get him down, our Iowa photographer can head for Florida with camera and samples in hand and take time off from basking in the sun to scout out markets and possible distributors. He can develop a line of Florida products. Or Texas products. Or Colorado products. The opportunites will be waiting. The Photo Products Alternative can be adapted to any area, no matter how stiff the competition!

Grab your camera and see the world while promoting and expanding your photo products business. And there are tax benefits as well, as shown in Chapter 12.

CRAFTS FAIRS AND ART SHOWS

The number of people involved in selling through crafts fairs and art shows increases dramatically each year. Rare is the place where there aren't several such shows within easy reach, most of them during late spring, summer, and early fall.

Indeed, a sort of subculture has evolved; the same exhibitors see each other in show after show, driving from one to another in campers or vans. Between shows, they work on building up their stock. We know one artist who spends most of his time in the mountains with his dog, coming down only for the show season.

For many, fairs and shows are the primary sales outlets for their products. Certainly, there is great potential in this kind of marketing if you enjoy people and being on the move. Others use the fair circuit to supplement their income from more conventional retail sales. An example of the latter is a San Francisco photographer who operates a small gallery and still finds time to attend fairs as far away as Kansas (he was surprised to find that his sales were even better there than in his home state).

If you don't wish to actually participate in a show, it's sometimes possible to locate an exhibitor who will display your work along with his own. These arrangements usually involve a commission on each sale.

There are shows based on two kinds of entry requirements. At *open shows* any artist or craftsperson is welcome as long as there is sufficient space for his display and he is agreeable to whatever financial arrangements are involved. The more popular open shows operate on a first-come, first-served basis. Some fairs will start out open, hoping to attract as many exhibitors and buyers as possible. If they catch on and too many artists show interest, the fairs may then set up screening panels.

Access to *juried shows* is determined by judging panels, who seek to ensure the quality of the merchandise. Some juried shows also give out awards for outstanding work in the various fields.

Crafts and art shows either charge a flat fee ($10 to $50, or even more, depending on such factors as the show's duration and popularity) or take a percentage of the participant's gross receipts, or both. Generally, the exhibitor is responsible for creating his own display, including whatever tables, display racks, etc., are necessary.

Shows and fairs can also be good places to make contact with buyers for stores, distributors, and sales representatives. In fact, some schedule "whole-

sale days" when attendance is restricted to such buyers, who shop and place orders for later delivery. If you participate in a show with this arrangement, be sure you determine in advance your wholesale prices, minimum orders, terms, and length of time it would take you to make up an order (say one hundred items) so you can figure delivery times.

Also be sure you have business cards and price lists (a brochure with black-and-white photos if possible) for interested people. Make an effort to record the customer's name and address every time you make a sale, or have a sign-up sheet available—this is a good way of compiling your own mailing list for mail-order marketing.

Locating fairs. If the idea of crafts fairs sounds appealing to you, check crafts magazines for listings of events—some may be in your area. Another excellent source of listings on the national level is the *National Directory of Shops/Galleries/Shows/Fairs* (see Appendix B). This annual reference lists more than 2,000 outlets for showing and selling your work. Local art or crafts stores, groups, or marketing cooperatives can also be sources of such information, as can arts and crafts departments of schools, YMCAs and YWCAs, seniors' groups, and even the newspaper. A letter to your state arts council can result in information about nearby fairs that will give you an idea of the activity in your area.

Picking the right fairs for you. Once you've located the fairs in your area, pay a visit to them. Talk to the exhibitors; you'll find most of them quite friendly and ready to help, especially if you pick times when business is slow. Ask them about costs, financial arrangments, and their opinions on the best fairs to enter. They might also be able to put you in touch with the editors of newsletters devoted to the subject. Get as much information as you can to help you decide if this method of marketing is for you.

DISTRIBUTORS AND MANUFACTURER'S REPRESENTATIVES

Essentially, distributors and manufacturer's representatives are paid salespeople. They are not paid by any one company, however; they are independent businesspeople who represent a number of manufacturers and who draw commissions from the sales of the products they handle. Because their income is based on *volume* sales, they are generally only interested in handling clients with *proven* sales records, who are set up to turn out a large volume of work.

Photo products can meet those criteria, but the photographer has to make a major commitment. He may find himself weighed down more and more with organization and management, with little time left for his photography. This could even reach the point where he buys photos primarily from outside sources.

To some, this shift in role may pose no problem. They may find themselves quite comfortable managing an expanding business and supervising employees and contractors. Others may find it an unwelcome intrusion on their time and too compromising of their creativity. In the final analysis *you* will have to decide how much, if any, mass production is right for you.

If having someone do your selling for you sounds like a good deal, how do

you make contact? Well, sometimes that's no problem. Sales reps and distributors will occasionally contact you if they've seen your work in shops or fairs and they're sufficiently impressed with the quality and sales potential.

And what if they don't?

One way to locate representatives is through your retailers, especially those that handle large numbers of handmade craft items. Ask if they buy through representatives and can make any recommendations. Most reps are regional in their operations, so you'll have to inquire locally to find those that service your area and would be likely to handle the kind of work you do.

Other possible sources of information are the artists and craftspeople themselves. Whomever you talk to, also inquire about reputations; don't automatically assume all sales representatives are equal and aboveboard. As with many other aspects of your business, some good advice early on can help you avoid costly mistakes.

Although it's a riskier approach, you can also locate representatives through trade magazines and papers or sometimes even in the Yellow Pages. Occasionally, you can find the names and addresses of distributors imprinted on products similar to your own, such as greeting cards and postcards.

Be certain that any arrangements with a sales representative are spelled out clearly on paper. The contract should specify: the percentage of gross sales you will be charged as commission and how that commission is to be paid; how many samples are needed; what additional charges, if any, will be levied for display promotion; who will be responsible for damage to products while away from your care; and how any loss for nonpayment will be shared (yes, there are merchants who will be slow or delinquent in paying). Be sure you understand a contract before signing it. If there's anything you have doubts about, consult a lawyer and have the legalese translated into English.

TRADE AND PRODUCT SHOWS

Yet another way to contact sales representatives, retailers, and buyers for large stores and retail chains is by displaying your work at a trade or product show. Such shows occur regularly in major metropolitan areas throughout the country. They differ from art and crafts fairs in that they are primarily intended to attract wholesale buyers or distributors. Since there are a great variety of these shows, locate those appropriate to your needs by talking to local retailers, many of whom do at least a portion of their purchasing at such events.

As an exhibitor you would rent space and prepare your display. Buyers wander among the displays asking questions and gathering information. As with crafts fairs you'll want to have business cards, price lists, and, if possible, illustrated brochures available. You should also be prepared to make decisions about delivery times, since buyers sometimes place orders on the spot.

SELLING YOUR PRODUCTS BY MAIL

For years photo products of one sort or another have been sold successfully through the mail. This marketing method is especially attractive to people who find the thought of person-to-person sales contacts distressing. It's the anonymity syndrome as we noted with regard to direct submission. And the problems are similar.

How to Create & Sell Photo Products

Although fortunes have been made in mail order, sometimes overnight, it is by no means an easy and surefire method of selling your products. The basic rules are still the same as for selling at a local outlet: You can't sell people something they don't want any better by mail than from the shelf of a store. You still have to do your market research and test, test, test.

This is even more important in mail order, since in most cases the key to success is generating a high volume of sales. You need this volume because your costs for advertising, for reaching your customers will be high. For this reason you can only afford to go with *proven* products—proven either through local retail sales or else on a limited scale in the mail-order marketplace.

We'll deal with some of these mail-order testing methods a little later. At this point we'll assume you've already proven some of your products locally and you're now ready to expand to mass marketing via the mails. There are a number of ways to go about this, including selling through mail-order retailers, placing advertisements in periodicals or other media and filling the orders as they come in, and sending your promotional materials directly to prospective customers. We'll start with the least risky.

Selling through mail-order retailers. There is a way to reach the mail-order market while keeping your costs to a minimum, and that's to interest a mail-order retailer in handling your line.

Mail-order marketing is a thriving and indeed rapidly expanding industry. As gasoline prices soar and the cost of shopping in person rises, more and more consumers are turning to the offerings of mail-order retailers. Catalog companies can often give their customers a wider selection of merchandise as well as lower prices. This is possible because these companies are able to reach a large audience while maintaining a relatively low overhead. Operating a storefront shop is expensive these days, and getting more so. And this increasing bite from the Fixed Overhead Gremlin is reflected in the prices the shop owner must charge for the merchandise he carries. Add to this the fact that he reaches only a small portion of the market (when compared to that available nationwide), and you will appreciate the advantage held by the mail-order retailer.

Again, in order to share this advantage, you must do your homework. If your speciality is wildlife photography, for example, then you'll need to locate those mail-order houses that cater to sports enthusiasts, hikers, campers, recreational-vehicle owners, conservationists, etc.

A good place to start is your local library. Check to see if it offers a selection of mail-order catalogs. Another good source of mail-order information is *Klein's Directory of Mail Order Houses* (B. Klein Publications, Inc., 11 Third St., Rye NY 10580), which lists over 5,000 mail-order firms. Another source of catalog companies would be magazines oriented toward your prospective customers—*Outdoor Life* and *Backpacker*, for example. If you look hard enough, you'll find a magazine for just about any interest. A reference work that will make this search easier is *Ulrich's International Periodicals Directory*, available at most libraries. It lists magazines by subjects, so look up wildlife or related topics (hunting, fishing) to find appropriate periodicals. As you research, keep an open mind; you might come across some marketing possibilities you hadn't thought of. Always be on the lookout for new ideas—and jot them down when you find them!

Leaf through the magazines. You can often tell from their ads what general kinds of products (and in what price ranges) a mail-order company carries. When you find one that looks promising, take down the name and address. If the company offers a catalog, write for it; in many cases they're free. The catalogs will give you a better feel for the remote retailer, just as your browsing and other forms of preliminary marketing research did for the local retailer.

Study the merchandise these companies offer. You may get some ideas for additional photo products or useful variations on a theme. Watch especially for items that appear in more than one catalog. You are looking for things with mass appeal, products adaptable to photography. If an item appears in several catalogs, chances are it's already attracted a market—or at least a number of retailers think it will. If it appears in too many places, however, or in too many variations, this could indicate that the market is (or is close to becoming) saturated.

Planning your production. Before you query, a little more groundwork is in order. You need to be certain you can actually and profitably fill a big order if you get one. It's one thing to market your line on a limited basis where you can make adjustments as needed for increased costs or for production problems such as a sudden scarcity of materials. It's quite another to suddenly have to meet agreed-upon specifications in large volume by a deadline!

So know your exact production cost before you send out that first letter of inquiry. Line up suppliers, assemblers, printers—whoever and whatever are necessary to turn out your product in a short period of time (we'll go into mass-production techniques more thoroughly a little later in this chapter).

In the beginning don't hire, contract. If you've already arranged with someone to do work for you—make clock frames, for example—be certain he or she is capable of fulfilling your increased needs under pressure of a deadline and with no sacrifice of quality.

Line up any potential assembly workers if necessary. There are always plenty of students or other persons looking for ways to make extra money. They can be contracted as home workers on a piece-work basis, but you must be able to accurately estimate the cost of their labor. Don't make the mistake of assuming they'll be able to assemble cards or paint plaques as fast as you can; have them actually do some work for you, so that you can better plan your production schedule (we'll consider costs a little later in this chapter).

Be certain, too, that materials will be available. If there is any doubt, seek out alternative sources. (It's wise to do this anyway, just in case an emergency should develop. Not to mention the possibility that you might uncover a better deal.) Ask your suppliers how long they can guarantee the prices they quote and get that commitment in writing. Above all, you must be confident they will stand by their agreement.

Try to leave your suppliers and your contractors with the feeling that this isn't just a one-shot deal (and if things go well, it won't be). If they understand that it could become a lucrative long-term relationship, they'll have more incentive to treat you fairly and to provide quality service, materials, and workmanship.

You also need to figure shipping and insurance costs in getting an order to a retailer. And if you plan to sell cards or other items in selections of a dozen,

How to Create & Sell Photo Products

say, then you'll have to investigate packaging.

Pricing your products. All these things need to be taken into consideration, because when you send out inquiry letters, you'll have to let the retailers know what you'll sell them your products for, and what they can expect to make as profit. You must be prepared to quote them a wholesale price and an estimated retail price, and both must be thoroughly realistic.

If you sell to a mail-order company, keep in mind that the company will bear the costs of advertising your product and probably at least a portion of the costs of final shipping to individual customers. And it also has to support its own Fixed Overhead Gremlin. You would have to pay many of these costs yourself if you were dealing directly with the customer. In direct mailing, for example, you would have to budget perhaps as much as 50 percent of the retail price of your product for marketing expenses (advertising, order processing, shipping, etc.).

What this boils down to in dollars and cents is that for an item in the $1- to $10-range you'll have to be able to offer the mail-order retailer a 60 to 70 percent discount off retail price. If you expect the item to sell for $3 in his catalog, you'll have to sell it to him for $1.20 (in larger-volume purchase, of course). As with any form of wholesale marketing, price your items to encourage such purchases by offering volume discounts (see Chapter 9).

On higher-priced items like clocks, the wholesale discount schedule will be somewhat different. As a rule of thumb, figure 40 to 50 percent of the retail price. This means you will have to be prepared to offer a $45 clock to the dealer for anywhere from $22.50 to $27. Taking $25 as average, you can expect a $10 profit per item if you can keep your production costs below $15.

Mass marketing generally requires a trade-off of per-item profit for the potentially greater rewards of high-volume sales.

Writing your query letter. Once you've figured production costs, profit margins, pricing, and the technical aspects of mass production, you're ready to send off your inquiries. If you haven't already done so, it would be wise at this point to invest in some business stationery. It's important to create the impression that yours is a stable business, able to enter into and fulfill a contract for a top-quality product. The importance of "image" can't be overstressed.

In your letter describe the product or products you have to offer and explain why you think they would be of interest to the retailer's customers—not why *he* will like them, but why *his customers* will like them. Few merchants can stay in business selliing only what they themselves like. The customers' tastes and desires are paramount.

Inform him of how your products differ from similar ones already in the marketplace (superior construction, high-quality materials, superb photography tailored to his customers' interests, etc.). Point out any success your products have already enjoyed and explain that you are interested in expanding your market.

Convince him that you're offering real money-makers. This is easy to do if those products have already convinced *you* that they're money-makers—just let your natural enthusiasm shine through.

Where practical, include a sample product. This can be done with inex-

pensive items such as cards, plaques, and coasters. You might also enclose a unique business card—a photo bookmark with your name (or your company's name) and address on the back. For expensive and bulky products include a brochure if you have one or photographs of the products. If a retailer is interested, he will ask to see a sample of the actual item.

How about doing it on your own? An alternative approach is to set up your own mail-order campaign by placing your own advertisements and having customers order directly from you. This method is being used by many entrepreneurs with a great deal of success.

Advantages:

1. No mail-order retailer is cutting into your profits, because *you* are that retailer.
2. You can start out more slowly and control your expansion as you see fit.
3. There's no need to interest another mail-order retailer in your products (competition is keen, as they are constantly bombarded with new products).
4. A mail-order operation can be carried out anywhere. No matter how small the community in which you live, you have access to a vast number of customers via the mails.

Disadvantages:

1. You're out on the limb by yourself (but that's life anyway!).
2. It will take you longer to build up your sales, because you won't have what the catalog retailer already has: a volume of customers with whom he's already done business. You will have to gradually accumulate your own.
3. You will have to foot the cost of promoting your products yourself (and learn how to do it effectively).
4. You lose the advantage of an illustrated catalog (unless you can afford to print a brochure yourself).

Before embarking on a mail-order venture, it would be wise to return to your library. Numerous books have been written on mail-order and related subjects, and some can give you valuable advice on writing and placing ads and on market testing your products. Since—in the beginning, at least—you will have to act as your own advertising agency, it's a good idea to get as much advice as you can. Beware, however, of the extravagant claims some of these books make. While it's true that some people have made overnight fortunes in mail-order, far more have made nothing at all, or even gone in the hole.

The following is not meant to be a definitive treatise on the subject of mail-order marketing. Our aim is to offer some general guidelines and comments, to give you an idea of what's involved. For more information, consult the "Suggestions for Further Reading" in Appendix B.

How to Create & Sell Photo Products

Setting up your own mail-order business. You can reach potential customers through newspaper advertising, magazine advertising, or ads placed in specialized publications, such as newsletters and journals. The first will give you quicker results; the others will reach a wider area and let you zero in on a particular audience. Test the mass appeal of your products by first using the least expensive type of ad, the classified. (Note: Other advertising media such as radio and television have been omitted from this discussion because they tend to be too specialized and expensive for the beginner.)

Mail-order market testing. With newspaper advertising you can expect a quick response. In fact, 50 percent of your total responses should arrive within four to six days after running the ad. And, there's only a few days between writing the ad and seeing it in print. On the other hand, magazine advertisng must be submitted two to three *months* prior to publication, and once the ad has run, it will be around thirty days before you've received 50 percent of your responses. With magazine advertising you may still be getting orders a year or more later!

Use your test ads to predict how successful your products will be in the mail-order marketplace. A rule of thumb devised by one mail-order consultant is to divide the cost of the ad by the number of responses it brings (tally responses up the the 50 percent point—six days for a newspaper ad, a month for a magazine ad—then double that number for a projected total). If the result is $4 or less, you've located a market where your product will probably do well. For example, if a $40 ad pulls twenty responses for a $2 cost/response ratio, you quite possibly have a winner.

If the response is disappointing, try rewording your ad. If interest still lags, try promoting a different product. Again, by paying attention to what has sold in the past, you have a better chance of hitting the profit mark early.

Market testing—mail order or whatever—is essentially limited marketing. You must be prepared (*before* you place your ad) to fill any orders you do get. The idea is to test small at first and then use those results as guides in adjusting your operation to a larger campaign.

As we've stressed repeatedly, it's difficult to sell photography with words. It's easier to convert inquiries to sales if you can offer potential customers something to look at, such as a brochure. Brochures or catalog sheets will, of course, be an added expense, especially if done in color.

If you're selling black-and-white products, you can have your job printer run off sales literature quickly and cheaply. This will also work for certain other items like T-shirts where the photo's subject matter may be more important than its colors, which can be described in words.

For inexpensive items like cards you might send a sample of the product itself instead of investing in a full-color promotion (at least during your market-testing phase). Where this isn't practical—as with clocks—you could offer a photo of each style in your line. No matter how you approach it, however, your advertising costs will increase anytime you add descriptive literature.

One way to recover some of these costs is by charging for samples or promotional material. If you run an ad inviting prospective customers to write for a brochure or sample, you can expect a higher response if those items are free. Unfortunately, a lot of people who have absolutely no intention of buying any-

thing are attracted by the word "free." You can weed these people out by requesting a small service charge, say $.25 to $.50, to help defray costs.

Now let's take a closer look at an inexpensive mail-order product test. Start by writing the ad:

AMERICAN WILDLIFE GREETING CARDS. Superb full-color photography—a unique gift! Write for FREE brochure to: [your name or company and address].

This ad is designed to test interest in one particular item. Since we are offering something for nothing—the free brochure—this ad would probably bring a good response. However, the ad itself brings in no money. We must recover its cost and make our profit through a follow-up brochure, which is an added expense. So we make an alteration:

AMERICAN WILDLIFE GREETING CARDS. Superb full-color photography—a unique gift! Send 25¢ for illustrated brochure to: [your name or company and address].

This ad will cost almost the same to run as the first, but will probably bring fewer inquiries, because of the $.25 charge. But we will waste fewer brochures on people who have no intention of buying anything, and those who do send in their quarters will help pay for the cost of the ad. We can probably speed up this flow of money with still another alteration.

AMERICAN WILDLIFE GREETING CARDS. Superb full-color photography—a unique gift! Sample Sea Otter card $2.25. Six different cards. $10. Brochure 25¢.[your name or company and address].

Although this ad will cost more to run, our strategy is to get it to pay for itself and possibly turn a profit. Our advertising campaign consists of two parts: the classified ad and the follow-up brochure. Our aim is to make *both* elements pay.

Next, we place the ad in the classified section of a newspaper or magazine or both (the merits of each will be discussed a little later). Since most magazines focus on specific audiences, select one whose readers are likely to be interested in what you have to sell. In this particular case *Natural History* or *Backpacker* might be a good choice.

Suppose the ad costs us $48 to run in a magazine, and at the end of one month has brought twelve responses. Since we can expect 50 percent of our responses in that period of time, we can expect a total of twenty-four responses to our ad, for a cost/response ratio of $2. Do we have a winner?

How to Create & Sell Photo Products

Well, let's do a cost analysis and find out.

Of the responses, if two request a brochure, five request the sample card, and five request the six-card package, we can project the following results (assuming, of course, that the second 50 percent follows the same pattern):

Income generated		
Brochures	4 x $.25	$ 1.00
Sample cards	10 x 2.25	22.50
Complete sets	10 x 10.00	100.00
	Total	$123.50

And now for expenses		
Advertising		$ 48.00
Brochure cost	24 x $.10	2.40
Card costs	70 x .70	49.00
Mailing		10.00
	Total	$109.40

This gives us a gross profit of $14.10—not very much, considering the time and work expended. Was the test a failure? Not at all. In fact, this element of our campaign was quite successful—it paid for itself and turned a profit.

We didn't make a fortune overnight. But then we didn't expect to from a test ad. The idea was to test interest in the product and this we did, with positive results. Besides, there's still the second element of our promotion. The brochures we sent out may result in further orders, and we've begun to accumulate customers for our other products—we've begun to compile our own mailing list. We hope that our wildlife cards will win us many repeat customers, not only for these and other cards but for our whole range of products. Our modest test ad could turn out to be very lucrative indeed, once all the returns are in.

But we don't want to wait that long before taking our next step. As indicated earlier, it could be months before we get all the responses to the ad alone, not to mention follow-up orders from the brochure. What we need to determine as quickly as possible is: Where do we go from here?

Our cost/response ratio has shown that there is an interest in our wildlife cards. We can get a better idea of how effectively we've exploited that interest by invoking another rule of thumb: Test ads should show a profit of 10 to 100 percent or more of their cost in order to be worthwhile. By this standard, we did all right (29.4 percent), but we could have done better.

To increase the "pull" of our ad, we could try rewording it, perhaps starting off with "A Unique Gift" instead of "American Wildlife Greeting Cards." This might attract gift buyers who wouldn't otherwise have considered cards. Or we could experiment with other lead-ins or with alterations within the body of the ad. We could experiment with different prices—$9.95 for the six-card package, for example. Or we could try advertising in a different magazine or newspaper. However, when varying your ad (different wording, different magazine, different price, etc.), remember this: Test only *one* change at a

time. Otherwise, if your responses increase or decrease, you won't know the cause. Sometimes one simple change in your ad will double or triple the number of orders. The idea is to arrive at the best possible combination of ad wording, product pricing, media exposure, and follow-up promotion before moving on to larger, more expensive ads.

And quite possibly, after running the gamut of changes, we might find that we just can't beat that 29.4 profit percentage. If that turns out to be the case, we have two choices: Either go ahead with that particular product, but with lowered expectations, or try a different product—one that, we hope, will have more appeal.

Expanding your mail-order operation. If your test ads pay off (show a profit of 10 to 100 percent of their cost), you can increase your number of responses simply by increasing your number of classified ads. This means you can run the same ad for several months in the same magazine, in several different magazines, or both. The same would be true, of course, for any advertising media, including newspapers.

Advertising salespeople will make the point that you should allow your ad to run for at least three consecutive insertions in order to give it a fair chance. In most cases they'll even give you a special rate if you do so. Other experienced advertisers say no; if an ad fails the first time, it will do likewise the second and third times. Our experience has tended to support the latter opinion.

On the other hand, if an ad performs well the first time, it is likely to continue to do so but at a diminishing rate. You may wish to continue running a successful ad in the same periodical until you notice a drop-off in response; then give that periodical a breather for six months or so before trying again.

Another option for increasing exposure is to run larger ads—space ads—especially if you're offering a seasonal product. Space ads are more expensive than classifieds, but they attract more attention if they're written and placed correctly.

You'll probably have a lot more to say regarding the actual placement of your ad in newspapers than in magazines. A newspaper will generally cooperate in placing space ads where you want them, and most advertising consultants agree that location is very important. For example, if you're selling a line of decorator kitchen clocks, a good place for the ad would be in the food or homemaker's section. If your products have a sports slant, the sports section might be a good bet. Photo T-shirts aimed at kids might be promoted on the comics page or alongside motion picture advertising. A more general audience might best be reached in the news or editorial sections.

Advertising specialists leave few stones unturned when it comes to reaching the public. Many even go so far as to specify that a space ad be placed on a right-hand page, just above the fold, so that people will automatically see it when turning the page.

You should be aware that newspaper audiences vary widely from city to city, indeed even from paper to paper within a given city. A cross section of a morning-edition readership is likely to be quite different from a cross section for the evening edition. Some media experts believe that advertising in the morning edition will reach more business people, whereas the evening paper is home-oriented.

How to Create & Sell Photo Products

The most obvious difference between advertising in a newspaper as opposed to a magazine is that the latter will generally spread your message over a much wider marketing area. Most newspapers are local, with a few exceptions such as the *New York Times*, the *Wall Street Journal*, and the *Christian Science Monitor*. Still, there are times when this local orientation can be an advantage, as, for example, in the case of products that feature a particular area.

However, if your products are aimed at specific groups—sportspeople, flower lovers, sailing enthusiasts, etc.—special-interest magazines or newsletters will allow you to reach them more efficiently than will newspapers.

To sum up this kind of mail-order marketing: The smaller you start, the less you risk. The less you risk, the smaller your profit. Test small and thoroughly to detemine the degree of interest in your product and to refine your advertising approach. If your test ads indicate that you have a promising product, increase your advertising accordingly. The more customers you can reach, the more money you will make.

And remember that you also want to gather a loyal following or repeat customers. Some photo products, like cards, are made to be used up. If your customers like your product, they'll reorder . . . again and again. Thus, even an ad that yielded a minimal profit initially may turn out to be a bonanza of repeat customers.

In fact, many mail-order retailers count on these follow-up sales for the bulk of their profits, occasionally to the point of advertising so-called loss leaders—items that actually *lose* money—as a means of attracting customers to the rest of their inventory.

So in your own follow-up advertising, don't forget to promote the rest of your product line. Occasionally, we've had someone order *one of everything*!

Direct mail marketing. Direct mail differs from the previous approach in that you don't place an ad and then wait for a response. Instead, you purchase or rent a list of names and addresses of potential customers. Then you send your descriptive advertising materials directly to these people.

An advantage of this method is that you can present a much more complete case for your products than you can in the limited space of an ad. You can also zero in on your target more effectively. For example, you can obtain mailing lists of persons who have previously bought greeting cards through the mail. Or if your specialty is flower photography, you can focus on gardeners or garden-oriented organizations or even appropriate retailers that might be in terested in handling your products. In this way you can contact people who don't read classified or space ads.

Even direct mailings to subscribers of magazines in which you've advertised can be productive. After all, who reads *all* the ads in a publication (unless they're really at a loss for things to do!). How many ads do *you* read, for example? The fact is, most ads go unread by the majority of the subscribers. So how do you reach them? Direct mail is one answer (repeating or enlarging successful ads may be another).

With a mailing list well suited to your purposes, it's possible to convert 2 percent or more of the names into customers. You can *never* expect to sell 2 percent of a magazine's readers through space or classified ads.

Mailing lists can be obtained from companies (magazine publishers,

mail-order firms, local stores) or list compilers or suppliers (see Appendix A). Most list compilers are listed in *Standard Rate and Data Service* (Standard Rate and Data Service, Inc., 5201 Old Orchard Road, Skokie IL 60077). See if your library has or can get a copy. If you would prefer working wth a list broker in your area, consult your phone book or that of the nearest city for names and addresses.

The major disadvantage of the direct mail approach is its high cost, which may be as much as fifteen times the cost of reaching the same number of customers through newspaper space advertising. This high cost results from having to deal in large volume in order to keep the cost per potential customer within reason (you may have to send out fifty letters to get one response, but the larger the mailing, the lower the cost of each letter). Thus, you incur large printing (letters, brochures, catalog sheets, envelopes) and postage costs, not to mention the initial charge for the mailing list itself. That charge can range from less than $20 to well over $60 per one thousand names.

A major advantage, however, is that the direct mail approach will usually convert a higher percentage of potential customers into actual buyers. Consider using this method to expand your marketing area and your business if (1) you can afford the high initial costs and (2) you have thoroughly market-tested your products and are convinced of their salability. Certainly you will want to use this method to contact people who have already purchased from you. Previous customers will make up the best possible mailing list for your future products—provided, of course, that you've left them feeling satisfied. Always aim for repeat business.

Some specific suggestions for a direct mail approach

1. Develop a complete products line so that you have a wide variety of offerings in all price ranges. The cost of reaching each customer is high; therefore, you simply cannot make money selling a $2 card, or even a package of six. To make your direct mail venture profitable, you must do everything possible to maximize your chances of obtaining orders, and those orders must be for substantial amounts (in order to pay for all the pieces of mail that didn't generate any income).

 Successful direct mail retailers maintain that the ideal direct mail product should cost $25 or more (when that's the only product offered). Your clocks will cost more, your cards and plaques less. But if you're going to spend money on a direct mail campaign for clocks, why not include your less expensive items as well? They will be getting a free ride and they might generate some orders from people who aren't at all interested in photo clocks. You can package your smaller items in assortments of ten, fifteen, whatever, or require a minimum order that will bring the total up near the optimum $25 level.

2. Write a selling letter to accompany your brochures. Write the letter as though you were writing to a friend, rather than using the formal tone of a business letter.

3. Start with an attention-getting headline. If you're marketing prod-

How to Create & Sell Photo Products

ucts featuring wild flowers, a suitable lead-in might be: "If you love flowers, you'll love this," or something similar. For a Christmas sales promotion you might go with: "Unique gifts for *everyone* on your Christmas list!" Some direct mail sellers even print such attention getters on the outside of the envelope.

4. Test the idea of including a sample product with your advertising material. This will of course add to your mailing costs, but it could be worth it in extra orders. Experiment by dividing your test mailing—half with a gift and half without. The added gift can be especially useful if you're trying to sell color products with a black-and-white brochure.

5. Offer potential customers some sort of incentive to act right away—perhaps a "limited-time-only gift" included with all orders received before a specified date. The gift could be a bookmark, a key chain, or any inexpensive item, including an extra of the product ordered—eleven cards instead of ten, for example. Sometimes, as in the case of Christmas cards or ornaments, this incentive is built in by the pressure of time.

6. Make it easy to order. Design an easy-to-understand, no-nonsense order blank. Where possible, compute any additional charges (taxes, shipping, insurance) for the customer, or provide an easy way for him to do it himself (a simple table, for example). Another alternative is to price the product to include as many of these charges as you can. Also consider accepting major credit cards (see Chapter 11).

One way to lower your direct mail cost is to locate some other craftspeople or small businesses that have products that could be marketed by mail. Obviously, you shouldn't include anyone who would compete directly with your own line. Then organize a cooperative mailing in which each person is responsible for his own advertising fliers, and all share equally in the mailing costs, including envelopes, postage, labor, and purchase or rental of mailing lists.

Occasionally, you can find a business with its own direct mail program that will allow you—for a fee, and provided you're noncompetitive with its own merchandising service—to include your advertisements in its mailings. This could be a good arrangement if that business' customers are likely to be interested in what you have to offer.

A word of caution at this point regarding mailing lists. When starting a direct mail marketing campaign, you should test before you buy or rent the entire list. Let's suppose you're interested in a list that contains the names of 200,000 people who have purchased products similar to yours through the mail. Ask first for a minimum sample for testing—the broker sets the minimum order. Let's further assume that in this case he supplies a sample consisting of 2,000 names. You can test these names at a much lower cost than mailing to the entire list of 200,000. If you get good results, you can go ahead and purchase the rest of the list.

Direct mail marketing can be very rewarding financially, but it can also be risky. Suppose you mail out 2,000 brochures to those sample names and get a dismal return—that's an expensive way to find out you've got the wrong list.

Just because you've paid for 2,000 names doesn't mean you have to use them all, at least not all at once. Start out slowly. Mail to 100 or 200 names and see what happens. If the results are good, proceed; if not . . . well, it's better to lose the cost of a few names than to lose the cost of an entire mailing.

And to protect yourself from unscrupulous list owners and compilers, do the following:

1. Request that your minimum sample be every nth name on the list—every tenth, twelfth, fifteenth, or whatever. This will help prevent owners from "salting" your sample list by including only the best prospects.
2. Be sure the broker or list owner is a member of DMMA (Direct Mail Marketing Association).
3. Be sure that the list is guaranteed as being 95 percent deliverable. This means that no more than 5 percent of your mailings will be returned unopened.

Finally, if you're interested in pursuing the direct mail approach, do some further reading on the subject. Learn as much as you can before you risk your capital. See Appendix B for some suggested references.

What to sell via the mails. Almost any of your products can be sold through the mails if they can be mass-produced. Some, however, are better suited than others.

In terms of convenience, "paper products" are an excellent choice. Of these, the easiest perhaps are black-and-white products such as cards, photo-calligraphy combinations, calendars, posters, and mini-posters. Black-and-white versions of these products can be quickly and inexpensively run off in any number by your local job printer. Color versions are considerably more expensive to produce, but when you're aiming for a mass market such as that afforded by mail order, the costs can be brought more into line through larger-volume purchases. Know exactly what these costs are, however, before you commit yourself.

Another consideration is the photograph itself. Photos with a local theme may sell very well in local retail outlets; they won't necessarily do the same in the mass market. When you branch out into mail order, you lose one of your initial advantages over the mass producers: producing local items for local markets. On the other hand, there's nothing to prevent you from giving products the local flavor of other areas and then marketing by mail *in those areas*.

Durability is still another concern. Paper products, key chains, and plaques—to name a few—are physically able to survive mail order in good shape, whereas other products like clocks and ornaments require careful attention to packing. So give some consideration to the matter of packaging (more about this subject later) before making your choices.

A fourth factor to consider is whether the same or a similar product has had a successful mail-order sales record. To get some feedback on this, leaf through magazines in which you might advertise your products. Take note of any items similar to your own (not necessarily *photo* products). Then go back through some old issues of the same magazines—six months, a year, even two

How to Create & Sell Photo Products

years ago (most libraries keep past issues this long)—and see if any of those products were advertised then. If so, they're obviously doing well, and your variation might be a good bet.

Products that have enjoyed a long run in the mail-order market include greeting cards, plaques, posters, T-shirts, puzzles, calendars, and a wide range of items with religious or inspirational themes.

One simple photo product—slide collections—has been in the mail-order market for years. Such collections are also seen in retail stores, especially in tourist areas. Buyers of slide collections and a related product, filmstrips, include educators who use them in their classrooms, or businesspeople who use them as training aids, to sell products, and as a public relations tool. Recently we've noticed a new wrinkle; instructive slide programs that are not designed primarily for schools or tourists. Such subjects as rock climbing, physical conditioning, gourmet cooking, and much, much more can be taught via slides. All it takes is a knowledge of the subject and enough general interest within the mail-order marketplace. You could even write a simple text or record a narrative to go along with the photographs. Remember those filmstrips you watched at school; it's the same principle.

In fact, you don't even have to *be* the expert . . . just be able to *locate* one. Thus, in league with a judo or karate expert, you could photograph and prepare an introductory course in self-defense—a subject that's on many people's minds these days. Again, study the marketplace and learn what interests people—large numbers of people—and then design a product to meet their needs.

Putting together such slide collections is relatively simple. Have your duplicates made by a custom lab. The prices are reasonable if you're having a large number of dupes made from the same slide. If your dupes cost $.20 each, a collection of twenty would run $4. Thus, a mail-order retail price in the $12-$15 range would cover marketing costs and turn a nice profit.

Of course, this product could also be sold locally, but it's particularly well suited to mail order for several reasons. First, slides are easy to package and mail (they can be packaged in plastic sleeves and mailed as in direct submission—see Chapter 13) and are small enough and light enough to travel inexpensively. Second, they can be easily mass-produced at low cost, if done in large volume (local sales might preclude this unless done in conjunction with mail order). Third, this product can be easily adapted to a wide variety of needs, depending on current public interest and taste. Although a particular subject may fall from favor, the product (slide collections) will undoubtedly stay in the market place a long time.

Shipping your products. We've had packages arrive soaked clean through with a mysterious liquid we hoped was water; we've had them arrive covered with footprints, with wrappers off in part or whole, boxes split with merchandise peeking out. We've had shipments arrive squashed flat or into some other peculiar shape. But in all fairness we must say that most packages seem to get through in pretty good condition. Nevertheless, damage or loss does occur; so "bombproof" your shipments as much as possible, especially when sending fragile items like clocks. Insuring them also helps to assure they'll survive, and protects you if they don't.

In the beginning you can save money by salvaging a lot of your packaging

materials. Local merchants, especially grocery and stationery stores, often have boxes free for the taking. In fact, they're usually happy to get rid of them. Even if you can't find any cartons the exact size you need, you can always cut larger ones to fit. Newspaper is the least expensive packing material, but you can also use Styrofoam pellets or any other appropriate material. It's a good idea to put items in plastic bags to keep them clean, especially if you're packing them with newspaper. Pack carefully, without overloading containers. And check with the post office; their packing guides may be useful. Do everything you can within reason to insure that your packages arrive in good condition.

When your business grows to the point where you prefer to order custom packaging materials, check the Yellow Pages for packaging manufacturers and specialists.

The postal service is usually a good bet for sending smaller packages and may be your only choice when shipping to a P.O. box address. Larger packages are often less expensive, move faster, and sustain less damage when shipped via United Parcel. Check rates and regulations and other alternatives in your area.

Who pays the cost of shipping? Generally speaking, the customer, although it might not always be evident from his point of view. Since you will probably be charging about the same price for your products as a retailer would, you'll have to keep your marketing expenses within the limit of his markup. This may or may not give you enough leeway to assume shipping costs. If not, and if those costs are relatively small, you may wish to simply add them to the price of the product itself. Thus, an item with a normal retail price of $5 might be sold by mail order at $6, including postage and handling. On larger orders, however, where the costs are higher, the customer should be billed for postage and handling and the figure should be listed separately on the order blank for income tax purposes.

AVOIDING THE PITFALLS OF EXPANSION

Obviously, the more money and time you tie up in your photo products business, the more you stand to lose if something goes wrong. Avoiding pitfalls is largely a matter of controlling your growth and conducting your business in an orderly manner, adding outlets and increasing production as sales and market research warrant. In a sense your business evolves naturally as you discover the photographs, the products, and the marketing and production techniques that work best for you and your area.

The key is patience: The faster your business expands, the greater the possible risks. What risks? Let's take a look.

The state of the economy. Although you can't do much about it (except try to protect yourself and proceed with caution), the economy can have considerable impact on how fast you expand your business.

How?

Increased production costs for one. If you're not careful, this can price your products right out of the market. Here's where the mass producers have a distinct advantage: They can cut cost through volume purchases of materials and services. You can, too, but there's a risk involved. You could end up with sagging sales and a garage full of materials.

How to Create & Sell Photo Products

Sagging sales represent a different kind of economic problem. When things get tight, people cut back on their spending and adopt a "wait and see" attitude. They buy only the necessities, and unfortunately, photo products don't often fall into this category. Nor do many of the gift and crafts items carried by the stores in which your products are placed. When sales seem to be slowing down at all your outlets, this may not be the best time to go in search of new ones. And if you do, try to be sure they're on solid footing financially.

Even in the best of years the attrition rate for small businesses of this sort is high. A sluggish economy can be disastrous, especially for arts and crafts cooperatives, which often lack strong business leadership. Shrewd businesspeople cut back and prepare to weather the downturn, while all around them shops and stores close and the number of marketing outlets shrinks. Some stores are forced into bankruptcy. If your products are in one of them on consignment, they could be tied up until the financial situation is sorted out.

At best, you could end up with a stack of products that may just sit around until consumer demand increases again, although consumer tastes might have changed in the interim. At worst, you could end up losing your merchandise entirely.

All of which means you've got to be even more cautious during bleak economic times, but then that's no news to any experienced businessperson!

Overextending yourself. Actually, this might be more likely to occur during periods when the economy is booming. Things look good, your products are selling, new shops are opening up everywhere. Everything looks terrific, so you get excited about the prospect of expanding, of making more money.

You hustle around making sales, locating outlets. You hire some workers to help you out, make some bulk purchases to cut your expenses. You crank into high gear and turn those orders out. And when the orders are filled, you concentrate on turning out more products so that you'll have a backlog for filling repeat orders and stocking all the new outlets you're going to acquire.

And all the while thinking: Got to spend money to make money . . . got to spend money to make money. (That's because it's carved in stone somewhere.)

But those repeat orders don't come in as fast as anticipated. And some of those new outlets suddenly become less promising and possibly even fold (remember that things can be tough even during the good times). Finally, your outgoing shipments have slowed to the point where you find yourself standing amidst stacks of products, looking at your employees, who are looking back at you. Some introductions are in order: Meet the Fixed Overhead Gremlin.

All those new tools you bought are lying idle on those new workbenches in this rented building where the lights are burning and the furnace is hissing as your investment goes up the flue.

Now what?

The best answer is to avoid the whole nightmare in the first place. Give yourself plenty of time to learn the ropes, to perfect your marketing and production techniques. Not to mention your record keeping. Pay attention to details. Determine exact costs. Make necessary alterations in photography, purchasing, production, and pricing in order to maximize your profits. Do this *before* you consider any large-scale expansion.

Often the difference between the success or failure of a particular product is simply finding a better, more cost-efficient means of production. When it seems you've run into a stone wall on some problem of this sort, turn it over to your unconscious idea generator. If you still can't come up with a solution, drop the product in favor of those that are doing well, and expand along those lines (a way to handle that problem product might come to mind at some future date).

And when you do start to grow, do everything possible to keep the Fixed Overhead Gremlin under control. As suggested earlier, instead of hiring additional help, consider contracting the work to people who can do it in their own homes. This will save you the cost of renting work space if your business license doesn't permit you to hire employees to work in your home. You can also avoid the problems of supervision, wages, employee insurance, withholding of Social Security and income tax—in short, much of the hassle of employer-employee relationships. Your subcontractors will be independent businesspeople who supply you with assembled cards, painted plaques, finished frames, or wooden coaster blanks. In fact, they can carry out as much of the production as you wish to delegate, thus freeing you to concentrate on photography and marketing.

And management. As the prime contractor you'll still have to oversee the operation and keep it cost-efficient so that your business makes a profit. This means, for example, that you'll have to know exactly how much labor is involved in making a card or a plaque, whatever, so that you can determine what to pay for the job. This is easy enough to compute if you have an accurate idea of the time and cost involved when you do the work yourself.

Let's say that in one hour you can paint or stain sixty plaques. Thus, you work at a rate of one plaque per minute for this phase of the operation. Mounting photos and varnishing, however, goes a bit slower: You can only complete thirty in this length of time, a rate of one plaque every two minutes. Furthermore, installing the hangers takes you another two minutes per plaque. This means that you spend about five minutes of labor per plaque. Your subcontractor could reasonably be expected to do the same. (These figures are meant for example only; the actual times may vary.)

Now let's figure the cost of having the job done for you. Assuming $5 an hour as a reasonable wage for this kind of work, and dividing it by 12 (the number of plaques *you* could complete in an hour at five minutes per plaque), we come up with a cost of less than $.45 per plaque.

Continuing with the cost analysis: If you keep the other expenses (cost of plaque blank, photo, hanger, paint, and varnish) around a dollar, you can still expect a profit of $1.50 per item if your wholesale price to dealers is $3. Thus, you can afford to pay your subcontractor $.45 to turn the raw materials into a finished plaque.

The figures will vary with the situation and product, but the method of analysis will stay basically the same: Start by determining how much it costs *you* to make the product yourself.

Whom can you get for subcontractors? That depends on the nature of the job you need done. In a sense the postcard manufacturer is your subcontractor for that item, or for a calendar or any other of his specialties. A manufacturer

How to Create & Sell Photo Products

can also be a subcontractor for other products, like jigsaw puzzles or photo T-shirts, that require specialized equipment. Instead of buying that expensive equipment yourself, try to find a manufacturer who will do your job on a custom basis, perhaps during slack periods in his own production schedule.

For less specialized work such as painting, assembling, even routine carpentry, there are usually plenty of people available locally. Among them are students, mothers or fathers at home with preschool children, retired persons looking for supplemental income, and physically handicapped persons. In fact, by contracting out portions of your business, you could be doing a real community service. Contact these potential home workers through schools, social agencies, or even by advertising in the help-wanted section of the newspaper.

Whenever possible, avoid borrowing money to expand your business. Instead, pour all or a portion of your profits back in. If you have a sudden need for a short-term loan—as with a large order that requires a correspondingly large purchase of materials—don't overlook credit possibilities. Once you've established credit with your suppliers, you can purchase those materials and have thirty days (or sometimes longer, by special arrangement) before payment is due. To spread payments over a longer period of time, consider using a credit card (preferably one you use exclusvely for your business).

In these ways your credit can function either as a short-term interest-free loan or as a longer-term loan (should the need arise) on which you pay interest. Obviously, you shouldn't overuse these sources of capital, or the payments may become more than you can handle. And these sources will dry up along with your valuable credit rating.

Finally, take advantage of any opportunity to cut expenses through larger-volume purchases or clearance sales. If your plaque supplier reduces the price of a discontinued style, buy as many as you can afford if you foresee a use for them. Do the same thing when the lumberyard lowers the price on the wood you use for framing. Plan ahead, but not *over your head*.

Illustration 12-1: Felis leo *on the subject of business. Steps for creating this black-and-white posterization are in Chapter 15.*

Chapter
12
BUSINESS BASICS

Ho-hum. What a drag. You may share this feeling when it comes to the straight stuff of business—books and record keeping, obtaining the necessary legal documents, guarantees, insurance, and so forth. But understanding sound business procedures can be the difference between success and failure. With this in mind, let's start at the beginning and see what must be done to establish a sound footing for your business.

STATE AND LOCAL REQUIREMENTS

Before you start, always check with appropriate state and local agencies to determine what specific steps you must take to establish a legal business. The procedures vary from community to community as well as from state to state.

A business license. Generally, if you plan to operate from your home (and this is recommended in the beginning to reduce fixed overhead) and you live within an incorporated area, you will need a business license. Sometimes this includes a permit to operate out of your home, sometimes you must obtain a separate "home use" permit.

To protect the quality of residential neighborhoods, there are usually restrictions on what you can or can't do from your home. For example, you may find you are prohibited from hiring people to work on the premises, or limits may be set on the amount of stock or materials you store or the amount of traffic you generate. For photographers involved only in direct submission to buyers through the mail, none of this presents much of a problem. It's only when you begin to manufacture and sell a product that these things enter the picture.

Fictitious-name statement. If you plan to operate your business under a name other than your own, you may have to publish a fictitious name statement in your local newspaper. The name of our business, Time Exposure, required such publication even though we were listed as owner-operators.

Check at your county clerk's office for the correct procedure in your area and obtain the necessary forms. Plan ahead, because the actual publication may require several notices over a period of several weeks. Once your fictitious-name statement has been published and the forms duly filed with the appropriate agency, you can open a business account at your bank. It's a good idea to keep your personal and business transactions separate, to make record keeping easier.

Some photographers who sell services (wedding photography, portraits, etc.) on an informal basis—that is, without a fixed studio or advertising—try to circumvent as much of the foregoing as possible. This attitude is generally resented by those photographers who establish themselves as legitimate businesspeople by fulfilling their legal obligations. Thus, some might be inclined to blow the whistle on corner-cutters. It's better to establish a sound legal footing before you start to advertise or pursue outlets for your products.

Sales tax. If purchases in your marketing area are subject to state or local sales taxes, then one other document might be required before you can start to sell your products: a seller's permit. Check with your local franchise tax office to find out what is necessary. The seller's permit will also work in your favor by allowing you to buy materials *that are to be resold* without paying tax on them. Wood for frames, acrylics and other construction materials, unfinished plaque blanks, clockworks, and even photographic paper for prints are examples of items that generally fall into this category.

Eventually you or your retailer will have to collect the applicable taxes on each sale of finished products. An exception to this is where the sale occurs outside the tax zone. For example, if we sell a photo clock through a store in California, it is subject to a 6 percent state sales tax. That tax still applies if we sell the clock by mail anywhere in the state. However, if we sell it by mail to someone in *another* state, there is no sales tax.

Be sure you understand the laws and requirements for your particular area.

FEDERAL INCOME TAX

We do not pretend to be experts on federal tax laws. These laws are far too complex (and constantly subject to interpretation and change), so you should consult a qualified accountant or tax specialist to determine how they apply to your specific case. You might also wish to pick up a copy of the Treasury Department's *Tax Guide for Small Business* (which may tell you more than you really want to know on the subject!). Even then you probably won't know enough to take full advantage of the tax structure, once your business really gets rolling. However, there are some considerations that can be helpful, so check with the experts to determine if and how they are applicable in your case.

Business start-up expenses. Such is the nature of the economy and the bite of the Fixed Overhead Gremlin that federal agencies like the Internal Revenue Service and the Small Business Administration estimate it takes anywhere from three to five years for a business to begin earning a profit. Although the Photo Products Alternative should start earning you money right away, there are times when expenses could gain the upper hand.

How to Create & Sell Photo Products

For this reason you should know that a new tax law now allows you to deduct over a sixty-month period certain expenses incurred in starting up a new business. This is a means by which the government encourages the starting of small businesses.

Expenses that could qualify for this deduction include travel for photography and market surveys, advertising, professional services (your accountant, lawyer, etc.), and initial purchases of office supplies (letterhead, envelopes, business cards) necessary to give your company a professional appearance. Normal expenses incurred in the course of business operation are deductible in the year they are paid, as is equipment depreciation.

However, the whole matter of taxes is never quite that simple. With the help of your tax consultant, you can deduct losses as a result of start-up expenses from your income (including the salary from your full-time job). In effect, the government is permitting you to use your business as a tax shelter for this period. But if you earn a profit, you must add it to your other income. And if, at the end of the five years, you cannot show that you made a profit in at least two of them, the losses you deducted in those years may be disallowed.

In any case, the first step is to establish yourself as a bona fide business, which you will have done by getting your business license, opening a business account, and, in general, following the procedures previously outlined.

Office or business at home. This deduction is reportedly a favorite target for IRS audits, simply because it has been so abused in the past. If, however, you meet the qualifications, you should be able to claim this tax benefit.

One important qualification is that your home office, shop, studio—your "business area"—be used *exclusively* for business. A separate room or specified business area is required; it cannot be used for other purposes.

Furthermore, the area must be the principal place in which you conduct your photo products business, even though your principal income may be earned elsewhere. The IRS, as of this writing, allows you to have a principal place of business for each trade or business in which you engage. But even if you operate your photo products business from more than one location, you can only deduct the *principal* place. The *principal* place is determined by the amount of time, type and intensity of the activity, and on the amount of income generated in each place.

As always, check with an expert for a current interpretation. And it's best to do so well ahead of tax time.

Business-related travel. It's always a good idea to find out what you can or can't deduct *before* you take a trip; it can be an important factor in how you travel and can possibly save you a great deal of money. Find out exactly what kinds of records are needed and what constitutes proof of business travel.

Generally, you should be able to deduct travel expenses for the following purposes:

1. Taking photographs either for your products or for your stock photo file.
2. Market research—traveling to different areas to scout out potential markets for your products.

3. Personal delivery of products to your outlets (if you decide, for whatever reason, not to have them shipped).
4. Education (classes, seminars, etc.) to improve your photographic or business skills.

For example, let's recall our Iowa photographer from Chapter 11. Suppose he's just starting up his photo products business while still employed at another job for $20,000 a year. In its first year of operation his products business earns him an additional $2,000 and he begins thinking expansion.

So he decides to take that Florida trip with an eye toward doing some subtropical photography and scouting out some potential markets for his products. Is that trip deductible? Yes, indeed, as long as the primary purpose is business and he complies with the IRS's documentation requirements; generally, this means keeping complete and accurate records of all business-related expenses, including receipts for gasoline (or car mileage in case he chooses to deduct a per-mile allowance instead of his actual transportation cost) or for rail, bus, or airfare and for lodging and meals. He would be wise to also keep a journal of exactly what he spent and where, and complete notes on his marketing research and photography, not only for the IRS but for his own business use as well. Forgetting important details is oh so easy, especially in the excitement of traveling . . . and the consequences can be both embarrassing and expensive!

Expansion . . . making the most of a business loss. Let's further assume that during this second year, in addition to taking the trip, he decides to set up a darkroom, purchase another camera, and take advantage of some reduced-price sales to lay in a store of supplies for those southward-bound products. As a result, at tax time his records show that expenses outweigh income, and his photo products business actually lost $2,000.

Although this is a temporary situation—the result of gearing up for higher production and profits next year—it is nevertheless a loss. And it can be claimed as such.

The net effect is this: His total taxable income for the year becomes $18,000 ($20,000 minus his $2,000 loss). Assuming taxes were withheld according to his original salary schedule, he could be due a refund, which would help compensate for the loss (and for retaining the expert who helped him take full advantage of the tax structure).

RECORD KEEPING

If at all possible, get your record keeping off to a good start by consulting an accountant. Complete and accurate records are essential, and his advice can be well worth the cost.

In lieu of that, one relatively simple method is to buy a dozen file folders and label one for each month of the year. Staple two pieces of 8 1/2X11-inch notebook paper inside the cover of each, either facing each other or one on top of the other. Use one sheet for recording expenses, the other for income. Some people prefer to use bound ledgers for these records.

Keep all purchase receipts, canceled checks, credit card records, shipping or sales invoices, orders, and so forth, in the appropriate folder. On the note-

book paper or in your ledgers, jot down the particulars—date of order, type and quantity of products wanted, date of shipment, date and amount paid—of each business transaction as it occurs. Try to channel as much as possible through your business bank account in order to make record keeping easier.

Accurate lists of sales and products on consignment are an important part of record keeping. The simplest approach is to buy a book of invoices (stationery or business-supply stores have them) and fill one out every time you send off a batch of products. Always make a carbon copy for your files. Invoice forms come prenumbered; you fill in your firm name, the name of the buyer, and list the products sold or left on consignment. (As your business grows, you may want to have your invoice forms printed with your firm name.) The invoice is then signed by both you and the retailer.

Be particularly methodical when it comes to handling mail orders. Sometimes a large volume of mail can catch you off guard, and in the flurry to get it all under control, pieces can be lost or overlooked if you aren't organized. Develop a procedure early in the game and stick to it. Start with a set of "In" and "Out" containers (drawers, baskets, whatever). As you open each letter, record important information on file cards—names, addresses, requests for information, orders, moneys received, date order arrived, date merchandise was shipped, and means of shipment (Postal Servce, United Parcel, etc.). Then make necessary entries in your ledger or on the notebook paper. Through your file cards you'll be building a mailing list for the future.

You might also consider accepting credit card purchases, although you

INVOICE							

Photo Products Inc.
428 West View Road
Bear Valley, CA

INVOICE NO.
9748

SOLD TO				SHIPPED TO			
Brown's Gift Shop							
STREET & NO.				STREET & NO.			
882 West Main Street							
CITY	STATE	ZIP		CITY		STATE	ZIP
Bear Valley, CA							

CUSTOMER'S ORDER	SALESMAN	TERMS		F.O.B.		DATE	
		on consignment				Oct. 7, 1982	
10	plaques @ $3.00 each--sug. retail $6.00						
	4 roses, 4 courthouse, two Yosemite						
10	bookmarks @ $1.00 each--sug. retail $2.00						
	all courthouse photos						
10	greeting cards @ $1.25 each--sug. retail						
	$2.50--5 courthouse, 2 Calif. Poppies,						
	3 sailboats on lake						
	By: Your name						
	Received by: Your customer						

7H 721

Illustration 12-2: *Pads of simple invoice forms can be purchased from stationery stores or many printing shops. Keep a record of all products you place on consignment or sell outright, and provide the dealer with a carbon copy.*

may want to set a minimum order of around $20. There will be an added cost to you, but it may be worth it in terms of customer convenience and additional sales volume. Your bank can inform you of the necessary procedures and costs.

RESTRICTIONS ON PHOTOGRAPHY

Generally, we've found people very cooperative—sometimes even flattered—when it comes to having their pictures taken. This is especially true when they're involved in an interesting activity. Many will go out of their way to help you get the best possible photograph. Perhaps the fact that we respect their right to privacy, that we try whenever possible to ask *before* we shoot, makes a big difference. On occasions when this isn't feasible—to do so might interrupt the action or cause a missed shot—we follow up with an explanation of what we're doing and why . . . and, of course, inquire about additional shots.

We developed this approach of necessity some years ago in Africa, where brandishing a camera in some areas was a foolhardy stunt, repayable with violent words and gestures and even well-aimed rocks. Photographing people and things without permission not only defied local customs and taboos, it was illegal! Even with legal permission it was sometimes necessary to have an armed guard to get the pictures.

Be aware that it's still unwise and even illegal under some circumstances both overseas and in the United States. Earlier, we mentioned that military bases offer numerous marketing and photographic possibilities. This is true. But be careful to obey restrictions and to get the necessary permission before photographing on near such bases. Otherwise, you could be asking for trouble.

Some zoos have restrictions when it comes to photographing animals for commercial use. Others charge for permits, though the fee is usually reasonable. It's best to inquire before photographing.

Many museums and art galleries prohibit photography, as do some churches. It's also possible to run into difficulty at major sporting events, which might admit only authorized or accredited photographers.

Remember, too, that certain subject matter may be offensive (and even illegal) in some communities. Photographs of the undraped (or partially undraped) human body may be considered "art" in one place and obscene in another. Again, fit your products to your market—learn what is and is not accepted.

And finally, as a product photographer, you must respect the right of a person *not* to have himself or his property photographed.

MODEL RELEASES

The laws are less stringent for publication, but for advertising and product use, a model release is required for recognizable people and property. A model release is a form, signed by persons in a photograph, granting permission to use their likenesses. While a great deal has been said (and written) on this subject, the exact line between when model releases are needed and when they are not remains vague. Model releases are definitely required for all advertising, and for trade purposes, which include using recognizable people on your own photo products or products of manufacturers you submit photos to.

How to Create & Sell Photo Products

[Your letterhead goes here.]

MODEL RELEASE

In consideration of $1.00 and other valuable consideration paid to me by

[the photographer's name]

, receipt of which is acknowledged, I consent for all purposes to the sale, reproduction and/or use of photographs of me (with or without the use of my name), by the photographer and by any nominee or designee of the photographer (including any agency, client, retail or wholesale seller, or periodical or other publication) in all forms and media and in all manners, including advertising, trade, display, editorial, art, exhibition, and products developed by the photographer or his designees.

In giving this consent, I release the photographer, his nominees and designees from liability for any violation of any personal or proprietary right I may have in connection with such sale, reproduction or use.

I am more than twenty-one years of age.

(signed) _____

WITNESS: _____

DATE: _____

GUARDIAN'S CONSENT

I am the parent and guardian of the minor named above and have the legal authority to execute the above consent and release. I approve the foregoing and waive any rights in the premises.

(signed) _____

WITNESS: _____

DATE: _____

Illustration 12-3: *Given the very commercial nature of the use of photos in your products business, you should use one of the more comprehensively worded releases.*

A release might even be necessary from the owners of property or animals that are distinctive or easily recognizable. The best policy is to get them in as many cases as possible. Preprinted model release forms are usually available at camera stores and sample wording for model releases is given in many books, including *Photographer's Market*.

Legally, you do not need a model release if the purpose of a picture is to inform or educate (as in newspapers or textbooks), particularly if the picture was taken in a public place. Even in these circumstances, however, you may need one if the picture is used on a cover (which some say advertises the book or magazine) or if the subject is shown in a compromising situation (i.e., smoking marijuana, or implying immoral behavior).

Of course there are always exceptions to the above rules, such as people who are considered "public figures." Remember that it can be dangerous trying to simplify complex laws—laws that are subject to constant interpretation and change. And sometimes even having a signed model release isn't enough.

So what's a photographer to do? If we see an interesting picture, we usually go ahead and take it. Most of the time there are some markets that will use it without a release. (*Photographer's Market* or a company's photo guidelines usually specify when a release is required.) But whenever possible, we ask for one and try to get it signed on the spot. Offering the subject a free photo can help, and it's a small price to pay since a release can open up many more markets.

It's a good idea to ask family and friends to pose in pictures for which a release is an absolute necessity. Or hire professional models (though this can be expensive for a beginner).

Generally speaking, we've found that politeness and respect for other people's privacy can win friends and cooperation, both in getting good pictures and securing the necessary releases. It can also win customers.

MAINTAINING SLIDE FILES

As your photo collection grows, you'll need some way to store it—and some way to locate specific slides when you need them. An efficient and protective filing system is essential. Storing slides in projector trays just won't work any longer—not only do they take up too much space, they're expensive, and both slow and inconvenient when it comes to locating material.

Filing. The best approach is to file your slides in the same type of plastic pages you use for mailing them to direct submission markets. (See Chapter 13). A twenty-slide page, held up to the light, can be scanned in a few seconds when making selections to fill specific requests. The pages can be stored in ordinary file cabinets. Since they tend to sag—and thus warp slides—unless held tightly in place, some companies sell rails and holders that make it possible to hang pages in file drawers (see Appendix A).

We prefer filing the plastic pages in three-ring binders. Most such pages have holes punched for this purpose. With this method, one notebook (sometimes more) is sufficient for most major categories—a notebook for wild flowers, for example, and another for animals or birds.

Each page within a notebook should be restricted to a single subject; those subjects should be arranged in alphabetical order. Thus, the wild flower bind-

How to Create & Sell Photo Products

er might contain two pages devoted to California poppies, two featuring columbine, five of scenics with wild flowers, and so forth. If some slides seem to fit into more than one category, put a few in each place and cross-reference. You can make your cross-references on three-ring notepaper inserted with the page, or write the notation on a small piece of paper or cardboard and slip it into a slot on the plastic page.

We prefer a system of shelves, rather than filing cabinets, for storing our notebooks (see Illustration 12-4). Making your own shelves isn't too difficult and is considerably cheaper than buying filing cabinets. Binders are stored flat to prevent sagging, don't take up much space, and are readily at hand. For greatest convenience, those used most often can be stored close to your desk.

Identifying slides. Some sort of permanent numbering system for individual slides will make it easier to keep track of them. This may sound like a big job, but it's not too difficult to keep under control if you label and number each usable slide as soon as it arrives from the developer.

Illustration 12-4: *Slide books can be stored on shelves that keep them flat and easily available. A hinged door can be added when dust is a problem. (See Appendix G for construction techniques.)*

We use Roman numerals for general categories, letters for subjects, and Arabic numbers to distinguish individual slides. The wild flower binder, for example, might be assigned XI and California poppies designated Cp. Under this system, an individual poppy slide might be numbered "XI, Cp-1," the next, "XI, Cp-2," and so on.

These numbers can be noted on your carbon copies of the slide lists you send out (See Chapter 13). Then, if a firm requests that cetain photos be resubmitted at a later date (a common enough occurrence), you'll know exactly which ones to send.

This may sound like a lot of busywork when you're just starting out and have relatively few slides. But as your collection grows, you'll find it makes the whole handling process much more efficient. And it can be an overwhelming job if you have to go back and set up your filing system after you have several thousand—or even several hundred—slides.

The main purpose of all filing and numbering systems is to help a photographer organize his collection, make things efficient and convenient. So don't hesitate to combine systems, make changes, or do whatever is necessary to keep your own methods working as smoothly as possible for you.

Recording Sales. This, and the section on "Contracts and Rights" apply more to the direct submission of photos (as outlined in Chapter 13) than to photo products. It's also useful to keep a record of each photo that sells. This can be done by listing its identification number, along with each buyer's name and the rights sold, on a 3x5 file card. Code the slide or negative to show that it has a card on file (a star, asterisk, or other symbol will suffice). This system provides easy access to a slide's publishing record should a buyer request it. And sometimes publishers and manufacturers do wish to know where and how a photo has been used before they make a decision.

But before you begin submitting photos to editors and agents for use on others' products, you'll need to know something about contracts and rights as they relate to direct submission.

CONTRACTS AND RIGHTS

When you sell a photo, what exactly are you selling? The photo itself? No, not usually. On your photo products you'll be selling a print made from your negative or transparency; in direct submission, the transaction is more like renting. You maintain ownership through copyright of the photograph, and grant the right to use that photo for a certain agreed-on period of time. It is that right that you sell.

Depending on how (and how long) the photo is to be used, you may have to sign a formal contract. This is generally true when the buyer purchases exclusive product use over an extended period of time (state law usually requires that contracts covering a period longer than a year be in writing to be enforceable). In other cases, such as one-time use for a magazine cover, a letter or a verbal agreement is sufficient.

Before you start to send out your photos, it's a good idea to know exactly what you're selling. The most common rights of usage are described below.

One-time rights. The buyer wants to use your photo once—say in a book or magazine. You're free to sell it again as soon and as often as you can.

From your point of view this is an excellent arrangement, because your photograph can earn money over and over (some have earned $10,000 or more through repeated sales). It can even be bringing in money on your products and through direct submission *at the same time.*

First rights. First rights are one-time rights with an essential difference: The buyer pays for the right to be the *first* user of a particular photo.

Second (reprint rights). These are one-time rights you sell once a picture has been published. Sometimes the distinction is made between selling these rights to the original buyer (reprint rights) or to a new market (second rights).

Serial rights. If a magazine purchases serial rights, the photo cannot be sold to any other periodical (such as a newspaper or another magazine). It could, however, be used by a book or a greeting card firm. A magazine might buy these rights to prevent the picture from being sold to a competitor. And you should receive a higher price than for one-time rights only.

Exclusive rights. When you sell exclusive rights, it does not mean that you give up all rights to the photo. Exclusive rights are usually defined by some qualifying phrase. Church bulletins, for example, will wish to purchase exclusive church bulletin rights for one year. Or a greeting card firm may buy exclusive greeting card rights. That still leaves you free to sell the photo to books or magazines or anyone else whose rights don't infringe on those already sold.

Calendar companies frequently seek to purchase first rights, combined with exclusive rights through the year the calendar is dated. Since they are usually working two years ahead, your photo will actually be tied up for about a two-year period. For this reason you should expect and get higher payment than from other buyers who return your photo to the marketplace more quickly.

All rights. A few people will want to buy photos outright. We generally avoid this arrangement—if a picture is good enough for someone to want all rights, then it's probably good enough to sell over and over. Be particularly wary of contests that require signing over all rights to a winning entry, and of people who want all rights to a photo for very little money. If a photo is good enough for them to want total rights to it, it's good enough for you to sell over and over again.

If you do decide to sell a picture outright, you should be well paid for it. This is one reason why prices are so high for photos used in advertising—the purchaser often buys all rights.

COPYRIGHTS, PATENTS, AND TRADEMARKS

Any photograph that you sell or "rent" should be copyrighted. This is an easy enough process. Simply mark the slide mount or the back of the photo with the word "copyright" or symbol c. or ©, followed by the year and your name (© 1982 Carol and Mike Werner). This is notification to all concerned that you own the photograph, and that it may not be used for any purpose without permission.

When you sell a product, there is an actual change in the ownership of that product. However, you still retain the copyright for the photo on the product. But in order to assure that the ownership stays with you, the print you sell

must be marked with the copyright information. Mark framed prints, greeting cards, bookmarks, key chains, and other flat items on the back. Other products may be marked wherever you can find an inconspicuous space. Though it's wise to show a copyright line whenever possible, the odds of someone rephotographing and using one of your product photos is small.

If you happen to come up with a photograph that is truly one of a kind with great sales potential, you may wish to go a step further and register your copyright with the Copyright Office, Washington, D.C. Registration requires the mailing of a copy of the photo (in some cases two), an application, and a filing fee. This registration makes it easier to prove ownership should someone use that photo without permission.

Since most photo products are variations on existing ideas or products, it's unlikely that you'll ever need to apply for a patent. Should such an occasion occur, it's best to consult a patent attorney, since the process is long and complicated. To avoid infringing on someone else's patent, check the product for the words "patented" or "patent pending."

It's more likely that you'll wish to use a name or symbol to distinguish your products from others in the marketplace. In order to prevent others from using the same designation (or to find out if anyone's already using it), it's necessary to register your trademark with the United States Patent Office, Washington, D.C. 20231. Obtain an Application for Trademark/Service Mark Registration form from that office. When the form, an application fee, and a drawing of the trademark are returned to the Patent Office, you will be protected against infringement.

GUARANTEES

For most of your inexpensive products, there won't be much to guarantee, since little is likely to go wrong with a framed printing, a plaque, a postcard, etc. On the other hand, clockworks can fail, as can music box mechanisms or light switches, leaving you with an irate customer. Although you may not have to, guaranteeing your products where appropriate is a good idea. Try to keep your customers satisfied; it's cheaper to replace a clock movement than a customer. But don't saddle yourself with an unreasonable guarantee; put a limit on it—for example, one year from date of purchase for a clock (unless the mechanism is guaranteed by the manufacturer for longer). After that time, you can offer to replace parts for a set fee. As a guideline, use a guarantee wording similar to that of the manufacturer.

INSURANCE

Since your photographic equipment can be a major investment, you will probably want to insure it against damage or theft. If you already have coverage as an add-on to a homeowner's or renter's policy, be sure it's not restricted to nonprofessional use. If it is, you should get a policy for professional photographers. That will probably be more expensive, and for this reason you may opt to put it off until you can better afford it; however, the cheaper add-on will do you no good at all if you can't collect on it!

Liability insurance is even more important, especialy if you plan to work with models or hire employees. Accidents with equipment can and do occur in

a variety of unforeseen ways. And they can cause considerable personal or property damage. If you are found at fault, an accident could turn out to be very expensive; it could even put you out of business permanently! Liability insurance should be for a minimum of $1 million while at home or work (including traveling and photographing on location).

Most of the products you make will pose no inherent danger to the buyer (you could hardly be held accountable if an improperly hung clock or framed print falls on someone's head, for example—unless it occurred at your home or place of business). But if you open a showroom or a manufacturing plant, consider buying coverage to protect you in case an employee or customer is injured on the premises.

Talk your particular situation over in detail with your lawyer and insurance agent and then act on their expert advice. If you prepare for the worst, it will probably never happen.

PART
FOUR
USING YOUR PHOTO PRODUCTS ADVANTAGE

Chapter
13

WHAT TO DO WITH THE *REST* OF YOUR PHOTOS

In the course of your product photography you'll accumulate a great number of salable photos. These shots, and the experienced eye that made them possible, are themselves products (from our point of view, *by*products of our main business). There's no reason they should gather dust in your files when they could be out making money for you!

If you're like us, you may take twenty-five "near misses" before you get the shot that's just right for your products. You'll probably collect another dozen or so photos that have nothing whatever to do with products—you knew that when you pressed the shutter, but you took them anyway because they were interesting (or because a little voice told you they might be important). We trust those little voices (that's your subconscious idea generator talking). So in the course of photographing Yosemite National Park, we might collect not only the scenics we came after, but also shots of a controlled burn, a medical evacuation by helicopter, a rescue mission to pluck climbers off the face of a cliff, or even some children playing in the river.

How can you put these extra photos to work earning money?

There are two possible answers; one for the photographer who wants to pursue additional sales on his own, and one for the other who'd rather turn the job over to someone else. Assuming that the latter has more appeal to the busy photo products entrepreneur, let's consider it first.

STOCK PHOTO AGENCIES

If you don't have the time or inclination to search out direct submission markets for your work, you can get someone else to do it for you. You can have a photo marketing professional sell those extra slides lying fallow.

Essentially, that's what a stock photo agency does. Such agencies are, in effect, picture libraries with thousands or even millions of images on file. Most of the larger ones are computerized and thus able to locate a selection of photos on almost any subject quickly and easily—whether the client's interests are

How to Create & Sell Photo Products

highly specific (frog eggs on a reed, showing the developing embryo) or more general (a series of photos that "say" Seattle).

Stock photo agencies may be classified as follows:

(1) Large, broad-based agencies with files in a great variety of categories. They try to supply every subject a client could possibly want. (2) General agencies with a great variety of photos on file, but who also specialize to some degree. One such agency might be particularly strong in nature and wildlife, another might cater to the advertising field. (3) Smaller agencies that deal almost exclusively with one specialty—underwater photos, historical photos, etc.

Most stock agencies are located in or near New York City—where the majority of publication markets are—though they may have branches elsewhere in the United States or in Europe. Smaller agencies located in other cities often specialize in shots of their particular geographic areas.

An agency's customers can be almost anyone. In a single day, an agency might provide a series of scenic shots to a jigsaw puzzle manufacturer, a sequence showing the mating ritual of the red deer to a nature magazine, photos depicting the major food groups to a textbook publisher, and many more. They constantly supply markets with needed photos and, in the process, sell the work of a great many different photographers.

You could become one of those photographers. But, as with most things, there are both advantages and disadvantages.

On the plus side. (1) *Less work.* The largest plus is that stock agencies sell your work for you. A stock of photos placed with an agency can provide a steady supplement to your photo products income without a large time commitment on your part. And the right shot may sell again and again, sometimes totalling $10,000 or more in sales.

(2) *More money.* Agencies are professionals in the business of selling photographs. As such, they can negotiate with buyers to get the best possible prices for the pictures they sell. If you're an independent selling your own work, this is almost impossible unless you're already a "name." An agency can frequently get a better price for your work than you can, which can offset, at least in part, the commission you pay.

(3) *More markets.* Agencies have access to a wide range of markets, some of which may not be available to individuals. Often the needs of these markets are too fast-changing to be well served by a market guide. Other buyers may prefer dealing with stock agencies, rather than being deluged with individual submissions. For one reason or another, these markets are difficult to contact except through an agency.

Some of the highest paying markets are in advertising. Since much of the photography in this field is done on assignment, the beginner is pretty well locked out—except through a stock agency. Many background shots—those on which a picture of the product is superimposed—are supplied by agencies. This can be one route to the lucrative ad market (and some agencies obtain assignments for their clients).

(4) *Fewer wasted photos.* If you don't have the time or inclination for selling your own photos, a stock agency is an excellent way to market the photos you don't need for your products business. Rather than let them sit around in

your files, place them with an agency and let them provide some supplementary income.

And the minus side. If all this sounds like a pretty good deal, don't rush out to mail your photos to an agency until you've looked at the negative side. Consider the following before you commit yourself.

(1) *Individual effort*. No one, including an agency, will work as hard to sell your photos as you will. If an agency sends a selection to a calendar company, perhaps only one or two shots out of several hundred will be yours. On the other hand, if you submit to the same firm, twenty to a hundred (or more) can be yours alone.

(2) *Accessibility of photos*. If you're going to sell photos yourself or use them on products, they must be in your files. Once a photograph is placed with an agency, that photo is lost to you as far as product use is concerned. Your photos may be tied up for as long as three years—even longer—and you might be charged a retrieval fee if you want any or all of them back before your contract expires.

(3) *Numbers*. Until you have a large number of slides on file with an agency, you can't expect much of a return. Generally, this means an investment of *thousands* of photos, and that is a major investment indeed! The fact is, you'll have to do a lot of shooting to adequately serve both needs—yours and those of an agency.

As a beginner, you'll be in the position of a small frog in a big pond—a *very* big pond, in the case of some agencies. The rule of thumb that applies to frogs and ponds in this instance is: The more slides you have on file with an agency, the greater your sales will be.

HOW A STOCK AGENCY WORKS

As observed earlier, many photo buyers prefer to work with stock agencies rather than individual photographers. There are a variety of reasons for this, not the least of which is cost. If a textbook manufacturer needs a photograph of the Golden Gate Bridge, for example, it would be much more expensive to hire someone to take that shot than to send out a request to an agency—especially if both the publisher and the agency happen to be in New York. Of course, that publisher could search his files for a stock list from a San Francisco photographer, but going directly to an agency would probably be not only quicker and more convenient, it would also mean a larger selection from which to choose.

When the request comes in, the agency will select from the work of a number of photographers. If you have a Golden Gate Bridge photo on file, it would likely be included. This selection is then packaged and sent off. Should the publisher choose your shot, you and your agency will have made a sale.

The agency will deduct its commission (usually 50 percent) and send you a check for the rest. Some agencies pay as soon as they make a sale for you; others, on a quarterly basis. This will be spelled out in the contract you sign, along with other consideratons such as commissions and whether or not you can be represented by more than one agency. An excellent discussion of contracts and stock agencies in general can be found in *You Can Sell Your Photos*, by Henry Scanlon (see Appendix B).

Perhaps that 50 percent commission seems high to you. True, you could have made the sale yourself and pocketed the full price . . . *if* you had been aware of that particular buyer and his needs. The agency *was* aware, and that's why photographers pay them a commission. Besides, that's roughly the same commission (or dealer discount) that most retail stores expect when they sell your photo products. And the stock agency has a Fixed Overhead Gremlin all its own, just like the retail store does. In both cases, you pay them to sell, so you won't have to.

PHOTOGRAPHING FOR AN AGENCY

Even considering the disadvantages, you'll probably want to find an agency to represent your work, especially if you do a lot of shooting. Stock photo agencies are in the business of selling. They're looking for photographers whose work will sell and who will provide large enough numbers of photos to make representing them worthwhile. In fact, it will take 200-300 slides just to get your foot in the door at most agencies. Some may even want you to send as many as 500 in your preview submission.

The answer is to plan ahead. Whenever you take a photo safari, think of yourself as shooting for three: your photo products business, your own freelance files (we'll talk about direct submission of photos later in this chapter), and the files of the photo agency of your choice. This means expanding your horizons, taking a variety of approaches to each subject. An afternoon in a mountain meadow, for example, might result in the following photographs:

For your products—locally popular flowers; flowers with a particular geographic feature, such as a mountain peak, in the background; a doe and fawn grazing in those flowers.

For your stock files—soft-focus mood shots, such as a single flower against the color blur of similar flowers, that leaves space for a message.

For your agency—doe and fawn behavior, close-ups of various flowers for identification purposes, scenes containing people, and also a variety of photos with message spots.

Naturally these categories will overlap. You must decide the best way to market each photo, although in some cases more than one approach is applicable. You could, for example, use a shot on your products and also submit it to a magazine publisher (where it won't be tied up for very long, and where only one-time rights are sought). You could also submit a *similar* shot to a greeting card or calendar firm (where the photo might be out of your hands for a year or longer).

Any photo you send to your agency will be out of your hands for at least as long as you remain with the agency. And it doesn't help to take two shots that are exactly the same—one for your files and the other for your agency—because it's standard practice for stock agencies to require exclusive use of the photos you place with them. However, you can and should shoot all subjects from different points of view: that way you'll have photos to use for all three situations.

What kinds of photos are agencies looking for? The large general agencies collect photographs of almost everything. Many agencies send their photographers periodic newsletters, needs lists that highlight the requests of

their customers. Illustration 13-1 shows a list compiled from several such sources; you can see how broad and how varied agency needs can be.

Some types of photos sell better than others, and the best-selling pictures convey a message (see Chapter 4). For example, pictures that "say" San Francisco, Minneapolis, New York, or even "city" can be very successful, as can those that communicate love or anger or tenderness or other human emotion. Such shots can sell over and over again in a variety of situations.

If a picture buyer wants to illustrate the sufferings of shy children in school, he will choose a picture that communicates this idea—not the most creative one, nor the most original, but the one that best delivers the message. As you photograph for stock agencies, keep this in mind: Whenever you can, deliver a message, though the approaches you take can be as diverse as your imagination.

Some subjects are always in demand, such as attractive couples of all ages doing things together—sailing, biking, talking over a candlelight dinner, strolling through a scenic meadow—almost any situation imaginable. But if those people can be identified, most agencies will require model releases (see Chapter 12).

Other popular subjects include individual attractive men and women, seasonals, babies, scenics, family life, and tourist attractions. People pictures are good sellers, especially ordinary people in everyday situations. And as might be expected, pictures of happy people sell more often than gloomy ones.

Picture agencies also reflect current trends in their needs. Today, behavioral photos of animals are more in demand than portrait-type shots. All energy-related subjects—windmills, solar heating, etc.—are presently being sought and probably will be for some time to come.

Try, when possible, to avoid dating your pictures. Automobiles and clothing styles change often and can make a picture look old-fashioned quickly, thus limiting its usefulness to a stock agency. An exception would be, say, a fifties photo used to illustrate an article on that subject.

Broaden the sales potential of your slides. Making your photos say something and leaving space for a commercial message are two ways to broaden their appeal. An image that speaks clearly of love can be used in many situations, whereas a shot of a tomato horn worm will probably have a limited number of buyers. Both will be of interest to an agency, but the first can be expected to earn more money.

There are other things you can do to make your photographs more valuable to an agency—and to you. One, as mentioned earlier, is to obtain a model release where necessary. Although an agency might sell a photo to some markets without a release, that shot will be excluded from many others—including the highest-paying of all, advertising. And there's an increasing likelihood for any legal action resulting from lack of a model release to end up on the photographer's doorstep. It is your responsibility to get that release, and to protect yourself.

Although you will generally keep the actual form, the fact that a release is available should be noted on the slide mount. The rest of the caption material on the mount should be as complete as possible—remember, you won't be able to add anything once it's in your agency's files. For animals, plants, and

How to Create & Sell Photo Products

other nature subjects, captions should include common and scientific names and the place the photo was taken. (If you took the shot in a zoo but it still looks natural, you might indicate the animal's range in your caption.) A slide labeled "KIT FOX" might find a sale in a general article on foxes. If, however, it were labeled "KIT FOX—*Vulpes macrotis* (Endangered species). Range: San Joaquin Valley, CA.," the photo could be used in articles on endangered species, on the San Joaquin Valley, and perhaps in a regional animal identification book. Complete labeling will have broadened the appeal—and the salability—of the photograph.

All slides should be imprinted with your copyright information—prefer-

Illustration 13-1: *A list of requests compiled from several stock photo agencies.*

Honeycomb with bees leaving and entering—Horses: especially verticals—Fossils: all types—Tennessee walking horses—All types of energy: solar, wind, geothermal, woodburning, installing insulation, etc.—Close-ups of black panthers—Grizzly bear in threat display—Whales breeching—Birds migrating—Fish spawning—Dairy farms—Trucks on highway—Art class with people working with clay—People outdoors having a good time—A group of different-size seeds—Package of tomato seeds opened with some seeds showing—Rosebush stalks—Wheat growing—Photos that indicate motion and speed (but not too blurry)—Birds fluffing feathers to keep warm—Interesting backlit images—Traffic light with green light showing—People at indoor concerts—Eagles in flight and in nests—Green polar bear (due to algae in water)—Angry cat with hunched back—Cat showing affection by rubbing against leg—Cat drinking from water dish—Dogs of all breeds—Photos that indicate Christmas—Airplanes seeding clouds—Rats or mice in a laboratory setting—Markets in Moscow, Russia—Seed sprouting and growing into plant—Birds in cities—Feral animals of all kinds—Weight lifter in action—Australian earthworm—Bloodhounds at work—Microscopic shot of grain of sand—Camels—Israel—Weddings—Strait or Canal of Hormuz in Iran—Winter in Chicago—Young women in spring fashions—Iranian women in traditional clothes—Contrast of Islamic and Western clothes in Iran—Cowboys—Newborn animals—Time-lapse photography of a flower opening—Aspen, Colorado—Woman basketball coach—Tumbleweed—Mirage—Vicunas, llamas, and pronghorns grazing—Latin or Hispanic women in office atmosphere—Mansions of San Francisco—Greece—Kangaroos "boxing"—Spider monkey—Snail darter—Dusky seaside sparrow—Plains prickly pear cactus—Shooting star—California poppy—Teddy bear cholla—Beaver-tail cactus—Calla lily—Poinsettia—Bird of paradise flower—Common camellia—Lemon bottlebrush—Lake Placid in New York—Commuters—Conductor on a train—Hashish—Hawaiian honeycreeper—Cape Town, South Africa—Finland—Sweden—Children learning to ski—Heart-shaped plants—European hare—Deaf-mute using hands to talk—Poison leaf frog—Cheerleaders—Black Hamburg Barbarossa grape—Lancaster, Pennsylvania—Cherry blossom festival in Japan—Sports stadiums—Hurricanes—Tornadoes—Animals in hibernation—Volcanoes—Apple trees—Imported cabbage worms—Columbus, Ohio—Cattle—Teenagers—Woodpecker pecking—Locomotives—Airports—Children—Great Wall of China—Group of children in classrooms—Honey locust tree—Buffalo gourd—Good-looking men and women on beaches—Sewage being dumped into the Mediterranean.

rably on the side of the mount. Your agency's guidelines will tell you whether to include your address or phone number (agencies have their own address labels).

If you choose one of the specialized agencies, rather than a general one, all your submissions must, of course, be related to that specialty. Their guidelines are the best source of information about their particular needs.

CHOOSING AN AGENCY

Choosing the right agency for you is very important. You'll be locked into a partnership for the duration of your contact—for as much as three years or longer—so you want to be sure that agency has the best chance of selling the kind of work you do. Switching to another, more promising agency before your contract has expired isn't always possible, since some agencies take a dim view of photographers dealing with more than one agency at a time (although we've heard of photographers who've gotten around this restriction by marketing under two or more different names).

So how do you go about picking that right agency?

If you know some photo professionals—photographers, gallery owners, camera store personnel—you might ask for their recommendatons. We did this and got one very negative observation that steered us away from one of the major agencies. But don't be surprised if all you get is a blank stare. It's surprising how many professional photographers have never heard of stock agencies.

Follow up any recommendations you get (or don't get) with some further research of your own. This research can be done while your looking for the direct submission markets discussed later in this chapter.

Look at photos that are similar in content to the ones you take. Check books, magazines, encyclopedias, textbooks, or anything that uses pictures, photo products included. Note the agencies whose names appear most frequently with your kinds of photos. In photo credits, the name of the photo agency is often included after the photographer's name.

Then check those names in the appropriate sections of *Photographer's Market*, *Literary Market Place*, or *Photography Market Place*. All list stock agencies along with information about their operations and specialities.

One word of caution: Tread carefully when it comes to recently established agencies. Again, there are pros and cons. A new agency will need photographers and may be more willing to give consideration to a beginner. And they'll certainly need pictures, so you can probably get large numbers of slides on file right away—slides that might be returned by larger agencies simply because they have too many of that kind already. Since you can place more slides, it follows that you'll make more money, right?

Maybe.

Sales don't come without customers. You may have to suffer along through the growing pains of that new agency for the time it takes to build a reputation and accumulate buyers. If the agency makes it, you could be in great shape, having gotten in on the ground floor. If they go under, your slides may go with them.

Older (pre-1981) editions of *Photographer's Market* tell when most agencies were established. You can also get a pretty good idea of the size of an agen-

How to Create & Sell Photo Products

cy (and from that, draw a conclusion as to how long it's been in business) from the number of photos it has on file. Again, check *Photographer's Market* for this information. Agencies listing only a few thousand images probably haven't been at it very long; those whose listings run into the millions are very big operations where a beginner's work might have too much competition. For this reason, it's a good idea to try for a medium-sized agency—one whose listings run in the hundreds of thousands of photographs.

Stories continue to circulate about agencies who sell photos to foreign markets (or other markets they figure a photographer won't see) without paying compensation to the photographer. While the majority of agencies are reputable, these problems do exist, which makes it all the more important to investigate your choice as thoroughly as possible before signing a contract.

SUBMITTING TO AN AGENCY

The first step is to query. Ask for guidelines and a current needs list, if available. The guidelines will give you a general idea of how the agency operates, the format they prefer (35mm, color, etc.), the number of photos they wish to see, and how those photos should be labeled. The guidelines tell you *how* to submit your work; the needs list will give you a clearer idea *what* to submit.

Some agencies may not be interested in adding new photographers. If that's the case, you want to know it. There's no use wasting time and postage on someone who's not interested.

Also request a sample copy of the agency's contract. They may or may not send one (if they don't, that may tell you something too!). The contract will tell you what rights the agency expects. There are often clauses specifying how long you must leave your work on file, the agency's commission, and whether or not representation by more than one agency at the same time is taboo. (Some photographers do sell their work through more than one agency, though usually they'll choose firms in different parts of the country or with different specialties.) If there are conditions in the contract you find unacceptable, you may be able to have them changed. Or you may have to seek a different agency.

Follow the agency's guidelines for submission and include a SASE. (More about packaging your slides later in this chapter.) Even if that agency decides to represent you, they probably won't keep your entire submission. They'll pick the shots they want for their files and return the rest to you.

All in all, a stock photo agency can be an excellent (though relatively passive) adjunct to your photo products business. If, however, you have time for more active involvement, direct submission may be the answer.

DIRECT SUBMISSION

If the statement "No one, including an agency, will work as hard to sell your photos as you will" is still ringing in your ears, and if you don't like the idea of losing that 50 percent commission, you might consider doing the selling yourself. You'll have to invest a fair amount of time and effort, but it may all pay off in the long run through increased sales. As you build up a "track record" with photo buyers, they'll start coming to you—in effect, you'll become your own mini stock agency.

The Rest of Your Photos

Attaining that enviable track record will be much easier for you because of your photo products experience. You will have developed an eye for what sells; the photographs you submit will herald this. Buyers will come to you because they know you can deliver what they want and need.

About the time we really got our photo products business going, there was a substantial upswing in the number of sales we were making through direct submission. Is there a correlation between the two? We think so.

Consider these points:

First, if you've conscientiously done market research for your own products, you know the kinds of photos that will sell in your area. You also know what other photographers are selling locally, in places you've visited, and to major manufacturers. The same people who buy your photo products also buy the greeting cards, posters, calendars, and what-have-you produced by those manufacturers. Your photos have become more salable in direct submission because you have researched the market (just as the big firms have) to determine the tastes of the buying public, and you have proven the results of your testing through your own products.

Second, photo products call for total honesty in evaluating your own work. "Well, *I* like it!" isn't good enough. Again, the important test is the marketplace: Will people buy it on your line of products? The final answer is undeniable: Either a photo sells well or it must be replaced. Salability is your primary concern, just as it's the primary concern of the major manufacturer.

Of course, not all photos can be judged by how successfully they sell as photo products. Many will be better suited to other markets, such as books, magazines, brochures, and film strips. Researching these markets has a lot in common with product research, and, again, the skills you've already acquired will give you a definite advantage.

With your own photo products you had to become the editor. You had to look at your work as though it were someone else's and pick the photos your research indicated would sell. Now you can turn this objectivity to the selection of photos for direct submission. Some "pretty good" pictures may get tossed aside in the process, but the long-range result will be improved sales. Not only will you improve the percentage of acceptances, you'll be more likely to *shoot* salable photos because you are more alert to the demands of certain markets.

EVALUATING PHOTOGRAPHS FOR DIRECT SUBMISSION

Before you begin your market research, you'll want to take these two steps: (1) evaluate and organize your slides from a direct submission point of view, and (2) determine what your specialties are. These steps will help give you a clear idea of the direction you want your photography to take, and show you where to start your research.

Step one—evaluation. In Chapter 2, we suggested you take some time to evaluate your photographs. The purpose of the critical overview at that point was to help you determine the photo products possibilities of your collection, and the directions your future efforts should take.

Another look at those lists now can help you organize your direct submission strategy. If most of the photos listed are black and white, then you'll need to locate markets that use mostly black-and-white. The majority of these buy-

ers want shots of people or products or both. Since selling to these markets is not a natural adjunct to a photo products business, we won't deal extensively with them here (but the same techniques for researching other markets can be used for these as well).

Black-and-white scenics will find only a limited number of buyers, many of whom are interested primarily in article/photo packages. If such photos are your primary interest, consider honing your writing skills to make your photos more salable.

The situation is much more promising for color, if your photos are slides. While negative-type film works fine for products, most direct submission buyers prefer to see slides exclusively. So if you're serious about pursuing this market along with your products, use color transparency film (Kodachrome 25 or 64 for 35mm cameras, Ektachrome 64 for larger formats).

If you shoot both black and white and color, there's no reason you shouldn't continue to do so. Many photographers submit both at the same time.

With that in mind, let's consider how one could take maximum advantage of a specific event—a rodeo, for example. Some of the events—bulldogging, roping, bronco busting, fancy dress parades—would make colorful subjects for your products line, if you can photograph them in such a way that there aren't identifiable people or personal property, or if you can obtain the necessary permissions. In shooting your way around these restrictions, you'll probably end up with a lot of photos that can't be used on your products. Since this is more or less inevitable, why not do some advance planning that would make these photos suitable for direct submission? Before you go, spend some time scouting possible markets and keep their needs and preferences in mind while you're shooting. Broad-view horizontal shots, for example, might be appropriate for some calendar companies you're interested in, whereas verticals with a clear area at the top for a title might be of interest to rodeo publications. Such magazines might also be looking for technique shots in both black-and-white and color. Unusual or effective action shots might be of interest to "how to" photography books.

It's not unusual at such events to see a photographer using two or more cameras—one for black and white, another with a standard lens for color, and perhaps a third with a telephoto. And as if that's not enough, some even add a larger-format camera.

And while you're there, don't forget to keep your eyes open for salable shots that have nothing to do with the rodeo. A charming little girl with an ice cream cone (and maybe with ice cream on her face) might sell to a local newspaper. A charming elderly couple in the audience might make a suitable cover for a church bulletin.

Opportunities are where you find them. A case in point: Remember that photo buyer we mentioned in Chapter 1, the one who spoke in terms of a thousand or more slides from a single photographer? Out of the many thousands that publisher receives, they buy only fifty-two a year, and one year one of them was ours. Was it some fabulous scene of rare beauty accessible only to a daring adventurer? Not at all. It was a picture of a pomegranate taken on a sunny morning in a neighbor's backyard. The assignment we had set for ourselves

that day was to photograph Monarch butterflies for our products, and their life cycle for our stock files. The pomegranate was a bonus.

Though your products photography can help, acquiring enough photographs suitable for direct submission is a problem for beginning photographers. That one great horse shot that so many different photo products were based on won't account for very many mailings to editors and other buyers. For that purpose, you'll need at least forty such shots—twenty verticals and a like number of horizontals. While occasionally an editor will prefer to see fewer, it's common practice to send a full plastic page (more about this later) of slides—twenty 35mm transparencies or six 2¼x2¼-inch transparencies. That way a quick glance will show that all photographs have been accounted for.

Why twenty of *each*? Some editors, of course, will look at both. But a horse magazine may prefer verticals for covers, while a calendar may use only horizontals. Good market research can help insure that you send editors only what they need.

Twenty is a good figure to aim for in all the major categories on your photo lists. Consider it, however, a good *starting* figure. Stock photographers add to their files constantly and you will too. Whether you make a sale or not, you may wish to follow up that initial submission of twenty horse photos with another one in about six months. By then, you'll need twenty different photos.

And, as mentioned earlier, some buyers expect and receive submission of a thousand or more slides from individual photographers. Chances are it'll be a long time before you're mailing off slides on such a grand scale. In fact, buyers who'll look at that many are pretty rare. Some may request that you send no fewer than 100; others place the responsibility of preliminary editing on your shoulders by specifying that you send no more than ten or twenty of your best photographs. Over the wide range of photo buyers, submissions of 60-100 slides are about average, and represent a good production goal to set for yourself.

Step two—specialization. For the purposes of direct submission, it helps to have a specialty—that is, some area that particularly interests you, one in which you have greater-than-average knowledge.

It doesn't have to be the subject area in which you've taken the most photographs. For most photographers, this largest grouping will probably be scenics. While your products experience will help you sell to the highly competitive markets that buy scenics, your specialty should be something else.

Look beyond your scenics. Examine the other major categories in your photo collection for interests that can be expanded into specializations. If you have a number of good sailboat photographs, this might be a good choice, especially if you enjoy sailing yourself and have a lot of contacts within the sport. The same could be said for any number of sporting or other activities, as long as there's a market for the photos you take.

Your own photo products can suggest specialties. Look for subjects with good sales records, then see if they are applicable to the direct submission market. If so, you can make your photo time pay double dividends, as in our rodeo example. A photographer who turns out a line of ski-related products could probably turn winter itself into a speciality. Certainly the chill factor thins out the competition, and this points out another consideration in picking your spe-

How to Create & Sell Photo Products

ciality: The tougher the subject is to handle (or the more specialized the knowledge or equipment it requires), the less competition you'll have. When snow and ice and biting cold drive other photographers indoors to a warm fire, you can turn out roll after roll of dramatic winter scenics, outdoor action shots, and pictures of animals in the snow that will not only sell on your products, but also to other companies for their calendars and greeting cards, to ski, outdoor, or nature magazines, and to many other markets.

A number of subjects that do well on products—wild animals, old cars, good things to eat, hot air balloons, you name it—will also have direct submission markets, to greater or lesser degrees. Explore all the possibilities in each and every case.

If you've photographed some classic cars for key chains or cards, why not try a picture story about the preparation of such a car for a concours d'elegance? Or a photo series about customizing a stock car or building a kit car? Or take in some nearby auto races, camera in hand. There are magazines that need these kinds of photos, both in black and white and color, on a regular basis.

And if your good-things-to-eat shots have sold in kitchen stores as photo clocks or trivets or wall decor, they can also sell to calendar firms or magazine editors. Or those shots can help you secure local assignments. Talk to the people who sell your products: Let them know you're available. Perhaps they need photos to promote cooking classes, a home show, or whatever. Or, they may be able to suggest someone who does. Use these opportunities to add to your stock photo file by obtaining model releases. The same is true of any situation involving people; there's always a great demand for photographs of people doing things. And that means almost anything—we once had a request for a picture of someone biting an apple.

A person at home with pre-school children might begin by producing photo products aimed at this age group—large, whimsical animal prints for room decor, for example. Photographs of the children themselves probably won't be well suited to products, but they can be perfect subjects for direct submission. Publishers of textbooks have a constant need for photos of children doing all sorts of things—playing with each other or with adults or pets, studying, etc.—as do publishers of children's, parent-oriented, and religious magazines, calendars, posters, and greeting cards, to name a few possibilities.

Make use of any special opportunities available to you. If, for example, you happen to be in the military (or have access to the military market) and have developed a line of products for that market, consider also the potential of direct submission. Numerous magazines slanted toward the armed forces are looking for photos of everything from amusing on-base signs to military equipment (antique or modern) to on-duty and off-duty life. But that's only the beginning. Many bases are as large and complex as cities, with a corresponding wealth of photo possibilities for more general markets as well.

While you're going through your photo collection, take some time to examine other areas of your life—past or present jobs, for example—for possible specialities. Someone who's worked in medicine would have an inside track for medical photos or perhaps access to photomicrography equipment (a microscope with necessary camera attachments). If you're a teacher, you might pho-

tograph your students (though you'll need model releases) or an avid gardener could photograph individual plants and flowers or whole gardens—both his own and his friends or other peoples' from whom he's secured permission.

It's important to expand your horizons, to use your knowledge of special subjects and the marketing expertise you've developed in your photo products business. They can give you that critical edge in these difficult markets.

MARKET GUIDES

By this time you have determined some possible directions for your photography; the problem now becomes one of finding out just how promising those directions are—in short, how to find likely markets. As with photo products, the first step in moving into any new area is market research. The point cannot be stressed too strongly: *Time spent in research will pay off in sales!* Editors buy photos because they *need* them. In light of that, you must find out two things: (1) who needs the general kinds of photos you take, and (2) how you can meet those needs in the future. You not only want to sell the shots you already have, you want a continuing market for those you're going to take.

However, keep an open mind toward other, more promising directions. You may feel you already have enough subjects to work with, but occasionally your research will turn up something that's so right, so perfect for you, that you'll wonder why you didn't think of it earlier. Any serious photographer is always on the lookout for new ideas—both for photography and marketing.

The best place to start your research is with any of the variety of market guides available at your local library or bookstore. The best-known include: *Photographer's Market*, *Where and How to Sell Your Photographs*, *Photography Market Place*, and the marketing newsletters (see Appendix B). All these references can be useful in locating buyers.

Each one, however, is a little different in its approach. The most extensive is undoubtedly *Photographer's Market*, which lists more than 3,000 photo buyers. Updated annually, this book tells what each buyer is looking for, how much each pays, and whom to contact regarding submission or more information. Editorial material (on pricing, making contact with publishers, and the business of freelancing) is found at the beginning of the book and in each separate market section, but the emphasis is on identifying buyers.

Where and How to Sell Your Photographs has longer editorial sections and lists fewer markets. It provides a slightly different slant on the subject of selling photos than *Photographer's Market* does, and offers some additional picture buyers.

Photography Market Place is more of a general reference than the other two. While it does list some picture buyers, it's also a sourcebook for photographic services. For example, it lists custom laboratories, camera repair services, special services such as retouching or photo coloring, equipment sources, modeling agencies, package express companies, publishers of photo books, and so on. It does not, however, include the detailed information about each picture buyer that is found in *Photographer's Market*.

Each book is useful in its own way, and any time spent studying them is worthwhile.

Marketing newsletters. The market guides discussed above offer

general information regarding buyers' photo needs. More specific information can be obtained from any of several photo-marketing newsletters listed in Appendix B. All are sold through subscription (current prices range from $20 to $75); their main goal is helping photographers sell their work.

There are both advantages and disadvantages to using any market guide. On the positive side is the fact that they make so many markets readily available. It would take you years to discover even a small percentage of those markets on your own.

But easy availability can also be a disadvantage. Some of the listed markets—particularly those that pay well for scenics—are deluged with submissions. Discouraging though this may be, keep in mind that your products experience can give you a better chance with these high-paying markets because you'll be better able to judge their needs. Your refined editor's eye and practical marketing knowledge will help you beat the competition in even the toughest direct submission markets.

ORGANIZING YOUR MARKETING INFORMATION

Keeping track of your submissions, of promising markets and the changing needs of buyers, of what did and didn't work—of all the information that accompanies the coming and going of slides—may not be too difficult in the beginning. But the more shipments you send out, the more quickly this information accumulates, and the easier it is to forget what you sent to whom and why. And why not. And whatnot.

It's wise to develop a system for recording this information right at the start. One way is to enter it on 3x5-inch or 4x6-inch filing cards as shown in Illustrations 13-2 and 13-3. Let's see how this would work for a photographer who's interested in the tough scenics markets.

```
CALENDARS                        File date:   July, 1982

Martha Mew, Art Director
M & A Calendar Company
624 First Ave.                   Guidelines available
Purrington, W. Va.   000½        Pays:  $200 per photo

Subject needs:  cats and dogs in cute situations

1.  Query letter with request for guidelines mailed
       July 14, 1982

2.  20 color transparencies mailed July 30, 1982

3.  Slides returned Nov. 15, 1982.  Purchased photo of
       cat peeking through hole in fence--VI-Ca-24
       [Code number of slide]
```

Illustration 13-2: *A sample index card for paper products.*

```
HORSES                            File date:  May, 1982

Frank Colt, Editor                Guidelines available
NEIGH Magazine                    Sample copy:  $1.50
407 Mare St.                      Pays:  $25 to $100
Gelding, Montana  100,001

Subject needs:  horses & people with horses
Issue research:  May, 1982
   26 photos:  21 b&w, 5 color; 14 vert., 12 horiz.;
      22 with people, 4 horse scenics
Notes:  Most photos show people at a horse-related event.
        22 accompany articles.

1.  Query letter & guidelines request mailed June 14, 1982.

2.  20 color transparencies mailed July 8, 1982.

3.  Slides returned July 28, 1982.  Purchased photo of
    horse w/sunset--VI-Ho-8 [Code number of slide]
```

Illustration 13-3: *A sample index card for a magazine market.*

Manufacturers of calendars, posters, greeting cards, and related items are listed under "Paper Products" in *Photographer's Market*. Read through the editorial portion of this section; study the listings. When you find one that sounds promising for the kinds of work you do, write it down on a card. Each card should include the kind of product (calendar, greeting card, or whatever), the name of the company, the editor or other person to contact, and the address. Also list any stated subject needs, whether photo guidelines are available, and any pertinent pricing information.

The card is also a good place to record communications with each firm—query letters, slides mailed, even that first sale. And when you do start to sell, you'll often get a marketing reseach bonus: special needs lists that editors often send to photographers they've worked with. It's one of the benefits of becoming known, and you should add any of this special information to the appropriate card (or add a reference to it and keep the list itself in your files).

When you've exhausted the "Paper Products" possibilities, use the same approach on other sections of the book—numerous magazines, for example, use scenic photographs. Don't forget to also look for markets for your specialties.

It's not enough just to check the index. Say you're looking up horses. Since listings are alphabetized by magazine title or firm name, you would find such periodicals as *Horse, Of Course!*, *Horseplay*, and *Horseman*, but you'd miss *California Horse Review* and *Quarterhorse Journal*. And what about calendar or greeting card companies that also use photos of horses?

Again, make a card for each possible market. We'll discuss the issue re-

search data shown in Illustration 13-3 a little later in this chapter.

The advantage of cards is that they can easily be updated or replaced as addresses and marketing needs change. The file itself can be a ready-made container from a stationery store, a simple shoe box, or why not one of your own photo boxes?

When you've completed your research in *Photographer's Market*, repeat the procedure with the other two market guides. Add any other marketing information you obtain from these sources to your card file.

RESEARCHING YOUR OWN MARKETS

Although the guides discussed above can be very useful, the most valuable markets might well be the ones you find on your own. Why? Because for one reason or another those markets have avoided the spotlight and the deluge of submissions. You'll have less competition in the markets you locate yourself than in those someone else has located for you (and for thousands of other photographers!).

Tracking down periodical markets. Your basic reference for this research will be *Ulrich's International Periodical Directory*. Your library probably has it or can order it for you. *Ulrich's* lists periodicals by subject (so you can look under "Horses and Horsemanship" for a complete listing of magazines that might be suitable for those horse photographs). Check the titles against those you obtained from the market guides and fill out cards for any you may have missed. If you find a magazine not listed in any of the guides, make a card for it, too—it could turn out to be one of your best markets, but you'll have to do your own follow-up research.

Next, go to your library's periodical room or reading area and take a look at the magazines themselves. Do this for all your listings, not only those you located yourself. Study three or more issues of each magazine, paying particular attention to the photographs. Again, as you did with your own work, make lists dividing them into categories: color, black and white, horizontals, verticals, close-ups, grand vistas. Do people dominate most photos, are they incidental, or are they totally absent? Do the photos accompany articles or are they used as fillers with captions only? Try to learn as much about them as you can and record the information on the appropriate file card.

If the publication isn't available through your library or newsstand, write to the subscription department, including cover price plus mailing costs. If the magazine has photo guidelines available, address your request to the appropriate editor. Always be sure you enclose a SASE.

Direct your research toward determining the kinds of photographs each magazine uses, and then tailor your submissions accordingly.

Tracking down book markets. While at the library, look up your specialty subjects in the card catalog. Then head for the shelves and browse through the books. Many a nonfiction book makes ample use of photography these days, and a little study can pay dividends in two ways. First, you can get a good idea of the kinds of photos used; second, you may find some new markets.

After all, book publishers have to buy pictures from someone. That might as well be you!

[Your letterhead goes here.]

Dear Publishers, Editors, and Art Directors: Below is a partial listing of
20,000-plus color transparencies we have on file in both 35mm and 6x4.5cm
sizes. Our work has been published in magazines and books, and on calendars,
greeting cards, and a variety of other photo products. Recent sales include
a cover for the HP Books, three covers for CALIFORNIA HORSE REVIEW, THE
PARAMOUNT LINE greeting cards, and both the 1982 and 1983 BO-TREE calendar
line.

Animals (domestic and wild)	Monterey, CA
Agriculture/California	Mountains/all seasons
Autumn color	Mountains/sunsets
Boats/many kinds	Mushrooms/California
Butterflies	Nevada
Cable cars/San Francisco	Ocean scenics/Pacific
Cactus	Ocean sunsets by the score
California poppies	Orchards/spring and fall
Carmel, CA	Oregon
Cats	Pelicans
Cattle	Redwood forests
Craftspeople at work	River rafters & kayakers
Crop dusting/California	Road signs
Cross-country skiing	Rocks and minerals
Deserts (scenic, flora, fauna)	Roller skaters
Elk, tule	Sailboats
Experimental/Kodaliths w/color	San Francisco/many photos
Farm machinery/antique & modern	San Joaquin Valley, CA
Fishermen & fishing boats	Sea lions
Flamingos	Sea otters
Forests (evergreen & deciduous)	Seashells/local & exotic
Fossils	Sequoia National Park
Frogs (incl. albino)	Silhouettes w/sunsets
Garden plants	Snow scenes
Gardens (formal and informal)	Somali Republic, East Africa
Geology	Special effects
Ghost towns	Spiders/macro of life cycle
Gold country/California	Sunrises
Hang gliders & Ultralights	Sunsets
Horses	Tidepools
Humorous signs	Underwater photos
Insects/macro	Vegetables
Kings Canyon National Park	Washington State
Landscapes w/full moon	Wetlands/wildlife refuges
Lizards	central California
Marshall Islands	Wild flowers/hundreds of
Military aircraft	varieties
Missions/California	Yacht racing

Illustration 13-4: *One format for a stock photo list. Type out your own list on your business letterhead and have copies run off by your job printer or on a photocopier.*

As you thumb through the books, try to determine whether the photos were supplied by the author or whether they came from a variety of sources. Picture credits are located next to the photo or in a separate list in either the front or the back of the book. If a number of different credits are given, the photos were probably supplied by freelancers like yourself, or by stock photo agencies.

The publishers who draw from a number of photo sources are the ones of greatest interest to you. Add their names to your card file. Check around to see what other books they've published. The more books they turn out on your specialty, the greater your chances of making a sale.

If the publisher's address is listed, add that to your card. If not, try *Literary Market Place* or *The Thomas Register*, available in the reference sections of most libraries. If you still can't locate an address, ask the librarian—he or she can be an important ally in your publications research.

Since book publishers don't have the same consistent need for photos as magazine publishers, a slightly different method of making contact is in order.

First, type up a list of the stock photo categories you have on file. Be as specific as possible, since potential buyers will decide whether or not to contact you on the basis of this list. For example, "Agriculture, crop-dusting" might get a response, while a simple "Agriculture" might be passed over. "Mountains—fall color" might get a call more often than "Mountains" alone.

On the other hand, a stock list can get too long. Four or five pages probably won't get any better results than one. In fact, with busy publishers (and those who aren't busy don't stay in business long), a single well-organized page may do much better. So try to be complete, but limit yourself to one page (two columns) and use your business letterhead.

A note of caution: Don't include a subject until you're prepared to deliver a reasonable selection of photos. One great shot just isn't enough to justify a separate listing. Earlier we mentioned twenty (enough 35mm slides to fill a plastic sleeve) as a minimum figure. This also applies to photo subjects on your stock list. Thus, if you have a terrific shot of a bald eagle feeding her chicks, don't make an "Eagles" listing unless you have nineteen other good eagle photos. Include the shot under "Raptors"—if you have at least nineteen other bird-of-prey shots—or a more general "Birds, nesting" category. Of course, there are exceptions to every rule. If an editor contacts you with a specific request—"Hey, I need a terrific shot of a bald eagle feeding her chicks. Have you got one?"—by all means send it off, even if that's the only photo you can supply.

It's also a good idea to include on your stock list any published photo credits you may have, an estimate of the total number of slides you have on file, and their sizes (35mm, $2\frac{1}{4}$x$2\frac{1}{4}$, etc.). However, if your total number is small (and in the beginning, it probably will be), it might be best not to mention it. No one will be impressed to know that you have fifty slides—wait until you can safely speak in terms of thousands.

Have your list duplicated. Most quick printers can run off a few hundred copies for a reasonable price if your list is camera ready (exactly the way you want to see it in print). Or, in the beginning and while your list is still growing, you may wish to run off only a few photo copies. Later, when you're ready to

order 500 to 1,000 copies at a time, more professional-looking results can be obtained by having your printer set the list in type, possibly including a photo or some color to make it more striking.

Mail off the lists to as many publishers as you can locate who might be interested in the kinds of photographs you take. Your initial research will give you a place to start, but continue to pursue new markets at every opportunity. The more lists you send out, the more editors are likely to contact you about your work.

Of course, not everyone will be interested. Some you may hear from right away. Others may contact you six months to a year later—long after you've forgotten you've mailed them a list. Many you won't hear from at all. But if you've done your research carefully and judged your strengths accurately, you stand a good chance of success.

Tracking down paper products markets. Much of your initial research in this area has probably already been done in connection with your photo products business. It's still a good idea, however, to look for products by the specific companies you've listed in your card file. Even if you can't find representative products for all of them, the additional time spent studying the general market can give you a better feel for the needs of the industry as a whole.

Pursue these markets by writing for photo guidelines. Many such firms review certain categories—Christmas, Mother's Day, calendar photos, etc.—only at certain times of the year. Their guidelines will help you make sure you send them *what* they want *when* they want it. Otherwise you may just be wasting time and postage.

While browsing through greeting cards or displays of any of the other paper products, look for names of companies you don't have listed in your card file. These may be local firms or small operations that prefer not to be listed in the market guides. If you can't find an address, check the library. Send a query letter (with a SASE) and ask about their current needs, rates paid, and the rights they wish to purchase.

Chances are you won't hear from all of them. Some may have gone out of business; others won't be interested in freelance photography. Still others may use their own photos exclusively or purchase only from stock agencies. But those you do hear from may prove to be good, low-competition markets.

YOUR PHOTO PACKAGE

Now that you've examined your photo collection and researched the markets, you're ready to put together a photo package to mail out to an editor. Your two sources of photos for this package will be the slides you already have on file, and those you take specifically to meet the needs of a particular market.

Points to remember. As you prepare your submission, keep the following things in mind.

1. Editors prefer to see slides in clear plastic pages. Those designed for 35mm format hold 20 slides; those for 6x4.5cm or $2^{1}/_{4}$x$2^{1}/_{4}$ inches hold six. Most camera stores stock such pages, or they can be ordered by mail (see Appendix A).

How to Create & Sell Photo Products

2. Even though you have two or three great slides that you *know* an editor will snap up immediately, send at least a full page. To send fewer would be an admission that you have a limited collection—an impression you definitely don't want to create.

 A company's photo guidelines can give you a more precise idea of how many slides to send, but sometimes even that number can be too few. Although you should stick to those guidelines, don't be surprised if your submission comes back with a notation to the effect, "We like your style, but don't see just what we're looking for here. Please send another selection."

3. Always send complete pages. This helps both you and the editor see immediately whether a slide has been misplaced or held for further consideration (or purchased).

4. Match your submission to your market as closely as possible. This is very important. No matter how terrific your grasses against a sunset or your canoe reflected in still water, don't send them to the editor of a motorcycle magazine. Believe it or not, some beginners do just that! Your submission should tell that editor that you are a professional. You've studied his magazine, calendar line, or whatever and are familiar with its format, style, and general photographic needs. An editor's time is valuable, so don't waste it—or the rest of your work may not receive the attention it deserves.

Labeling your slides. Each photo should be identified by a brief caption written on the slide mount. This should include the main subject in capital letters, followed by a short description, including a scientific name where appropriate. Illustration 13-5 shows how this might be done in two cases. A calendar company considering the poppy photo might not be too interested in its scientific designation; on the other hand, that information would be important to the publisher of a flower identification manual—better to plan for all options by complete labeling. Our caption for the second photo indicates that we wish to emphasize a particular geographical feature: Yosemite National

Illustration 13-5: *When labeling your slides, you can put your own identification number on the back to avoid confusion. When sending to an agency, be sure to leave the largest margin blank for the agency stamp.*

Park. If, however, Yosemite Valley were not dominant in the photo but merely the location of a brilliant fall display, we might label the slide "FALL COLOR—Yosemite National Park," or perhaps "FALL COLOR—Cottonwood trees." Make your caption match the emphasis of the photograph.

Each slide should also contain your copyright information. It's convenient to have a copyright stamp made that also includes your address or telephone number (so you can be contacted in case a slide is misplaced).

In addition to caption, name, and copyright information, each slide should have two identifying numbers (not counting the number stamped there by the developer). One of these numbers should refer to your permanent slide filing system (see Chapter 12); the other to the specific submission. Quarter-inch press-on dot labels (available at most stationery stores) work well for the latter purpose. Number each slide in your submission (1-20 for 20 slides, etc.).

Type a list to go with your slides. If you don't type, or if you don't have access to a typewriter (some public libraries have them), get a friend to do it for you. Better yet, buy a used typewriter and learn. Even with an improvised two-finger method, you'll soon pick up enough speed to get the job done. In the long run you'll turn out a lot of lists, and you want them to look as professional as possible.

On the list, type each submission identification number and the corresponding caption, plus any other information you feel is appropriate (slide captions are necessarily brief and this is the place to add any additional explanatory material). Keep a carbon copy for yourself so you'll know what you sent.

Assembling the package. Should you write a letter to accompany your submission? That depends. If there is some important information you believe needs to be included (your price per photo, return mailing instructions, any photo credits you might have that pertain to that specific market, etc.), then write a brief, businesslike letter. Some authorities feel that you should make it a practice to quote prices for your photos. This is easy enough to do if you have some guidelines, either from *Photographer's Market* or from the company itself. Otherwise, knowing how much to ask can be a problem for a beginner. If your price is too high, you could lose the sale; too low, and you lose money. Lacking specific information, you might set your price by checking *Photographer's Market* to see what similar companies pay. Or, since many firms have a set price scale, it might be best to let your slides speak for themselves.

Put your slide pages and list between two sheets of sturdy cardboard (similar to mat board in stiffness) and slip a couple of rubber bands around them. The cardboard should be large enough to overlap the slide pages by a quarter inch on each side. Address a large 10-by 12- or 13-inch manila envelope to your prospective market and another one to yourself (SASE). Fold the SASE and put it inside the envelope along with your slides. At the post office you'll have to ask the clerk to weigh the package and add the necessary postage to the SASE. You may find it convenient to purchase your own postal scale if you anticipate sending out many submissions.

This return envelope is not just a courtesy. It insures that your slides will

be returned. Without an SASE, some companies simply will not bother, and who can blame them? They're in business, too. They can't afford to foot the bill for returning unsolicited slides.

Incidentally, "returned" does not necessarily mean "unsalable." A buyer isn't likely to want all the slides you subimit—the chances of that happening are about as good as poking your lawn with a screwdriver and striking oil. It's much more likely that you'll sell one or two and have the rest returned. But those "returnees" might very well find other markets, so don't give up on them.

Always send slides by first class mail, either insured (at least the minimum $20), certified, or registered. This is expensive, but it greatly increases the odds that your package will be delivered in good condition. You can also use UPS, but for them you will need to use a small box. (Check their minimum size requirements to be sure your package meets them.) Be sure you include enough postage on your SASE to cover the cost of returning them the same way.

The same mailing procedures will work for your black and white photos, although special mailing cartons are available at stationery stores. Caption material can be typed on a sheet of 8½x11 paper, which is then taped to the back of the photo and folded over the front as a protective covering. Or all the information can be typed on a separate sheet as for the slide submission. If your submission consists of too many photographs to fit into an envelope, use a photo paper box as a mailing carton.

Consider your extra photographs as products in themselves. Use direct submission or work through a stock agency to round out your total photo marketing strategy—let those extra shots gather money instead of dust.

PART FIVE

ADDING PUNCH TO YOUR PHOTOS

"Wow! How did he do that?"

Who hasn't had this feeling on seeing a particularly appealing photograph? Sometimes the image is bold and dramatic; other times the effect is so subtle as to go unnoticed except by the trained eye. Whatever the final result, it goes beyond what nature had to offer at that particular point in time.

Mood and special-effects photos have been mentioned many times earlier in this book. While the great majority of slides in a photographer's files will probably have been taken without any special equipment, the use of such equipment can add a dimension that will turn your products and portfolios into real attention getters.

Special effects can rescue ho-hum photographs—transform throwaways into magazine or book cover sales. This has happened to us, and it can to you.

Special effects can also create something entirely new and exciting from an overworked subject, and this can be of critical importance when your marketing area is highly competitive.

While nature herself can come up with some spectacular effects, you may have to wait a long time to get exactly the photo you had in mind. So when you don't want to wait, why not help her along? A mediocre sunset, for example, can be greatly enhanced by simply under-exposing the photograph. Try it. The next time nature paints the sky in cold, uninspired pastels, stop your shots down by one-half, one, or even two f-stops; see what you come up with.

Special-effects photography is a continuum ranging from minimal enhancements through obvious creations and beyond—to fantastic and even outlandish visions. All have their uses and their markets, both as products and in direct submission.

Generally speaking, the bulk of your special-effects products sales will come from the "minimal enhancement" end of the continuum. This is especially true in tourist areas, where people want to remember an area as it was, not as some photographer conceived it to be. They will accept a certain amount of image tinkering to enhance the beauty or mood of a scene, but don't go too far. When it comes to the buying habits of the general public, special effects can be very easily overdone. However, even obvious creations have a definite place in photo decor, as either custom or limited-edition products.

In direct submission the bulk of your special-effects sales will probably be slightly further along the continuum than they would be for products. In fact, less realistic effects, which wouldn't sell well on products, can greatly increase your chances of making sales in this highly competitive area. Even here, however, photos at the far end of the scale may find sales only to photo magazines and books.

Aside from drawing attention to the rest of your work, special-effects photography has another important role. It's simply this: The more you can shake yourself free of the great mass of photographers, the better your chances of hitting it big. If you dare to be different, you could come up with something with truly major appeal, something no one else has done yet. And as a photo product it could make you a fortune.

SPECIAL EFFECTS IN YOUR CAMERA

It's not necessary to be a darkroom technician in order to do special-effects photography. There are plenty of ways to stamp your own individuality on an image before it reaches the film, and that's the scope of this chapter, starting with the easiest way to alter what your camera sees.

FILTERS AND LENS ATTACHMENTS

Filters can be an effective way to transform the images of your imagination into reality. Not everything you come up with will work or be salable; the important point is to begin to expand your photographic horizons.

Go back to your library, browse through the photo books available, study the use of filters by others. Check the *Readers' Guide to Periodical Literature* for back issues of photo magazines with articles on filters.

Read the ads in current photo magazines and send away for catalogs. You'll find not only complete descriptions of the various filters but often ideas for their use as well. Feed this information into your own unconscious idea generator, then follow its lead. Invest in those filters that suit your purposes, and experiment, experiment, experiment. As always, your best results will probably be those you create yourself from your own inner vision.

Remember that filters can be overdone. Extreme color alteration, such as can result from color polarizers, can be interesting but not necessarily salable, except perhaps to specialized markets such as photo magazines. For product use it's best to be subtle, to enhance the natural drama of a scene or develop a mood. The same is true for direct submission, though usually you have a little more latitude.

Choosing a filter system. These days, there are two general categories of camera filters. The old standby screw-in type works fine if all your lenses are the same size. Those who buy only "system" lenses (all Nikon, all Canon, whatever) should have no problem unless a particular lens is highly specialized—an ultra-high-power telephoto, for example. However, for those

of us with a mixed bag of lenses gleaned at sales or for special purposes, fitting them all with screw-in filters can be both expensive and confusing. For example, if a new lens has a smaller diameter than your present lens, a single adapter will make filters usable, but if the lens diameter is larger, you'll probably have to buy new filters.

The alternative is the recently developed square system, which has as its basis a filter holder and various adapter rings to fit lenses from 49mm to 77mm in diameter, so that you don't end up having to buy a new set of filters when you buy a new lens. Depending on the brand, this basic unit can cost under $10. Almost all of the commonly used filters are available to round out the system. They cost about the same as comparable screw-in types and may be easily and quickly interchanged by slipping them in or out of the holder.

The advantage of the square system is its adaptability. By selecting suitable adapter rings, you can fit it to any of your lenses. Thus, even if you update your equipment or switch to a different kind of camera, your filters will still be usable.

For active photographers the square system has one disadvantage. Because of its design, it's somewhat ungainly and susceptible to damage when attached to a lens. This presents no great problem for studio or tripod work; but when you're creeping through the underbrush in pursuit of wildlife or skiing cross-country, it's another matter. Unless you're very careful, you could spend a lot of time backtracking, looking for lost filters and broken holders. Under these conditions it's wise to remove the holder before moving on, or else use screw-in filters.

Filter factors. Since filters are placed between camera and subject, they can sometimes reduce the amount of light reaching the film. This difference is called a filter factor. For most diffusion filters (unless they also add color) there will be no noticeable difference; for a polarizer it might be two f-stops or more.

Most cameras with through-the-lens metering will make the necessary adjustment, but to determine what's right for your camera, test it with and without the filter. The difference should correspond to the factor recommended by the manufacturer. Once you've determined what appears to be the correct exposure, take the photo. Then bracket by taking another shot one f-stop above and a third shot one f-stop below the original exposure. For a complete filter factor chart and discussion, see Kodak's *Filters and Lens Attachments*, available at most photography stores. In the end, however, your own experimentation will best tell you how to get the effects you want from your filters.

The polarizer. If you're a scenic photographer, a polarizer could turn out to be your most frequently used filter, since its effects are both dramatic and natural. A polarizer will darken skies and enhance cloud formations. It can also deepen colors by reducing reflections, particularly on water. This ability to "see through" reflections is also helpful when shooting through glass—at aquariums and zoos, through airplane or car windows, etc. Winter photographers find a polarizer useful for reducing glare on bright, snowy days.

Diffusion filters. Diffusion filters—sometimes called fog or mist filters—are used to create the soft "mood" popular with many greeting card manufacturers. The effect can be that of a uniform mist over the entire photo

How to Create & Sell Photo Products

Illustration 14-1: *A polarizer will reduce the amount of light entering the camera. In theory a through-the-lens metering system should compensate for this; in fact, however, it may not. Test your equipment with and without the filter—there should be a difference of two f-stops.*

Illustration 14-2: *Compare this photograph, taken without a polarizer in the same location on the same day, with Illustration 14-1. Notice how the polarizer darkens a rather undramatic sky and makes the clouds stand out.*

or a sharp center area with diffused edges, depending on your choice of filter. In both cases the mood can be further enhanced by a subtle addition of color (for example, blue for pensive, reflective; yellow for warm, joyful) either as part of the filter itself or by combining it with another. Fog filters range in strength: The stronger the filter, the greater the diffusion.

It's not necessary to buy a mist filter in order to get this diffusion effect. A piece of nylon stocking stretched over the lens and held in place with a rubber band will work nicely. Or if you happen to have an old skylight or UV filter, try smearing it with petroleum jelly. This method will give you the greatest control over the image. Use a light fingerprint touch for a very soft romantic effect or keep the center clear and apply pinwheel stripes to create a swirl focusing on your subject. A word of warning, however: Use a filter you don't need for any other purpose. Once spread with petroleum jelly, it will be almost impossible to get completely clean.

Color polarizers. Color polarizers offer a gradation of color changes. Some are self-contained units; others must be combined with a standard polarizer. A red color polarizer, for example, produces colors that range from a very pale pink to a full red simply by rotating the front element. Thus, one filter can be very versatile.

And that's just a start. Two-color filters allow a different kind of flexibility. A red/blue color polarizer will give you the two primary colors and all the shades in between. All you do is rotate the front element and watch the colors change before your eyes.

Half filters. Half filters, half color and half clear, are available in a variety of shades. A blue half filter can brighten up a lifeless sky, whereas a pink or tobacco one can enhance or even create a sunset. Half filters in neutral gray (neutral density) can be particularly useful when lighting conditions within a single photo differ by as much as an f-stop or more, as might be encountered with reflections. A tree, for example, will normally be "seen" by the camera as brighter than its reflection in a pool of water. The result is either a properly exposed reflection and a burned-out tree, or a tree that's right and a reflection that's too dark. A neutral-density half filter allows both to be exposed correctly.

Some other useful filters. There are numerous other filters, both for black and white and for color. Filters for use with black-and-white film come in a variety of colors. Their function is to heighten contrast or correct the balance between light and dark so that a scene will appear more as the eye perceives it.

Filters for color film, on the other hand, add color, correct problems associated with various types of light, or create a special lighting effect. They come in a variety of solid colors including a sepia tone, which gives photos an "old time" look, and a deep blue, which turns day to night. Especially useful is a light yellow or orange filter, which softens harsh midday light. Such filters also help compensate for the cold blue effect frequently encountered near the ocean.

There are various cross-screen filters that turn any spot of light into a star with from two to eight points (see Illustration 14-4). And there are diffraction gratings that let you add a streak of rainbow color to your pictures. Both work best with small bright highlights.

Illustration 14-3A: *A diffusion filter creates a misty effect, softening the entire photo. Other filters leave the center sharp and soften the edges.*

Illustration 14-3B: *Effects similar to that of a diffusion filter can be created using an old filter and petroleum jelly. The swirl effect is created by applying pinwheel stripes from the clear center area to the outside edge.*

Illustration 14-3C: *Create a striped, pinwheel appearance by swirling the petroleum jelly in a circular pattern.*

Illustration 14-4: *Star filter effect with eight-point star.*

Lens attachments. Also available are lenses that work like filters and attach to your regular lenses like filters. For macrophotography there are screw-in close-up lenses that can be used singly or in combination for a wide range of magnification. For startling special effects there are multi-image lenses that will repeat a subject three or six times on the same photograph!

MAKING THE MOST OF DEPTH OF FIELD

Earlier, we looked at a variety of ways to get diffusion effects in your photos. Another approach to softness is through the use of selective focusing, or depth of field. If you set your lens at a small aperture, say f/11 or f/16, most of what you're shooting will be in clear focus, from things relatively close to infinity (the depth-of-field scale on the lens barrel will tell you more precisely).

As shown in Illustration 14-5, the use of larger apertures, such as f/4 or f/2.8 can sometimes result in a more interesting (and salable) picture. (If the day is too bright for such large apertures, a neutral-density filter can help.)

Special Effects in Your Camera

Illustration 14-5: *Depth of field can be used to highlight a subject by eliminating background and foreground distractions.*

This works best with a longer lens—100mm to 200mm—because the depth of field is generally shorter. Thus, a single flower in clear focus can be made to stand out from a background that becomes a blur of color. Likewise, a distant mountain peak can be framed with soft focus wild flowers. Or a deer may be set apart from a tangle of forest undergrowth by fading the latter to a soft, indistinct mass that doesn't compete with the subject.

Some cameras have a depth-of-field preview button that stops down the aperture so you can see exactly what is and isn't in focus. If yours has this handy feature, make use of it for more creative work. If not, experiment with the depth-of-field scale on the lens barrel. The results are well worth the effort and planning.

DOUBLE EXPOSURES

Gone are the days when a photo of Aunt Fanny unexpectedly has Fido's head on her shoulders. Those mental lapses known as double exposures were usually good for a few laughs and maybe a red face or two. However, modern camera construction has pretty well assured that Aunt Fanny and Fido will keep their respective heads. Unfortunately, it's also made double exposing difficult with many cameras. Now in order to make that old "mistake," you really have to try.

But if you're willing to make the effort, most single-lens-reflex cameras will oblige. Check your manual to see if there are any specific instructions regarding double exposures. Some cameras are better suited than others, but with a little practice with almost any camera, you should be able to add a full moon to a scenic photo, impose a pensive face on a field of flowers—in other words, combine a variety of elements to achieve the effect you wish.

Avoid double trouble. A few simple techniques for double-exposure photography can help you get started.

First of all, refer to your camera manual and follow its instructions. If the manual includes no specific information on the subject, try the following steps:

1. If you've already taken some pictures on the roll of film, begin by taking a blank shot. Do this by snapping the shutter with the lens cap in place.
2. Take up all the slack in the film cassette by turning the rewind crank in the direction of the arrow.
3. When the film is tight, take your first photograph. Next, rewind the shutter without advancing the film as described below.
4. With your thumb hold the rewind knob so it can't turn. Press in on the rewind button (usually on the bottom of the camera) with the little finger of the same hand. This can be done quite comfortably with the camera resting on your other three fingers. Now with your other hand you should be able to cock the shutter without advancing the film.
5. Take the second exposure.
6. Take a second blank shot. No matter how careful you are, the film has a tendency to slip during multiple exposures, and the blank shots are safeguards against the next photo overlapping to spoil your effort.

Illustration 14-6: *A double exposure featuring a giant full moon.*

Now let's consider the photos themselves. Whenever possible, try to keep your background dark and uncluttered. Suppose, for example, you wish to photograph two views of the same face. To begin, set your camera up on a tripod and pose your subject in front of it. Light the subject according to your tastes, but keep the background as dark as possible (preferably black). Take the first view of the face at normal exposure, positioning it so that it occupies no more than half the frame.

As far as the film is concerned, the areas where the face appears are being normally exposed while little or nothing is happening in the dark portions—these can be successfully reexposed with another subject.

Next, rewind the shutter without advancing the film, as described above.

Move your model so that the second view of the face will be recorded on the other side of the frame. Take the second shot, again using normal exposure. As long as the two images don't overlap, there's no need to adjust exposure settings.

If, however, you plan overlapping images—as with the face on a field of flowers—some compensation is necessary. The face, photographed against a dark background, as suggested above, should be underexposed by one f-stop. The second shot—the field of flowers—should also be underexposed to the same degree. If you are planning a *triple* exposure, generally speaking, each shot will need to be underexposed by *two* f-stops. As with many special effects it's difficult to predict the right exposure for every situation. So, to protect yourself, be sure to bracket your shots.

How to Create & Sell Photo Products

Moon over Miami—or almost anything else! It seems to be a law of nature that beautiful moons only occur when, photographically speaking, there's nothing else to include in the photograph. Or if the other elements we want are present, the moon makes its appearance at the wrong time or in the wrong place. Or just when we think we've got everything planned, a bank of clouds rolls in and that's that. No photograph.

Well, there's a simple solution. The next time a terrific moon presents itself, try catching it in a can. Take a full roll of photographs with just moons for the express purpose of double exposures. Or take a full roll with fields of flowers to which you'll later add faces, or use the technique for any of a variety of creative mood effects.

Since the roll will likely be removed from the camera between first and second exposures, you'll have to make some special preparations. Before you shoot the first series of moons, you'll need to record the position of the film in the camera. This can be done by threading the film as usual, then, before closing the camera back, turning the rewind crank to take up any slack within the cassette. When the film is tight, use a grease pencil to mark both the film and a corresponding spot inside the camera (or make a permanent mark in the camera with a dot of paint), as shown in Illustration 14-7. Realign these marks when inserting the moon roll for the second series of exposures, again drawing the film taut within the cassette.

When you're photographing a moon for a double exposure, it must be done at night. At night, the metering system of your camera will often give an erroneous reading as a result of the surrounding dark sky. You can calculate your own exposures for this purpose if you remember that moons are photographed at f/16 at 1 over the ASA of the film you're using. Thus, a moon on Kodachrome 25 film could be photographed at f/16 at 1 over 25, or 1/25 of a

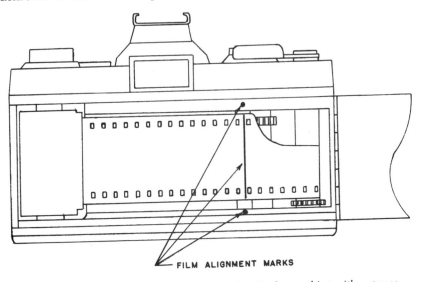

FILM ALIGNMENT MARKS

Illustration 14-7: *Record the position of the film by marking with a grease pencil on both film and camera.*

second. Translating this to a more functional setting, a good moon exposure would be f/8 at 1/125 (or f/11 at 1/125 for Kodachrome 64). For an ASA 400 film the formula would yield an exposure for f/16 at 1/500 (the closest shutter speed to 1 over 400) second.

Except for special circumstances, it's a good idea to keep your moons in the same position. Choose the upper left or upper right corner of the frame when the camera is in a horizontal position. The idea is to have the moon at the top of the picture, whether you're shooting a horizontal or vertical. With this in mind, choose the spot that seems most natural to you. Then position your second sequence of exposures accordingly. Keeping your moons in a consistent position helps ensure that you don't end up with a moon in the middle of a building or a mountain or some equally inappropriate place.

While in most instances the superimposed photograph could be shot without any exposure compensation, it's perhaps more appropriate to simulate late day or even night. This can be done by underexposing the second photo (take two photos—one at minus one f-stop, the second at minus two f-stop, or you can use a blue filter).

THE MAT BOX

A mat box is a black box that attaches to the front of your camera lens and is used for creating vignettes, montages, multiple exposures, and other kinds of in-camera special effects.

Creative use of a mat box allows a photographer to create a variety of twin effects against any sort of background; to frame photos in various shapes such as hearts, stars, and crosses; to produce multiple images on a single frame in various patterns and layouts; to take double exposures using positive and negative masks; and to achieve many other unusual results.

It is, in fact, a valuable creative tool well worth mastering. Start out with the simple effects outlined here, and when you've learned the techniques, free your own creative genius.

You can buy a ready-made mat box along with a variety of masks and accessories (see Appendix A). Some can also be combined with a square filter system for even more creative effects. Or you can save money by constructing your own mat box from simple materials and designing your masks to suit your own purposes.

HOW TO: A Mat Box

Materials needed: an 11x14-inch piece of double-weight mat board (available from photo or art supply stores), some black electrical or heavy-duty strapping tape, and a can of flat black spray paint. You'll also need some squares of clear glass to use for masks.

For lenses that use 55mm filters, you'll also need a series 7-8 step-up adapter ring and a series 7 retaining ring (available from a camera store). If your lens has a different diameter, buy adapter and retaining rings that will fit.

First cut five 4-inch squares from the mat board. In the center of one of the squares cut a hole 2⅝ inches in diameter. Next, cut a front cross brace mesuring ⅜x4 inches. Then cut sixteen strips of mat board, each ¼ inch wide and 4 inches long. Glue eight strips, absolutely parallel to each other and ¼ inch apart (see Illustration 14-8), to one cardboard square and eight strips to anoth-

300 How to Create & Sell Photo Products

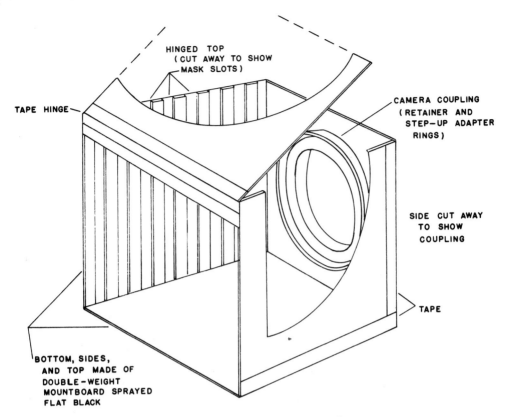

HINGED TOP
(CUT AWAY TO SHOW
MASK SLOTS)

TAPE HINGE

CAMERA COUPLING
(RETAINER AND
STEP-UP ADAPTER
RINGS)

SIDE CUT AWAY
TO SHOW
COUPLING

TAPE

BOTTOM, SIDES,
AND TOP MADE OF
DOUBLE-WEIGHT
MOUNTBOARD SPRAYED
FLAT BLACK

Illustration 14-8: *Construction of a mat box.*

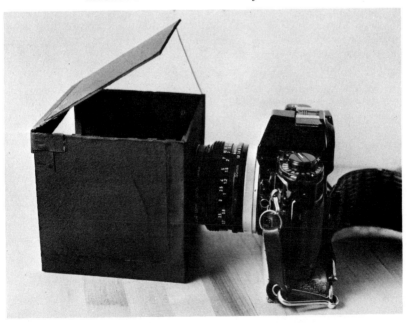

Illustration 14-9: *The finished mat box mounted on the camera.*

er. Now spray both sides of each square and the front cross brace with flat black paint and allow to dry. Apply a second coat if the first doesn't cover completely.

Tape the mat box together as shown in the illustration. The open side is the front; the square with the hole is the rear, the camera side. Be sure the quarter-inch strips are aligned vertically—they will act as slots to hold the masks. The top of the box should be hinged to the front cross brace so that it can be opened and closed to insert the masks.

From the inside of the box insert the retaining ring, pushing the threads through the $2^{5}/_{8}$-inch hole so they show outside the box. Screw the step-up adapter ring in place.

Cut another cardboard square and trim it so that it slips into the slots inside the mat box. It should fit firmly, but slide in and out with ease. Use this square as a pattern to cut (or have the local glass, framing, or hardware store cut) ten squares of clear glass. Ten is a good starting number; you may want more later if you really get involved.

Now you're ready to put your mat box and your creative imagination to work. If, after you've attached the mat box to your camera, it isn't upright, there should be enough play between the two rings so that you can twist it into an upright position. Although primarily a studio tool, it can be used on location if you remember the box isn't designed to take too much wear and tear.

Mat box twins. This effect could be used on custom products: a customer playing chess with himself, for example, or jogging or engaged in brilliant conversation with his double. It also lends itself to humorous situations with animals and a variety of other possibilities.

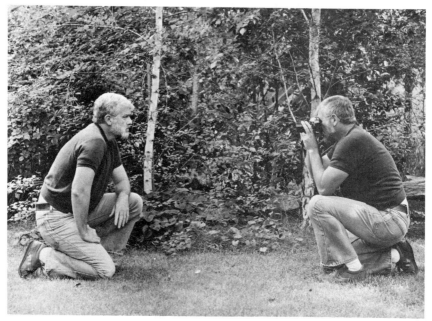

Illustration 14-10: *Mat box twins.*

To create a twin illusion as that shown in Illustration 14-10, cover half a glass slide with masking tape, then spray the other half with flat black paint. When the paint is dry, remove the tape and you'll have a half-frame mask.

Set up your camera on a tripod, attach your mat box, and insert the glass mask in the front slot. Compose the picture with a model (or yourself, if you're experimenting with the technique) posing in the half frame and snap the shot using a normal exposure.

For the second exposure cock the shutter without advancing the film, as described earlier. Then, being careful not to move the camera or the mat box, remove the glass mask, reverse it, and return it to the same slot. Now rephotograph the subject on the opposite side of the frame in a corresponding pose. Again, use the normal exposure. *Voilà!* Twins!

The advantage of a mat box over the double-exposure method is twofold: (1) the background does not have to be dark—in fact, you can use any background— and (2) you can, if you wish, use a different background for each exposure without any of the problems that would result in a double exposure.

Positive-negative masks. Suppose you're working on a series of Valentine photos in which you would like to feature a romantic couple surrounded by a heart shape. Just the job for a mat box.

For this project start by drawing a heart (about 1¼ inches at its greatest width) on a 4-inch square of mat board. Cut out the heart with a sharp knife (an X-acto knife works well). Since you will be using only the surrounding cardboard, be careful to keep it intact.

Take a piece of glass and tape to it the square of cardboard from which the heart has been cut. Spray the cardboard and the glass that shows through the heart-shaped hole with flat black paint. Separate them when dry; you now have (shades of an old-time melodrama!) a black-hearted slide plus a mat board with a clear heart design.

Photograph your romantic couple through the clear heart mask. The result will be as you see it through the viewfinder, with the sharpness of the heart outline determined by three factors:

1. The distance of the camera from the subject (the closer, the sharper). For example, if you're taking a close-up of two heads, the outline will be more distinct than if you're photographing a distant couple on the beach.
2. The placement of the slide in the mat box. Select a slot close to the lens for a soft outline; a slot further away for a more distinct outline.
3. Your choice of aperture. A small f-stop will result in a much sharper heart than a wide-open setting.

Now that you've taken your first shot, let's consider the possibilities using both masks. How about outlining your romantic couple with a red heart, or a field of flowers, or a background of small hearts?

With your mat box you can do all that and more.

To avoid the solemn black border that results when you use only the cardboard mask, photograph your subjects through this heart-shaped hole as before, then change to the black-hearted mask, which will block out the area

already exposed. Cock the shutter without advancing the film. Now take a second exposure to fill that border area. Photograph a piece of red cardboard, for example. Or a field of flowers. Or a bouquet of red roses. Or a sheet of white paper covered with stick-on hearts—whatever you fancy. Since the aperture influences the sharpness of the outline, it's best to keep that factor constant in both exposures. If necessary, make adjustments in shutter speed, not f-stop; this will give you the best match-up in both parts of your photograph.

Hearts are only one possibility. Make masks any shape you wish. Choose a star or a cross or an evergreen tree; choose them to suit a holiday such as Christmas or Easter or Halloween. Use a champagne glass for New Year's greetings or a turkey shape for Thanksgiving. Or for a portrait with a simple oval vignette, place the mask in the front slot of the mat box. One photographer we know even tried the famous Playboy bunny symbol for . . . well, use your imagination. (For product use it's best to avoid such shapes unless you know for a fact that they are not registered trademarks.)

Soft focus effects. Your mat box can also give you those soft, moody photographs discussed in connection with diffusion filters. The process is the same as smearing an old filter with petroleum jelly, except that you use a glass slide instead. Cover the entire glass for a total mist effect or leave the center clear.

A swirl effect can be achieved by applying the petroleum jelly in strokes from the center outward to the edge. Smearing in ever-widening circles will give a different result. Again, do some experimenting on your own. Experimentation is crucial to special effects . . . to fire up your creativity . . . to translate the photographic visions of your mind into dramatic pictures.

WHEN ONE PLUS ONE EQUALS ONE

To paraphrase Sir Walter Scott: "Breathes there a photographer, with soul so dead, who never to himself hath said, 'Boy, I wish I'd taken that photo!'" Maybe it was a perfect V-formation of migrating geese in front of a dramatic sunset. Or perhaps a lone horse with rider against a giant yellow sun in an orange sky. Or a boat bobbing in the purple mists of evening.

So, out you go with camera in hand and idea in mind, off to bag a few terrific shots of your own. But what if the day turns out gray and foggy and the sun makes no appearance at all, let alone igniting a brilliant display as it slips below the horizon? Or what if the sun cooperates and the geese don't, steadfastly refusing to fly across those red and gold streamers? Or maybe no lone cowboy passes through just when the sun is a huge yellow ball. Or you've got plenty of evening mist all right, but it isn't purple, and there's no boat riding at anchor anywhere in sight.

You pack up your gear, muttering a few choice comments about luck—in your case, bad, in the case of those photographers who took those much-admired shots, good. But were they really just lucky? Maybe they were persistent, keeping after that shot until they finally got it.

But there's no natural law that says persistence *has* to pay off. A photographer can persist till his hair turns gray, and there's still no guarantee that all the elements will come together and turn vision to reality. In fact, sometimes none of the elements you seek may turn up. On the other hand, another pho-

How to Create & Sell Photo Products

tographer can turn out those striking pictures with the facility of a magician pulling rabbits out of a hat. What's the difference? Luck? Probably not. Maybe that second photographer has learned to accept the various elements as they come and then assembles them later to his liking. And in some cases he may even set up the elements himself.

The single elements. There are several ways these kinds of pictures can be put together. Some will be discussed here, others in the next chapter, on darkroom techniques.

The first step is to photograph each single element whenever it comes your way. If you see a dramatic sunset, photograph it, even though there's no center of interest beyond the sunset itself. Take several shots, placing the sun in various parts of the frame. Trot out your telephoto (300-400mm) if you have one, and capture some really big suns. (And if, by some bit of incredible chance, a lone rider moves across your viewfinder—or a flock of geese or a soaring hang glider—by all means take the shot and count your lucky stars. These things do happen, but generally not if you stand around waiting for them.)

Now that you've got your backdrop, you need to collect some suitable centers of interest. If you came across a lonely rider on that grim, gray day when the sun refused to shine, let's hope you got the photo. The same for any flock of geese or soaring hang glider or boat at anchor you may have found. Collect interesting images. If the day is grim and gray, all the better. For these foreground images, try to keep the backgrounds as pale and empty as possible. Photograph against a bleached-out sky or a white building. No matter that when you see them as slides you'll feel like hiding them or even tossing them in the wastebasket. Don't do either. They can become some of the most striking photos you've ever taken! (Okay, you can put them in the back of a drawer where no one will see them until you're ready to use them. Just don't forget them.)

Combining the images. Once you have the separate elements, then what?

One approach is to put them together literally—make a photo sandwich and then rephotograph it to create a single new image. Keep in mind when photographing that sandwiching works best (as do other methods of combining images) when one of the slides is primarily light-colored, except for the dominant center of interest (horse and rider, hang glider), which should be close to a silhouette to keep the background slide from showing through. Conversely, areas where you want the background to show through must be as clear as possible. If the hang glider, for example, was photographed against a deep blue sky, that sky would block out much of any sunset behind it.

Test your images to see how they'll work together. Start with two slides you think might match up well, place one on top of the other, and hold the sandwich up to a bright light. Try this with various combinations until you find something you like.

The next step is to make a duplicate slide combining the two. There are numerous devices in all price ranges for this purpose, so the cost and the quality of your dupes can vary considerably. The simplest and cheapest approach, however, is to use your own slide projector and a smooth white wall or piece of

Illustration 14-11: *One overexposed shot of a couple on the beach plus one photo of flowers—a photo that's more than the sum of its parts.*

cardboard. (You can sometimes use a projection screen, but the beading on most will add excess graininess to the final result.) In copying projected images you will lose some sharpness, but the creative latitude makes it well worth the experimentation. And good results will sell—both on products and through direct submission—despite minor problems with graininess.

HOW TO: Rephotographing Slide Sandwiches

Start by purchasing some glass mounts—Gepe double glass binders or Kodak metal and glass mounts. Most photography stores either have them in stock or can order them for you. Next, remove the two transparencies from their cardboard mounts and clean them thoroughly. Use Kodak film cleaner to remove any stubborn fingerprints or dirt. Then finish off with several blasts from a can of compressed air such as Omit or Dust-off. Clean one of the glass mounts as well and place both slides in it, in the position you want them for rephotographing.

How to Create & Sell Photo Products

Set up the projector, insert the sandwich slide, and photograph the projected image. It's a good idea to put your camera on a tripod for maximum stability. And focus very carefully. Each time a slide is reproduced, a little clarity is sacrificed. So in order to make a usable transparency, take great care in focusing both the camera and the projector.

We've had good results using Kodachrome film with no compensating filters. However, this may not be true with all projectors, so do some testing. If the final color isn't satisfactory, take the slide to your local camera store; they can help you choose the necessary correction filter.

THE REAR-PROJECTION SCREEN

Another approach to photographing sandwiches is to use a rear-projection screen. These screens come in a variety of shapes and sizes, ranging from small and relatively inexpensive (18 inches square and under $50) to the large ones used in advertising photography.

Essentially, a rear-projection screen is a translucent piece of plastic designed to eliminate any "hot spot" caused by the projector bulb. The projector itself is placed behind the screen, rather than in front, and the image is projected through it. Instructions are given in Appendix H for the construction of a frame to hold your screen upright.

In addition to using your rear-projection screen for sandwiches, you can use it as a backdrop for still-life setups. Silhouette some dandelion seed heads or some interesting grasses against a sunset or use a colored lightbulb to backlight a floral arrangment—the possibilities are wide and varied.

The rear-projection screen also offers entry into another world of special effects, which, along with a variety of other approaches, will be covered in the next chapter.

THE CREATIVE
DARKROOM

You don't need a darkroom to start and operate a successful photo products business. However, the ability to do your own printing can be a great advantage. Throughout this book we've discussed alternatives to maintaining your own darkroom but the more you experiment with photo product ideas, the more useful it becomes.

And it can pay its way at every step in the development of your business. In the beginning it helps keep costs down. You can afford to print a greater variety of photos than if you were having them done commercially, and this can speed up the testing phase. Since your costs are lower, you can afford to keep your retail prices more reasonable—an important consideration in establishing markets. You can also be more versatile right from the word go—you have the ability to turn out photos in any size or shape needed. This means there are fewer restrictions on the kinds of products you make. Bookmarks, for example, will be easier to turn out and can be produced in greater variety.

As your business grows, you may no longer wish to do all your own printing, simply because of the time involved. Even then, it's advisable to print your own standards, from which your color lab will work. Your darkroom will still be invaluable for developing and testing new photo product ideas, as well as for creating the special effects that will make your work stand out in a competitive marketplace.

LEARNING THE BASICS

If you haven't had any darkroom experience, start by taking some photography classes if they're available in your area. You'll probably have to work your way through beginning and intermediate black-and-white techniques before you get to color.

Although you *can* develop the necessary skills on your own by simply consulting the appropriate books or by some other self-teaching method (home-study courses for example), a formal classroom situation has certain

advantages. First, it can speed up the learning process and make it more efficient, since an instructor is close at hand to answer questions or to catch and correct problems as they occur—subtle problems that a beginner could easily overlook and that could lead to other much less subtle difficulties later on. Second, it can help you develop important contacts among your community's active photographers, professional and otherwise.

Let's go back for a moment to the first of those advantages. For many people one of the hardest aspects of color printing is develping an "eye" for color. This "eye" is crucial to determining correct color balance and to knowing what adjustments to make when things aren't quite right. You can develop this color sense on your own through trial and error, but it comes much faster with outside guidance.

While taking your classes, familiarize yourself with the kinds of equipment available. Talk over the pros and cons of different makes and models with your instructor. Find out what enlarger he recommends and why. This information can be of great help when you're ready to buy your own. Pay attention to the design and other details of the class darkroom—this knowledge can be invaluable when you set up your own darkroom.

Also learn as much as you can about the various color printing systems—Kodak, Cibachrome, Besseler, Unicolor. If possible, try them all to find out which is best suited to your purposes. The best approach to color printing is to find one system that you feel comfortable with, and then stick to it. If you know your system well, results will come more quickly and without a lot of testing.

We take slides exclusively (for our color work) and use the Cibachrome system. It is a simple, direct slide-to-print process, and we like the results. The newer Cibachrome II materials have reduced the contrast and improved some of the more subtle color shades. These advances, along with pearl-finish paper, have eliminated some of the earlier objections to this process.

SETTING UP YOUR OWN COLOR DARKROOM

Your major expense will be a good-quality color enlarger. In addition to talking to other photographers, read all the literature you can gather on the subject. Your local camera store will have some; in other cases you may need to write to the manufacturer. A thorough knowledge of the different enlargers and their special features will make your decision easier. Keep in mind, too, your own eventual goals. If, for example, you don't plan to use any negatives or transparencies larger than $2\frac{1}{4}x2\frac{1}{4}$ inches, you can spend far less for your enlarger than if you involve yourself with larger formats.

Space, too, is a consideration, although it need not be a problem. In the beginning you can operate just about anywhere you can set up your enlarger and get the required darkness.

For a number of years we did all our darkroom work in a four-foot-square closet. Once the enlarger had been installed on a counter along one wall and storage cabinets and shelves on a perpendicular wall, there was barely enough room left over for one person to catch a deep breath, let alone two persons. Talk about togetherness!

It had no fancy stainless-steel sink—in fact, no running water at all. It

may not have been as convenient or showy as some setups, but it had everything necessary to get the job done.

A friend of ours has used a kitchen darkroom for years. He keeps all his supplies and equipment in a specially designed cabinet and has a swing-out arrangement for his enlarger. He's content to work only at night, but heavy drapes could convert the room to daytime use as well. Other photographers have done the same thing with their bathrooms (although if you have a mate, it's easier if he or she is a photographer also!).

So don't let a supposed lack of space slow you down. Find or clear away an empty corner in your house or apartment—kitchen, bathroom laundry room, spare bedroom, closet—whatever is available.

Setting up a darkroom can cost a fortune if you buy the top-line enlarger, color analyzers, temperature monitoring devices, trays to help control temperature, motorized bases for rolling processing drums, and the like. If you're an equipment nut and you've got the money, fine. Otherwise, invest only in the essentials. Most of the frills are convenient but unnecessary. There are plenty of good books (see Appendix B) on setting up a darkroom; use them and any other information you've collected to help you decide what's necessary for you.

If you're on a tight budget, look into the possibility of acquirng used equipment, either through local want ads or from some of the clearinghouses that specialize in this sort of thing (to locate them check the ads in the photo magazines). Many of the larger mail-order camera stores also deal in used equipment.

However, before you buy anything used, shop around—and you may be able to buy new equipment from the large mail-order camera stores (see ads in photo magazines) cheaper than used equipment. Of course, you may find more leeway for bargaining locally, especially if you find someone who's trying to sell everything: enlarger, trays, processing drums—the works.

On the other hand, if you have the money to spend, set up the best darkroom you can afford, including those "frills" that make the job easier. It will be a worthwhile investment in your photographic future.

PRINTING MASKS

Many photo products call for small or irregular-sized prints. Bookmarks, for example, measure 2x4, the smaller plaque photos 3x4 inches. And cards seem to look best with 5x3½-inch photos. It's better to print one 8x10-inch piece of paper with several photographs and cut them apart later than to print individual pictures. There are several reasons why:

1. It's less expensive to use one 8x10 sheet than, say, four 4x5 sheets.
2. It saves time and uses less chemistry to process one large sheet than four small ones.
3. You simply can't buy paper in many of the sizes necessary for product use, and cutting larger sheets accurately in total darkness can be very trying, to say the least.

When you're just starting out in color processing, it may sound impossible to print four card-size photos on one sheet—or worse yet, ten bookmarks—

and get them all right. But as you become familiar with your equipment and the processes involved, the job will become easier and easier. Remember, too, that as your business grows and you learn what sells, repetition will work to your advantage—you'll be printing the same photos over and over. Consequently, you'll have your exposures and color corrections down pat. You can also speed up the operation by printing an entire sheet of duplicates of the same photo.

Constructing a greeting card mask. In order to get four 3½x5-inch prints for greeting cards from one 8x10-inch sheet of photo paper, we created a mask that allows multiple printing. Thus, four 4x5-inch prints may be processed as a single larger sheet, cut apart when dry, and trimmed to finished 3½x5-inch size.

HOW TO: Greeting Card Mask

To construct such a mask, you'll need the following: three pieces of 11x14-inch white or light-colored mat board (the light color makes positioning the image easier), a ruler, a felt-tip pen, an X-acto.or utility knife, and tape. Strapping tape works well because of its strength.

Draw an 8x10-inch rectangle in exactly the same place on two of the mat boards. Use a ruler and measure carefully. It's important that the positioning be correct. Then divide each rectangle into quarters. On one of the rectangles, draw the paper exit slot as shown in Illustration 15-1.

Using a sharp knife, cut along all the lines in mask piece A. As you separate the smaller rectangles (Numbers 1, 2, 3, and 4), be sure you keep them in their original places so they don't get mixed up. Proper fit is essential to prevent light leaks. The piece cut from the exit slot can be discarded.

Add a tape hinge to hold each of the 4x5-inch rectangular doors in place. Put two hinges at the top and two at the bottom, as shown in Illustration 15-2. Add handles made from pieces of tape about 2½ inches long.

Assemble the printing mask as shown in Illustration 15-3. Place mask piece A (the piece with the doors) over the third piece, which is unmarked. Tape them together on all four sides.

For further protection from light leaks, add the top sheet (piece B). Make certain the two 8x10-inch retangles are aligned one on top of the other. Tape only one end so that this top piece swings open.

Finally, number the retangular doors and the corresponding outlines on the top protective sheet—the numbering order should be the same on both sheets. This helps keep track of the printing order so that you don't double-expose one area while leaving another blank.

Using your printing masks. A printing mask is used in the darkroom in approximately the same way as an easel. For illustration, let's go step by step through the procedure for printing greeting card photos. The same steps will apply to other printing masks as well.

First, select four transparencies or negatives with approximately the same printing areas. Don't use one where the whole picture is to be reproduced, a second where only a half frame is desired, a third that requires cropping around all the edges. You could start with just one slide, but if you haven't used it before, you risk four bad exposures. In using four different slides, you can

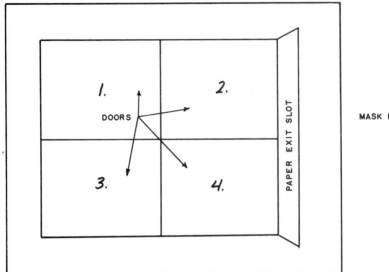

MASK PIECE A

MASK PIECE B
(COVER)

Illustration 15-1: *Two mat boards showing rectangles divided into quarters and paper exit slot.*

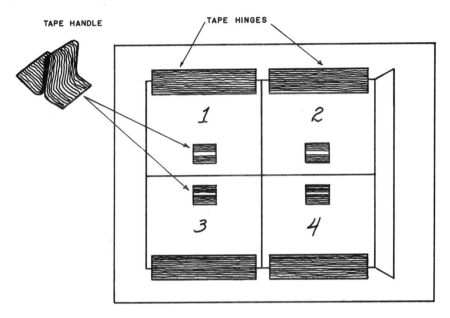

TAPE HANDLE

TAPE HINGES

1 *2*

3 *4*

MASK PIECE A

Illustration 15-2: *Add a hinge and a handle to each door.*

PROTECTIVE COVER (PIECE B)

2

1

4

3

MASK (PIECE A)

TAPE HINGE

TAPE
TOGETHER

BASE (PIECE C)

Illustration 15-3: *Assemble the greeting-card mask as illustrated here.*

test and gain information about each. When you're certain your exposure is right, you can do a full sheet of four on each one. Try to choose slides of about the same density so you can test all four with the same exposure.

In the darkroom place a piece of testing paper (a piece of photographic paper that has been developed and fixed but not exposed to light) in your mask, place a slide in the enlarger and position it so the print will be the correct size, and focus carefully. Once you've made this initial preparation, remove the testing paper. You should now be able to print all four slides without moving the enlarger or refocusing.

When you're ready to start printing, place your paper in the mask in total darkness and close all the mask doors including the top cover. Now you can switch on the enlarger and move the mask until door # 1 is in the proper position. Once the image is in place, turn off the enlarger. Open the top cover and door # 1 in total darkness. Turn on the enlarger, with timer, and make the correct exposure. As soon as you've finished, close door # 1 and the top cover to avoid accidental reexposure.

If you wish, you can now turn on a low-wattage room light to aid in changing slides. With the second slide in the enlarger, turn off any room light and position the projected image as previously described, this time on door # 2.

When all four exposures are completed, remove the paper and develop as you would any 8x10-inch sheet. The card photographs can be cut apart and trimmed to 3½x5 inches when development and drying are finished.

Bookmark and plaque masks. You can adapt the greeting card mask design to bookmarks or plaques by simply altering the number of exposure doors to suit your purposes. For a bookmark printing mask, draw and cut ten exposure doors instead of four. Each door should measure 2x4 inches (see

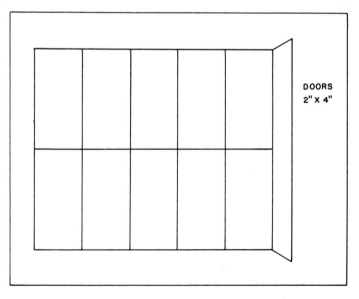

DOORS
2" X 4"

Illustration 15-4: *A bookmark printing mask has ten 2x4-inch doors.*

Illustration 15-5: *A plaque printing mask has six 3x4-inch doors.*

Illustration 15-6: *A combination mask has four plaque photo doors and four bookmark photo doors.*

Illustration 15-4). In the same manner, draw and cut six 3x4-inch doors for plaque photographs. This will waste one inch of paper (see Illustration 15-5). You can avoid this waste by making a combination mask—four plaque photo doors and four bookmark photo doors (see Illustration 15-6).

Message masks for mini-posters. A different type of darkroom mask can be used to put quotations or messages onto mini-posters. Other than your usual darkroom equipment, you will need a sheet of clear plastic (report covers available at stationery stores work well for this—see Appendix A) the same size as the poster you plan to print, and some transfer letters. (Transfer letters come on a sheet of translucent plastic and can be transferred to another sheet of plastic or a piece of paper by rubbing them lightly with a pencil. We use Chartpak Velvet Touch Lettering, which comes in a variety of sizes and styles—also available at most stationery stores.)

First, choose a photo and a message that seem compatible. Transparencies should have a white or light-colored area in which to put the message; negatives should have a dark area. Insert the slide into the enlarger and adjust the image until it's the proper size. Study it carefully and decide on the best location for the message. Put a sheet of plain white paper into the easel and mark the place where you want the message to appear. Using the paper as a guide, transfer the letters by rubbing them onto the plastic sheet, exactly as you wish them to appear in the final print.

In the darkroom put photographic paper into your easel in the usual manner. Align the message mask with the edges of the paper—the message should now be positioned correctly. Expose the print normally. The message should come out printed exactly as planned.

Illustration 15-7: *A message mask and a printed mini-poster, in this case demonstrating poor planning. The lettering is partially obscured by the foreground trees and becomes hard to read.*

Unless damaged, this printing mask can be used over and over again. Or you can rephotograph the poster if you wish to have it printed in volume commercially.

Since finding good messages and transferring them to printing masks takes time, try to choose those that suit more than one situation. "Dare to Test Your Wings," for example, could be used with pictures relating to flight (hang gliders, birds, aircraft such as balloons or airplanes) or feats of daring and adventure (river running, skiing) or simply the growing-up process. Before making a mask, go through your photo collection for appropriate pictures, then choose a message that's adaptable to the two or three you like best.

Calendar masks. The same plastic overlay and rub-on letter technique used for mini-posters can also be used to create calendar masks that allow you to print your calendar right onto the photographic paper along with your picture. The transfer job can quickly become tedious, however, so it's preferable to purchase ready-made calendar masks from commercial suppliers (see Appendix A). Such calendar masks can be purchased in a variety of sizes, for wall or desk use, horizontal or vertical, for use with color or black and white, or for negatives or transparencies.

HIGH-CONTRAST FILMS

The use of high-contrast films will result in striking black-and-white photographs. While noncolor photos are commonly referred to as black and white, they actually contain a great range of grays as well. High-contrast film eliminates those grays, resulting in an image of stark simplicity—if the original composition was well chosen.

This graphic-arts effect can be further enhanced by using a rear-projection screen to add color. The procedure is similar to the sandwiches described in Chapter 14 in that a dramatic backdrop photograph is employed—a sunset or other sun effect, a moon, mist, etc. However, a high-contrast positive takes the place of the foreground photo. The combination can be a real attention getter, both on your products and in the direct submission market. We have had such creations appear on commercial greeting cards, book jackets, and the covers of not only national but international magazines. In short, the technique is well worth your time and effort.

At this point a logical question might be: If I've already got a good silhouette of a runner, why bother with all this high-contrast rigmarole? There are several reasons:

1. Through a high-contrast process you can eliminate any distractions or background colors that exist in your foreground image.
2. You have much greater control over the final results. You can see exactly what's happening and make alterations on the spot, rather than wait until the new image is developed. You effectively do away with the element of chance that plays a big part in sandwiching.
3. Sometimes you have what could be a terrific foreground shot, but the sky is too blue or there are distracting elements that make it unusable for sandwiching. A high-contrast process can make it usable.
4. Your foreground image will be sharper than when duplicating a slide.

HOW TO: High-Contrast Positives

One way to accomplish this is to use a high-contrast film in your camera (Kodak high-contrast copy film 5069 or Kodalith ortho film 8556—the latter must be purchased in 100-foot rolls and hand loaded into cassettes). Some custom processing labs can convert the resulting negative into a positive for you. However, it's much more useful to be able to do your own darkroom work.

For this you'll need the following in addition to your regular darkroom equipment: a red filter—Kodak safelight filter no. 1A—for your darkroom safelight (or you can work in total darkness); Kodak graphic-arts film—Kodalith ortho film, type 3 in the 4x5-inch size—and the appropriate developer.

If you plan to do a lot of high-contrast work, the Kodak developer is the most reasonably priced. It comes with A and B chemicals, each of which makes one gallon. The two are mixed together just prior to each day's use. Tray life is four hours, but as separate solutions they have a fairly long shelf life. Edwal makes a ready-mixed solution called Litho-F in a one-quart size that is more convenient if you plan only a limited number of films. It has a tray life of one week, but can be used for a few hours at a time, then returned to the bottle to be reused at a later date. In smaller communities both Kodalith film and developers may be hard to find, so you may have to plan ahead and order by mail (see Appendix A). When you go to your local camera store, ask for Kodalith film and chemistry, since many people refer to any high-contrast film by the Kodak brand name.

You can start with a color slide, color negative, or black-and-white negative (though the results of course will be in black and white). For purposes of illustration, let's assume you're using one of the color slides you took for your sandwiches—a child with a fishing rod, say, that you want to combine with a sunset.

Dust the slide thoroughly with a brush and compressed air, place it in your enlarger, and adjust the image to a 4x5-inch size (one of the openings in your greeting card mask will work well for this purpose). With only your red safelight on (or in total darkness), remove a sheet of Kodalith film from the box and place it in the mask openining, emulsion side up.

Start with some tests to determine the correct exposure. Do three exposures of ten seconds each: one at f/5.6, one at f/8, and one at f/11. Use cardboard to cover the sections you're not exposing.

Develop the test sheet in high-contrast developer according to package directions. The stop bath and fixer steps are the same as for any film. However, you will be doing your processing in trays. Small trays will conserve chemicals, but if you already have the larger sizes, they will work as well.

When the film has been fixed, rinse it off in water and hold it up to a bright light. Make a careful examination to determine the correct exposure. The blacks must be opaque, with little or no light showing through. (Don't be concerned about a few pinpricks of light—you can eliminate them later.) The white areas should be clear. Pick an exposure that's as close to this as possible. If none of the tests seems quite right, you may be able to estimate the correct exposure based on the test results, or you may wish to do another test.

Once the correct exposure has been determined, proceed with the printing of the negative. Again, when it has been completely fixed, check it against

How to Create & Sell Photo Products

the light. If you can see any light streaks in the blacks, you may wish to try a slightly longer exposure. On the other hand, if the whites look gray, try a shorter one. After you complete this one, follow the same procedure for any additional slides you wish to print. A new test strip may be necessary to determine the correct exposure for each one.

Wash all the negatives thoroughly (a hypo-clearing agent will reduce washing time; follow package directions) and hang them to dry in an area as dust-free as possible.

The next step is to convert these negatives into high-contrast positives so they can be rephotographed. Before doing this, however, go over each very carefully in front of a bright light. With a bottle of Kodak opaque black and a 00 size brush, carefully paint out any unwanted light areas that show through the blacks. Do any required painting on the glossy sideof the negative; if you make an error, it can be washed off.

Now you're ready to return to the darkroom to make the positives. Before turning off the lights, be sure the negative is dust-free and lying emulsion side down. This step is contact printing, using the enlarger as a light source only. Working under your red-filtered safelight (or in total darkness), remove a fresh sheet of high-contrast film from the box. Slip the sheet under the negative, with the emulsion side up (the emulsion side of the negative should be in contact with the emulsion side of the unexposed film). Exposure time is less critical in this step. Ten seconds at f/11 should be about right.

After exposure, develop as before, remembering to check your black areas to be sure they're dark enough. Opaque blacks are critical at this point because you will rephotograph the positives in front of a rear-projection screen. If any light shows through, the believability will be lost. After the positives have been washed and dried, they too can be touched up with Kodak opaque black to eliminate pin-hole light or dust spots.

If in the beginning you choose to start with a black-and-white or color negative instead of a transparency, your first step will lead directly to a positive, and the second step, of course, will be unnecessary.

Black-and-white high-contrast prints can be quite striking in themselves. If you plan to try a few, be sure you make the negatives in a size that will fit your enlarger, rather than in the 4x5-inch size that is good for rephotographing.

Using opaque for additions and deletions. As you work with high-contrast negatives and positives, you'll become more adept at choosing those slides or negatives that work best for this process. You'll also learn what to leave in and what to take out through the use of opaque. We've touched up antlers, legs, and tails on animals, restored wing struts on an ultralight aircraft (they were lost during processing), and darkened ground beneath trees to make it more substantial. On the other hand, we've elimintated distractions such as branches, telephone poles, and even other horses and riders when we wanted only one.

Things that appear just fine in a regular photograph may become strange or confusing shapes when seen in silhouette. Additions on positives or deletions on negatives can help improve the final image, but it's best to keep this doctoring minimal by choosing only those original photographs that are well suited for high-contrast images.

High-contrast creativity. The basic high-contrast positive is only the beginning of a variety of special-effects photos.

The simplest approach is to tape your positive to a clean window where you'll have the sky as a background. Then set up your camera in front of it and rephotograph it with a variety of filters. Or you could tape colored transparent plastic behind it instead. Use a tape that won't leave a gummy residue, such as Scotch Magic Transparent Tape No. 810, available at most stationery stores. You can add any color that seems appropriate to your chosen image. Sunset effects, for example—thumb through any photo book to see how popular silhouettes against orange skies are . . . or pink skies . . . or purple skies.

Any of these can be done with a positive taped to a window. And that's just a start. Experiment with other special-effects filters mentioned earlier, including half filters, diffusion filters (which can be combined with a color filter), or a combination of two different-colored filters using half of each (this can be done with a square filter system by pushing one filter halfway into the frame from the top and a second halfway in from the bottom).

You can get even more creative with a rear-projection screen instead of a window (see Chapter 14). Set up your equipment as shown in Illustration 15-8. A simple frame (see Appendix H) can be constructed to hold the positive in front of the screen. If a frame is used, the background may be slightly out of focus (if there is insufficient depth of field) in the resultant photograph. This can be useful in highlighting the foreground point of interest. To be certain the background will be in clear focus, place the positive directly against the screen.

With the high-contrast positive/rear-projection screen combination, the possibilities are as limitless as your imagination. You can include all or only part of the positive in the photograph. You can create a different mood each time you slip in a different backdrop slide. This is an excellent way to adapt an image to the full spectrum of colors so useful in decor-art photography (see Chapter 7).

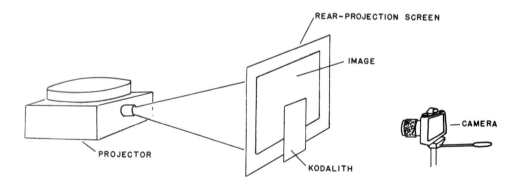

Illustration 15-8: *A rear projection screen set up for photographing a high-contrast positive in front of a sunset or other background image.*

High-contrast positives without a darkroom. What if you'd like to try your hand at high-contrast graphics, but you haven't done any darkroom work, and you don't plan any? The obvious answer is to have someone prepare them for you.

Perhaps the easiest approach—and the one that will give you the greatest control—is to find someone local. Most communities have numerous photographers, many of whom have darkrooms. Locate them through camera stores or clubs. If you live near a college or junior college, the photography department would be another good place to try.

There are several advantages to having your work done locally. First, it will probably be cheaper than turning the job over to a custom processing lab. Second, you can work more closely with a local photographer and learn more quickly what is going to work and what isn't. And a local person will probably get the results back to you sooner.

On the other hand, if it's a case of the blind leading the blind, you might be better off with a professional. It may be difficult to find anyone locally who has experience or enough interest in high-contrast photography to pursue it with sufficient diligence to get the job done properly.

Most large metropolitan areas have commercial color labs, a number of which also offer mail-order service. Check the photo magazines or the Yellow Pages to find one near your home, and query regarding special effects. Faulkner Color Lab, for example (listed in Appendix A), offers zoom and motion effects, composites, posterizations, and Kodaliths in its catalog and claims it will develop any special effect you need.

It will probably be expensive to have high-contrast positives done commerically, but keep in mind that each one can be used over and over to create an exciting variety of dramatic and attention-getting photographs. A few properly chosen positives could be well worth the investment.

MORE SPECIAL EFFECTS IN THE DARKROOM

A great variety of special effects can be created in the darkroom, and an equally large number of books have been written on the subject. Two good ones to help you get started are Kodak's *Creative Darkroom Techniques* and HPBooks's *How to Create Photographic Special Effects*.

Spending time on special effects has its advantages and disadvantages. The main disadvantage seems to be just that—time. Creating these effects can be very time consuming. A second disadvantage is that, even after spending the time, results are not always rewarding. Yet even disappointments add to your knowledge and technique. Here, as elsewhere, your unconscious idea generator can transform failure into success very quickly, and those successes can make the time spent very worthwhile.

Since this is not a definitive special-effects book, we have chosen to deal with only two darkroom techniques: Sabattier effects and posterization. We've chosen these two because they're particularly suited to photo products and direct submissions—eye catching, yet not so far out as to have only very limited appeal—and, generally, they're a good place to start. Both can enhance your black-and-white photography, but they adapt themselves even better to color.

THE SABATTIER EFFECT

Sometimes called solarization, the Sabattier effect is a color reversal effect created by reexposing a print or slide to light while it's in the developer. The technique can be used for both paper and film, including high-contrast film, and for both black and white and color. The resultant image has a sort of positive-negative appearance, as shown in Illustration 15-9. The results are dramatic and unpredictable, sometimes surprising even the photographer.

Equipment. In addition to the usual darkroom equipment, Sabattier effects require a second light source. This can be an enlarger, an unmasked safelight, or even the darkroom light itself. Some photographers prefer using their enlargers because it gives them more exact control over the exposure. This requires moving the tray of developer into a normally dry area, so if you choose this method, anticipate problems and give yourself a little margin for error by placing the developer tray in another larger tray that will catch any spillage.

Illustration 15-9: *The original black-and-white photograph and (see next page) two degrees of Sabattier effect. The darker photo was re-exposed for a longer time.*

Since special-effects people are the "explorers" of the photographic world, they tend to draw their own maps—notes of exposure times, development times, and sort forth. These carefully kept notes are the guidelines for successful duplication of desired effects as well as the basis for further experimentation. *Don't trust your memory.*

HOW TO: Sabattier Effects in Black-and-White Prints

1. Begin by choosing a fairly simple image, since too much detail can be confusing. Starting with a simple image will also make it easier to see the results of the process. It's desirable to have the subject strongly lighted from the side so that the image consists of deep shadows bordered by bright highlights. The boundary line between these contrasting areas is called a Mackie line, a characteristic of the Sabattier effect.

2. Determine correct exposure time by making a test strip as you would for any black-and-white print, and expose the print normally under the enlarger.

3. Put the paper into the developer with the emulsion side up.

4. Develop the picture for about one third of the development time, with normal agitation. Stop agitation about ten seconds before this period is up and allow the print to settle to the bottom of the tray. For example, if your development time is normally two minutes, one third of that time would be forty seconds. Develop the print with agitation for thirty seconds, then allow it to settle in the tray for another ten seconds.

5. Reexpose the print to light for a brief time (we use one or two seconds with the room light). Use a 10-watt bulb in an unmasked safe-light not less than four feet away; your enlarger pushed up to the top and set at f/16 or f/22; or, if the room light is dim, you may be able to turn it on and off briefly. You may have to experiment some to get the correct reexposure time for the method you're using.

6. Continue the development, with agitation, for the remainder of the time (in our example, for the rest of the two minutes). Then complete the processing of the print as you would normally.

If you're not satisfied with the results, try again but do a little experimenting. Three things will influence the final effect: the length of time for the first development, the brightness and length of the reexposure, and the length of the second development. Alter these factors (but only one at a time) until you get the desired results.

With all special effects, instructions are intended primarily as guidelines to help you get started. Differences in equipment and techniques will definitely affect results. Each "explorer" must become familiar with his own equipment and taste through experimentation.

HOW TO: Sabattier Effect Using High-Contrast Film

When the Sabattier effect is used with high-contrast film, the resulting image is similar to a line drawing. It may be printed in black and white, or color may be added through any of the methods described previously.

How to Create & Sell Photo Products

1. As with a black-and-white print, begin your high-contrast process by making a test strip to determine the correct exposure. Then expose the film accordingly.
2. Set your timer for 2¾ minutes. Place the film in a high-contrast developer, emulsion side up, and start the timer.
3. Develop for fifty seconds, agitating continuously. Then let the film settle to the bottom of the tray for ten seconds.
4. Reexpose the film to light for one to two seconds, just as you did for the prints.
5. Continue to develop for the rest of the 2¾ minutes *without further agitation*. This is very important: Agitation of high-contrast film after reexposure can cause mottled or streaked effects.
6. Stop, fix, wash, and dry the film normally and examine the image. Again, experiment until you get what you want. With practice you will be able to see the desired effects emerging and will be able to make your own determination of the correct time to remove the film from the developer tray.

Illustration 15-10: *High-contrast cattails combined with a Sabattier effect.*

HOW TO: Sabattier Effect in Color

The Sabattier effect can be a simple means of getting dramatic effects in color slides. This effect can be achieved in color prints, but if used in creating color slides, the exact same effect can be more easily reproduced over and over.

Needed: Unicolor's K-2 processing chemistry, a color enlarger, small processing trays, 4x5-inch Kodak Vericolor II print film 4111, and a few other items, such as a timer and thermometer, usually available in a darkroom.

1. Pick several color slides with simple, clear images. Remove the mounts and tape them to a piece of clean glass (use your contact printer if you have the glass-topped variety) in a 4x5-inch shape, with the emulsion side away from the glass. Mix your chemicals according to package instructions and place in trays. Maintain their temperatures at 75 degrees.

2. Prepare your film for exposure, in total darkness. Layer your materials in the following order on the easel: first the Vericolor film with emulsion side up, then the slides.taped to the glass. The film and slides should be in contact with each other, emulsion sides together.

3. On the first try, expose the film for sixty seconds at f/5.6 with the enlarger set at 60 magenta. As with other special effects, you may have to experiment a bit to get exactly what you want. And once you become familiar with the system, you can alter color to suit your tastes.

4. The film will be developed for a total of 6 minutes. First, develop in total darkness for 3½ minutes with constant agitation.

Illustration 15-11: *A tree at sunset, reproduced using the Sabattier effect.*

5. When 3½ minutes have elapsed, move the developer tray, with film floating, back under the enlarger. Allow thirty seconds to make the move and for to film to settle, bringing total time to 4 minutes. Reexpose the film to the enlarger light (still set at 60 magenta) for thirty seconds.

6. Remove the film from under the enlarger and continue development for an additional 1½ minutes with agitation, until the total time of 6 minutes is reached.

7. Place the film into the blix (bleach and fix) for 6 minutes with agitation. After this step you can switch on the light and view the results.

8. Wash for three to four minutes in running water, then stabilize with agitation for one minute and dry.

These steps should produce some brilliantly colored slides with dramatic effects. If the colors seem a little muddy, try less light for the first exposure.

POSTERIZATION

Posterization is a slightly more complex process than the Sabattier effect. Most black-and-white photos are printed from continuous-tone negatives; that is, both black and white and the entire range of grays in between are possible in any given print. With posterization a single black-and-white photograph might exhibit only black and white and one or two gray tones.

Posterizations can be made in either the darkroom or your camera. They can be in black and white or color, but all start from a series of high-contrast negatives (for black and white) or negatives and positives (for color) made from a single photo.

Posterization can be done with any number of high-contrast negatives or positives from two on up, although with black and white three or four negatives is about the limit. For color posterizations, however, the number of negatives and positives can run as high as ten or more if you have the time and patience. The black-and-white posterization in this book was made from three negatives.

HOW TO: Black-and-White Posterization

For a black-and-white posterization you'll need the following: high-contrast negatives (we used three for Illustration 15-15C), some method of registering your negatives, and the usual darkroom equipment for making black-and-white prints.

The Negatives. Start as you would for any high-contrast negative—make a test strip. Suppose that after doing tests at ten seconds for each of three f-stops—f/5.6, f/8, and f/11—you determine that f/8 appears to be the correct exposure. For a posterization you will want to do three negatives (if you start with color slides, your first results will be negatives): one at the correct exposure, a second for the same length of time but at one f-stop above, and a third for the same length of time but at one f-stop below. You should end up with one normally exposed negative, another that is mostly white, and a third that is primarily black, as shown in Illustration 15-12. If you start with a black-and-white negative, your first results will be high-contrast positives that must be

Illustration 15-12: *Three high-contrast negatives ready for posterization. The middle photo is correctly exposed for a normal high-contrast negative. The one* on the left *has a high percentage of white (clear), while the one* on the right *is mostly black.*

converted (use contact printing method described earlier) to negatives before you begin printing.

The major problem with posterization is matching your images exactly. The negatives must be put into the enlarger so that your three images match perfectly on the paper. This can be accomplished in several ways.

Using registration pins. For this method you will need a paper punch with two holes permanently fixed in relation to each other and two registration pins—bullet-shaped pieces of metal attached upright to flat strips of metal about 1 inch wide and 2 inches long (see Illustration 15-13). The diameter of the pins should be the same as that of the holes made by the punch.

Start by taping the pins to a flat, rigid surface (a size that will fit under the enlarger) so that the distance between them is exactly the same as that between the two holes made by the punch. This is used while you're making your high-contrast negatives. Each piece of film is then punched and placed over the pins before exposure. The result is a series of images that match perfectly.

This system works well enough if you are contact printing from large negatives. If, however, you want to enlarge the image, problems emerge. First, your flat, rigid surface would have to be glass so that you can project your enlarger light through the image. Second, it must be fitted into your enlarger in a fixed position so that you can be certain that each negative will end up in exactly the same position. Third, the addition of that extra piece of glass means one more surface to keep clean while printing.

A simpler method. For enlarger use we prefer the following method. First, set up your easel. Most are heavy enough to remain stationary during the printing process if you're careful not to bump them. If yours seems light, add some sort of heavy weight. Then, once your slide is in the enlarger, print all of your negatives in one session so that the image ends up the same size and in the same place on each piece of film. Don't fill the entire film with image. You'll need a blank end in which to punch holes.

How to Create & Sell Photo Products

Illustration 15-13: *Homemade registration pins (similar to commercial ones) and a fixed two-hole paper punch.*

Illustration 15-14: *Registration pins taped to a flat, rigid board with the negative in place.*

Illustration 15-15A: *Posterization after first exposure.*

Illustration 15-15B: *Posterization after second exposure. Areas that have been exposed twice have taken on deeper gray tones.*

Illustration 15-15C: *Completed posterization. The black areas are those that have been exposed three times.*

Once the negatives have been processed and dried, examine them over a light table (or some other light source) to be sure the images match in size and position. When the images are lined up, punch all three at once with hand-held punch on the edge of the film. Punched holes should coincide with the film alignment buttons on your negative carrier. Careful alignment of images before punching assures they will remain aligned in the enlarger.

With the first negative (order is not important) in place in the enlarger, do a test strip on printing paper. When printing from high-constrast negatives, times are quite short—probably only one or two seconds. You want to determine the exposure times for a light gray, a dark gray, and a total black. Let's suppose that your tests indicate that times of two seconds, four seconds, and six seconds at f/16 will give you the tones desired. Now, place a fresh sheet of paper in the easel. With that first negative still in the enlarger, expose the paper for two seconds. Replace it with the second and expose for an additional two seconds. Repeat with the third, exposing the same piece of paper for the final two seconds. If all went well, the result should be a completed posterization. Instead of continuous tones, it will have black, white, and only two shades of gray.

Although most people prefer to expose their negatives in sequence (lightest to darkest or vice versa), it doesn't really matter. The results will be the same regardless of the order in which the negatives are exposed.

Troubleshooting. If, on your first try, the image match-up leaves a bit to be desired, try this technique: Take a thin sheet of typing paper and place it in the easel just as you would a sheet of print paper. Pick the places in your pho-

The Creative Darkroom 331

to where match-ups are most critical. For example, on the lion in Illustration 15-15C, both the nose and mouth are important match-up areas, whereas the hair in the mane is less critical. With the first negative in the enlarger, sketch those critical areas onto the paper.

Before you begin your print, test each negative in the enlarger to see that it will line up with your drawing. Now, put the first negative back into the enlarger and align it with the drawing. Then between each of the exposures, take the photo paper out of the easel and put it into some light-safe place, then align the next negative with the drawing. Be sure that you get the photo paper back into the easel the same side up each time.

COLOR POSTERIZATION

Color posterization can be done in a variety of ways. Some photographers prefer to do it in the darkroom with color filters, building up colors one step at a time. Others make diazo (see below) images and sandwich them for posterization. However, both of these appoaches require rephotographing in order to get a usable transparency or negative for mass printing (this is true for the black-and-white process as well). Therefore, we prefer an in-camera process using a rear-projection screen or a light table and camera filters.

Diazochrome film is a nonsilver product available in many colors. It can be sandwiched with slides to improve their color or to create images with bright, contrasty colors for graphic effects. It can be used in ordinary room light so that a darkroom isn't required. The material can be purchased from some graphic supply stores, but may be difficult to locate, especially in smaller communities. For further reading on the subject, try *How to Create Photographic Special Effects*, published by HPBooks.

HOW TO: In-Camera Posterizations

For this process you'll need a minimum of four high-contrast films: two negatives of different exposures and their corresponding positives. Also needed

Illustration 15-16: *Four high-contrast films intended for color posterization: two positives and two negatives. The numbers indicate the order in which they are to be used.*

is some way to add color. Camera filters are excellent if you have them. But you can use almost any material that transmits light.

Using a light table. Begin by lining up your films in the order you plan to photograph them (see Illustration 15-16). The darkest negative should come first, then the lightest negative, the lightest positive, and the darkest positive, in that order. Begin by taping the first film to the light table, but only tape along the top edge. Use Scotch Magic Transparent Tape No. 810. Lay the second film on top of the first; matching up the outside edges should align the images, but check to make sure. Tape this one on the right. Do the same with numbers 3 and 4, taping one on the bottom and the other on the left so that each is taped on a different side. This way each one can be turned back without disturbing those below.

Photograph the films in the following order: number 1 by itself, numbers 2 and 3 together, and number 4 by itself. Use a different (but complementary) color for each exposure. Since this will be a triple exposure, see Chapter 14 for a review of this subject. A slight film slippage in the camera can add to the posterization effect.

Experiment with different exposures. Do a series at normal settings, another at minus one f-stop, and a third at minus two f-stops. Depending on the type of light used in your table, you may need to use tungsten film to be sure of getting good color. Experimentation will give you an idea of what is possible and how to get the results you want. As always, experimentation is the key to success with special effects.

Using a rear-projection screen. With a rear-projection screen you must devise some method for holding the films in exactly the same place for each shot. The simple frame shown in Illustration 15-17 (see Appendix H for building instructions) will accomplish this when used in conjunction with the frame for rear-projection screens described in this book. If your rear-projection screen has a different frame, you may have to make some adjustments.

In using this frame, follow the same steps as with light-table photography. Photograph the films in the following order: number 1 by itself, 2 and 3 together, then 4 by itself. You can add color in one of two ways: (1) use the rear-projection screen for light only and put filters on the camera or (2) choose color slides with large blocks of color that you can project onto the screen.

Obtaining commercial posterizations. As with previously mentioned special effects, many commercial firms will do posterizations for you. They'll be expensive, but could prove worthwhile additions to your portfolios, especially if you plan to specialize in custom photo-art decor. And, of course, they can serve as attention getters in your products line as well.

You might also wish to look into laser printing, a relatively new process that makes possible a great variety of color posterizations (even negative or black and white) from a single color slide. Contact PEC Laser-Color, Fairfield Drive, West Palm Beach FL 33407, for further informaton.

At this point some photographers might wonder whether those days spent in the darkroom are sufficiently rewarding when one could be out taking pictures. For us, and for many other professionals, the answer is an unqualified yes.

Why? Again, we come back to that old problem of competition . . . of

Illustration 15-17: *Snug is the key word here. The frame base fits snugly between the braces on the projection screen frame (see Appendix H). The mount board frame slides snugly into its cove-molding receptacle and opens out for film insertion.*

visibility. Special effects, whether they're used on your products or as part of your portfolios, can help you stand out from the crowd. People may not always buy your special effects, but they do attract attention and they do showcase your versatility and creativity.

Special effects take time and work and planning. The rare exception aside, they don't "just happen." It may take quite a while to perfect the techniques that will give you the effect you're after. But when you achieve it, there's a tremendous feeling of exhilaration and accomplishment at having created something new . . . your own unique vision. And other people's reactions can be equally exciting . . . and often lucrative. This world of special effects is open to any photographer with the imagination and the persistence to turn his or her visions into reality.

APPENDIX A—Supplies and Services

Possibly the best (and certainly the most convenient) suppliers are those you can find locally. Consult the Yellow Pages of your phone book or that of the nearest city to find suppliers in your area. Mail-order suppliers can usually be found through their advertising in photography and crafts magazines. A few of these, whose merchandise, prices, and service we've found satisfactory in the past, are listed below. Chances are, you'll find numerous others equally good.

Contact suppliers on your business letterhead to assure best service. Request catalogs, brochures, or descriptive information and price lists.

CALLIGRAPHY

Calligraphy blanks, custom calligraphy:

Pic-Tocks
P.O. Box 767
Merced CA 95341

CLOCK SUPPLIES

Movements, hands, dial markers, etc.:

Clock Crafters, Inc.
5605 N. Peterson Ave.
Sedalia CO 80135

Klockit
P.O. Box 629
Lake Geneva WI 53147

Primex
720 Geneva St.
Lake Geneva WI 53147

Music box movements:

Klockit
P.O. Box 629
Lake Geneva WI 53147

CUSTOM COLOR WORK

Developing, printing, special effects, etc.:

Faulkner Color Lab, Inc.
P.O. Box 7607, Rincon Annex
San Francisco CA 94120

LaserColor Laboratories
P.O. Box 8000, Fairfield Dr.
West Palm Beach FL 33407

CUSTOM PHOTO PRODUCTS

Postcards, calendars, advertising sheets, etc.:

Kolor View Press
11854 W. Olympic Blvd.
Los Angeles CA 90064

MMM Color Press
107 Washington
Aurora MO 65605

MAILING LISTS

For direct mail advertising:

Fritz S. Hofheimer, Inc.
88 Third Ave.
Mineola NY 11501

Fred Woolf List Co.
Fortune Bldg.
280 N. Central Ave.
Hartsdale NY 10530

METAL PRODUCTS

Hangers, key chains, craft hardware:

Larson Wood Mfg.
P.O. Box 672
Industrial Park
Park Rapids MN 56470

Stanislaus Imports, Inc.
75 Arkansas St.
San Francisco CA 94107

Gallery frames:

Graphik Dimensions Ltd.
41-06 DeLong St.
Flushing NY 11355

PLASTIC PRODUCTS AND MATERIALS

Acrylic sheets, casting and pouring resins, etc.:

Stanislaus Imports, Inc.
75 Arkansas St.
San Francisco CA 94107

Ornaments, plastic frames, cubes:

Accento Craft, Inc.
100 Anclote Rd.
Tarpon Springs FL 33589

Slide storage and submission pages, laminating film, etc.:

20th Century Plastics, Inc.
3628 Crenshaw Blvd.
P.O. Box 3763
Los Angeles CA 90051

SPECIAL-EFFECTS EQUIP-MENT

Camera filters, rear-projection screens, etc.:

Spiratone, Inc.
135-06 Northern Blvd.
Flushing NY 11354

High-contrast materials:

Freestyle Sales Co.
5124 Sunset Blvd.
Los Angeles CA 90027

SPECIALTY PHOTO MATERIALS

Calendar masks and blanks, postcard blanks, texture screens, etc.:

Porter's Camera Store, Inc.
P.O. Box 628
Cedar Falls IA 50613

TSP Corporation
4142 Pearl Rd.
Cleveland OH 44109

Custom photographic decals:

Philadelphia Ceramic Supply
1666 Kinsey St.
Philadelphia PA 19124

Battjes Decals
5507 Twentieth St.
Bradenton FL 33507

Liquid photo emulsion:

Porter's Camera Store
P.O. Box 628
Cedar Falls IA 50613

Freestyle Sales Co.
5124 Sunset Blvd
Los Angeles CA 90027

Rockland Colloid Corp.
302 Piermont Ave.
Piermont NY 10968

Photo decal paper and supplies:

Advance Process Supply
400 Noble St.
Chicago IL 60622

Ulano
210 E. 86th St.
New York NY 10028

Transfer sheets for electrostatic transfer:

Quick-Way Color Copies
100 E. Ohio
Chicago IL 60611

How to Create & Sell Photo Products

WOOD PRODUCTS

Clock kits, photo products supplies:

Pic-Tocks
Box 767
Merced CA 95341

Frames, plaques, boxes, children's puzzles, custom orders:

Larson Wood Mfg.
P.O. Box 672
Industrial Park
Park Rapids MN 56470

Frames, plaques, etc.:

Stanislaus Imports, Inc.
75 Arkansas St.
San Francisco CA 94107

Framing materials:

Mr. Frame, Inc.
7217 Centreville Rd.
Manassas VA 22110

APPENDIX B—Suggestions for Further Reading

PHOTOGRAPHY

General "how to" books:

Feininger, Andreas. *The Complete Photographer.* rev. ed. Englewood Cliffs, N.J.: Prentice-Hall, 1978.

Hedgecoe, John. *The Book of Photography.* New York: Alfred A. Knopf, 1976.

How to Improve Your Photography. Tucson: HPBooks, 1981.

HPBooks. Camera manual series for Canon, Nikon, Minolta, Olympus, and Pentax cameras.

Sussman, Aaron. *The Amateur Photographer's Handbook.* 8th ed. New York: Crowell, 1973.

Direct submission marketing:

Ahlers, Arvel W. *Where and How to Sell Your Photographs.* Garden City, N.Y.: Amphoto, 1952, most recent edition 1977.

Canavor, Natalie. *Sell Your Photographs.* Seattle: Madrona Publishers, 1979.

Engh, Rohn. *Sell and Resell Your Photos.* Cincinnati: Writer's Digest Books, 1981.

Photographer's Market. Cincinnati: Writer's Digest Books. Annual.

Photography Marketplace. 2nd ed. New York: R. R. Bowker, Inc., 1977.

Scanlon, Henry. *You Can Sell Your Photos.* New York: Harper & Row, 1980.

Special effects:

Creative Darkroom Techniques. Rochester, N.Y.: Eastman Kodak Company, 1975.

Horvath, Allen. *How to Create Photographic Special Effects.* Tucson: HP-Books, 1979.

PRODUCTS

Photo product crafting:

Howell-Koehler, Nancy. *Photo Art Processes.* Worcester, Mass.: Davis Publications, 1980.

Newman, Thelma R. *Crafting with Plastics.* Radnor, Pa.: Chilton Book Co., 1975.

Working with Plastics. Home Repair and Improvement Series. Alexandria, Va.: Time-Life Books, 1982.

Product marketing:

Arco Editorial Board. *How to Win Success in the Mail-Order Business.* New York, N.Y.: Arco, 1972.

Garrison, William E. *Selling Your Handicrafts.* Radnor, Pa.: Chilton Book Co., 1974.

National Directory of Shops/Galleries, Shows/Fairs: Where to Exhibit and Sell Your Work. Cincinnati: Writer's Digest Books. Annual.

Schwab, Victor O. *How to Write a Good Advertisement.* New York: Harper & Row, 1962.

Simon, Julian L. *How to Start and Operate a Mail-Order Business.* New York: McGraw-Hill, 1965.

OTHER REFERENCES

Gebbie House Magazine Directory. Burlington, Iowa: National Research Bureau.

Ulrich's International Periodicals Directory. New York: R. R. Bowker, Inc.

MARKET NEWSLETTERS

The marketing guides discussed in Chapter 13 offer general information regarding buyers' photo needs. More specific needs can sometimes be determined by contacting buyers directly, but even that can be too slow: To sell to these rapidly changing markets, you must know in advance what they're looking for, so you can go out and get the necessary shots. You need marketing information that is updated frequently—the more frequently, the better. This is where the marketing newsletters come in—they research these specific needs for you on a continuing basis . . . for a fee. All are sold through subscription; their main goal is helping photographers to sell their work. At the present time, they range in price from $20 a year to around $75. Following are the names and addresses of three of the better-known publications:

Associated Photographers International. *APIdea.* 21822 Sherman Way, Canoga Park, CA 91303.

Engh, Rohn. *The Photoletter.* Osceola, WI 54020.

Writer's Digest Books. *The Photographer's Market Newsletter.* 9933 Alliance Road, Cincinnati, OH 45242.

APIdea is the only marketing newsletter that regularly deals with photo products, but all three of these newsletters offer information on pricing your work. *The Photoletter* recommends quoting a price every time you send out slides, and includes a pricing guide with your subscription. *Photographer's Market Newsletter* provides payment information supplied by the buyer. However, it is intended as a general guideline and "in many cases is open to negotiation within certain limits." *APIdea* suggests prices for various marketing methods. For example, an article on photo decor would recommend prices for prints and related products.

APPENDIX C—The Photo Products Workshop

Although your photo products workshop will require little as far as space, skill, and tools are concerned, there are a few bare necessities.

Many products can be assembled just about anywhere, but it's helpful to have a sturdy table or workbench for those that involve extensive work with wood or plastic. That way you won't have to worry about damaging your furniture while sanding, hammering, or gluing your various projects.

If you can attach a wood vise to your worktable, so much the better. It will serve as a pair of "extra hands" for sawing and gluing. In lieu of a vise, a pair of locking-grip pliers (such as Vise-Grips) will serve a similar function.

Your work area should be well lighted, preferably with an overhead light plus a work lamp that will zero in where needed.

The basic tools:

1. *An accurate ruler for measuring. This should be longer than an ordinary 12-inch ruler. A folding carpenter's rule works well, as does an old-fashioned yardstick if graduated in sixteenths of an inch.*
2. *A combination square or an L-square for measuring angles and obtaining square cuts.*
3. *A backsaw and miter box for cutting frames.*
4. *A retractable utility knife for cutting cardboard and plastic.*
5. *A screwdriver.*
6. *A drill. A ratchet-type hand drill works fine, but a ¼-inch electric drill makes the job quicker and can also be used for sanding and polishing.*
7. *A curved claw hammer for general nailing. A tack hammer is also useful for driving brads in tight situations like adding picture supports to clock frames.*
8. *A pair of slip-joint pliers.*
9. *Sandpaper in various grades.*
10. *Paintbrushes, including one of 1-inch width, and artist's brushes in ¼- and ½-inch widths.*
11. *A can of wood dough or spackling compound for filling joints and nail holes.*
12. *A bottle of top-quality wood glue such as Elmer's Professional Carpenter's Wood Glue.*
13. *A bottle of rubber cement or spray-on photo adhesive.*

Nice but not absolutely necessary:

1. *Corner clamps for gluing frame joints.*
2. *A sanding block for easier sanding.*
3. *A set of hobby knives (X-acto or something similar).*
4. *A crosscut saw for larger projects.*
5. *A wood rasp for rough shaping of wood or plastic.*
6. *A glass cutter.*
7. *A metal straightedge for cutting mat board and plastic (a large L-square works well for this).*
8. *A nail set (or use a large nail).*
9. *A brad starter.*
10. *A coping saw for intricately curved cuts such as those required for puzzles.*

How to Create & Sell Photo Products

APPENDIX D—A Frame Assembly Jig

A jig helps to align the pieces of a frame and hold them in place while the glue sets. A little time invested in constructing the jig will not only make frame assembly quicker and easier but also eliminate the need for corner clamps.

To make a jig for the standard inset clock frame, cut the base from ½-¾-inch plywood to the dimensions shown. Position the sides, made from 2x4-inch lumber, so that the corner is perfectly square. Glue the sides to each other and to the base, then reinforce with nails from underneath. The optional backing clamp, also cut from 2x4-inch stock (dimensions, 17½x14 inches), applies pressure to the frame by means of two rubber bands. Use waxed paper to keep the frame from sticking to the plywood base.

Make a variety of similar jigs to fit the sizes of frames you plan to use.

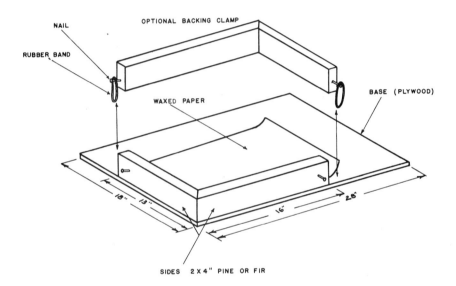

Illustration A-1: *A frame assembly jig.*

APPENDIX E—Copying Bookmark (or Other) Photos

Here is a stand used for copying photographs. If you have one, or one available for your use, this is the best way to copy a page of bookmarks so you can have the entire sheet reproduced commercially.

With a copy stand the camera is attached to an upright column, which is anchored to a base. Your photo is placed on the base. The two lights shine down at equal angles to produce even, shadowless illumination.

Illustration A-2: *A copy stand.*

If a copy stand is not available, set up your own lights in a like pattern. Ordinary lights work well for this purpose (preferably high-intensity lights or spotlights that focus their beam in one direction). Set up two of them to balance each other and use tungsten film in your camera. You could also do your copying outside by fastening your photo to a wall in the shade. In either case, use a tripod to support your camera.

APPENDIX F—Display Racks

Display racks can vary widely in design. Create your own or use the styles shown here.

Print display box. The print display box can be made from ¾-inch thick pine shelving. Choose 4-6-inch-wide shelving for smaller prints, 6-10-inch-wide shelving for larger prints. Make the base from ¼-inch plywood and vary the dimensions to suit the size of the prints you plan to display. The box will work for matted 5x7- and 8x10-inch prints. Glue, then nail all joints, and finish with paint or stain and varnish.

The deeper rack can be used where no counter space is available. A Plexiglas front provides for easier viewing of smaller prints.

Greeting card racks. Adapt the print display box for greeting cards by making a narrower version and adding a center divider. The divider can be made of ¼-inch plywood and offset, if desired, to provide spaces for vertical and horizontal cards. Adjust the front-to-back dimension to suit the space you have available.

A slightly fancier card rack designed for either counter use or wall hanging is shown in Illustration A-9. The back and base are made from ¼-inch ply-

How to Create & Sell Photo Products

Illustration A-3: *Construction details for a print display box designed to sit on a counter.*

Illustration A-4: *A print display box designed to be hung on a wall.*

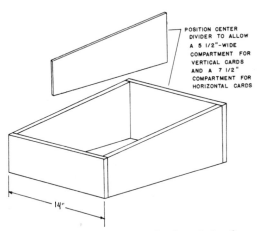

Illustration A-5: *Adapting the print display box design for greeting cards.*

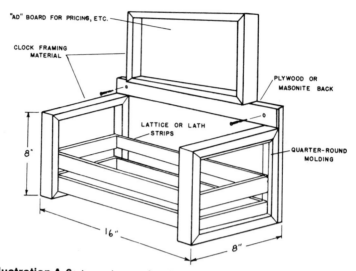

Illustration A-6: *A greeting-card rack that can be hung from the wall or used on a counter.*

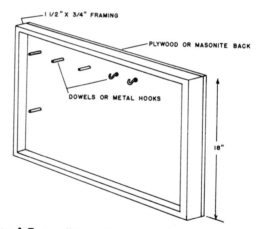

Illustration A-7: *A wall-hung display rack for bookmarks, key chains, ornaments, plaques, and even small framed prints.*

wood; the back measures 9x16 inches, and the base is sized to fit inside the side frames. The side frames are made from the same material used for clock frames (1⅝x¾-inch stock), and the front, side, and back strips from lattice molding. A top frame made of the same material as the side frames will provide space for pricing or for descriptive information about the products or the photographer. All pieces are glued together, and the frames are reinforced at the joints with brads.

Bookmark or key chain racks. A wall rack for bookmarks or key chains may be made from ½-¾-inch plywood and 1⅝x¾-inch framing material. Glue, then nail the corner joints of the frame, then glue it to the back. Use ¼-inch dowels or screw-in hooks for hanging the products. Alter the dimen-

How to Create & Sell Photo Products

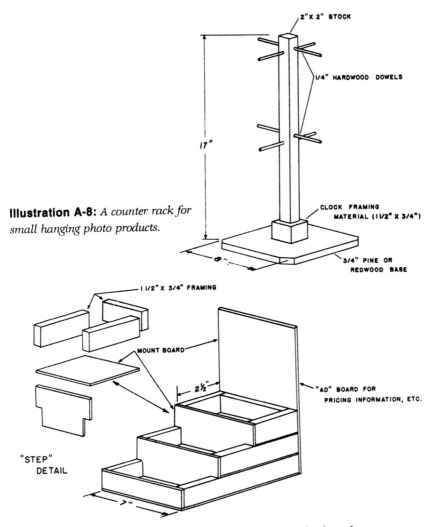

Illustration A-8: *A counter rack for small hanging photo products.*

2"x 2" STOCK

1/4" HARDWOOD DOWELS

17"

CLOCK FRAMING MATERIAL (1 1/2" X 3/4")

3/4" PINE OR REDWOOD BASE

9"

1 1/2" X 3/4" FRAMING

MOUNT BOARD

2½"

"AD" BOARD FOR PRICING INFORMATION, ETC.

"STEP" DETAIL

7"

Illustration A-9: *A step-up rack for photo bookmarks.*

sions to suit the number of products you plan to display and the amount of space available.

A simple counter rack for bookmarks, key chains, and ornaments can be constructed as shown in Illustration A-8. Use ¾-inch-thick pine for the base and 2x2-inch stock for the upright. The upright fits into a socket formed of 1⅝x¾-inch framing and is glued to the base. Drill the upright to accept¼-inch dowels (3-4 inches long) from which to hang the products. The corners of the square base and the top of the upright may both be beveled if you wish (this will help protect them from splintered and broken edges.)

Another style of bookmark counter rack is shown in Illustration A-9 Make each "step" from 1⅝x¾-inch framing material and double-weight mount board. The base and back can be made from ¼-inch plywood or double-weight mount board. The rack may be enlarged by simply adding more steps to the bottom. Glue all materials together.

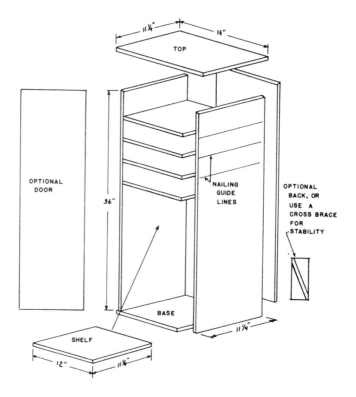

Illustration numbers.

Illustration A-10: *A slide storage cabinet.*

APPENDIX G—Slide Storage Cabinets

This inexpensive cabinet for storing slides in three-ring loose-leaf binders is made from ⅝-inch-thick particle board or ½-inch plywood.

To construct one cabinet, you will need five particle board shelves (4 feet long by 11¼ inches wide). An optional plywood back will add rigidity and dust protection, as will a hinged front door. If you plan to paint the finished cabinet, be sure to do the inside surfaces, including the shelves, *before* assembly. Cut the 4-foot pieces into cabinet shelves according to the dimensions shown in the drawing (two pieces should be divided into four shelves each, and a third into one shelf plus the top and bottom). To simplify installing the shelves, draw nailing guidelines on both side panels, marking the first and last ones 4 inches from the ends and the rest 3½ inches apart. Be sure the guidelines are square with the edges of the side panels. Start three nails along each guideline, then center each shelf opposite the line and finish driving the nails.

Removal of slide books is easier if you cut grip openings (approximately 4 inches wide by 1 inch deep) into the front of each shelf before installation.

How to Create & Sell Photo Products

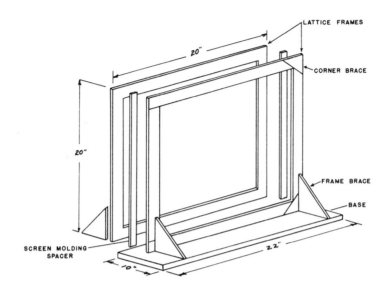

Illustration A-11: *A rear projection screen frame.*

APPENDIX H—Rear-Projection Screen Frame

Make a frame to support your rear-projection screen from 1¼-1½-inch-wide lattice molding, as shown in Illustration A-11. Essentially, the frame consists of two separate frames separated by spacers made from ¾-inch flat screen molding. The corners of each frame are glued, then reinforced with triangular braces cut to fit from ¼-inch plywood. The base is made of ¾-inch plywood, pine, or particle board. Glue the frames and spacers together, then glue the projection screen frame to the base. Cut triangular support braces from ¼-½-inch plywood (or the same material used for the base) and glue them in place.

APPENDIX I—Frames for High-Contrast Positives

Option I. A simple frame for use with a rear-projection screen. Cut two frames as shown in Illustration A-12 from double-weight mount board. Glue them together using ½-inch-wide mount board spacers. Use cove molding or triangular pieces of plywood or lattice to hold the frame erect on a ¾-inch pine base.

Option II. Posterization frame. Begin by cutting two 5x6-inch rectangles from mat board. Then cut interior openings of 3¾x4¾ inches in each. Cut a third rectangle from tagboard with the same outside dimensions but a

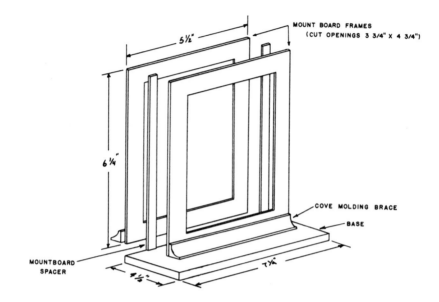

Illustration A-12: *Construction details for a simple high-contrast positive frame.*

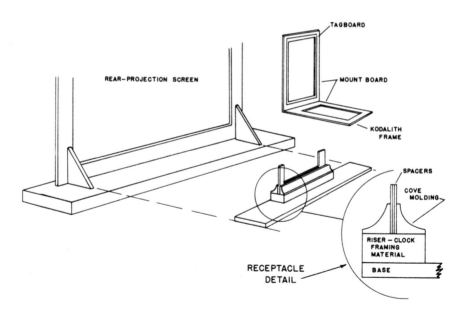

Illustration A-13: *Construction details for a posterization frame.*

larger—4x5-inch—opening. Glue the tagboard piece to one of the mat board frames, then attach the other mat board frame with a tape hinge at one end, as shown in Illustration A-13.

Cut the base of the frame from Masonite or plywood so that it fits snugly between the corner braces of your rear-projection screen frame. The riser should be thick enough to elevate the opening in the mat board frame above the bottom edge of the rear-projection screen frame. Glue the riser to the base. Glue cove molding to the riser to form a receptacle for the mount board frame. Spacers made of the same material as the frame hold the pieces of cove molding the proper distance apart.

The frame may be used in the position shown in the illustration or with the hinge at the top, whichever you prefer.

INDEX

How to Create & Sell Photo Products

How to Create & Sell Photo Products

V

Visibility, *6, 10, 21, 159, 188, 194*

W

Where and How to Sell Your Photos, 276
Wholesale marketing, *195-196*

Window hangings, *89-91*

Y

You Can Sell Your Photos, 266

Z

Zoos, *67, 254*

Other Writer's Digest Books of Interest

British Journal of Photography Annual—The latest developments in the world of photography are summarized in more than 150 color and black and white photos, plus articles on the history, trends, and developments in a range of photographic sectors and a technical section with all the chemical formulae needed to mix processing solutions. $9\frac{3}{4}x10\frac{1}{2}$, 222 pages, $24.95.

How You Can Make $25,000 a Year with Your Camera (No Matter Where You Live), by Larry Cribb—Scores of profitable jobs for freelance photographers that can be found right in your community, with details on how to find and get the job, necessary equipment, what to charge, and more. 194 pages. $9.95 (paper).

National Directory of Shops/Galleries, Shows/Fairs—Lists 2,200 outlets for showing and selling your photography, fine art, and crafts, with information on whom to contact and where, pay rates, terms, and type(s) of work wanted. Articles, illustrations, and interviews provide additional insight into this field. 576 pages, $12.95 (paper).

Photographer's Market—Lists thousands of buyers for all types of photos. Listings give buyers' names and addresses, pay rates, photo needs, and tips on meeting those needs. Plus articles on pricing, copyrights, recordkeeping. 576 pages, $14.95.

Sell & Re-Sell Your Photos, by Rohn Engh—Takes you step-by-step through the process of selling your photos by mail, using the right techniques for each market. Plus advice on taxes, recordkeeping, marketing, and more. 323 pages, 40 b&w photos, $14.95.

Writer's Market—Lists thousands of places to sell every type of writing. Listings give editors' names and addresses, pay rates, editorial needs, and tips on meeting those needs. Plus articles on how to work like a pro. 936 pages, $18.95.

Use this coupon to order your copies!

YES! I'm interested in your photography books. Please send me:

_____ (1083) British Journal of Photography Annual 1983, $24.95*
_____ (1423) How You Can Make $25,000 with Your Camera, $9.95
_____ (1701) 1982/83 National Directory of Shops/Galleries, Shows/Fairs, $12.95*
_____ (1819) 1983 Photographer's Market, $14.95*
_____ (2059) Sell & Re-Sell Your Photos, $14.95
_____ (2706) 1983 Writer's Market, $18.95*
*current edition

Add $1.50 postage and handling for one book, 50¢ for each additional book. Ohio residents add sales tax. Allow 30 days for delivery. 1025

☐ Check or money order enclosed Please charge my: ☐ Visa ☐ MasterCard

Account # _____ Exp. Date _____

Signature _____ Interbank # _____

Name _____

Address _____

City _____ State _____ Zip _____

☐ Please send me your current catalog of Writer's Digest Books

Send to: Writer's Digest Books Credit card orders call TOLL-FREE
 9933 Alliance Road 800-543-4644
 Cincinnati, Ohio 45242 (In Ohio call direct 513-984-0717)

(PRICES SUBJECT TO CHANGE WITHOUT NOTICE)